T5-BPY-937

WILLING TO KNOW GOD

 ILLING TO KNOW

 OD

DREAMERS AND VISIONARIES
IN THE LATER MIDDLE AGES

JESSICA BARR

 THE OHIO STATE UNIVERSITY PRESS • COLUMBUS

PN
682
.V57
B37
2010

Copyright © 2010 by The Ohio State University.

All rights reserved.

Library of Congress Cataloging-in-Publication Data

Barr, Jessica (Jessica Gail), 1976–

 Willing to know God : dreamers and visionaries in the later Middle Ages / Jessica Barr.

 p. cm.

 Includes bibliographical references and index.

 ISBN-13: 978-0-8142-1127-4 (cloth : alk. paper)

 ISBN-10: 0-8142-1127-5 (cloth : alk. paper)

 ISBN-13: 978-0-8142-9226-6 (cd-rom)

 1. Literature, Medieval—History and criticism. 2. Visions in literature. 3. Dreams in litera-
ture. 4. Marguerite, d'Oingt, ca. 1240–1310—Criticism and interpretation. 5. Gertrude, the
Great, Saint, 1256–1302—Criticism and interpretation. 6. Julian, of Norwich, b. 1343—Criti-
cism and interpretation. 7. Pearl (Middle English poem)—Criticism, Textual. 8. Langland,
William, 1330?–1400? Piers Plowman—Criticism and interpretation. 9. Chaucer, Geoffrey, d.
1400. House of fame—Criticism and interpretation. 10. Kempe, Margery, b. ca. 1373. Book of
Margery Kempe. I. Title.

 PN682.V57B37 2010

 809'.93382—dc22

 2010000392

This book is available in the following editions:

Cloth (ISBN 978–0–8142–1127–4)

CD-ROM (ISBN 978–0–8142–9226–6)

Cover design by DesignSmith

Type set in Times New Roman

Printed by Thomson-Shore, Inc.

♾ The paper used in this publication meets the minimum requirements of the American Na-
tional Standard for Information Sciences—Permanence of Paper for Printed Library Materials.
ANSI Z39.48–1992.

9 8 7 6 5 4 3 2 1

For my parents,
Loel Ann Barr and William Douglas Barr

Contents

Acknowledgments

I would like to thank the following friends, colleagues, and organizations for their help in the writing of this book.

Above all, I thank Elizabeth J. Bryan, my advisor, mentor, and friend, whose critical eye constantly pushed me to strengthen and complicate my arguments. Without her, this book could not have been written. Likewise, the support and critical feedback of Michel-André Bossy, Joseph Pucci, and Susan Harvey encouraged—no, *required*—me to become a better scholar and writer. Their astute readings and wide-ranging knowledge has contributed enormously to this project. I also deeply appreciate the patience with which they approached the many versions of these (many) chapters.

I am grateful to the members of the Brown University Mellon workshop on embodiment that convened in 2005–06: Jennifer Feather, Gill Frank, Jennifer Thomas, and Coppelia Kahn. Their questions and insights helped me to better articulate my argument, and Gill's suggestion that we go on sharing drafts after the termination of the formal group provided a wonderful continuation of what had been a very constructive set of conversations. I thank the 2006–07 Fellows of the Cogut Center for the Humanities at Brown; the discussions that occurred in our weekly forum did much to stimulate my thinking and contributed directly to the development of my chapter on Chaucer.

The editorial team at The Ohio State University Press, especially Malcolm Litchfield and Eugene O'Connor, deserve great thanks for their help at every stage of the publication process. I am grateful to Chet Van Duzer as well for his meticulous copyediting. I especially thank Kathryn Lynch and the other, anonymous reader for their astute and critical suggestions. As readers of the manuscript for OSUP, they offered through, sharp, and extremely constructive criticisms that gave me a lot of work to do, but it is work that I am very glad to have done; this is a much better book for their comments.

Further constructive feedback was provided by the readers for two journals that reviewed individual chapters of this book for prior publication. An early version of my study of Marguerite d'Oingt was published by *Mystics Quarterly* in 2007, and the readers who critiqued it offered excellent suggestions for improving the article that would become chapter 2. I am also grateful to the readers at *Modern Philology* who reviewed the article that would become my chapter on *Pearl*. Although that article had to be withdrawn from *Modern Philology*'s publication queue due to the timing of this book's publication, their suggested revisions ultimately resulted in a stronger, better argued, better written chapter 5. I greatly appreciate the time that all of these anonymous readers donated and the care with which they read and commented on my manuscripts. Such work, largely invisible as it is, is what makes scholarly conversation possible.

In addition to intellectual prodding, the writing of this book has required time—time that was provided in large part through generous institutional support from the Department of Comparative Literature and the Cogut Center for the Humanities at Brown University. Oberlin College also helped to make this work possible with an Alumni Research Grant; I am very grateful to Oberlin for its continued support for its graduates. I am also very much indebted to the Richard III Society and the Medieval Academy of America for the Schallek Award that enabled me to bring the initial draft of this manuscript to completion. Finally, I thank Eureka College for providing me with the time and resources to prepare the manuscript for publication.

For emotional support and much-needed distraction I thank my family: Loel Barr, Bill Barr, Pam Ross, and Alex and Faith Barr, as well as Jerry Berke. Their constant love and support have been a source of great strength for me—not just through this project, but always. I also thank my friends, including (but not limited to) Hope Saska, Lilian O'Brien, and Jason D'Cruz, who kept me sane and happy. I thank my friends and colleagues at Eureka College for their interest and support. I thank Derek Ettinger, whose cheerful encouragement saw me through several years of writing and revision. And I thank Bill Wright, for his generosity and care and excellent conversation. Thank you.

Introduction

IVINE VISIONS abound in medieval literature. Dante ascends to Paradise, innumerable saints and holy women hold intimate converse with representatives of the divine, Margery Kempe lies in dalliance with Christ, and Langland's Will observes the Harrowing of Hell in the course of his struggle to come to a "kynde knowing" of God. The widespread appearance of the vision in the literature of the later Middle Ages suggests that visions, if not actually common occurrences, were at least widely accepted as catalysts to spiritual development: the vision is often portrayed as having the capacity to effect a profound transformation in its recipient.

A vivid illustration of the transformative potential of the vision can be found in the late fourteenth-century *Showings* of Julian of Norwich. Julian writes that, although she already believed in Christ and the teachings of the Church, when she was young she "desirede a bodilye sight" of the Passion, wishing to have more "felinge in the passion of Criste" than she already had.[1] Her desixre for a "bodily sight"—a vision—is based on the assumption that such an experience would have a powerful effect on her faith and strengthen her devotion to God. Indeed, the visions that she then receives in her sickness fundamentally change her understanding of the divine; even her first vision, of the blood trickling down from under Jesus' crown of thorns, awakens her to a new profundity of devotion and the assurance that "this was strengh enoughe to me—ye, unto alle creatures lyevande that shulde be safe—againes alle the feendes of helle and againes gostelye enmies."[2] Julian's *Showings* indicates the powerful spiritual and affective

1. Nicholas Watson and Jacqueline Jenkins, eds., *The Writings of Julian of Norwich: A Vision Showed to a Devout Woman and a Revelation of Love* (University Park, PA: Pennsylvania State University Press, 2006) 63.

2. Ibid., 69.

impact that a vision could have, as it transforms her understanding of the godhead and propels her into a deeper devotional experience. She has been given a wholly new outlook on the divine and, consequently, the entirety of creation.

Some imaginative dream vision texts, such as *Piers Plowman,* similarly project a sense of the vision as a transformative force. But *Piers* shows a rather different side of the transformative power of the vision. Instead of documenting the dramatic effects of a visionary experience upon its recipient, it shows a dreamer in anxious pursuit of an experience that could have the power of Julian's visions. That this pursuit takes place primarily in dreams suggests that not all visions have the ability to immediately transform the visionary, as it is unclear whether each of Will's dreams effects a real revolution in his consciousness or in his understanding of the divine.[3] Nonetheless, Will's restless quest indicates that he believes in the possibility of a profoundly transformative experience—something that could move him beyond the superficial knowledge of Christ that he possesses and into the "kynde knowing" that he craves. And finally, it is the vision of the Harrowing of Hell in Passus 18 that most successfully triggers Will's awakening to a knowledge of Christ, prompting him to act for the first time in the waking world. It is after this vision that he goes to church with his wife and daughter.[4] Yet *Piers* ends on an ambiguous note, with Will falling asleep again and witnessing the besieging of Unity Holychurch by the seven sins.[5] Langland's narrative thus questions the efficacy of the vision even as it affirms it. The vision has the power to transform the dreamer and grant him new knowledge, but that power is threatened by—among other things—the dreamer's spiritual and intellectual limitations.

Julian's *Showings* and Langland's poem thus present two faces of the same issue: the vision's ability to impart transformative knowledge to its recipient. In light of this common concern, it is reasonable to assume that their authors shared at least a broad understanding of the utility of the vision in transforming the visionary or dreamer. Of course, there remains a significant difference between these works. Julian's text purports to describe true events; Langland's does not. This difference may, in part, explain the major differences in how they represent the vision's power. In this book, I

3. For a comparison of the validity of dreams and of waking visions in late medieval England, see Gwenfair Walters Adams, *Visions in Late Medieval England: Lay Spirituality and Sacred Glimpses of the Hidden Worlds of Faith* (Leiden: Brill, 2007) 173–75.

4. References are to the B text. Will's decision to go to church occurs at B.XVIII.427–33 (William Langland, *The Vision of Piers Plowman,* ed. A. V. C. Schmidt [London: Everyman, 2001]).

5. See B.XX.74–380.

will argue that it is only through an analysis of this difference—and therefore, necessarily, of both "literary" and "authentic" vision texts—that we can begin fully to grasp the idea of the vision that was current in the Middle Ages.

The terms that I have just used to describe these two types of vision text—"literary" and "authentic"—are, of course, problematic. Indeed, the notion of there being two *types* of vision text at all is problematic, as several scholars have recently demonstrated. Among these scholars is Lynn Staley, who argues that *The Book of Margery Kempe,* a fifteenth-century account of the life of a lay mystic that documents both her private visionary experiences and her struggles against a skeptical world, is more appropriately studied as an imaginative work than as a historical chronicle of a medieval mystic's actual experience. Pointing out that the tendency to equate the author of the *Book* with its protagonist limits the interpretive possibilities of the text and is largely a function of the author's gender,[6] Staley argues that the *Book* may actually be a work of fiction.[7] Whether or not one agrees with Staley's conclusion, her analysis of Kempe's book underscores the literary, constructed nature of even those mystical and vision texts that purport to record authentic experiences. It takes little imagination to realize that visionaries could reorder their experiences for the sake of their retelling, highlight or downplay certain episodes, and alter details in the reconstruction of what they perceived in their visions; furthermore, vision texts and hagiographies themselves have been shown to be carefully constructed narratives whose authors make highly strategic decisions in order to sustain the impression of their subjects' sanctity.[8]

6. Lynn Staley, *Margery Kempe's Dissenting Fictions* (University Park, PA: Pennsylvania State University Press, 1994) 3.

7. Ibid., esp. 171.

8. This is the argument advanced by Else Marie Wiberg Pederson in her article on the theology of Beatrice of Nazareth. Emphasizing the mediated nature of a visionary experience's translation into textual form, she writes, "Instead of viewing the visions and auditions of medieval women, transmitted in their *vitae,* as some expression of direct experience opposed to a speculative, and higher, form of mysticism represented by men, one should see them as literary texts written by authors recognized as such. . . . [T]hey are not unmediated experiences. How can a text ever be that?" (Else Marie Wiberg Pedersen, "Can God Speak in the Vernacular? On Beatrice of Nazareth's Flemish Exposition of the Love for God," in *The Vernacular Spirit: Essays on Medieval Religious Literature,* ed. Renate Blumenfeld-Kosinski, Duncan Robertson, and Nancy Bradley Warren [New York: Palgrave, 2002] 186). For more wide-ranging studies of hagiographic rhetoric, see Thomas J. Heffernan, *Sacred Biography: Saints and Their Biographers in the Middle Ages* (New York: Oxford University Press, 1988) and Rosalynn Voaden, *God's Words, Women's Voices: The Discernment of Spirits in the Writing of Late-Medieval Woman Visionaries* (Woodbridge, UK: York Medieval Press, 1999). I treat this subject more fully in my discussion of *The Book of Margery Kempe* in chapter 8.

Staley's argument is focused on one side of the equation: the ways in which a purportedly authentic vision text resonates with fictional texts, such as *Piers Plowman,* that critique their contemporary social worlds. But the porosity of the boundaries between presumably authentic and presumably fictional vision texts is even more complex. Arguing that the boundaries between "authentic" and "literary" visions—if indeed these boundaries exist—are far more difficult to define than most scholars have recognized, Barbara Newman demonstrates that many vision texts cannot be said to fall clearly into one or the other generic category. Vision texts of both kinds make claims to theological as well as experiential authenticity while also employing literary and even fictionalizing conventions. Mechthild of Magdeburg is perhaps the paradigmatic example of a "visionary" who overtly employs literary strategies to construct her text, creating, for instance, elaborate allegorical dialogues between the soul and Lady Love to express the soul's relationship with God. On the other hand, Christine de Pisan's apparently fictional *Book of the City of Ladies* employs rhetorical strategies suggestive of "authentic" visions.[9] While Newman recognizes that "many, perhaps most, texts fall clearly on one side or the other of the line" demarcating fiction from fact, there are a large number of such "in-between" cases.[10] Even in seemingly clear-cut instances, however, "authentic" and "fictional" fail as accurate descriptors of these texts. In Newman's words, "'authentic' visions, no matter how real the experience they record, necessarily become constructed visions when they come down to us as texts, while 'fictional' visions . . . may convey impassioned and articulate belief by means of allegorical personae."[11]

And yet, it seems like a mistake—or at least an overstatement—to claim that there are *no* generic distinctions between Julian's *Showings* and *Piers Plowman.* Although the categories of authenticity and literariness do not work consistently as ways of distinguishing these texts, they can be useful; after all, Mechthild's *Flowing Light* is a "literary" work of poetry, drama, and allegory, but we nonetheless understand it to have a basis in lived experience that *The House of Fame* does not. Superficially, we do seem to have, if not two different genres, at least two ends of a spectrum of experiential basis. The paradigmatic type of the mystical vision text typically claims to be authorized—or even "authored"—by God himself and relates visions that illuminate doctrinal points, provide evidence of God's grace, or designate an individual as specially chosen by God. Dream vision poets, on the

9. Barbara Newman, *God and the Goddesses: Vision, Poetry, and Belief in the Middle Ages* (Philadelphia: University of Pennsylvania Press, 2003) 19–26.
10. Ibid., 26.
11. Ibid., 33.

other hand, do not usually employ the same kinds of authorizing strategies as visionary authors and their amanuenses. Instead, dream poems often hearken back to classical models—essentially literary models—as a means of establishing authority rather than laying claim to direct, divine inspiration. At first glance, too, the purpose and subject matter of the dream vision distinguish it from the revelatory vision. Dream visions do not address exclusively Christian subjects, but may instead concern themselves with such topics as love sickness (*Le Roman de la rose, La Fonteine amoureuse*), an individual's death (*The Book of the Duchess*), and questions of ethical behavior (*Wynnere and Wastoure*). Dream visions frequently employ allegory and do not always express a declared concern with eschatological, salvific, or doctrinal matters, whereas visionary literature is usually at least partly theological. But of course, some dream visions—such as *Piers Plowman,* the *Divina Commedia,* and *Pearl*—do explore religious issues and seek to make valid theological claims via the construct of the vision, and some mystical texts—such as *The Flowing Light of the Godhead* and Henry Suso's *Life of the Servant*—employ the literary technique of allegory to describe their authors' experiences. Subject matter and claims to the authenticity of the text's message cannot be used to distinguish these works.

We may, however, fruitfully compare the relationships between these texts' narrators and their authors. Most mystical vision texts feature narrators who are idealized representations of the visionary subject; even narratorial self-effacement reflects such an idealization, as humility was an important part of the evidence used to assess the sanctity of the visionary.[12] But the narrators of the dream vision poems that I will discuss in the second half of this book seem to be *counter*-idealized.[13] The dreaming Jeweler of *Pearl,* while not precisely a bad person, is not, in his inability to focus his attention upon the image of Christ, an embodiment of holiness; Langland's Will is stubborn, quarrelsome, and surprisingly sleepy; and *The House of Fame*'s Geffrey is fearful and a trifle ignorant. This difference from mystical vision texts is important, as it establishes a distance between the author of the text and its contents. While this assuredly is not the only or even a consistent distinction between dream vision poems that are more or less

12. Voaden notes that, while "[w]riters in the early Church tend to look to the fruits of spiritual revelation" to determine the vision's validity, "the scholastics were more concerned with the virtue of the visionary." This shift had important implications for women visionaries "and is reflected in the emphasis in the discourse [of *discretio spirituum,* or the discernment of spirits—the process used to test the validity of a vision] on meekness and submission" (*God's Words,* 49).

13. The term is Newman's; see *God and the Goddesses,* 14 for a discussion of this quality in *Piers Plowman.*

clearly works of fiction and accounts of mystical visions that might be presumed to have a basis in lived experience, it does offer us a rough means of conceptually distinguishing between the two kinds of text—a way that, as I discuss in chapter 8, still leaves *The Book of Margery Kempe* in a state of tantalizing ambiguity.

Where, then, ought we to draw the boundaries between vision texts that are to some degree taken to be true, and those that are not? And how are we to distinguish between these types of text—as in a comparison between Julian's *Showings* and Chaucer's *Fame,* where a distinction seems largely indisputable—when no terminological or categorical distinction truly holds up to scrutiny? In an important sense, the need to make these distinctions reflects a limited understanding of medieval vision texts in general. This book argues for the necessity of reading both presumably "fictional" and "nonfictional" vision texts in relation to one another as parts of a larger dialogue in which they both shared. On the other hand, in order to make this argument, I will need at times to refer to these works within their conventionally held generic categories. Adhering to at least a superficial distinction between "authentic" and "literary" vision text allows us to examine the ideas underlying the use of the vision in late medieval literature. I have, in the course of writing this book, weighed and rejected a number of lexical possibilities for making this distinction. Although none has proven entirely satisfactory, for the sake of clarity and efficacy I will simply use the term "visionary" literature (or text) to designate accounts of visions that were presumably experienced by their narrators and "dream vision poems" to designate those that were not. When I have used the terms "authentic," "mystical," or "literary," it is merely to avoid confusion and is not intended as an assertion of strong categorical distinctions.

Until recently, most scholars have taken for granted that "literary" and "authentic" vision texts occupy clearly discrete categories. Scholarship that focuses on medieval visions has tended to be split into two different disciplines, with visionary literature largely relegated to the field of religious studies and dream vision poems considered the province of literary scholars. In recent decades, however, the boundaries between the two genres have begun to break down, as visionary literature has come to be studied by literary scholars as well as by scholars of religion.[14] Yet very little critical

14. This development may be attributed in part to the rise of feminist scholarship. Because most of the literature known to be written by women in the Middle Ages falls into the category of visionary literature, considering this genre is essential to the reconstruction of women's roles in medieval literary and social history. See, for example, Elizabeth Petroff's introduction to her anthology of visionary literature by women, in which she discusses these works' "literary significance" (Elizabeth Alvida Petroff, *Medieval Women's Visionary*

work has examined from the same vantage point both mystical visionary literature and dream vision narratives. Few scholars have attempted to establish an explicit connection between these two literary modes,[15] even though they both achieve their fullest flowering at roughly the same time— a number of visionary texts were produced between the thirteenth and the fifteenth centuries,[16] while the thirteenth-century *Roman de la rose* seems to have rekindled interest in the literary dream vision.[17] The fact that many dream vision poems were written during the period in which visionary literature was in its fullest blossoming suggests that the two "genres" did not develop in isolation from one another, despite the fact that they stem from different traditions. The contemporaneous predominance of both kinds of vision text provides a clue to late medieval theories of epistemology, perception, and the acquisition of transcendent knowledge, issues that are particularly apparent in several fourteenth-century English dream poems that engage actively with the difficulty of apprehending the divine.

This book argues for the necessity of reading these two kinds of vision text as manifestations of a shared set of presuppositions about the visionary

Literature [New York: Oxford University Press, 1986] 21). Other seminal works that consider women's visionary writing within the framework of literary studies include Katharina M. Wilson, *Medieval Women Writers* (Athens: University of Georgia Press, 1984); Peter Dronke, *Women Writers of the Middle Ages: A Critical Study of Texts from Perpetua († 203) to Marguerite Porete († 1310)* (Cambridge: Cambridge University Press, 1984); Barbara Newman, *From Virile Woman to WomanChrist: Studies in Medieval Religion and Literature* (Philadelphia: University of Pennsylvania Press, 1995); and Laurie A. Finke, *Women's Writing in England: Medieval England* (London: Longman, 1999).

15. Recent exceptions to this general neglect include Newman's *God and the Goddesses* and Renate Blumenfeld-Kosinski's *Poets, Saints, and Visionaries of the Great Schism, 1378–1417* (University Park, PA: Pennsylvania State University Press, 2006). An earlier example of such a study is Denise Despres' *Ghostly Sights: Visual Meditation in Late-Medieval Literature* (Norman, OK: Pilgrim Books, 1989). Despres considers the influence of Franciscan techniques of visualization upon such works as *The Book of Margery Kempe* and *Piers Plowman;* although her work spans both visionary and dream vision literature, however, her focus is not upon drawing explicit connections between them but rather on considering an influence that was shared between both kinds of works.

16. Finke discusses the enormous proliferation of visionary and devotional women in the thirteenth through the fifteenth centuries in *Women's Writing in English: Medieval England,* 125–26.

17. Steven Kruger remarks that the "middle vision," which is neither assuredly somatic nor assuredly divine and is therefore characteristic of dream vision literature that probes inner experience and questions the fruitfulness of revelation, comes to prominence only in the later Middle Ages (Steven F. Kruger, *Dreaming in the Middle Ages* [Cambridge: Cambridge University Press, 1992] 130). The dream vision poems of this period include *Le Roman de la rose, Pearl,* and Chaucer's dream poems, and are distinct from the "instrumental" dreams that appear in, for example, Middle High German epics. (For an analysis of the dream vision in Middle High German epics, see Steven R. Fischer, *The Dream in the Middle High German Epic* [Bern: Peter Lang, 1978]).

experience. It is my contention that a specific understanding of how visions "worked" influenced and structured medieval dream vision poetry, especially English dream poems of the fourteenth century. While we cannot know whether the authors of these dream poems were actually acquainted with specific visionary texts, it seems clear that a broad cultural understanding of the value and limitations of the vision informs their narratives, which in at least several cases openly question the vision's ability to convey knowledge to its recipient. At the same time, an analysis of the vision's status in dream vision literature helps to illuminate the assumptions underlying mystical visionary literature. In the following chapters, I examine the use of the vision as an epistemological tool in both kinds of vision text by focusing on visionaries' and dreamers' practices of *visionary knowing:* the combination of innate abilities and cognitive strategies that they are shown to employ in order to receive and ultimately comprehend the knowledge granted in their visions. I argue that the vision's success depends upon the recipient's engaging with its content both actively and passively. Visionary knowing, in other words, does not always simply "happen" through a flash of divine insight, but may instead require cognitive and volitional work on the part of the dreamer or visionary. When that work is misdirected, the vision does not succeed.

Dream vision poems are an essential complement to visionary literature because they are able to show visions that *fail* to communicate knowledge to their dreamers. Because the authors of dream vision poetry were not constrained by the necessity of transmitting divine knowledge or presenting themselves as idealized figures of unimpeachable religious authority, they were free to depict visionaries or dreamers who did not immediately grasp the content of their visions. Dream vision poems and visionary texts can therefore expose two very different faces of the epistemological potential of the supernatural vision: while mystical visionary texts typically describe visionaries who successfully grasp the meanings of their experiences, dream vision poems can feature dreamers who do not learn from their visions, thus exploring the limits of revelation's potential to convey knowledge. Reading these two genres together, then, tells us a great deal both about the role of the vision in the Middle Ages and about the role that the psychological faculties were thought to play in visionary knowing. Such a comparison gives us a far fuller picture of what it meant to have a vision in the Middle Ages than would a study of one literary category alone: ultimately it enables us to discern the shadowy workings of the vision itself—how it was understood and what, it was believed, had to happen for it to effectively communicate divine knowledge.

Chapter 1 lays out the terminology that I will be using throughout this book. My readings of the vision texts that follow depend upon a number of seemingly dichotomous categories: active and passive, educative and revelatory, *intellectus* (intuitive understanding) and *ratio* (reason). While the terms in each of these major pairings seem opposed, my work will argue for their interrelationship; active and passive engagement, reason and revelation must work together for the vision to be effective. Prior to demonstrating the interactions of these terms, however, I must show what the terms mean, and in the second half of chapter 1 I read three major dream visions that present an educative approach to knowledge and that illustrate the categories that inform my argument. These dreams—Boethius's *De Consolatione Philosophiae, Le Roman de la rose,* and Dante's *Divina Commedia*—depict dreamers who ascend to visionary knowledge in a more or less orderly, rational fashion and do not openly question the vision's ability to convey knowledge—although the *Commedia* already shows the necessary interplay between *ratio* and *intellectus,* as the ordered ascent led by Virgil gives way to the loving revelations of Beatrice in later cantos of *Purgatorio* and in *Paradiso.* This chapter frames my later analyses by showing effective dream visions that can be compared to "authentic" visionary literature. The book's central argument, however, is developed in chapters 2 through 8; these chapters address four visionary texts and three fourteenth-century English dream poems. For each text, I consider how knowledge is received in the vision, what preconditions the visionary or dreamer must meet for the transmission of that knowledge to be successful, and what limitations upon visionary knowing these preconditions reveal. The answers to these questions suggest a clear conceptual link between dream vision poems and visionary literature in that, in both, knowledge is seldom simply handed over to the visionary or dreamer. But whether or not the visionary appears to be spontaneously imbued with divine knowledge, there is almost always a precondition that must be met for such knowledge to be received and understood. First, the visionary or dreamer must be properly motivated by a love for God; second, the visionary or dreamer's will must be directed by that love and, therefore, in accord with the divine will; and third, the visionary or dreamer's cognitive faculties must be driven by his or her rightly motivated will.

The three visionaries that I discuss in chapters 2 through 4—Marguerite d'Oingt, Gertrude of Helfta, and Julian of Norwich—all exemplify these characteristics, albeit in different proportions. I selected these three visionaries, who come from different regions and traditions and span about a century and a half, in part to illustrate the recurrence and persistence of

these characteristics. But the differences between their modes of visionary knowing are equally significant. Although all three mystics exemplify the importance of the rightly ordered will and the necessity of employing both *intellectus* and *ratio,* their means of apprehending and understanding the visionary message are distinct. Marguerite d'Oingt's climactic moment of visionary comprehension is realized through the proper understanding of a single word's meaning, a meaning that is only available through a viscerally experienced allegorical vision. Her quest for the meaning of *vehemens* and its fulfillment indicate the potentially edifying role of language in visionary knowing—but only when language refers to its proper, i.e. divine, referent. Her ability to understand the word (and therefore the divine) is based upon her volitional turn to God. The visionary knowing of Gertrude of Helfta, a thirteenth-century German mystic, is similarly founded upon a volitional union with the divine. Her knowledge, however, is ultimately revealed both through direct visionary experience and through the divinely sanctioned use of her own powers of reason and reflection. As the Lord tells her, "all of the angelic spirits must submit to your pious desires . . . henceforth they will do whatever is pleasing to you";[18] a vivid confirmation of Gertrude's God-given intellectual and volitional abilities, this utterance validates the text and the mystic herself in a radical affirmation of cognitive agency. Finally, Julian of Norwich's *Showings* documents the process of reflection and meditation that she must undergo in order fully to understand her visions. In the changes from the Short to the Long version of her text, we witness Julian's increasing integration of *intellectus* and *ratio* as she explicitly employs rational reflection in the process of coming to know. All three of these women, despite their differences, illustrate the ways in which reason and understanding are integrated into the visionary experience, as well as the powerful role that could be played by the mystic's will.

Pearl and *Piers Plowman,* on the other hand, depict narrators who fail across one or more of these dimensions, and therefore cannot—or cannot without great difficulty—achieve the full knowledge that their visions attempt to convey. The problem with knowing in *Pearl,* the subject of chapter 5, is the dreamer's improperly directed will; his unwillingness to subordinate his will to God's becomes apparent in his argument with the Maiden and his resistance to her transcendent message. This resistance, which indicates an excessive reliance on his rational faculties and an attachment to the material world, ultimately prevents him not only from fully absorbing the contents of his revelation, but also from actually desiring divine

18. Gertrude d'Helfta, *Œuvres spirituelles,* ed. Pierre Doyere, 5 vols., Sources Chrétiennes 127, 139, 143, 255, 331 (Paris: Les Éditions du Cerf, 1968) 4: 2.15, SC 4: 44–46; my translation.

knowledge. Conversely, as I discuss in chapter 6, *Piers Plowman*'s Will desires the illumination of his *intellectus* but seems stuck in the quarrelsome mode of rational argumentation and education. *The House of Fame,* which is the subject of chapter 7, differs from these other texts in that it does not depict an explicitly Christian vision. What it reveals, however, is the importance of a functionally authoritative speaker to the success of the vision and the role of the dreamer's faculties in determining the vision's meaning and source. I conclude with a chapter on Margery Kempe that both posits the importance of visionary knowing to Margery's spiritual practice and engages with the issue of the boundary between "fictional" and "authentic" vision texts. Examining how the validation of Margery's visionary knowing enables her to engage in her desired devotional praxis while also asserting her sanctity to her readers, I argue that the need for such validation reveals the uncertainty of visionary knowing in the changing landscape of late medieval English spirituality.

The core of this book is thus a comparison between the writings of four female mystics and three presumably male-authored dream poems. The gendered nature of this comparison is not accidental. Through my analysis I hope to suggest the intersections between the writings of medieval women mystics and the male-dominated discourses of poetry, theology, and philosophy. Marguerite, Gertrude, and Julian engage with many of the issues raised by authors such as Chaucer and Langland (not to mention Aquinas and Augustine, whose theories inform much of my study); implicit—and, at times, explicit—in their writings is the awareness of a broader intellectual culture. Few scholars would deny, at this point, that visionary women of the Middle Ages had an understanding of their religious and cultural contexts; their works are no longer seen as the childish aberrations that many earlier scholars characterized them as being.[19] By placing them in dialogue with dream poems—in particular the dream poems of late fourteenth-century England, texts that at first glance seem rather distant from, especially, Marguerite and Gertrude—I explore the pervasiveness of the medieval understanding of the vision's efficacy and

19. Consider, for example, Wolfgang Riehle's criticism of Margery Kempe's "crude realism which intrudes in a very embarrassing manner" and his remark that she "draws a much too forceful analogy between her mystical love and her earlier married sexuality" (Wolfgang Riehle, *The Middle English Mystics,* trans. Bernard Standring [London: Routledge & Kegan Paul, 1981] 38), or, from the earliest years of the twentieth century, William James' comment that Gertrude of Helfta's revelations are "of the most absurd and puerile sort." Her text, James adds, is a "paltry-minded recital. In reading such a narrative . . . we feel that saintliness of character may yield almost absolutely worthless fruits if it be associated with such inferior intellectual sympathies" (William James, *The Varieties of Religious Experience* [New York: New American Library, 1958] 269).

the extent of the challenge posed to this understanding in the fourteenth and fifteenth centuries. This exploration, in turn, illuminates some of the issues confronting medieval visionary women, who may have been particularly vulnerable to charges of inauthenticity and heterodoxy.

By examining dream vision and visionary literature in light of one another, then, we are able to gain a far greater understanding of how the vision was understood in the Middle Ages than we can through the study of one genre alone. The idea of the mystical vision informs dream poems, while dream poems expose the status of the vision itself. Examining these "genres" and comparing their representations of visionary knowing powerfully foregrounds the active role that the visionary or dreamer had to play in the comprehension of the vision while problematizing the generic distinctions between them. By featuring counter-idealized narrators who are limited in their volitional or intellectual abilities, dream vision poems could evade the necessity of asserting either the visionary subject's sanctity or the divine authorship of their messages, the establishment of which is fundamental to many visionary texts' claims to authenticity and authority. The writers of dream vision poems were thus free to explore the possibility of a visionary experience's being unsuccessful, thereby highlighting the qualities and characteristics that were seen to be necessary for a vision to achieve its aim. By comparing these texts' approaches to the possibility of knowing from a vision, we can learn far more about the role of the visionary or dreamer in coming to grasp the vision's content than we could from either one in isolation. Arising out of a similar cultural understanding of the workings of the human mind, they expose different sides of the same assumptions about what was necessary for a vision to succeed.

1

Knowledge and
the Vision in the Middle Ages

1. Active Understanding and the Rhetoric of Passivity

Visionary knowing, or the reception of knowledge through a visionary experience, is often superficially figured in medieval vision texts as a transparent process that takes place with little or no active participation on the part of the visionary or dreamer. The vision occurs and the visionary is enlightened; according to this model, the recipient is a passive vessel infused with divine knowledge through the medium of the vision. Such a model of visionary knowing is suggested in the late twelfth-/early thirteenth-century satirical poem, *The Apocalypse of Golias the Bishop.*[1] Near the end of the poem, Golias narrates the lengths to which his visionary guide goes to ensure that he will recall the details of his vision:

His michis plenius visis et cognitis
dux meus manibus me cepit insitis
et caput quattuor discerpens digitis
solvit in quattuor compagem capitis.

Et ne misteria vidissem perperam
figens occipitis in partem teneram
rigentem stipulam, siccam et asperam
scripsit in cerebro cuncta que videram.[2]

1. *The Apocalypse of Golias* was probably composed in England; F. X. Newman notes that Golias "is neither the name of a person nor a pseudonym, but rather the name of a personification of contempt for official hypocrisy." The name appears frequently in medieval satire. F. X. Newman, ed. and trans., "The Apocalypse of Golias," in *The Literature of Medieval England,* ed. D. W. Robertson, Jr. (New York: McGraw-Hill, 1970) 253.

2. Karl Strecker, ed., *Die Apokalypse des Golias* (Leipzig: W. Regenberg, 1928) 36.

(When I had heard and seen all this,
My guardian seized me until I cried for pain,
And then, with delicate, angelic skill,
He split my skull and opened up my brain.
He next took out a little piece of straw,
And, lest that I forget my wondrous vision,
Inscribed the whole thing on my tender brain,
Then carefully sewed up my odd incision.[3])

The image of Golias' brain actually being inscribed upon by the angel vividly suggests the total transparency of visionary communication. What Golias has seen is carved into his mind, allowing the vision to be fully absorbed into his organ of consciousness. The angel's actions imply that the visionary himself plays only a passive role in the vision's reception, as it is the angel who causes the vision to be recorded. With the substance of his vision literally inscribed into the flesh of his brain, Golias seems guaranteed to remember accurately what he has seen in his burlesque visit to the otherworld; to all appearances, he has become an ideal vessel for the retention and communication of the divine lesson. And yet this is not the case. Golias' vision continues beyond the point of the angel's inscription, to his great disadvantage—he reaches the beatific culmination of his vision *after* the angel has written on his brain. This is to have disastrous consequences for Golias, as he then goes on to eat poppy-bread and drink the waters of Lethe, thereby causing himself to forget all of the contents of his vision "except the little that / The Angel has engraved upon my brains."[4] While he seems to remember the *fact* that he has "seen God! The angels! Paradise!,"[5] the specifics of the vision—God's "deep decrees"[6]—can no longer be recalled, rendering the beatific vision useless: the remarkable vision of the heavenly realm, which occurred after the angel inscribed the first parts of his experience upon his brain, is lost. Golias is incapable of adequately communicating the climactic moment of his vision to his readers because of his own irresponsible behavior, and a problem with the angel's timing becomes catastrophic; Golias' absentminded consumption leads to his being able to recall *only* what was physically recorded on his brain. The poem, while clearly comic, thus gestures towards what may have been a very real concern: the visionary's reliability in accurately recalling and transcribing the content of his or her revelation. In admitting the

3. Trans. F. X. Newman, 260 (stanzas 103–104).
4. Ibid., 261 (stanza 109).
5. Ibid., stanza 110.
6. Ibid., stanza 106.

fallibility of its visionary protagonist, *The Apocalypse of Golias the Bishop* effectively critiques not only the clergy and monastic orders—the primary targets of its satire—but the possibility of visionary writing, as well.

Although Golias is clearly a comic figure, the image of the angel writing into his brain reflects a view of the vision's efficacy in medieval religious literature. The establishment of the divine vision as a transparent medium for the communication of otherworldly messages and of the visionary as a vessel for that vision who can accurately convey the content of those messages to a wider audience is a common goal of hagiographic and visionary texts. The representation of the vision as transparent means that the visionary is, ideally, responsible for neither the content nor the communication of the visionary message, and a rhetoric of passivity consequently permeates many visionary accounts. Hildegard of Bingen (1098–1179), for example, depicts the illumination that she says gave her a deepened understanding of the scriptures as a divine light that fills her with knowledge:

> . . . igneum lumen aperto caelo ueniens totum cerebrum meum transfudit et totum cor totumque pectus meum uelut flamma non tamen ardens sed calens ita inflammauit, ut sol rem aliquam calefacit super quam radios suos ponit. Et repente intellectum expositionis librorum, uidelicet psalterii, euangelii et aliorum catholicorum tam ueteris quam noui Testamenti uoluminum sapiebam [7]

> (Heaven was opened and a fiery light of exceeding brilliance came and permeated my whole brain, and inflamed my whole heart and my whole breast, not like a burning but like a warming flame, as the sun warms anything its rays touch. And immediately I knew the meaning of the exposition of the Scriptures. . . . [8])

Hildegard describes her vision as infusing her with knowledge, giving her a full understanding of the scriptures through no effort of her own. The image of the sun that warms its object characterizes her as acted *upon* rather than acting; she is "permeated" with knowledge through the action of the divine illumination. The passivity of this process is echoed in the divine inspiration that enables Hildegard to record the content of her visions in writing and that ensures the authenticity of the visionary text. She writes, "Et dixi et scripsi haec non secundum adinuentionem cordis mei aut ullius hominis,

7. Hildegard of Bingen, *Hildegardis Scivias,* ed. Adelgundis Führkötter, Corpus Christianorum, Continuatio Medievalis vols. 43–43A (Turnhout: Brepols, 1978) 4.

8. Hildegard of Bingen, *Scivias,* trans. Mother Columba Hart and Jane Bishop (New York: Paulist Press, 1990) 61.

sed ut ea in caelestibus uidi, audiui et percepi per secreta mysteria Dei"
(And I spoke and wrote these things not by the invention of my heart or
that of any other person, but as by the secret mysteries of God I heard and
received them in the heavenly places).[9] Not only is Hildegard's knowledge
directly from heaven, but the written text of her visions is also authorized
by God. Even in the composition of her text, then, Hildegard depicts her-
self as a passive vessel of the divine, performing God's work without add-
ing or changing anything to the content—or even the experience—of her
revelation.

Hildegard is not unique in her claim to be passively recording a mes-
sage received from a heavenly source. Numerous visionary authors invoke
a similar rhetoric of passivity. The fourteenth-century mystic Birgitta of
Sweden prefaces one of her visionary texts with a description of her writing
process that presents her as imbued with unmediated knowledge that awaits
only a translation into textual form: "This *Book of Questions* then remained
fixed in her heart and her memory as effectively as if it had all been carved
on a marble tablet. But she herself immediately wrote it out in her own
language; and her confessor translated it into the literary tongue."[10] Like the
object illuminated by the sun in Hildegard's *Scivias,* the image of Birgitta's
heart as a marble tablet evokes the visionary's utter passivity: the vision's
message is inscribed upon her, immutably fixed in the mass of her heart.
And although there is a secondary translation, from the vernacular into
Latin, Birgitta herself is represented as a transparent medium of commu-
nication; the vision is received as a text that she merely rewrites or copies
out. In both cases, the visionary portrays her role in the reception and trans-
mission of her visions as essentially passive. The vision implants knowl-
edge within her and she transmits that knowledge when she is enjoined or
required to do so.

But when Golias follows his vision with a meal of poppies and Lethe-
water, the very food and drink of forgetfulness, his actions imply that a
visionary could go wrong in important ways—ways that would make him
or her an unsuitable vehicle for communicating divine knowledge. Beneath
the rhetoric of passivity that is almost a commonplace of visionary literature
runs an underground current of assumptions and anxieties about the cogni-
tive and volitional activities in which the visionary or dreamer must engage
if the vision is to succeed in conveying knowledge to its recipient. Golias
errs when he engages in a post-vision activity that directly hinders his abil-

9. *Corpus Christianorum,* 6; trans. Hart and Bishop, 61.
10. Birgitta of Sweden, *Life and Selected Revelations,* trans. Albert Ryle Kezel, ed. Mar-
guerite Tjader Harris (New York: Paulist Press, 1990) 102.

ity to act as a visionary messenger, and his act illustrates the possibility that the visionary might fail to fulfill his or her role. Golias is unsuited to his task, and his behavior reflects that unsuitability. Naturally, the idea that a visionary could fail to understand or accurately record a vision could not be voiced within a text that purported to describe a real revelation; expressing the possibility of failure would undermine the visionary's credibility. But satirical vision poems, such as *The Apocalypse of Golias, could* express this possibility. And when the potential failure of the vision is acknowledged, a new model of the visionary emerges: he or she is an active participant in the reception and transmission of visionary knowledge and is at least partly responsible for the failure or success of the revelation.

Acknowledging the active component of the visionary experience opens up the possibility for failure (the visionary might not have understood accurately the content of the vision, or might be unprepared to grasp its meaning) while simultaneously pointing out the important role played by the visionary's cognitive abilities. The significance of the cognitive faculties in the apprehension of the vision is confirmed by many dream vision poems' and visionary texts' overt anxiety about the role of the visionary or dreamer in the reception of a vision. Frequently at stake in both visionary texts and dream vision poems is the basis of the dreamer's or visionary's understanding of the vision's message. Even when visionary knowing is presented as a passive experience that inherently grants knowledge to its recipient, the vision typically is understood only when the recipient exhibits certain qualities. Quite frequently in both dream vision and visionary literature, the proper alignment of the recipient's will is necessary for the vision to be understood, as the recipient can only grasp its content if his or her will is wedded to God's. The volitional union of visionaries and dreamers with God enables them to successfully exercise the active power of the *ratio* (reason) as well as their interpretive and reflective abilities. Only through the use of these powers can the message of the vision truly be understood, indicating the active role that the visionary frequently plays in the reception and transmission of the divine message.

Yet the argument that, in some cases, the vision can only convey knowledge with the active participation of the visionary or dreamer requires an important caveat. In making the case that the visionary is an active participant in the visionary experience, I do not mean to suggest that it is *only* through active engagement with the vision that he or she obtains divine knowledge. Indeed, the visionary must to some extent be passive, and this passivity should not be denigrated as a sign of weakness or inferiority. As Barbara Newman reminds us, "[t]he common prejudice which views the

passive role as demeaning and undignified, or at any rate inferior to the active, assumes the absence of . . . [a] divine point of reference."[11] In the theocentric universe of the Christian Middle Ages, God, as the creator, is necessarily active vis-à-vis the created human. In claiming to play a purely passive role in the receipt of their visions, Hildegard, Birgitta, and other medieval visionaries are not simply deflecting attention away from their "real" work of interpreting visions and composing texts. The passivity that they assert is an essential characteristic of their relationship to the divine. God works upon the visionary, who receives his message as completely as possible—a reception that depends upon the visionary's ability to passively take in the revelation. My point is that the vision does not end with the passive reception of a revelation. In order to understand their revelations fully, visionaries frequently must direct their wills towards God (thereby becoming suitably passive vessels through the paradoxically active engagement of the volitional faculties) and, in many cases, interpret and analyze the content of the revelations themselves. In asserting visionaries' active roles in the reception and transmission of their knowledge, then, I wish nonetheless to acknowledge their deeply held theological convictions: the belief that they—and all of humankind—operate from a position of passivity relative to the divine.

But the essential passivity of the visionary experience in many cases is complemented by the active work of the visionary, who must align his or her will with God's and even engage in meditation and interpretation in order to understand the divine message.

The pairing of active and passive work in the understanding of the vision is borne out in Aquinas' influential theory of knowing. Aquinas' view of how the human intellect acquired knowledge, while not universally accepted in the Middle Ages, provides a useful illustration of how knowing could be understood as both active and necessarily passive. In the *Summa Theologica,* Aquinas argues that "to understand is in a way to be passive" in the sense that "what is in potency [potentiality] to something receives that to which it was in potency without being deprived of anything. And accordingly, whatever passes from potency to act may be said to be passive." Human understanding exists in its potential and is made actual by the action of God. The human intellect, which derives its power from the divine or angelic intellect, is passive by virtue of its derivation and distance from the divine intellect. "[W]e are only in potency to understand," Aquinas writes,

11. Barbara Newman, "Divine Power Made Perfect in Weakness: St. Hildegard on the Frail Sex," in *Peace Weavers: Medieval Religious Women,* ed. J. A. Nichols and Lillian Thomas Shank, vol. 2 (Kalamazoo, MI: Cistercian Publications, 1987) 109–10.

"and afterwards we are made to understand actually."[12] In this sense, Aquinas believed, the human intellect is necessarily passive. Just as the visionary women cited above are acted upon by God, who reveals divine truth to them and infuses them with knowledge, the intellect exists chiefly in its passive potentiality. But, as Aquinas argues, the intellect's passivity derives from its passing from potency to activity. As the divine acts upon the intellect, the intellect itself becomes active. In a similar manner, perhaps, visionaries' passive reception of their visions enables them to become active participants in the revelatory experience and the process of coming to know.

II. Knowing in the Middle Ages: *Ratio* and *Intellectus*

The contention that visionary knowing is simultaneously active and passive finds support in medieval theories regarding the role of the mental faculties in knowing. Although medieval scholars' theories of knowing were seldom in complete agreement, they largely agreed that both active and passive mental faculties played a part in the reception of knowledge. This pairing can be seen most clearly in the interplay between the reason (*ratio*) and the understanding (*intellectus*). *Ratio* was conceptualized as a primarily active power, while *intellectus* describes the intuitive grasping of truth that may depend upon illumination to succeed. Generally, medieval thinkers perceived both of these faculties as instrumental in the acquisition of knowledge. The *ratio* involves the use of rational deduction, while the *intellectus* is the faculty that is capable of apprehending truth and that is responsible for granting us knowledge of the "first principles" upon which the deductive efforts of the *ratio* depend. Aquinas, who was one of the most influential theorizers of the mental faculties, argues that the *ratio* and the *intellectus* were not actually separate "powers," but rather parts of the same faculty. Yet he posits a clear difference between them: reasoning "is compared to understanding as movement is to rest, or acquisition to possession."[13] When the mind is at rest, apprehending and contemplating

12. Thomas Aquinas, *The Summa Theologica of Saint Thomas Aquinas,* vol. 1, ed. Daniel J. Sullivan, trans. Fathers of the English Dominican Province (Chicago: Encyclopaedia Britannica, 1952), I: 79.2, p. 415. All translations of the *Summa* are from this edition. "'[I]ntellegere est pati quoddam.' . . . [Q]uod est in potentia ad aliquid, recipit illud ad quod erat in potentia, absque hoc quod aliquid abiiciatur. Secundum quem modum omne quod exit de potentia in actum potest dici pati. . . . [I]n principio sumus intelligentes solum in potentia, postmodum autem efficimur intelligentes in actu" (Thomae de Aquino, *Summa Theologiae,* ed. Institutum Studiorum Medievalium Ottaviensis [Ottawa: Commissio Piana, 1953] I: 480b–481b).

13. Aquinas, *ST* I: 79.8, p. 422. "[R]atiocinari comparatur ad intelligere sicut moveri ad

truth in a flash of insight, it is employing the *intellectus;* when it is moving from point to point, understanding through logical deduction, the *ratio* is engaged. The *intellectus* is commonly seen as the higher of the two faculties; Aquinas asserts that it is the intellectual power exercised by the angels, who possess "no other power than the intellect, and the will, which follows the intellect."[14] Human *intellectus* approximates but is not equivalent to the divine and angelic intelligence.[15] It is what enables the human mind to grasp knowledge without needing to progress through the stages of rational deduction.

While the human mind must employ both *intellectus* and *ratio,* the *intellectus* is the power that is associated with divine knowledge. Aquinas links the *intellectus* to knowledge of the infinite, towards which the mind constantly strives. "Nothing finite can satisfy the intellect's desire," he writes:

> whatever finite object it apprehends, it strives after something greater; just as with lines and numbers the mind goes on adding to infinity. Now in being and power every creature is finite. Therefore, intellect, of its nature, does not rest in the knowledge of created natures, however great these may be, but must tend always towards an understanding of the infinitely great substance which is God.[16]

Aquinas posits the *intellectus* as the vehicle for apprehending the highest truth; moreover, it is the drive that pushes the mind towards knowledge of the absolute. In our cognitive lives, however, humans use both modes of knowing. According to the Thomist theory of the faculties, angels, "possess[ing] perfect knowledge of intelligible truth, have no need to advance from one thing to another, but apprehend the truth simply and without mental discursion"; if humans were capable of apprehending truth solely through the *intellectus,* simply perceiving it without the use of rational deduction, we would be cognitively identical to angels. However, "man arrives at the knowledge of one intelligible truth by advancing from one thing to another, and therefore he is called rational. . . . [Human reasoning] advances from certain things simply understood—namely, the first principles."[17] Both

quiescere, vel acquirere ad habere" (I: 489a).

 14. *ST* I: 79.1, p. 414. "[I]n angelis non est alia vis quam natura intellectiva, et voluntas, quae ad intellectum consequitur" (I: 480a).

 15. *ST* I: 79.4, p. 417.

 16. *Contra Gentiles* III: 50, quoted in Kenelm Foster, *The Two Dantes and Other Studies* (Berkeley: University of California Press, 1977) 75.

 17. *ST* I: 79.8, p. 422. "Et ideo angeli, qui perfecte possident secundum modum suae naturae cognitionem intelligibilis veritatis, non habent necesse procedere de uno ad aliud sed simpliciter et absque discursu veritatem rerum apprehendunt. . . . Homines autem ad intelligi-

intellectus and *ratio* are therefore necessary, as the immediate knowledge of first principles accorded by the former enables the reason to advance and move towards higher understanding. Thus the intuitive understanding that is acquired through the *intellectus* gives us the basic set of truths out of which the *ratio* functions. Visionary knowing usually seems to arise out of the *intellectus,* as the vision grants its recipient privileged knowledge through a flash of divine insight. Yet, as I will show, both the *intellectus* and the *ratio* are essential to visionary knowing. In order to fully comprehend the visionary message, the rational powers often must be brought into play along with the illuminated understanding of the *intellectus.*

Medieval scholars were divided, however, on the issue of whether it was the intellect (both reason and understanding) or the will that played the greatest role in acquiring knowledge and determining action (*liberum arbitrium*). According to Aquinas, it was the combination of these two faculties—intellect and will—that distinguished humankind from animals and also made up the mind itself.[18] Of these two powers, however, Aquinas believed that the intellect was superior, and he taught that the will must follow the dictates of the reason. This issue became hotly contested in the second half of the thirteenth century, when Franciscans such as Walter of Bruges and Matthew of Aquasparta argued that, although the will relies upon the guidance and illumination of the intellect, it also activates the intellect and is hence the dominant power in determining action. Stephen Tempier made this argument an issue in the condemnations at Paris in 1277, declaring unorthodox the belief that the will is a passive power or that it must follow the reason, as Aquinas had argued.[19] Following the condemnations of 1277, the question of whether the intellect or the will was primary remained an extremely contentious issue,[20] and the dispute continued into the fourteenth century, as scholastic philosophers debated whether the will or the intellect was "prime" (*nobilior*) in the human mind.[21] The issue of

bilem veritatem cognoscendam perveniunt procedendo de uno ad aliud . . . et ideo rationales dicuntur. . . . Et quia motus semper ab immobili procedit, et ad aliquid quietum terminatur, inde est quod ratiocinatio humana secundum viam acquisitionis vel inventionis procedit a quibusdam *simpliciter intellectis,* quae sunt prima principia" (I: 488b–489a; my emphasis).

18. Anthony Kenny, *Medieval Philosophy,* A New History of Western Philosophy, vol. II (Oxford: Clarendon Press, 2005) 233.

19. J. B. Korolec, "Free Will and Free Choice," in *The Cambridge History of Later Medieval Philosophy: From the Rediscovery of Aristotle to the Disintegration of Scholasticism, 1100–1600,* ed. Norman Kretzman, Anthony Kenny, and Jan Pinborg (Cambridge: Cambridge University Press, 1989) 636–37.

20. Gordon Leff, *The Dissolution of the Medieval Outlook: An Essay on Intellectual and Spiritual Change in the Fourteenth Century* (New York: New York University Press, 1976) 28.

21. Lois Roney, *Chaucer's Knight's Tale and Theories of Scholastic Psychology* (Tampa: University of South Florida Press, 1990) 21–22.

primacy was framed in terms of which power caused action. Dominican intellectualists followed Aquinas in arguing that *ratio* and the knowledge of first principles guided the individual's actions, which were then checked against the conscience. As the "rational appetite," the will, according to Aquinas and his followers, was naturally oriented towards the good; by definition, it adhered to the dictates of reason.[22] Intellectualists further held that the mind should be naturally oriented towards "truth, knowledge, [and] rational comprehension."[23] But this idea was challenged in the fourteenth century by the voluntarist arguments of Duns Scotus and William of Ockham. Seeing the will as the root of human activity, voluntarists maintained that the will was under no compulsion to follow the dictates of the intellect and was therefore the more powerful faculty.[24] They argued that the mind forms an intention that is then checked against reason and conscience. This position was largely held by the Franciscans, who believed that the natural orientation of the mind should be towards love, which would then determine action.[25] The division between these two positions formed a major split in the terms in which the cognitive and psychological faculties were understood at this time.

Because both the intellectualist and the voluntarist positions entail specific understandings of how the human mind obtains knowledge, both have very real implications for the assumptions underlying visionary knowing. On the intellectualist view, rational understanding and deduction are the most essential tools in the process of knowing. The *ratio,* according to the intellectualists, is thus the vital element in knowledge acquisition. Voluntarists, on the other hand, emphasized the orientation of the will towards love for and devotion to the divine. This loving orientation towards God enables the mind to rest in contemplation of the divine and is associated with knowing via the *intellectus.* Knowledge that comes from devotion and love rather than reason is received through the *intellectus,* which is employed in contemplative practice. Thus for intellectualists, knowing hinged primarily on the use of the *ratio,* while voluntarists emphasized the *intellectus.* Franciscans were predominantly voluntarists; they also promoted a form of affective spirituality that included meditation on the events of Christ's life and vivid techniques of visualization. These practices—with their stress on affective experience and visions as a means of coming into a closer relationship with God—suggest that the Franciscans also believed in personal

22. Alan Donagan, "Thomas Aquinas on Human Action," in *The Cambridge History of Later Medieval Philosophy,* 644.

23. Roney, 22.

24. Korolec, 638.

25. Roney, 22.

experience (rather than argumentation) as a means of acquiring knowledge. The Franciscans' voluntarist approach to divine knowledge can be linked to a growing emphasis upon visionary experience in the later Middle Ages. As Denise Despres has shown, Franciscan meditation practices became increasingly popular in fourteenth-century England,[26] coinciding with the production of a number of texts—including *Pearl, Piers Plowman, The Book of Margery Kempe,* Richard Rolle's *Incendium amoris,* and Julian of Norwich's *Showings*—that indicate "a preoccupation with private religious experience."[27] Visualizing the events of Christ's life, Despres notes, was a "means of knowing" that opposed the traditional monastic reliance upon received authority.[28] Such an emphasis upon personal experience has profound ramifications for the development of the visionary tradition, as visionary literature by its very nature stresses personal experience as a means of coming to know God. Visionary experience thus emerges as an effective way of obtaining divine truth. While the rational faculties remain central to the acquisition of visionary knowledge in many texts, in the works explored here the vision's epistemological possibility depends upon a voluntarist model of human psychology in which knowing is made possible by the orientation of the visionary's will towards a loving dedication to God.

III. Education and Revelation as Paths to Dream Knowledge: Three Case Studies

Where knowing in "authentic" vision texts occurs through the use of two faculties, the *ratio* and the *intellectus,* medieval dream vision narratives can be roughly divided into two categories based upon the ways in which their dreamers gain knowledge. Indeed, these two means of knowing mirror the *ratio/intellectus* pairing outlined above, as a dreamer may receive knowledge through a process of rational education or through direct revelation. Dream visions that emphasize the former process, which I will call "educative," are those in which the dreamer obtains privileged knowledge through the reason and that tend to depict knowing as relatively transparent and efficacious. The dreamers of such dreams readily absorb the information communicated to them, receiving visions or visitations that instruct them in matters pertinent to their particular problems, as in Boethius' *De Consolatione Philosophiae.* The efficacy of the vision as an educational tool

26. Denise Despres, *Ghostly Sights: Visual Meditation in Late-Medieval Literature* (Norman, OK: Pilgrim Books, 1989) 8–9. I discuss this issue at greater length in chapter 8.

27. Ibid., 49.

28. Ibid., 36.

tends to be uncontested in these narratives. Even educative dream visions in which the dreamer refuses to follow the "right" authority, such as *Le Roman de la rose,* accept the dream's ability to convey knowledge to a receptive dreamer. The category of educative dream vision includes the texts that Kathryn Lynch argues form a subgenre of dream vision, the "philosophical" vision. Philosophical visions, as Lynch defines them, take Boethius' *De Consolatione* as their "paradigmatic 'source'"; these texts may not openly imitate Boethius, but are strongly influenced by his work. Authors whose dream poems fall into this subgenre include Alain de Lille, Jean de Meun, and John Gower.[29] As philosophical dream visions, educative visions are based upon the rational, progressive acquisition of knowledge from an authoritative source. The love visions of Guillaume de Machaut also fall into this group, as do such moralistic visions as *Wynnere and Wastoure.* In these dreams, "a hero—or mock-hero—is invited to ascend to truth" through a series of successive lessons,[30] usually accompanied by an authoritative guide. Oracular elements are prominent in these texts, although the dreams are not generally *oracula,* or prophetic dreams.[31] They tend to emphasize the rational faculties rather than divine illumination as the primary tools of knowledge acquisition, and a specific moment of revelation is not clearly present in such works. The key element of the educative vision, which is articulated in Lynch's description of the philosophical dream, is a hero who "ascend[s] to truth." The spatial metaphor implies a conception of knowledge as something ordered and rational; it is a system through which one moves, obtaining greater and greater understanding along the way. The ordered scale of knowledge that is comprehended through reasoning and didactic instruction is the major characteristic of the educative dream vision.

Some dream visions, however, foreground revelation as the primary means of acquiring knowledge. Such works include *Piers Plowman, Pearl,* and the *Paradiso* section of the *Divina Commedia.* These texts present a

29. Kathryn L. Lynch, *The High Medieval Dream Vision: Poetry, Philosophy, and Literary Form* (Stanford: Stanford University Press, 1988) 7.

30. Ibid., 119.

31. The term *oraculum* comes from the taxonomy of dreams that Macrobius articulated in his fifth-century work, *Commentarii in Somnium Scipionis.* Macrobius describes five categories of dream: two of these, the *insomnium,* or nightmare, and the *visum,* which occurs in the moment between waking and falling asleep, are meaningless. The other three kinds of dream all have some cognitive value: the *oraculum,* the most unambiguously revelatory kind of dream, is a dream in which an authority figure appears and speaks to the dreamer, offering revelations that lie beyond the human ken; the *visio* is a clearly prophetic dream; and the *somnium,* the most ambiguous of the meaningful dreams, offers a vision of true events couched in fiction and requires interpretation to be understood (Macrobius, *Comentarii in Somnium Scipionis,* ed. Jacob Willis [Leipzig: B. G. Teubner, 1963] I.3, pp. 11–13).

perceptual shift as the basis of the dreamer's transformation, utilizing a mode of visionary knowing that I will call "revelatory." Educative processes may be present in these dreams; in fact, while some dream visions may feature only an educative ascent to knowledge, revelation is rarely the only way that a dreamer learns. More often, as in the *Commedia,* a dreamer is led to a certain point by education and reason—but then revelation takes over to impart a different kind of knowledge to the dreamer. The revelatory dream's most significant moment comes when the various voices of instruction give way to an experience that is expected to profoundly transform the dreamer, though whether the desired transformation actually takes place is sometimes debatable.

Whether a dream vision's success is based upon educative or revelatory modes of knowing depends in some measure upon its subject matter. The progressive nature of the educative process of knowing implies that the reason or *ratio,* by moving from one step in an argument to the next, generally is suited to achieve whatever knowledge educative dreams are intended to convey. Systematic education is not, however, suited to all kinds of knowledge. The questions that educative dreams purport to answer are typically within the normal purview of human comprehension. In the case of *De Consolatione,* the dreamer-narrator seeks to understand fortune; in *Le Roman de la rose,* he desires an amorous conquest. Revelation, on the other hand, is used to convey knowledge that goes beyond what the human intellect normally can grasp through rational argumentation, ordinary experience, and logic. Such knowledge typically pertains to faith and the divine: both *Pearl* and *Piers Plowman,* for example, treat religious themes, while most strictly educative dream visions are concerned with secular matters.[32] As I illustrate in the next section, the mode of visionary knowing represented in dream visions is ostensibly suited to the content of the visionary message: progressively rational education instructs dreamers in secular matters, while revelation purports to convey religious truths.

As I have suggested, the visionary must meet certain volitional and cognitive criteria in order to correctly comprehend the knowledge imparted by the vision. These criteria, especially the role of the individual's will in

32. As I indicated above, despite Lynch's reference to the *Divina Commedia* as a philosophical vision, I am excluding it from the category of strictly educative dream visions because it includes elements of both progressively educational and revelatory modes. As in educative dreams, its dreamer ascends through rationally ordered levels of knowledge; however, Dante also allows the rational ascent to give way to revelation in the character of Beatrice in *Paradiso.* Lynch includes the *Commedia* among the philosophical dream visions because Dante presents a clear "order of knowing" in *Inferno* and *Purgatorio.* As she notes, however, the "path of ascent" set out in these first two sections "breaks down" in *Paradiso* (*The High Medieval Dream Vision,* 151–52).

visionary knowing, are also central to the dream vision poems that I will discuss in the second half of my study. *Pearl* and *Piers Plowman* both concern themselves with the misguided will as an obstacle to visionary knowing, illustrating the difficulties that arise when the dreamer's will is not directed unconditionally towards God. *The House of Fame* goes even further than these poems, presenting the locus of visionary authority as shifting between the dreamer and his reader, finally falling entirely upon human—and therefore fallible—sources. On the voluntarist understanding of the mental faculties, to which these dream visions largely adhere, the will is responsible for directing the cognitive faculties as well as the individual's actions. By positing the misdirection of the will as the fundamental flaw in the dreamers' abilities to understand the divine messages of their visions, these poems reinforce the notion that the will and the *ratio* are intrinsically involved in the process of visionary knowing. Where revelation works smoothly in mystical visionary literature, then, it is not equally effective in all dream visions. Revelation can fail in dream vision poems, and that failure is the consequence of the dreamer's inadequate or inappropriate use of his volitional and cognitive faculties. Where educative dreams typically "work," then, revelation is subject to failure, owing to the all-too-human capabilities and limitations of the dreamer. By distinguishing between educative and revelatory modes in dream vision poems, we can see more clearly where the dreamer's knowing is impeded. It is precisely in the revelatory moment—the moment that is essential to visionary literature, that *defines* such literature—that these dream visions fall apart and that the limits of revelation's perceived effectiveness come powerfully to the fore.

Golias' failure to recall the most significant aspects of his vision may not be so much an exception to the visionary tradition as the rule. Visionaries express considerable anxiety about the possibility of slipping into the kind of irresponsible action that Golias describes, and their hagiographers often go to great lengths to represent them within a discourse of sanctity that does much to validate their texts.[33] Given the suspicion with which visionary women were sometimes viewed in the later Middle Ages and the perceived fallibility of the human senses with respect to the divine, it is no wonder that Chaucer depicts the vision as an almost meaningless epistemological tool. And yet many visionaries were esteemed, revered, and in some cases canonized.[34] Through a consideration of visionary knowing in this

33. See Rosalynn Voaden, *God's Words, Women's Voices: The Discernment of Spirits in the Writing of Late-Medieval Women Visionaries* (Woodbridge, UK: York Medieval Press, 1999), particularly Voaden's discussion of Alfred of Jaen's work towards the canonization of Birgitta of Sweden (78–93), for an exploration of such representations of sanctity.

34. Birgitta of Sweden and Catherine of Siena were the only two medieval visionary

period, conflicting images of the human mind's ability to grasp revealed knowledge emerge. But these images existed, in tension, at the same historical moment, and their elaboration gives us a fuller understanding of both the way that visionary women represented their experiences and the broader cultural sense of the vision's importance in late medieval Christian Europe.

Three interrelated pairs of terms thus underlie my study: active and passive, *ratio* and *intellectus,* educative and revelatory. The *ratio* and the will are the active powers that enable educative dream visions to lead their dreamers to the epistemological goal of the dream; they are also, as I will show, vital to the way in which many visionaries acquire their knowledge of the divine. The *intellectus* is the more passive faculty—knowledge is acquired in a sudden flash; the vision's recipient is infused with understanding—and is the power that comes into play in revelatory dream visions. While distinguishing between these terms is important, as they provide us with a clear vocabulary for differentiating between the ways in which knowledge could be received in a vision, visions themselves seldom conform to only one half of each set of terms. Two of the three dream vision narratives discussed in this section are primarily educative: their dreamers reach a changed sense of themselves and their worlds through a largely ordered, rational process. (Dante's *Divina Commedia* is the exception: at the brink of Paradise, the dreamer-visionary's educative ascent gives way to revelation.) But revelatory visions, including mystical visionary texts and the dream visions *Pearl* and *Piers Plowman,* do not rely solely upon the intuitive flash of understanding that comes through the *intellectus* for visionary knowing to succeed. In all of these texts, both active and passive processes are necessary: as the *ratio* clears the way for the moment of revelation, reasoned interpretation buttresses the insight gained through the *intellectus,* or, indeed, the dreamer's failure properly to employ his or her active cognitive faculties limits his or her ability to understand the visionary message.

In this section, I consider three earlier dream visions—Boethius' *De Consolatione, Le Roman de la rose,* and the *Divina Commedia*—which seem to presuppose the efficacy of the vision as a means of transmitting knowledge. These works are less concerned with the epistemological ambiguities of the vision than are later English dream visions, but they do raise issues about the conditions upon which the reception of the vision is based. By examining these texts within the simplified framework of the educative

women to be canonized in the late Middle Ages (Nancy Caciola, *Discerning Spirits: Divine and Demonic Possession in the Middle Ages* [Ithaca: Cornell University Press, 2003] 277).

and the revelatory dream, we can begin to discern the basis for what we might call "successful" visionary experience: the orientation of the dreamer's or visionary's will and the limits of human reason in perceiving the divine. These three texts all represent the vision as a potentially fruitful means of acquiring knowledge and employ the dream as a liminal space where wisdom that would otherwise be difficult or impossible to grasp can be acquired. By considering the paths to knowledge depicted in these works, all of which were important to the development of the dream vision genre, we can trace the ways that knowledge is conveyed, and knowing represented, in the dream poem: *De Consolatione* and the *Rose* illustrate the educative, *ratio*-based acquisition of knowledge, while the *Commedia* highlights the contrast between educative and revelatory modes of visionary knowing. That these three works are somewhat earlier dream visions— the latter two roughly contemporary with Marguerite d'Oingt and Gertrude of Helfta, the mystics that I discuss in chapters 2 and 3—also indicates the philosophical discontinuity between them and the later dream visions of fourteenth-century England. In many ways, *De Consolatione,* the *Rose,* and Dante's vision have more in common with the works of medieval mystical writers than they do with fourteenth-century poets such as Chaucer or Langland.

DE CONSOLATIONE PHILOSOPHIAE: TRANSFORMATION THROUGH EDUCATION

Boethius' sixth-century *De Consolatione Philosophiae* vividly illustrates the transformative potential of education in the dream vision, tracking the narrator's development of and ultimate conversion to an optimistic state as he comes to understand that justice in this world is seldom a measure of justice in the next, and that, while the pleasures of earthly existence are fleeting, the rewards and punishments meted out in the next are eternal. Although, as I will argue, later medieval English dream visions deviate markedly from the route to knowledge laid out in *De Consolatione,* Boethius' text had a significant impact on the development of dream vision literature, most notably in its use of the vision to radically alter the dreamer-narrator's world-view. Kathryn Lynch argues that Boethius' vision expanded the potential of the dream vision form by emphasizing "the healing power of vision";[35] the expanded scope of the dream's potential in *De*

35. Both Lynch and Michael Cherniss identify the potential to transform the dreamer's consciousness as one characteristic of *De Consolatione,* emphasizing the presumed transformative power of the literary vision. See Lynch, *The High Medieval Dream Vision,* 51–52 and

Consolatione can be seen in the way that it not only conveys otherworldly wisdom but transforms the dreamer, as well. Boethius does not simply come to comprehend what Lady Philosophy tells him. Rather, he arrives at a fundamentally new understanding of justice, and, in consequence, discovers a new way of being in the world.

The medieval conviction that the dream can transform the dreamer arises out of the assumption that the dreaming mind is more receptive than the waking to otherworldly wisdom—precisely that wisdom which, be it oracular or conveyed figuratively through allegory, has the ability to radically alter one's worldview. Constituting an exploration of a liminal space where knowledge can be granted through means other than the rational intellect, visions are often characterized by a reliance upon epistemological tools other than the *ratio,* and traditional explanations of knowing in dreams have tended to emphasize its non-rational aspects. For example, in her analysis of medieval dream theory, Lynch notes that thinkers such as Avicenna argue that the "imagination's increased visionary potency during dreams comes about because certain faculties (common sense, reason, memory) doze so that the soul can concentrate its energy in another lobe of the brain, imagination."[36] Giuseppe Mazzotta calls this the "state of passivity" that overcomes the mind during sleep, rendering it "acquiescent and nonresistant as it surrenders to the imperious powers of the 'imaginativa.'"[37] According to these theories, the imagination is activated at the expense of the rational intellect, allowing different kinds of knowledge to be processed and acquired. The dreaming mind finds itself in a state peculiarly receptive to otherworldly wisdom, a state that has often been seen as excluding or inhibiting the use of the *ratio.* However, the suppression of the rational faculties and the heightening of the imagination that were thought to occur during sleep are not the only reasons that literary dreams are capable of transforming their dreamers. The vision or dream also enables the dreamer to interact with supernatural and allegorical figures that possess knowledge not ordinarily available in the waking world. Moreover, by actually experiencing the lessons that these figures teach—rather than learning about them from books or clergy—the dreamer's rational comprehension of the dream's message is bolstered by a (frequently affective) experience.

In *De Consolatione,* however, experience is less important than reason and education. The narrator's progressive ascent to wisdom through

Michael D. Cherniss, *Boethian Apocalypse: Studies in Middle English Vision Poetry* (Norman, OK: Pilgrim Books, 1987) 35.

36. Lynch, *The High Medieval Dream Vision,* 65.

37. Giuseppe Mazzotta, *Dante's Vision and the Circle of Knowledge* (Princeton: Princeton University Press, 1993) 118.

logical discourse effects a transformation in his worldview and, given Lady Philosophy's grounding in human knowledge and reason, it is appropriate that Boethius' transformation comes about through the acquisition of knowledge via the *ratio*. Boethius' distress is caused by forgetfulness and ignorance; he has lost the perspective formerly accorded him by his study of philosophy, and Lady Philosophy's intervention is intended to rectify this ignorance. Early in her interrogation of Boethius she asks him to define "what a human being is" ("Quid igitur homo sit poterisne proferre?").[38] As though he were declaring the obvious, Boethius responds, "a rational and mortal animal" ("rationale animal atque mortale"); when asked whether man is anything else, he says no (I.Pr 6.15). This limited understanding of man's nature is the source of his anguish, and his answer permits Lady Philosophy to diagnose his illness and formulate a cure: "Now I know . . . possibly the greatest . . . cause of your disease—you have ceased to know who you yourself are. And it is for this reason that I have discovered fully and absolutely the explanation for your sickness, and the entryway for winning back your recuperation" (I.Pr 6.17).[39] The figuration of his spiritual suffering as an illness that can be cured through her "medicine" suggests that the visionary experience can act beneficially upon the recipient's soul. Moreover, this action is direct: the oracular figure speaks, the dreamer hears and understands, and the ailment is remedied.

The remedy, here, pertains to more than the particular sufferings undergone by the imprisoned narrator, but Philosophy must "treat" Boethius for his personal unhappiness before moving on to larger issues. Among the overarching concerns of *De Consolatione* is the apparent disconnection between action and consequence, which means that unjust actions are rewarded and virtuous people suffer,[40] and Philosophy's initial conversation with Boethius serves primarily to move the discussion towards this issue. As Pierre Courcelle notes, Philosophy spends very little time actually addressing the narrator's problems; she is concerned with greater issues than one person's sufferings and provides Boethius with only enough direct consolation "pour qu'il soit en état de l'écouter jusqu'au bout; car elle prétend l'élever jusqu'à Dieu, source du vrai bien" (to render him capable of listening to her until the end of her discourse—for she strives to raise

38. For the Latin text, I have used Boethius, *De Consolatione Philosophiae Opuscula Theologica,* ed. Claudio Moreschini (Munich: K. G. Saur, 2000). English translations are from Joel C. Relihan's translation, *The Consolation of Philosophy* (Indianapolis: Hackett Publishing Company, 2001).

39. "Iam scio . . . morbi tui aliam vel maximam causam; quid ipse sis nosse desisti. Quare plenissime vel aegritudinis tuae rationem vel aditum reconciliandae sospitatis inveni."

40. William Asbell, "Boethius and the Circular Journey to Wisdom," *Carmina Philosophiae: Journal of the International Boethius Society* 7 (1998): 98.

his awareness to God, the source of real good).[41] Philosophy's emphasis upon issues other than those of immediate, personal concern to Boethius is echoed in the structure of the dialogue; Courcelle comments on the relative paucity of passages in which she reviews Boethius' past and present blessings.[42] Philosophy's purpose is to instruct him in the principles of divine reason, but this instruction—her "stronger cures"—can only come after the "darkness" of his current misfortunes has been eased through "gentle and routine poultices" (I.Pr 6.20–21). The preparation that he undergoes at the beginning of the vision, when Philosophy addresses his private troubles, readies him for the path ahead—a path ending with the acquisition of a wholly different outlook on creation and earthly existence.

The new outlook that Boethius attains through his vision, however, is bounded by the limits of philosophy and human understanding: the visitation does not culminate in a vision of the divine.[43] While purporting to expand his understanding, Boethius' vision does not give him access to divine knowledge. This limitation, argues Courcelle, is only to be expected. Identifying Philosophy's limits with the limits of human reason, he claims that, for Boethius, Philosophy is "la sagesse humaine à son degré de perfection; elle sait tout ce que l'homme a pu et peut apprendre par l'exercice de la raison, mais cela seulement" (perfected human knowledge; she knows everything that man could and can learn through the exercise of reason, but only that).[44] Philosophy has not been sent to instruct the visionary about eschatology and the afterlife. Rather, she is the personification of human learning, and her wisdom is confined to the accomplishments of the philosophers. If a transformation is to occur in this work, it must come about through philosophical reasoning, not divine revelation. *De Consolatione* thus explores the realm of the *ratio* without making the leap to that knowledge which can only be grasped by the *intellectus*.

Nonetheless, a transformation in Boethius' perspective seems to occur. And, in keeping with the text's concern with philosophical knowledge, his education follows a linear, rational progression. In the beginning of the narrative, he is preoccupied with his own misfortunes, feeling bitterness over his unjust treatment and the punishment that he is suffering despite having lived a virtuous life (I.Pr 4). Initially, his focus is on his experience alone;

41. Pierre Courcelle, *La Consolation de philosophie dans la trandition littéraire: Antécédents et postérité de Boèce* (Paris: Études Augustiniennes, 1967) 18; my translation.

42. Ibid.

43. Commenting on the narrator's acquisition of new knowledge, Cherniss notes that, by the work's end, "he has reached the limits of Philosophy's power; there is no leap into the realms of theology or eschatology" (27).

44. Courcelle, 22; my translation.

he lacks a broader perspective. By the end of the dialogue, however, he has acquired a perspective that transcends individual experience, acknowledging that, for the virtuous, "every fortune is good whatever it is," as it serves as either a reward or a correction (IV.Pr 7.15). Extrapolating from personal experience to universal experience and finally to divine justice, the narrator apparently acquires a new perspective on his own situation, understanding that seemingly bad fortune in fact accords with the guiding principles of the divine. By the end of the work, the narrator's voice is all but silent; Lady Philosophy dominates the final pages, perhaps suggesting that he has given himself over entirely to philosophy, no longer harboring the doubts that plagued him at the opening of the book.[45] For all intents and purposes, Boethius has been "cured": Philosophy's strong remedies have worked and the narrator has recovered from his ailments.

De Consolatione is a paradigmatic example of how progressive learning can effect a transformation in the vision's recipient. Boethius' dream is capable of systematically leading the dreamer to a state of higher understanding. But by relying upon a rational process of intellection, the educative vision pursues only the path of the *ratio*. Boethius' vision therefore stops within the realm of human understanding; the knowledge that he receives is bounded by the limits of philosophical learning and rational analysis. He does not have the indescribable moment of illumination that Dante, for example, attains in the *Commedia*. But he does learn an important lesson, following Philosophy's argument until apparently he is converted to her point of view. *Le Roman de la rose* shows a different possible outcome of the educative dream vision. While following Boethius' model of the progressive ascent to wisdom from an authoritative source (or an assortment of such sources), the *Rose* illustrates the dangerous possibility that a dreamer's interests could affect the outcome of his vision.

LE ROMAN DE LA ROSE: THE PROBLEM OF THE WILL

The thirteenth-century *Roman de la rose* is in many respects a literary descendant of *De Consolatione*. That Jean de Meun, author of the second portion of the *Rose,* was familiar with *De Consolatione* is undisputed; Jean in fact translated Boethius' work. It has also been argued that Jean used *De Consolatione* as a source for his share of the *Rose*.[46] The link to Boethius

45. The dominance of Philosophy's voice in the final pages of the vision may raise questions about the extent to which Boethius actually has been converted by her lessons. Rhetorically, however, the shift to Philosophy indicates the erasure of his earlier distress.

46. A. J. Minnis demonstrates that a large portion of the *Rose,* spanning lines 4837–6630,

is often seen in the character of Raison, who is read as a figure of Lady Philosophy. Her lessons on fortune, justice, and the source of true happiness resemble Philosophy's, while her attack on Amant's misplaced desires echoes Philosophy's invective against the Muses who keep Boethius in misery.[47] In addition to espousing views similar to those of Lady Philosophy, Raison also plays a role that resembles Philosophy's. Hers is a clearly authoritative presence within the dream, and she is the allegorical figure to whom the Lover, if he were to follow in Boethian footsteps, would turn.

But the Lover does not follow the Boethian model, and he refuses to accept Raison's advice. Whether this is because Raison herself is ultimately unable to counsel someone in love is a matter that has sparked much debate; what is important from my perspective is, quite simply, the fact of the Lover's refusal to follow her.[48] This refusal gives rise to one of the major

"reads as an elaboration of several major themes from *De Consolatione Philosophiae* and its glosses, with materials from other sources being deployed within the Boethian framework of ideas" (A. J. Minnis, "Aspects of the Medieval French and English Traditions of the *De Consolatione Philosophiae*," in *Boethius: His Life, Thought, and Influence*, ed. Margaret Gibson [Oxford: Basil Blackwell, 1981] 324). Noting an even greater dependence upon Boethius in Jean's portion of the poem, Ernest Langlois traces more than 2100 lines directly back to *De Consolatione* (Lynch, *The High Medieval Dream Vision,* 122).

47. See, e.g., Minnis, 324 and Cherniss, 82. Raison's similarity to Lady Philosophy has been noted by a number of other scholars, as well. For example, John Fleming remarks upon the influence of Boethius in both Guillaume and Jean's presentations of "Old Woman and Girl" figures of authority (or, as Fleming calls them, "Old Girls") that echo Lady Philosophy. Although Guillaume's version of this figure is more "oblique" than Jean's, and Guillaume was not as clearly influenced by Boethius, Fleming sees Raison as the analogue to Lady Philosophy in both sections of the poem (John V. Fleming, *Reason and the Lover* [Princeton: Princeton University Press, 1984] 38–40). For more on Boethius' influence on the *Roman de la Rose,* see also Sarah Kay, "Sexual Knowledge: The Once and Future Texts of the *Romance of the Rose,*" in *Textuality and Sexuality: Reading Theories and Practices,* ed. Judith Still and Michael Worton (Manchester: Manchester University Press, 1993) 71.

48. A number of critics maintain that Raison is inherently ill-equipped to advise the dreamer on questions of love. For example, Gillian Rudd writes, "Reason in *The Romance of the Rose* is not always the most appropriate advisor for the Lover. . . . [This text] admit[s] of limitations in the jurisdiction of Reason, yet . . . also present[s] her as the undisputed final judge of earthly, intellectual matters, indispensable for proper government of either state or individual" (Gillian Rudd, *Managing Language in* Piers Plowman [Cambridge: D.S. Brewer, 1994] 52). Considering Raison's function from the perspective of generic distinctions, Peter Allen argues that Raison's "vision of love" is "completely out of place in a courtly romance," "demonstrat[ing] little understanding of human nature, and the discordance between her message and its situation and audience shows how much she misses the mark" (Peter L. Allen, *The Art of Love: Amatory Fiction from Ovid to the* Romance of the Rose [Philadelphia: University of Pennsylvania Press, 1992] 85). Susan Stakel goes even further, arguing that Raison in fact undermines the validity of her own assertion that Amant should turn to her: she instructs Amant to "'le mean eslire' in order to restore a peaceful frame of mind (4205). But having established *Raison* as the polar opposite of *folie* in love she has eliminated herself as a possible middle ground or source of compromise" (Susan Stakel, *False Roses: Structures of*

points of difference between this poem and *De Consolatione:* the presence of multiple, conflicting voices of authority. Whereas Boethius envisions a single authoritative figure dispensing words of advice that seem unambiguously wise, the *Rose* virtually explodes with "authorities," although the very presence of so many characters purporting to speak the truth about love throws all of their putative authority into doubt. This multiplication of authority fundamentally undermines any clear sense of a functionally authoritative voice within the poem. Despite the absence of any clear figure of authority, however, Amant manages to pursue a course of "education" that ultimately enables him to achieve the goal that he desires. Viewed broadly, *Le Roman de la rose* describes a successful quest for knowledge and experience. Amant, enamored of the Rose, swears allegiance to Amor and dedicates himself to pursuing the object of his desire (1896–1922).[49] He then encounters a series of characters who seek either to help or to hinder him in his pursuit and wages a war against Jalousie and her vassals. Finally, he not only gains access to the Rose itself, but evidently undergoes a wide range of sexual experiences, resulting in his self-professed expertise in amorous affairs.[50] Amant's path is unlike Boethius' in his renunciation of reason and in the extent to which he takes control of the direction that he pursues. Yet his trajectory parallels Boethius' in its adherence to a traceable process of education. Although we cannot say with certainty that the dreamer, once awake, has been changed in any significant way—the rather terse ending, "Alors il fit jour et je me réveillai" (Straightway it was day, and I awoke, 21783),[51] does not provide us with any insight into the dreamer's waking life, either pre- or post-dream—Guillaume's assurance at the outset of his poem that "en ce songe onques riens n'ot / Qui trestout avenu ne soit, / Si com li songes devisoit" (in this dream was nothing which did not happen almost as the dream told it, 28–30)[52] suggests that we are meant to believe that the vision he recounts eventually came "true" for

Duality and Deceit in Jean de Meun's Roman de la Rose [Saratoga, CA: ANMA Libri and the Department of French and Italian Studies, Stanford University, 1991] 75). This brief survey covers only a few of the many critics who maintain either that Raison is intrinsically unsuited to comprehend human love, or that her arguments are inherently flawed.

49. All references are to Guillaume de Lorris and Jean de Meun, *Le Roman de la rose,* ed. Armand Strubel (Paris: Librairie Générale Française, 1992).

50. See 21381 ff., in which Amant reflects upon the "sage" and "bon" use that he has made of his genitalia in the past.

51. Guillaume de Lorris and Jean de Meun, *The Romance of the Rose,* trans. Charles Dahlberg (Princeton: Princeton University Press, 1995) 354; all translations are from this edition. Strubel's edition of the *Rose,* which follows MSS BN 12786 and BN 378, does not contain the last 106 lines of the poem in their original form; BN 378, he notes, is lacking a folio (1119n).

52. Trans. Dahlberg, 31.

the dreamer.[53] Regardless of the extra-oneiric events hinted at in the text, however, it is clear that within the world of the dream, Amant's experiences grant him the knowledge that he seeks.

But Amant does not attain the universal perspective acquired by Boethius' narrator: the knowledge that Amant acquires is limited, bounded by his desire. His second dialogue with Raison reveals the limit of the knowledge that he is capable of gaining. In this conversation, Amant is quite clear about what he is and is not interested in learning, and his predetermined notions of what he wants to achieve fully inform his response to her speech. After Raison's sermon on youth and age and the proper (procreative) sort of love to pursue, Amant reflects upon his own unwillingness to learn:

> Ainsi raisons me preeschoit,
> Mais amours tout empeschoit
> Que riens a oevre ne meïsse,
> Ja soit ce que bien entendisse
> Mot a mot toute la matire,
> Car amours si forment m'atire,
> Que par trestouz mes pensers chace
> Com cil qui partout a sa chace,
> Et toz jorz tient mon cuer souz s'ele;
> Hors de ma teste, a une pele,
> Quant au sermon seant m'aguiete,
> Par une des oreilles giete
> Quanque raisons en l'autre boute,
> Si qu'ele i pert sa paine toute
> Et m'emple de corrouz et d'ire. (4625–4639)

(Thus Reason preached to me, but Love prevented anything from being put into practice, although I heard the whole matter word for word, for Love drew me strongly and hunted even through all my thoughts like a hunter whose course lies everywhere. He kept my heart constantly under his wing, and when I was seated for the sermon, he kept watch over me, outside of my head, with a shovel. Whenever reason cast a word into one ear, he threw one into the other, with the result that she wasted all her efforts and only filled me with anger and wrath.[54])

53. For the purposes of this argument, Guillaume's and Jean's sections of the poem will be treated as a single narrative.

54. Trans. Dahlberg, 99.

In this aside, Amant makes it plain that Raison is incapable of persuading him to change his course. He has pledged himself to Amor—he is, both literally and figuratively, subject to Love—and the only real effect of Raison's arguments is to provoke the dreamer's ire. Raison seeks to bring Amant under her sway, but his determination to conquer the Rose is too strong. The image of the hunt employed in the passage above recalls Amor's pursuit of the lover (1310 ff.) while also indicating Amant's loss of agency—his total commitment to his amorous adventuring. While it is certainly possible that Amant is simply deflecting the responsibility for his failure to listen to Raison onto the God of Love, rhetorically he makes it clear that, at this point in the narrative, Raison has no chance of changing his mind.

Amant *does* pay attention to a subsequent advisor, however, when Ami effectively assumes the role of the dreamer's chief counselor. Amant's decision to renounce Raison and select an advisor more congenial to his desires vividly demonstrates the dangers of introducing a willful dreamer to a variety of conflicting "authorities," but Ami is not initially intended to act as an advisor. Amant's determination to follow his own desires leads him to promote Ami to an authoritative role, although, according to the God of Love, Ami is meant to serve as the lover's sounding-board, to be a friend with whom he can share the gift of Douz Parlers (2669) when his "mal [1]'angoisseront fort" (troubles wring [him] with anguish, 2689).[55] "Saches que c'est mout plesant chose," Amor explains, "Quant on a home a cui l'en ose / Son consoil dire et son secre: / Ce deduit penras mout en gre / Et le tenras por bien paié / Puis que tu l'avras essaié" (Know that it is a very pleasant thing when one has a man to whom one dares to tell one's counsel and one's secrets, 2709–14).[56] The primary function of the friend is not to provide actual counsel but to allow the lover to indulge in verbal reflection upon his beloved and to be comforted in his amorous torment. Yet Ami ultimately assumes the role of a counselor. Having disposed of Raison (7231–32), Amant recalls his friend and wishes to return to him (7233–34). The lover thus consciously chooses to replace Raison with Ami, putting him in the very role that Raison had inadequately (to Amant's mind) performed.

Ami's success in guiding Amant's course of action arises from his ability to appeal to Amant's desires rather than from the inherent value of his message; this is most clearly demonstrated by Amant's changing reaction to Ami's advice. Ami first counsels Amant to practice deceit and treachery by flattering Male Bouche and Jalousie (e.g. 7593–7670). Despite his earlier

55. Ibid., 68.
56. Ibid.

rejection of Raison's advice and his conscious choice of Ami as his counselor, Amant is not initially open to his friend's recommendation, refusing to play the part of a traitor. His response to Ami's advice is adamant: "Nus hons, s'il n'est faus ypocrites, / Ne feroit ceste deablie. . . . Trahistres seroie mortieus / Se servoie pour decevoir!" (No man who was not a false hypocrite would commit such deviltry. . . . I would be a deadly traitor if I were to serve in order to deceive!, 7798–99, 7806–7).[57] Yet, sixty-two lines later, Amant has changed his mind and accepted Ami's words as wisdom (7869 ff.). In fact, Ami has so thoroughly convinced Amant that treachery against Male Bouche is justified that Ami must restrain Amant in his newfound zeal (7873–78). Ami's dramatic success in converting Amant to his way of thinking does not stem from appeals to reason or morality—the tactic employed by Raison—but from an appeal to Amant's self-interest. Whereas Raison's aim was to convince Amant to abandon his desire for the Rose altogether, Ami's advice is successful because Amant has already chosen to follow it: his resolve to win the Rose at any cost predetermines his course of action, leading him to reject Raison as an advisor.

Ami's virtual repetition of Raison's advice in a later speech further demonstrates that it is not the advice itself that appeals to Amant, but rather the context in which the advice is delivered. Earlier, Raison advocates the rejection of Fortune's favors, arguing that "Ne riens que fortune feroit / Nus sages hons ne priseroit" (nothing Fortune did would entrap a wise man, 5343–44).[58] She marshals this argument in her discourse on the benefits of renouncing Amor and espousing the higher love of reason by abandoning worldly desires. Amant rejects this argument (5374–83). Later, however, he is swayed by Ami's story of failed love, which plainly echoes Raison's advice. Ami describes how Fortune deprived him of his property:

> Fortune ainsi les me toli
> Par povreté qui vint o li.
> Toli? non pas, par foi, je ment,
> Ainz prist ses choses proprement,
> Car pour voir sai que se mien fussent,
> Que par li laissié ne m'eüssent . . .
> Siens, voire, mais riens n'en savoie
> Car tant achatez les avoie
> De cuer et de cors et d'avoir;
> Que les cuidoie touz avoir:

Mais quant se vint au darrenier,
Que n'oi pas vaillant .i. denier (8025–30; 8033–39)

(Fortune robbed me of them thus through Poverty, who came with her.
Robbed! In faith, no, I lie; rather she took rightly the things that were her
own, for I know for a truth that, if they had been mine, they would never
have left me for her. Hers, indeed, but I knew nothing about them, for I
thought that I could possess them all, and I had bought them so much with
my heart, my body, and my possessions, that when it came to the end, I had
nothing worth a penny[59])

Ami's story is an exemplum of Raison's counsel. Just as she warned it would,
excessive attachment to worldly goods and the privileges that they entail
has resulted in disaster for the lover's friend. But where Raison speaks in
the abstract, Ami's wisdom is based on experience, and the greater rhetori-
cal effect of the latter's tale is evident in his audience's response. Although
Amant does not speak again for more than a thousand lines (chiming in
next at 9459, and then only briefly), his ongoing complicity in Ami's plans
suggests that the tale told from Ami's experience supports his project of
obtaining the Rose. His desire for the Rose is unshakable and any knowl-
edge that he acquires must be in furtherance of his goal; otherwise it will
be discounted as irrelevant or even false. Amant is not, then, hostile to
Raison's advice as such (at least in this case), but rather to the use that she
would have him make of it. Upon the conclusion of Ami's discourse, in fact,
Amant remarks that "au moins de fait, / . . . il [Ami] set plus que raisons ne
fait" (indeed . . . he knew at least more than Reason did, 10009–10)[60] and
that his own reason strongly agreed with Ami (10012), confirming that the
purpose to which Ami's counsel is put is at least as important as the counsel
itself in determining whether it will convince his listener.

The process of education undergone by Amant, while successful in one
sense, thus raises serious questions about the moral utility of such education
when it is administered by a questionable figure of authority. The *Rose* does
not problematize the process of gaining knowledge, but calls into question
the attribution of authority and the role of the dreamer's will. Raison is an
inadequate advisor because Amant has no interest in her advice, however
solid it may be. Amant's decision to follow Ami's counsel stems largely
from the fact that he finds Ami more congenial—not necessarily because
Ami's advice is better than Raison's. Human willfulness undermines the
effectiveness of any one authority while the presence of multiple authori-

59. Ibid., 149–50.
60. Ibid., 179.

tative figures gives Amant the choice between different types of amatory practice, ultimately allowing him to follow the one that best suits his own interests rather than the one that is best in itself. In Boethius' vision, the way advocated by Philosophy is the only option: either the narrator continues along the mournful path of the muses or he adopts her broader outlook, and Philosophy's early action of chasing the muses out of his cell arguably limits this choice even further. Amant, on the other hand, can choose between a number of possible counselors, and his choice reflects his own wishes, not the path of truth that Raison purports to lay out.

The multiplication of authority figures is a key component of the *Rose*'s structure, undermining the dream's potential to convey truth. Arguing that the *Rose*'s form evokes the principles of the scholastic debate, Susan Stakel notes that "the Lover plays the role of student vis-à-vis a panoply of instructors each eager to express his or her views on love."[61] Stakel links this structure to Jean's troubling of the possibility of acquiring knowledge through the dream. The prominence of characters such as Faux Semblant, she argues, suggests that words cannot be trusted:

> Speakers *cannot* be believed. When Ami instructs the lover "*say* this" or "*say* that" the synonym pool of *dire* is "to lie" and its associates. Faux Semblant sums up the problem: "Ne ja certes par mon habit / ne savrez o quex genz j'abit; / non ferez vos voir aus paroles" (11041–43). Words are as deceptive as outward appearances.[62]

The outcome of this is that "[*k*]*nowing* becomes almost impossible,"[63] and Amant is left without any assured means of following the proper path towards understanding. Yet, as William Calin notes, Amant's shift from despairing passivity to action indicates that he has gained some knowledge. By the end of the poem, "whatever may be his cynicism and selfishness the Lover has joined those who are lucid, open to reality, and capable of dealing with it. . . . Having discovered the reality of life, he is able to use deceit for his purposes, and not to be used by it."[64] Although it is true that the possibility of learning is complicated both by the presence of multiple authorities and by the text's emphasis upon deceit and hypocrisy, the dreamer's transformation by the end of his dream indicates that he has acquired the knowledge that he set out to gain.

61. Stakel, 16.
62. Ibid., 40. Italics in original.
63. Ibid., 41.
64. William Calin, *The French Tradition and the Literature of Medieval England* (Toronto: University of Toronto Press, 1994) 177–78.

While knowing is certainly problematic in the *Rose*, then, it remains possible. The educative model of visionary knowing leads the dreamer to a new mastery of seduction and carnal love. But the outcome of this process suggests the disturbing possibility that one can pursue a course of learning that is largely in accordance with one's desires rather than with any higher good. When the dreamer's will is not in line with the proper authority, it can lead him ever deeper into error. Even when confined to secular knowledge, education can go wrong, and the fault, in this case, lies squarely with the dreamer's misapplication of his will. By prioritizing desire over reason, the dreamer misses the edifying effects of Raison's discourse and fully embraces carnality.

THE *DIVINA COMMEDIA:* FROM EDUCATION TO REVELATION

In stark contrast to the *Rose*, the *Divina Commedia* dramatizes a man's successful ascent to divine knowledge and, of the three dream visions discussed in this chapter, is the one that is most clearly related to the eschatological vision tradition. Like *De Consolatione* and the *Rose,* the *Commedia* tracks the protagonist's successful attainment of the knowledge that he desires, but it differs from these other works in its ascent from the worldly to the heavenly. It is fitting, then, that Dante depicts the path to knowledge as following not only the linear process of rational education that we saw in Boethius and the *Rose,* but also direct revelation as the key to understanding God. The narrator undergoes a lengthy process of education with Virgil as his guide before being handed over to Beatrice, who initiates the revelation and conversion that are essential to the fulfillment of his vision. The *Commedia* thus exploits both modes of visionary knowing—educative and revelatory—and these modes coincide with the type of knowledge that the narrator gains in each stage of his journey.

Roughly the first two thirds of the poem comprise Dante's educative ascent, as Virgil leads him to a progressively fuller understanding of hell and purgatory and the justice that dictates a soul's placement in these realms. Virgil's function in the *Commedia* has been sufficiently well established that I need not rehearse it at length here;[65] it is enough to observe that Virgil serves as Dante's guide through the lower realms of the otherworld, explaining what he sees and anticipating and answering his questions. Virgil's role is unlike anything found in the *Rose,* in which the absence of an

65. See, e.g., Jeffrey T. Schnapp, "Introduction to *Purgatorio,*" in *The Cambridge Companion to Dante,* ed. Rachel Jacoff (Cambridge: Cambridge University Press, 2007) 91–106.

unambiguous guide contributes substantially to Raison's failure to govern Amant. Amant does not depend upon any particular character's guidance; he is free to choose between Raison and Amor, Reason and Eros. Unsurprisingly, Amant chooses the path that is most in harmony with his immediate desire for physical pleasure. Dante, on the other hand, more closely resembles Boethius' narrator in that he has little choice but to follow the guide that has come to him. Virgil's task is to "dar lui esperïenza piena" (give [Dante] full experience, *Inf.* XXVIII.48) of the otherworld to remind him of the way to salvation.[66] Virgil's appearance before the wanderer recalls Lady Philosophy's appearance to Boethius, who has similarly forgotten the higher truths that he once knew and that have the power to comfort him in his trouble. And just as Philosophy raises Boethius to an understanding of universal justice, Virgil elevates Dante's consciousness to the more encompassing view from which he is able to receive Beatrice's grander revelations. But there is a significant difference between them, as well, in that Virgil's personal limitations reveal the limits of the function that he has been assigned. He is a pagan and thus barred from heaven, which he lost "per null' altro rio . . . che per non aver fé" (for no other crime than not having faith, *Purg.* VII.7–8). Capable of leading Dante along the path to truth, he cannot accompany him on his final steps. It is fitting that Virgil must retreat before Beatrice and vanish, as he does, in the final cantos of *Purgatorio* (XXX.49–51).

It is through Beatrice that Dante explores the revelatory potential of the vision. Beatrice's powers transcend didactic education; not only does she instruct Dante, but she offers him an experience: the experience of her presence, which manifests grace. In Thomas Finan's words, Beatrice is "the reflecting image of what she reveals."[67] As both virtue and its image, she renders the divine comprehensible. She therefore gives Dante something that a guide grounded in human reason cannot: herself, as a reflection of the divine. In consequence, Beatrice's methods of instruction are intrinsically different from Virgil's. She teaches Dante through methods that are both rational and intuitive, didactic and experiential.[68] Where Virgil teaches through illustration and explanation, she adds the quality of revelatory experience—of the divine embodied in her form—to Dante's journey.

66. All references, both in the original and translation, are to *The Divine Comedy,* trans. and ed. Charles S. Singleton, 3 vols. (Princeton: Princeton University Press, 1980).

67. Thomas Finan, "Dante and the Religious Imagination," in *Religious Imagination,* ed. James P. Mackey (Edinburgh: Edinburgh University Press, 1986) 68.

68. Argues Irma Brandeis, "She has two ways of teaching: by the sheer radiance of her face . . . and by her speech, in which intuitive knowledge is translated into rational discourse for her companion's sake" (Irma Brandeis, *The Ladder of Vision: A Study of Dante's Comedy* [London: Chatto & Windus, 1960] 118).

The distinction between Virgil's instruction and Beatrice's revelation maps onto the difference between *ratio* and *intellectus*. Virgil explicitly connects himself with human reason and Beatrice with faith when he says, "Quanto ragion qui vede, / dir ti poss' io; da indi in là t'aspetta / pur a Beatrice, ch'è opra di fede" (As far as reason sees here I can tell you; beyond that wait only for Beatrice, for it is a matter of faith, *Purg.* XVIII.46–48):[69] faith can only be explored and understood via the *intellectus*. As the narrator later remarks, "what we hold by faith" cannot be understood through rational logic: it cannot be "demonstrated," but must be "known of itself, like the first truth that man believes" ("Lì si vedrà ciò che tenem per fede, / non dimostrato, ma fia per sé noto / a guisa del ver primo che l'uom crede," *Para.* II.43–45). These lines concisely summarize the difference between the knowledge gained through rational education and that gained through revelation. The "first truth," like Aquinas' first principles, is known via the *intellectus;* it is not understood through the application of reason. In like manner, Beatrice's lessons are apprehended through the *intellectus,* while Virgil's knowledge and the measured ascent through hell and purgatory teach through the *ratio*. Virgil can lead Dante through these realms, but he must yield to Beatrice when the limits of reason are reached and matters of higher theological knowledge are at stake.

Once Dante has reached paradise, the difference between *ratio* and *intellectus* as ways of knowing comes to the fore and the narrator's inner readiness for the reception of divine truths is essential. Not only do *ratio* and *intellectus* enable the apprehension of different sets of truths, but the mental preparation for enlightenment by the *intellectus* requires an affective and devotional involvement that the *ratio* does not. Early in *Paradiso,* Dante stresses the importance of revelation via the *intellectus:* "Io veggio ben che già mai non si sazia / nostro intelletto, se 'l ver non lo illustra / di fuor dal qual nessun vero si spazia" (Well do I see that never can our intellect be wholly satisfied unless that Truth shine on it, beyond which no truth has range, IV.124–26). The level of understanding achieved by the *intellectus* cannot be attained through the individual's own efforts; divine revelation is required for it to be successful. This idea is in keeping with Aquinas' conception of the passivity of the *intellectus,* which requires the action of

69. Jeremy Tambling argues that this passage is also significant because it indicates Virgil's awareness of his limits: "That Virgil, not Dante, makes the 'ragion'/'fede' ['reason'/'faith'] distinction is important: not that Virgil has become Christianised, but that he can already, as it were, see the hollowness of what he has to say. To speak about 'fede' shows that, despite his inability to talk about it in formal terms, he is there already: he is over the limit of reason and into something else" (Jeremy Tambling, *Dante and Difference: Writing in the* Commedia [Cambridge: Cambridge University Press, 1988] 10).

the divine to understand the truth.[70] Without the proper preparation, however, Dante cannot gain access to Beatrice's revelations. For him to acquire the knowledge that she offers, he must admit to and confess his sins, in particular the errant path that he has followed since Beatrice's death. In the final cantos of *Purgatorio,* after Virgil has disappeared, Beatrice chastens Dante for having abandoned the way that she had set before him previously. Thus reproached, Dante is "stung" by the "nettle of remorse" and faints (XXXI.85–87). Only then is he able to approach Beatrice (94–96). Chastisement and repentance prepare Dante for the revelations that she will grant him. Even though the entire *Commedia* has been a privileged vision of divine justice in which Dante has been given the highly unusual favor of seeing the other world before leaving his body, he must still undergo purgation before being allowed to attain the pinnacle of divine understanding. The prerequisite of purgation sets Beatrice's revelations apart from Virgil's, stressing the difference between the kind of knowledge that Dante is about to receive and that which he has already gained by foregrounding the necessity of the dreamer's inner preparation for the moment of revelation.

That revelation, when it comes, is explicitly linked to the *intellectus.* In the final cantos of *Paradiso,* the almost literal illumination of Dante—and heaven itself—that is caused by Beatrice's explanation of the rings of light that are made up of the blessed powerfully evokes the transformative potential of the revelation. Dante describes the effect of her speech upon him as the sudden clearing away of clouds,[71] and the repercussive effect that her words have on heaven—there is "sparkl[ing]" ("sfavillaro") in the circles of light, and "Io sentiva osannar di coro in coro" (Hosanna sung from choir to choir, XXVIII.88–9, 94)—reflects the transformative power of her lesson. This climactic moment of revelation is understood through the *intellectus.* Beatrice's explanation of its source makes this clear:

> . . . e dei saper che tutti hanno diletto
> quanto la sua veduta si profonda

70. Thomas Aquinas, *Introduction to Saint Thomas Aquinas,* ed. Anton C. Pegis (New York: Modern Library, 1948), *ST* I 79.2, pp. 338–39. See also my discussion of Aquinas' views above.

71. "Come rimane splendido e sereno / l'emispero de l'aere, quando soffia / Borea da quella guancia ond' è più leno, / per che si purga e risolve la roffia / che pria turbava, sì che 'l ciel ne ride / con le bellezze d'ogne sua paroffia; / così fec'ïo, poi che mi provide / la donna mia del suo responder chiaro, / e come stella in cielo il ver si vide" (As the hemisphere of the air remains splendid and serene when Boreas blows from his milder cheek, whereby the obscuring mist is cleared and dissolved, so that the heaven smiles to us with the beauties of its every region, so I became after my lady had provided me with her clear answer, and like a star in heaven the truth was seen, *Para.* XXVIII.79–87).

nel vero in che si queta ogne intelletto.
Quinci si può veder come si fonda
l'esser beato ne l'atto che vede,
non in quel ch'ama, che poscia seconda (XXVIII.106–111)

(And you should know that all have delight in the measure of the depth to
which their sight penetrates the Truth in which every intellect finds rest;
from which it may be seen that the state of blessedness is founded on the
act of vision, not on that which loves, which follows after)

Seeing, not reasoning—or even loving—brings the mind to the highest
truths. The position espoused in these lines runs counter to the Francis-
cans' emphasis on love as the foundation of knowledge; for Dante, intel-
lectual understanding, rather than the loving will, is the basis of beatitude.[72]
Beatrice clearly associates this form of intellectual understanding with the
angelic *intellectus,* which is grounded in a continuous vision of the divine:
"Queste sustanze, poi che fur gioconde / de la faccia di Dio, non volser
viso / da essa, da cui nulla si nasconde: / però non hanno vedere interciso / da
novo obietto, e però non bisogna / rememorar per concetto diviso" (These
substances [the angelic nature], since first they were gladdened by the face
of God, have never turned their eyes from It, wherefrom nothing is con-
cealed; so that their sight is never intercepted by a new object, and therefore
they have no need to remember by reason of interrupted concept, *Para.*
XXIX.76–81). Uninterrupted sight of the divine is contrasted to recollec-
tion and discourse; angelic *intellectus* rests in the truth, while the *ratio* is
secondary and discursive. When Beatrice later tells Dante that they have
emerged into the realm of "light intellectual" (XXX.40), it is clear that he
is about to be granted a hint of the knowledge in which the angels habitu-
ally rest.

Despite the importance of intellectual understanding, however, the illu-
mination of the *intellectus* is also associated with the volitional union with
God that is effected through Dante's confession and repentance. Through
the recognition of his errors, Dante—with Beatrice's prompting—brings
his will into harmony with God's. In the words of Magnus Ullén, "the
desire of the poet is ultimately brought into harmony with that of the Cre-
ator . . . moving towards its fulfillment in God."[73] This union is spurred by
the purgation that he undergoes prior to the realization of his vision; his

72. David Higgins explains this interpretation in his note on these lines in Dante, *The
Divine Comedy,* trans. C. H. Sisson (Oxford: Oxford University Press, 1998) 721.
73. Magnus Ullén, "Dante in Paradise: The End of Allegorical Interpretation," *New Liter-
ary History* 32 (2001): 177.

shame for his transgressions against Beatrice prepares him to witness the fullness of the divine.[74] It is in fact through shame, argues James Chiampi, that Dante is made ready for his vision: "illumination and ecstasy require shame's aid to complete the rejection of love of the *saeculum*."[75] Through his shame, Dante overcomes his earlier willfulness and unites his will with that of the divine. Beatrice's role in turning him away from his sins and towards a volitional union with God gives the experience the character of a conversion; noting the elision of the precise nature of Dante's sins, John Freccero argues that "[t]he return of Beatrice . . . marks the return of an Eros now domesticated and transformed into [an] amalgam of Christian and cosmic love."[76] His conversion is a conversion of the tenor of his life from the secular, as signified by the erotic, to the heavenly; Beatrice's presence as a heavenly queen is an emblem of the redirection of his life towards the divine.

The union of his will with God's signifies the limits of rational discourse, transcending the world of philosophy and reason that Virgil represents. Writes Marjorie O'Rourke Boyle, "*Paradiso* transgresses the limits of scientific discourse through the exhaustion of analytical methods in the volitional delight of the beatific vision":[77] volitional union is outside of rational analysis and it clears the way for an illumination that appeals not to the *ratio* but to the *intellectus*. As such, Dante's final vision, unlike his vision up to that point, cannot be translated onto the page: the intellectual light of angelic knowing resists all reduction to language. When Beatrice has retired to her point in the third circle nearest the center, Bernard indicates that Dante is to look up and follow her eyes to the ray of "Eternal Light" at the center of the circles (XXXIII.40–50). What he sees there is described in abstract language: at once a "semplice sembiante" (simple appearance) of "vivo lume" (Living Light, XXXIII.109–110) and "'l ben, ch'è del volere obietto" (the good, which is the object of the will, XXXIII.103), it annihilates the possibility of description and recollection (XXXIII.106–8). Elsewhere, Dante records the feelings generated in him by the vision as a way of describing the experience, although this, too, is destined to fall short of accurately reproducing the vision for his readers.[78] The

74. For a detailed discussion of the role of shame in Dante and its philosophical and theological context, see James T. Chiampi, "Dante's Education in Debt and Shame," *Italica* 74.1 (1997): 1–19.

75. Chiampi, 3.

76. John Freccero, "Allegory and Autobiography," in *The Cambridge Companion to Dante,* 167.

77. Marjorie O'Rourke Boyle, "Closure in Paradise: Dante Outsings Aquinas," *MLN* 115 (2000): 5.

78. Dante's translation of his vision into his feelings is discussed at greater length in

closest that Dante comes to a pictorial description of what he sees is when he provides the Trinitarian image of three circles of equal circumference (*Para.* XXXIII.115–120), but even this causes his language to fall short (121). The indescribability of the vision reflects its basis in intellectual, rather than rational, understanding. Dante compares the moment of revelation to a geometer's trying to measure a circle without the proper principles (133–35), a problem that is impossible but is, in this instance, illuminated by the divine. "[M]a non eran da ciò le proprie penne," he notes, "se non che la mia mente fu percossa / da un fulgore in che sua voglia venne" (but my own wings were not sufficient for that, save that my mind was smitten by a flash wherein its wish came to it, 139–141): revelation succeeds where *ratio* fails, appealing directly to the *intellectus* and granting the dreamer a fleeting moment of angelic understanding.

The *intellectus* is necessary for Dante to grasp the knowledge proffered by his vision. But it is not, in itself, enough. The rigorous preparation that he must undergo in order to show himself worthy of the divine vision, his long ascent through hell and purgatory, and his need to unite his will with God's implicate other processes into the visionary experience. With Virgil as his guide, Dante's preparatory experiences are analogous to using the *ratio* to come to the limits of learning. Moving from stage to stage in a rational progression, he reaches the boundaries of human knowledge and the realm of the divine. But while the *ratio* may be inadequate to achieve the fullness of visionary knowing, it is also essential to Dante's journey. Virgil takes Dante to Beatrice just as the *ratio* takes him to the threshold of the *intellectus*. Moreover, Dante's confrontation with Beatrice leads to the perfection of his will as the precondition of his final visionary experience. Only when his will is in harmony with that of the divine and he has proven himself ready for the ultimate vision is Dante brought into that "sweetness" that still "drop[s] within [his] heart" ("e ancor mi distilla / nel core il dolce," XXXIII.62–63). The *intellectus* does not stand on its own, just as a *Commedia* without Virgil is unimaginable.

THE *DIVINA COMMEDIA* mirrors many of the concerns found in eschatological and mystical vision literature. Dante's emphasis on the indescribability of his heavenly vision, for example, rhetorically links his poem to the visionary tradition, in which divine revelation is often presented as impos-

William Franke, "The Ethical Vision of Dante's *Paradiso* in Light of Levinas," *Comparative Literature* 59.3 (2007): 212–13. Franke argues that "Dante's vision in paradise, specifically of the glory that according to *Paradiso* I.1–3 in fact radiates throughout the universe, can be described only indirectly by its effects upon the emotions of the poem's speaker" (213).

sible to convey in human language.[79] Further, as we will see, the visionary writers Marguerite d'Oingt, Gertrude of Helfta, Julian of Norwich, and Margery Kempe rely on more than the illumination of the *intellectus* in their visionary knowing; similarly, cognitive and volitional engagement as well as divine revelation provide the necessary preconditions for Dante's knowing to succeed. But what happens when the revelation does not clearly instill the dreamer with knowledge, when even an experience of the divine does not lead—at least, not unambiguously—to wisdom? The three works discussed in the second half of this chapter all had narrator-dreamers who reached the goals of their visions, who ultimately *got it*—even if, as in Amant's case, the "it" in question is not the most morally or philosophically defensible result possible. Boethius understands Philosophy's instructions and Dante's vision of heaven leaves him forever transformed, the sweetness of his experience echoing within him even if he cannot remember it in its entirety or express it through the written word. We have the sense, in the *Commedia,* that it cannot be otherwise: Dante has without question attained paradise, and everything that came before in the work has readied him for this moment. In his travels with Virgil, he came to understand the human condition with respect to divine justice. Beatrice then prepared him, through confession and penance, for his heavenly vision. The trajectory of the *Commedia* is straightforward, even linear, despite its switch to a revelatory and experiential way of knowing.

Regarding education and revelation as discrete modes of knowing in the dream vision provides a framework for exploring the points of resistance in visionary knowing. In Dante's poem, revelation follows education and is predicated on the dreamer's preparation for his vision. Volitional preparation, as seen in Dante's decision to follow Beatrice's guidance, is particularly important to the successful conclusion of his experience. Revelation falters when the education that precedes it fails—and education can certainly fail. If the dreamer's will is misdirected, his vision cannot convey the knowledge that it is intended to transmit. Amant rejects the righteous path that Raison presents to him, opting instead to follow his own willful desires and pursue the Rose. Even in this pursuit, however, Amant demonstrates the single-mindedness necessary for the successful achievement of visionary knowing: refusing to be deterred by the counsel of Raison, he perseveres in his quest at the cost of everything else. It is only as a consequence of this determination and the total direction of his will at the Rose that he

79. See, e.g., Gertrude of Helfta, *Œuvres spirituelles,* ed. Pierre Doyère, vol. 2 (Paris: Les Éditions du Cerf, 1968) 2: 10.1; Hildegard of Bingen, trans. Hart and Bishop, 60–61; and Birgitta of Sweden, trans. Kezel, 102.

ultimately achieves his aim. These texts clearly indicate that the dreamer plays an active role in the comprehension of the vision. The grounds for the reception of the visionary message must be prepared within the dreamer if he or she is to understand the dream—and, I will argue, such preparation is equally important in mystical vision texts.

2

Marguerite d'Oingt

ACTIVE READING AND THE LANGUAGE OF GOD[1]

 UCH VISION LITERATURE of the thirteenth and four-
teenth centuries prioritizes the subjective experience of
the vision. Visionary texts of this kind usually center
upon a felt relationship with God, exploring an inti-
mate union with the divine. Peter Dinzelbacher associates these texts with
a category of hagiographic literature that he calls "Offenbarungsvitae"
(Revelation-vitae), a "sub-genre" of the mystical biography that developed
around the thirteenth century. Beginning in this period, Dinzelbacher argues,
visionary writing with a strong focus on the subject's inner life became pre-
dominant: "das subjektive Erleben bekommt eine ganz wesentliche Rolle
neben dem äußeren Leben. . . . Waren früher Tat und Wunderwirken nach
außen das Zeichen der Heiligkeit . . . , so ist nun gnadenhaftes Erleben und
Schauen in der Seele ein wenigstens gleichwertiges" (Subjective expe-
rience takes on a truly fundamental role alongside [the saints'] exterior
lives. . . . Previously, deeds and miracle-working were the signs of holi-
ness . . . but now the experience of divine gifts and apparitions in the soul
are of at least equal value).[2] Like Offenbarungsvitae, first-person visionary
accounts focus upon the interior, divine gifts given to the visionary at least
as much as upon his or her external actions.

 Marguerite d'Oingt (c. 1240–1310), a Carthusian prioress from Pole-
teins, does not at first glance fit with the affective mystics of the Offenba-
rungsvitae whose texts emphasize personal experience of the divine. Her

 1. An earlier version of this chapter was published as "The Meaning of the Word: Lan-
guage and Divine Understanding in Marguerite d'Oingt," *Mystics Quarterly* 33.1–2 (2007):
27–52.
 2. Peter Dinzelbacher, "Die 'Vita et Revelationes' der Wiener Begine Agnes Blannbekin
(† 1315) im Rahmen der Viten- und Offenbarungsliteratur ihrer Zeit," in *Frauenmystik im
Mittelalter,* ed. Peter Dinzelbacher and Dieter R. Bauer (Stuttgart: Schwabenverlag AG,
1985) 167; my translation.

writings—the *Pagina Meditationum,* the *Speculum,* a *Vita* of Saint Beatrice d'Ornacieux, and a handful of letters—do not express a deeply personal relationship with God. Nor is Marguerite exemplary in the way that the subject of a hagiography is exemplary; in her writings, she does not present herself as an ideal woman living in a state of virtue unattainable by the rest of humankind. Instead, she represents herself as a person who has achieved, through reflection and with the help of divine grace, a state that anyone could presumably achieve through a similar reflexive process. Marguerite portrays the perfection of the soul as being attained through the prayerful reading practices that she implicitly advocates throughout her works. Prayer, as a means of subjecting oneself to God, provides the grounds for her transcendent knowledge and is what enables her to understand the divine in an intimate, lived way.

Marguerite's visions successfully imbue her with a greater understanding of the divine and thus enable her to live a life of increased devotion and virtue. While her visions show her receiving this knowledge through extrarational insight via the *intellectus,* her ability to receive and comprehend these visions depends upon her actively turning to God and directing her will towards the divine. By praying and reading with a devotional intent, Marguerite indicates her volitional union with God, which allows him to illuminate her understanding. The purpose of prayer and prayerful reading is to enable Marguerite to prepare herself spiritually for these visions. Reading is thus an active practice in Marguerite's texts, as her engagement with both literal texts (such as the scriptures) and the books that appear in her visions provide her with the opportunity to move from the active reflection of the *ratio* to the state of volitional union and passive receptivity required for the *intellectus* to be illuminated. Similarly, the subordination of her will to God's is figured as an active practice that requires Marguerite's full devotional intent—an intent that is made most evident in her response to words and texts.

Marguerite's emphasis upon textuality and reading further points out the utility of her experiences for her readers. The importance of devotional reading in her works indicates a replicable path towards the divine: by reading her works with the same kind of devotional intent that she demonstrates in responding to her visionary and mystical experiences, the reader may similarly amend his or her own soul. Building upon the Augustinian tradition of revelation and inner transformation as essential to the development of faith, Marguerite uses her visionary experiences and writings as instructional media that provide a template for devotional meditation. The didactic function of her writings is evident in her apparent confidence in language as an effective medium of visionary communication. Throughout

her texts, language, words, and reading are given primacy as revelatory tools, and Marguerite's work is grounded in the conviction that a proper understanding of words leads to a profound, intuitive understanding of the concepts that they signify. Knowing is thus inextricably bound up with linguistic signification, and Marguerite's understanding of language as an epistemological tool has much in common with Augustinian theories of reading and language.

In this chapter, I will consider the continuities between Marguerite's representation of linguistic signification and these theories. Like Augustine, Marguerite demonstrates the ultimate importance—indeed, the necessity—of directing one's attention to God in order to understand fully the reality behind the sign. Illumination, signification, and devotion are intertwined in her writings, and I will illustrate these connections through a consideration of three of her works. First, I will discuss the *Pagina Meditationum,* which argues for the revelatory significance of texts. The *Pagina* is the first of Marguerite's known writings and the only one written in Latin. Second, the *Speculum,* a Francoprovençal work, underscores the necessity of active reading as a way of unlocking the revelatory potential of the text. Finally, I will examine a letter in which Marguerite's quest for the meaning of the word *vehemens* exposes the intersections of language, understanding, and faith. In this letter, the revelatory potential of language is realized when a single word expresses a divinely charged reality and redirects Marguerite's soul to God. Taken together, these writings suggest a view of words and language as provocative agents of deepened religious awareness and as a potentially powerful means of obtaining revealed knowledge.

I. The *Pagina Meditationum:* Active Reading as Devotional Practice

Almost from the outset of the *Pagina Meditationum,* Marguerite makes it clear that language is intimately bound up with devotional practice. The *Pagina* recounts a direct experience of the divine and the subsequent increase in her love for Christ. The experience that generates this love—and that is the basis of the *Pagina*—occurs while she is meditating upon a passage from scripture.

[I]ncipiebat cantari introitus misse, scilicet: "Circumdederunt me gemitus mortis," et cepi cogitare miseriam in qua sumus dediti propter peccatum primi parentis. Et in illa cogitatione cepi tantum pavorem et tantum dolorem quod cor mihi deficere videbatur ex toto. . . . Postea cum audivi

versiculum introitus quem David psallebat ita dulciter domino dicens: "Diligam te, Domine et cetera," cor meum fuit totum alleviatum. . . .[3]

(the following verse was being sung: "The sighs of death will surround me." And I began to think about the misery to which we are consigned because of the sin of the first parents. And while thinking about this I began [to feel] such fear and such pain that my heart seemed to fail me completely. . . . When I heard afterwards the introductory verse that David sang so sweetly to the Lord, "I love you Lord etc.," my heart was completely relieved. . . .[4])

The Psalm that she hears being sung (17:5, Vulgate) performs a dual function. First, it recalls to Marguerite's mind the memory of original sin and the suffering that all of humankind must endure because of it; and second, it reminds her of the love between humankind and God, which "relieves" her of this pain. Both of these actions occur within her soul. The effects of the psalm are not rational: they prompt a visceral response that augments her love for and understanding of God. The immediacy of her realization suggests that it has occurred via the *intellectus* rather than the *ratio*, as she is spontaneously cured of her suffering and finds herself launched into a state of increased devotional fervor—which she terms, in fact, a "conversion" ("me converti ex toto ad ipsum")[5]—by entering imaginatively into a scriptural text. She *experiences* the meaning of the text; literally, she "begins" fear and pain in her thoughts ("in illa cogitatione cepi tantum pavorem et tantum dolorem"). There is no mediating term here such as "feel." Marguerite is taken up into the language, granted an experience of the text that transcends mere verbal recognition. That this experience leads directly to her "conversion" further underscores the transformative power of the text[6]: reading or listening attentively prompts reflection, then understanding, and finally increased devotion and the turning of the soul to God.

The text's ability to prompt a devotional experience when properly read or heard is an essential component of Augustine's theory of reading.

3. Marguerite d'Oingt, *Les Œuvres de Marguerite d'Oingt,* ed. Antonin Duraffour, Pierre Gardette, and Paulette Durdilly (Paris: Les Belles Lettres, 1965) 71. Original language references to the text will be cited with the designation *Œuvres.*

4. Margaret of Oingt, *The Writings of Margaret of Oingt, Medieval Prioress and Mystic,* trans. Renate Blumenfeld-Kosinski (Newburyport, MA: Focus Information Group, 1990) 25. Unless otherwise indicated, translations are from this edition and will be cited as *Writings.*

5. *Œuvres,* 72.

6. Because this "conversion" is not a conversion in the sense that it is commonly used today—she was, obviously, already a Christian prior to this experience—I've placed quotes around the word.

According to Augustinian hermeneutics, Stephen Russell notes, "the only worth that inheres in the act of reading is the invisible inner worth of a soul moving imperceptibly to God."[7] The affective response generated by Marguerite's meditation upon the Biblical text is such a movement. Through the reflections triggered by the psalm, the visionary's soul is recalled to contemplation of and love for the divine. By directing her will towards God, turning away from worldly cares and allowing herself to be absorbed in the words of the psalm, she gains a deeper understanding of the text: her engagement with the words enables her to perceive their meanings in a moment of revelatory understanding driven by the *intellectus*. Of course, in Marguerite's case, the movement is hardly imperceptible; David's song of love to God immediately and efficaciously relieves the suffering of her heart. The opening lines of her work function as a testimonial to the power of the text—in this case, *the* text, scripture itself—both to arouse and to assuage spiritual anxiety.

In Augustinian terms, Marguerite is properly "using" (rather than merely, inappropriately "enjoying") scripture.[8] Proper use of the text is dependent upon the reader's intention: to read with love and charity, in a spirit of devotion, is essential. As Luigi Alici argues, Augustine sees the grace of God as necessary; it is what helps one overcome "the gap between thing and sign." Overcoming the gap and moving beyond the sign, Alici suggests, only happens when reading is inspired by divine grace, which "transforms this [gap] into a space for salvation, a space that is intelligible to and transversible by human beings, on condition that an ordered love plans the concrete itinerary by which human beings . . . are effectively raised above their condition."[9] From an Augustinian perspective, Marguerite's comprehension of the text—and, importantly, the experiential, affective elements of this comprehension—must arise from a gift of grace. And she receives this gift of grace because of her devotion. By willfully directing her attention towards the divine, Marguerite creates the space for illumination to occur and for grace to act upon her. Alici's assessment of Augustine's theory of signification implies that the gap between sign and thing is actually necessary in language: it is what provides the opportunity

7. J. Stephen Russell, *The English Dream Vision: Anatomy of a Form* (Columbus: The Ohio State University Press, 1988) 87.

8. On the distinction between use (*usi*) and enjoyment (*frui*) in Augustine, see, e.g., Augustine, *Teaching Christianity (De Doctrina Christiana),* trans. Edmund Hill, from *The Works of Saint Augustine: A Translation for the 21st Century,* ed. John E. Rotelle, vol. I.11 (Hyde Park, NY: New City Press, 1996) I.3.3 and I.4.4. (Hereinafter, *De Doctrina Christiana* will be cited as *DDC.*) See also my discussion in chapter 5.

9. Luigi Alici, "Sign and Language," in Augustine, *Teaching Christianity (De Doctrina Christiana*), 40.

for revelation and transformation. If language were immediate, there would be no possibility of transcendence. Marguerite thus requires God if she is to leap from mere attention to signs into an experiential understanding, but she also suggests that such understanding—direct and, in a sense, immediate[10]—is possible, that the words are potentially transparent. In other words, while God may be necessary for a full understanding of the text, such an understanding can in fact be reached. But the reader cannot simply await the arrival of divine illumination. She must actively direct her attention to God and read the text in the proper devotional attitude. In a sense, then, activity enables passivity. By reading with devotional attention, Marguerite prepares the ground for God's work in her soul.

Despite the need for divine grace that this theory of reading implies, however, words themselves have an inherent potential to transform the reader or auditor, as the opening passages of the *Pagina* indicate. Marguerite's confidence in the revelatory potential of language is evident throughout her works. Her central images are of books and words; the *Speculum,* for example, details a vision of the book of Christ's life that has been written into Marguerite's heart, as I discuss in the next section; the meditations of the *Pagina,* as we have seen, are prompted by a scriptural reading; and writing is described in one of her letters as a cure for the physical ailments caused by the burden of her revelation: "elle [Marguerite] se pensa que s'ela metoyt en escrit ces choses que sos cuers en seroyt plus alegiez" (she thought that if she put these things in writing, her heart would be lightened).[11] The title of the *Pagina* itself also underscores the importance of language and reading to Marguerite. As Renate Blumenfeld-Kosinski notes, it "indicates that Margaret thought in terms of a text, a 'page'" and "signals the literary or bookish character of her meditations."[12] This title not only categorizes the work as a textual production, however, but reminds us that it is a work to be read—that the content of her devotional experience can be communicated through writing.

Underlying Marguerite's writings, then, is the assumption that texts can effectively communicate the knowledge received in the vision and that the reader can gain knowledge of the divine by reading her work. Although it is a commonplace of visionary writing to remind the reader of the impos-

10. Naturally, her experience is mediated by language in that her feelings of devotion arise and are expressed entirely in relation to a written (and spoken) passage, but her apparently God-given ability to "feel" and comprehend the scriptural text grants her experience a kind of immediacy, as well.

11. "Item Ex Alia Epistola," *Œuvres,* 142; my translation.

12. Renate Blumenfeld-Kosinski, "The Idea of Writing as Authority and Conflict," in *The Writings of Margaret of Oingt, Medieval Prioress and Mystic,* 74.

sibility of fully communicating a revelatory experience through language,[13] Marguerite says only that she wrote her *Pagina* "sine alio exemplari nisi gratia Dei fuisset operata in me" (without any other model [exemplar] than the grace of God which is working within me).[14] By calling God's grace an "exemplar," the mystic's claim to be transcribing her experience takes on further textual overtones, invoking what Blumenfeld-Kosinski calls the image of a "spiritual scriptorium" in which she copies out the "text" of her vision.[15] By implication, then, the grace that she has received is itself a kind of text. With this understanding of the visionary experience, the potential difficulty of translating a lived experience into writing is overcome: she has only to "copy out" the experience for it to be accessible to her readers. For Marguerite, the vision can be communicated and the understanding that she has gained passed on to others with relative ease.

Of course, to understand the entirety of her experiences, her readers must understand the words through which they are described. But it is not enough passively to read (or hear) her accounts; the reader must actively pursue their meaning. The necessity of accompanying reading with imaginative activity is apparent in the *Speculum,* which uses the image of a series of books to describe the process of self-reflection that Marguerite's mystical experiences trigger in her soul. Likewise, the purpose of the *Speculum* is to inspire similar self-reflection in her readers. Reading becomes equated with meditative practice, with clear implications for the readers of Marguerite's book: just as Marguerite "reads" the book of Christ's life and is thereby led to amend her own life, so can her readers amend their lives by considering her example.

II. The *Speculum:*
Spiritual Imitation as Textual Emendation

In the *Speculum,* the transformative potential of the vision is articulated entirely in images of texts and reading. The work describes a series of books

13. Consider, for example, Gertrude of Helfta, who worries about the difficulty of finding "the right expressions and words for all the things that were said to me, to make them intelligible on a human level, without danger of scandal" (Gertrude of Helfta, *Œuvres Spirituelles,* ed. Pierre Doyère, Sources Chrétiennes [Paris: Les Éditions du Cerf, 1968] 2: 10.2 (SC 2: 274). Translation is from Gertrude of Helfta, *The Herald of Divine Love,* trans. Margaret Winkworth [New York: Paulist Press, 1993] 109). Similarly, the basis of Hildegard's authorial reluctance rests in "doubt and bad opinion and the diversity of human words" (Hildegard of Bingen, *Scivias,* trans. Mother Columba Hart and Jane Bishop [New York: Paulist Press, 1990] 60). Numerous other examples can be found in the works of visionary writers.

14. *Œuvres,* 72; *Writings,* 26.

15. Blumenfeld-Kosinski, 75.

that are rhetorically framed by the book of the *Speculum* itself. It opens
with an explanation of Marguerite's reasons for writing that introduces
the role that reading and writing can play in devotional practice: "Et per
co que jo desirro vostra salut assi come jo foy la min, je vos diroy . . . una
grant cortesi que Nostre Sires a fait a una persona que jo conoisso non a
pas mout de tens" (And because I desire your salvation as I do my own,
I will tell you . . . of a great favor our Lord did not long ago to a person
that I know).[16] In the passage that follows, she states that "Citi creatura
[Marguerite] . . . aveit escrit en son cor la seinti via que Deus Jhesu Criz
menet en terra et sos bons exemplos et sa bona doctrina" (this creature
[Marguerite] . . . had written into her heart the holy life that Jesus Christ
had led on earth and his good examples and his good teachings).[17] Thus the
second book, contained by the text of the first (the *Speculum*), is the life of
Jesus. The third book is presented as an aspect of the second and is simi-
larly contained by it: "oy li eret semblanz alcuna veis que il li fut presenz
[in her heart] e que il tenit un livro clos en sa mayn per liey ensennier" (it
sometimes seemed to her that He was present [in her heart] and that He
held a closed book in His hand in order to teach from it).[18] The book held
by Christ is the third book, and much of the remainder of chapter 1 is an
explication of this book and the writing inscribed upon its covers. The third
book, moreover, gives rise to a fourth: "el livro de sa [Marguerite's] con-
cienci" (the book of her conscience).[19] Book four, though not contained by
the third book as the third is in the second or the second in the first, arises
as the result of her contemplation of the book of Christ's life (the third
book).[20] Thus we are presented with a series of telescoping books, each
giving rise to the next.

Marguerite's description of the book in the vision (the third book) sug-
gests the power of the text while also indicating its limits as an image.
This book, the book of Christ's life, is the speculum to which the title of
Marguerite's work refers. Its interior is like "uns beauz mirors" (a beautiful
mirror) and its two pages contain "uns lues delicious, qui eret si tres granz
que toz li monz no est que un po de chosa a regar de cen" (a delightful
place, so large that the entire world seems small by comparison).[21] Of its
contents, she writes, "jo ne vo conteray pas mout, quar jo no hay cor qui lo

16. *Œuvres*, 90; my translation.
17. Ibid.
18. *Œuvres, 90; Writings*, 42.
19. *Œuvres, 92; Writings*, 42.
20. A fifth and sixth book are suggested by Blumenfeld-Kosinski, who notes that the
book of Revelation and the book of the seven seals described therein are echoed throughout
Marguerite's vision (*Writings*, 44n1).
21. *Œuvres, 94; Writings*, 43–44.

puit pensar, ne bochi qui lo sout devisar" (I will only tell you a little, for I have neither the understanding that could conceive of it, nor the mouth that could tell it).[22] She then describes a place of surpassing beauty, great light, sweet songs, and wonderful odors.[23] The splendor of paradise is presented to Marguerite via sense and image, and thus its beauty cannot be adequately represented in language. Despite the *Speculum*'s central metaphors of texts and writing, this powerful experience—"si tres granz joys que cors d'ome ne lo porit pensar" (a joy so great that no human heart could imagine it)[24]—transcends linguistic representation. Marguerite can only describe the book's contents; she cannot "read" or "translate" them.

Marguerite can, however, read the letters inscribed on the outside of the book. The white, black, and red letters that appear on its cover and the gold letters on its clasps reveal different aspects of Christ's roles in the incarnation and salvation. In the white letters is written "li conversations al beneit fil Deu" (the life of the blessed Son of God[25]); in the black, "les viutinances que on fit Jhesu Crist" (the evil things which had been done to Jesus Christ); the red letters write "les plaes et li espanchimenz" (the wounds) of Christ; and finally the gold letters, whose text is curiously elided, teach Marguerite "a desirrar les choses celestiauz" (to desire the things of heaven). The white, black, and red letters similarly teach her various lessons: the white, to correct her faults; the black, "a sofrir les tribulations en patienci" (to bear tribulations with patience); and the red, to enjoy her tribulations and detest "tuit li confort de cet mundo" (the pleasures of this world).[26] Not only is the meaning of each of these texts readily apparent to her, then, but its application is, as well. Examining the book thus inspires her devotion and leads her to improve in virtue. Where sensory visionary experience cannot be adequately transmitted in words, textual and linguistic communication is clear in Marguerite's vision: the words written on the divine book are understood and their lessons imparted with little or no interpretive difficulty.

Like the mirror to which the work's title refers, the book of Christ's life prompts Marguerite to reflect upon the state of her soul, and it is here that the text's capacity to provoke a transformation in its reader is fully realized. Comparing the book of her conscience to the book of his life, the prioress is able to see where she has fallen short of the ideal: she sees at once

22. *Œuvres*, 94; *Writings*, 43.

23. *Œuvres*, 94–96; *Writings*, 44.

24. *Œuvres*, 96; *Writings*, 44.

25. Duraffour, Gardette, and Durdilly's modern French translation supports Blumenfeld-Kosinski's translation of "conversations" as "life" (*Œuvres*, 93).

26. *Œuvres*, 92; *Writings*, 43.

Christ's perfection and her own failings. This use of the speculum accords with James Wimsatt's description of the mirror as a trope in medieval literature. "The literary mirror," Wimsatt writes, "is designed to be an image of truth. The writer sets before his audience how things are, which at the same time expresses how things should be."[27] The book in Marguerite's vision functions as such a mirror, simultaneously revealing both ideal and reality. Through this very act of comparison and contemplation, moreover, she is able to draw closer to the divine and achieve greater virtue. The first chapter of the *Speculum* concludes with the words, "Mays li coventavet [toz] jors retornar al comenciment de la via que Nostri Sires Jhesu Criz menet en terra, tant que illi ot bein emenda sa via a l'essimplairo de cel livro; illi se estudiavet grant teins en ceta maneri" (she always had to return to the beginning of the life that our Lord Jesus Christ led on earth, until she had amended her life, based on the example of this book. In this way, she meditated for a long time).[28] The book of Christ's life thus functions as a corrective to her own life and to her conscience (the fourth "book"). Christ acts as the literal embodiment of the means of achieving salvation. His life is the text to be imitated, or rather copied. Marguerite's description of this process reinforces the textual metaphor that structures the *Speculum:* by basing her own emendations upon the model ("essimplairo") of Christ's text, the "text" of her conscience is corrected. Just as she bases the *Pagina Meditationum* upon the "exemplari" of God's works in her soul, here again she employs the idea of the spiritual scriptorium to amend her life in much the same way as she would emend a text.

The idea of textual emendation as a metaphor for correcting one's life is further developed through the suggested analogy between Marguerite's *Speculum* and the mirror that is the book of Christ. Through the act of reading the book of her conscience and comparing it to the story inscribed in the white, black, red, and gold letters upon the cover of the book held by Jesus, Marguerite achieves greater virtue. The reason that she gives for writing her own (literal) book—"per co que jo desirro vostra salut assi come jo foy la min"—suggests that it is to serve a similar function: the *Speculum* itself is to lead souls to salvation. The thematic development of her meditation

27. James I. Wimsatt, *Allegory and Mirror: Tradition and Structure in Middle English Literature* (New York: Western Publishing Company, 1970) 29.

28. *Œuvres*, 94; *Writings*, 43. Marguerite uses the same image earlier in the *Speculum*, again to describe the process of self-improvement, after having read the life of Christ in the white letters on the book: "Apres quant aveit bein regarda totes ses defautes, illi se perforsavet de l'emendar tan come illi puet a l'essemplayre de la via Jhesu Crist" (*Œuvres*, 92) (when she had well considered all her faults she made an effort to correct them, as much as she could, following the example of the life of Jesus Christ [*Writings*, 43]).

upon Christ's life through the second and third chapters of the text further weaves the reader's salvation into her work, since the reader is indirectly called upon to examine the book of his own conscience during the process of reading Marguerite's text.

Yet it is essential that this reading be active. In order to derive the proper benefit from the text, one must engage with and reflect upon Marguerite's words. Her hope that the reader will actively enter into her text is apparent when she declares, "Or poes pensar la tres grant bonta que est en luy qui ensi a dona tot quanque il ha sos amis" (Now you can imagine the great goodness that is in Him who has thus given everything He has to His friends).[29] Addressing the reader directly, she instructs him or her to imaginatively recreate Christ's goodness. A few paragraphs later, she follows this up with an even stronger injunction:

> Certes jo ne croy que el mont ait cor si freyt, se il saveyt bien pensar et cogneitre la tre grant beuta de Nostrum Segnour, que il no fu toz embrasas d'amour. Mays oy ha de cors qui sont si abastardi que il sont come li porcez qui ama pluis lo fla du fangez qu'il no faroyt d'una bella rosa. Assi fant cil qui amont plus pensar en les choses de cest seglo et plus y ant de confort que il non ant en Deu.[30]

> (I truly believe that there is not a heart in this world so cold that it would not be set on fire with love, if it could imagine and know the very great beauty of Our Lord. But there are some hearts so debased that they are like the pig who prefers the smell of the mire to that of a beautiful rose. Those who prefer to think about the things of this world and find more comfort there than in God are like that.[31])

Blumenfeld-Kosinski's translation of "pensar et cogneitre" as "imagine and know" captures the effort of cognition that Marguerite is implicitly encouraging in her readers.[32] The use of two verbs suggests that "pensar" and "cogneitre" somehow happen together but remain separate actions of

29. *Œuvres*, 100; *Writings*, 46.
30. *Œuvres*, 102.
31. *Writings*, 47.
32. This translation is supported by Dominique Stich, whose glossary gives "imaginer" as the Modern French translation of "pensar" and "connaître" for "cogneitre" (spelled "cognètre" in Stich). See Dominique Stich, *Parlons Francoprovençal: Une Langue méconnue* (Paris: L'Harmattan, 1998). Duraffour, Gardette, and Durdilly similarly translate the phrase as "imaginer et connaître" in the *Œuvres* (103), although their glossary gives only "penser" for "pensar" (197).

the intellect: by imagining, one comes to know. This separation of "imagining" from "knowing" accords with contemporary theories of the mental faculties. Aquinas, for example, believed that it is "impossible for our intellect to perform any actual exercise of understanding (*aliquid intelligere in actu*) except by attending to phantasms,"[33] phantasms being products of the imagination.[34] These phantasms provide the "sensory context" required for thought.[35] For Aquinas, the imagination serves as a substitute for sensory experience. By imagining the "great beauty" of the Lord, as Marguerite recommends, the devout soul is able to conceive of him and thus to know him. Entering imaginatively into the content of the visionary text—transforming it into phantasmata, the material for intellectual thought—leads the reader to knowledge, and thence to love, of the divine.[36]

Beyond the power of the text to transform lies the ability of individual words to signify reality—a reality, more precisely, that conveys essential truths about God. For this reality to be understood, something beyond the human capacity to signify is necessary. To reveal a meaning that lies beyond the indicative power of human speech and signification, a meaning that touches on the action of the divine in the soul, the visionary requires more than a discursive understanding of the meaning of the word. In one of her letters, Marguerite confronts the power of language not simply to communicate but actually to express meaning. By "expressing meaning," I mean that the word conveys its significance in a way that goes beyond pure linguistic signification and instills in the hearer a deep understanding of the divine. This understanding is instilled through revelation. A reliance on divine revelation might seem to contradict the efficacy of language in the *Speculum,* which suggests Marguerite's confidence in her ability to understand through reason and the intellect. This seeming contradiction can be resolved, however, and I will address its resolution below. But first I will discuss an incident in which Marguerite demonstrates that depending upon prayer and divine grace to gain knowledge may be the most effective way of obtaining an understanding of the divine referents underlying linguistic signs.

33. Quoted in Anthony Kenny, *Aquinas on Mind* (New York: Routledge, 1993) 94.
34. Ibid., 37.
35. Ibid., 97.
36. It may be objected that this conception of imagination and thought precludes understanding of the divine, as it is impossible to truly (or, at least, accurately) imagine God. Aquinas responds to this objection, however, with the assertion that we are capable of a genuine, if limited, understanding of "non-bodily entities." "Incorporeal things," he writes, "of which there are no phantasms, are known to us by comparison with empirical bodies of which there are phantasms" (*ST* 1.84.7 *ad* 3, quoted in Kenny, *Aquinas,* 98).

III. *Vehemens:*
Linguistic Understanding and Divine Truth

In a seeming paradox, the full revelatory potential of language is realized when Marguerite finds herself *unable* to comprehend a word. She describes "a person" (herself) who was "deeply touched" upon hearing the word *vehemens.* She asks what it means and is given the definition "fort" (strong). Not content with this definition, which she senses is inadequate, she becomes fixated upon the word:

> . . . cete parole chait forment el cuer e li fut semblanz que co fut trop granz chosa, mays illi ne li oset unques demandar que li espondit cele parole: vehemens. Totes voys ele demanda apres a mout de genz que voloyt dire cete parole, mais elle ne trova qui li sout respondre a son cuer. Ciz mot li eret si fichiez el cuor que ele ne se puyt delivre ne en oreyson ne autra part tant que illi priat a Nostrum Segnour forment qu'il per sa tres grant bonte li volit ensegnyer que voloyt dire cete parole ou qu'il la li ostat dou cuor.[37]

> (. . . it seemed to her that all this was of great importance, but she never dared to ask him [the "worthy man" present at this conversation] to explain the word "vehement" to her. Nonetheless, she subsequently asked a lot of people what the word meant, but she could find no one who could answer her to her [heart]. This word was so deeply driven into her heart that she could not get rid of it, not while she was praying nor under any other circumstances, until she finally addressed a fervent prayer to our Lord that He in His great goodness may teach her what this word meant [or] remove it from her heart.[38])

This passage is a striking description of the power of language to affect the hearer's soul. What is particularly interesting is that the effect of the word depends upon Marguerite's ignorance of its meaning. Finding the definition that she has been given to be inadequate, she is so troubled by her ignorance that she experiences it as a physical thing, a presence—even a wound—in her heart. Given that Marguerite does not provide us with the context in which she originally heard this word (other than to say that it came up in a conversation about God), it is hard to understand the persistence with which she pursues its meaning. But this persistence demon-

37. *Œuvres*, 146.
38. *Writings*, 66. I am indebted to Suzanne Kocher for suggesting a few emendations to Blumenfeld-Kosinski's translation of this passage. Changes based upon Kocher's remarks are indicated in brackets ([heart] and [or]).

strates an absolute confidence in the potential power of the word to convey a meaning beyond simple definition. To understand the word is, in a sense, to understand God.

The possibility that an accurate comprehension of a word could bring Marguerite into greater knowledge of the divine suggests a view of language similar to that held by realist poets. "For the [realist] poet," writes Kathryn Lynch, "the actual words and images of his craft [bear] a real relation to an idea about them that he and his reader might share, a real power to lead the reader beyond the poem to the apprehension of an intended divine truth."[39] Lynch is, of course, describing writers of literary works, but her description holds for Marguerite as well. The word whose meaning she cannot grasp has a significance for Marguerite that she herself cannot explain, and she feels compelled to uncover the "truth" to which it refers. Even as she fails to fully understand the meaning of *vehemens,* she remains convinced that a full understanding would reveal a divine reality. That her prayer for God to help her understand the word and thus "remove it from her heart" should lead directly to a vision that apparently clarifies the word's meaning implies that God himself endorses her desire to understand it.

Marguerite's tireless search for the "true" meaning of *vehemens* thus demonstrates her confidence in the power of language to signify absolute realities, even when those realities (as in this instance) may seem somewhat abstract. The pursuit of this reality is of paramount importance for the reader or auditor. As Marcia Colish argues, "The speaker's words serve only to show him in what direction the realities they represent lie. The subject will not become a believer by perceiving the sign, but by perceiving the reality."[40] This approach to language resonates with a Neoplatonic understanding of the relationship between linguistic signs and divine reality in which "textual signifiers . . . are considered to be an allegorical veil hiding a spiritual or philosophical truth—a transcendent signified—that is articulated beyond or behind the accidents of the text."[41] Not content with

39. Kathryn L. Lynch, *The High Medieval Dream Vision: Poetry, Philosophy, and Literary Form* (Stanford: Stanford University Press, 1988) 14.

40. Marcia L. Colish, *The Mirror of Language: A Study in the Medieval Theory of Knowing,* rev. ed. (Lincoln: University of Nebraska Press, 1983) 40. Colish's argument pertains specifically to Augustine, but this formulation is applicable much more broadly; as she points out, Aquinas was heavily influenced by Augustine (111), and in the Middle Ages Augustine's notion that words "serve as signs in the knowledge of God" came to be "applied to a number of forms of expression other than theological discourse" (152).

41. Ruth Evans, Andrew Taylor, Nicholas Watson, and Jocelyn Wogan-Browne, "The Notion of Vernacular Theory," in *The Idea of the Vernacular: An Anthology of Middle English Literary Theory, 1280–1520,* ed. Wogan-Browne, Watson, Taylor, and Evans (University Park, PA: Pennsylvania State University Press, 1999) 314. See also Rita Copeland, "Medieval

the translation "fort," Marguerite inquires into the meaning of *vehemens,* attempting to perceive the reality behind the locution. Only by uncovering this reality can she understand the divine significance of the word.

It is not necessarily the case, however, that all words can signify divine reality. *Vehemens* is, importantly, a Latin word; *fort* is apparently a poor substitute, suggesting that Latin has greater revelatory potential than the vernacular. As Serge Lusignan notes, Latin was held to be "the only language for the sacred" in medieval France; it had a "singular and sacred nature" that could not be claimed by the vernacular.[42] Marguerite obviously valued the vernacular as a language appropriate for writing about spiritual matters: Blumenfeld-Kosinski notes that "she almost singlehandedly established a French tradition of mystical writing," and her reliance upon the vernacular after producing her first work indicates a confidence in the ability of Francoprovençal to communicate theological discourse effectively.[43] Nonetheless, it is the Latin *vehemens* that can signify divine reality, and the words that appear in the divine vision that follows are also in Latin, further suggesting that Latin is the language of God: these are the words that make accessible a deeper reality.

That Marguerite has trouble comprehending the word is not in conflict with her devotional practice. Ignorance provides the space for revelation— indeed, it seems to trigger it; her failure to understand prompts her to turn to God. Again, Augustine's hermeneutic theory helps to explain Marguerite's use of language and learning as a way of knowing God. Her need for divine aid in understanding this word renders what is initially an intellectual exercise—the search for a linguistic explanation—into a salvific experience. Augustine argues for the importance of struggling to understand difficult words and passages when he notes that "in order for us to make progress in our understanding we need the mental exercise of wrestling with the text as well as the intellectual satisfaction of discovering what it means."[44] More important than such intellectual work, however, is that the reader pray for

Theory and Criticism," in *The Johns Hopkins Guide to Literary Theory and Criticism,* ed. Michael Groden and Martin Kreiswirth (Baltimore: Johns Hopkins University Press, 1994) 500–501.

 42. Serge Lusignan, "Written French and Latin at the Court of France at the End of the Middle Ages," in *Translation Theory and Practice in the Middle Ages,* ed. Jeanette Beer (Kalamazoo: Medieval Institute Publications, 1997) 186. Lusignan notes further that the conviction that Latin was descended from Hebrew by way of Greek contributed significantly to Latin's authority, as it was thought to be related to the originary, "unfallen" language. See also Lusignan, *Parler vulgairement: Les Intellectuels et la langue française aux XIIIe et XIVe siècles,* 2nd ed. (Paris: Librairie Philosophique J. Vrin, 1987) 53, 58–60.

 43. Blumenfeld-Kosinski, "Idea," 77.

 44. Augustine, *DDC* IV.6.9, 205.

understanding.[45] Accordingly, Marguerite declares that she cannot find a satisfactory answer to her question "ne en oreyson ne autra part" until she finally prays that God "ostat" the word "dou cuor":[46] it is only when she prays for assistance that she receives her vision. The linguistic difficulty that she encounters through *vehemens* focuses her devotional activity upon a single concept, leading her back to God. In the end, Marguerite uses this difficulty, in the sense of Augustinian *usi,* as a reminder to surrender herself to God.

When she finally achieves an understanding of the word, then, it is not through sensible (worldly) perception or rational comprehension—not, that is, because someone gives her an adequate definition of the term—but through a vision sent from God. The vision is the result of her prayer that he help her to understand its meaning. This use of prayer as a means of obtaining greater understanding through grace develops an idea suggested in Augustine's *De Magistro.* Augustine sees prayer as functioning primarily to turn one's thoughts to God, rather than to implore him for a particular gift or teach him something—it is, after all, incoherent to imagine that a human could teach God anything. Augustine writes, "Hence there is no need, when we pray, for language, that is, for the spoken word, except, perhaps, to express one's thoughts, the way priests do, not so God may hear, but in order that men may hear and, by this verbal reminder, fix their thoughts upon God by a unity of heart and mind."[47] The purpose of prayer is to remind oneself and others of the "reality of God,"[48] to redirect one's energies towards the divine. It is therefore appropriate that Marguerite turns away from the inadequate guidance of this world to request divine instruction. Her prayer functions as a rededication of herself to the divine as she abandons hope that human explanation can enlighten her and comes to trust in God's ability to illuminate her understanding. And her prayer is answered. She has a vision of a dried-up tree with downward-turning branches on which are inscribed the Latin names for the five senses (*visu, auditu, gustu, odoratu,* and *tactu*[49]); this tree is overturned by a sudden rush of water, which brings it back to a verdant state and redirects its branches so that they point towards the sky.[50] The account ends here and the letter moves on to other

45. Augustine, *DDC* III.37.56, 197.

46. *Œuvres*, 146.

47. Augustine, "The Teacher (De Magistro)," trans. Robert P. Russell, in *Saint Augustine: The Teacher, The Free Choice of the Will, Grace and Free Will. The Fathers of the Church: A New Translation,* vol. 59 (Washington, DC: Catholic University of America Press, 1968) 9.

48. Colish, 40.

49. The letter itself, other than these words and *vehemens,* is written in the vernacular Francoprovençal.

50. *Œuvres*, 146.

matters. We are not given Marguerite's reaction to this vision, but as her quest for the meaning of *vehemens* is not touched on again, it seems reasonable to assume that the vision has satisfied her desire for knowledge.

It would not be going too far, I think, to see the overturned tree of this vision as signifying Marguerite's redirection towards God. By praying, she evinces faith in God's ability to illuminate her understanding where human explanation is destined to fall short. While maintaining an implicit confidence in the ability of language to convey meaning and reality, her letter nonetheless indicates the need for divine revelation to help the human mind grasp that reality. The power of divine revelation both to illuminate the visionary's understanding and to "convert" her to a greater faith in God is a vivid example of Augustine's conviction that God's intervention is necessary for the gaining of religious knowledge. According to his theory of divine illumination, argues Colish, "verbal signs are never held to be cognitive in the first instance," but "must be energized by the action of God in the mind of the knower in order for them to lead to the knowledge of their significata."[51] In Marguerite's case, the vision is indicative of God's action in her mind; direct revelation is posited as an essential means of understanding the divine referent behind the signifying word.

In the *Speculum,* Marguerite presents visionary revelation as a similarly effective means of achieving knowledge and directing one's soul towards God. Yet the depiction of human understanding and language in the *vehemens* passage differs in an important respect from the portrayal of reading in the *Speculum*. In the latter, Marguerite grasps the content of the text that appears in her vision without any apparent problem, and—as she tells it— promptly applies the lessons of spiritual improvement contained therein. With *vehemens,* on the other hand, she must seek out a proper definition, finally turning to God and prayer as a last recourse. On the surface, these two episodes depict rather different views of the revelatory potential of language, one requiring divine translation and the other directly comprehensible to the visionary. The key difference between these episodes, however, lies not in her approach to language and understanding, but rather in the sources of the words to be interpreted. The divine text of her vision in the *Speculum* is God's work. Its interpretation is built in, coming to her in the same moment of revelation as the vision of the book. *Vehemens,* on the other hand, is a word spoken by a human mouth in a conversation about God. Without divine intervention, human language is incapable of accurately conveying the sacred reality to which it refers. Marguerite's search for the meaning of *vehemens,* in contrast to the visionary "reading" that

51. Colish, 58.

occurs in the *Speculum,* graphically illustrates the need for divine revelation if one is to comprehend the divinely charged reality underlying language.

This difference between the comprehensibility of divine and human texts gestures towards the differences between two distinct kinds of knowledge, *sapientia* and *scientia.* Gillian Rudd offers the following definition of these concepts:

> *Scientia* comes from a verb (*scio*) and so is associated with active acquisition of knowledge and learning. . . . In contrast *sapientia* comes from a noun—*sapor* (taste)—which summons up the world of the senses and trusts to the reality of experience rather than theory.[52]

In asking others about the definition of *vehemens,* Marguerite is pursuing *scientia.* She seeks a deductive, rational meaning of the word—a meaning that is comprehensible through the *ratio.* When she turns to prayer, however, she is granted sapiential understanding: her vision gives her an intuitive glimpse of the meaning of *vehemens* and its significance for the salvation of the soul, which she grasps through the use of the *intellectus.* The knowledge that she gains through her vision is experiential knowledge and is therefore appropriate and effective as a means of understanding God. Scientific knowledge, knowledge associated with the *ratio* and accordingly limited by the limits of the rational human intellect, is insufficient for Marguerite to attain this kind of understanding. That the *ratio* might be limited in its ability to discern the divine was, of course, hardly a new idea; of significance here is the privileging of sapiential knowledge in a specifically linguistic matter. Marguerite's vision at once implies that language does signify a divinely charged reality and that revelation is (at least sometimes) necessary to understand it.

What this finally means, then, is that—regardless of how it is achieved—the proper understanding of words and of the concepts that they signify leads to a true understanding of God as well as a deepening of faith. How, we might ask, does this affect the status of her text as an instructive medium? Her text cannot directly impart the experiential knowledge that she has gained through her visions, but in writing those visions, she must have sought to transmit her newly acquired knowledge to her readers. The highly pictorial, concrete language used to describe her vision of the tree

52. Gillian Rudd, *Managing Language in* Piers Plowman (Cambridge: D. S. Brewer, 1994) 19. For more on the distinction between *scientia* and *sapientia,* see Anthony Kenny, *Medieval Philosophy* (Oxford: Clarendon Press, 2005) 168–69 and Gordon Leff, *The Dissolution of the Medieval Outlook: An Essay on Intellectual and Spiritual Change in the Fourteenth Century* (New York: New York University Press, 1976) 59.

in the vehemens letter and the "lues delicious" of the *Speculum* suggests a way that this knowledge might be transmitted. In reporting the former vision, Marguerite does not rely upon abstractions (such as *fort* or, indeed, *vehemens* itself), but provides a visual, imagine-able allegory of the concept.[53] The reader can easily envision the content of Marguerite's vision, thus, perhaps, grasping it in a way similar to her grasping of the original visionary message. Allegory therefore acts as a sapiential substitute—a non-rational means of grasping an abstract concept. This use of allegory is not novel, as its reliance upon metaphor and intuitive understanding makes it a natural fit with *sapientia*. Argues Rudd, "*Sapientia*'s alternative, emotive approach does not place . . . emphasis on a rational progression," such as that foregrounded in the educative visions discussed in chapter 1, but enables writers "to capture the state of understanding as closely as they can and proceed by means of parable, allegory and figurative language."[54] Translating vision into allegory, Marguerite's letter aims to teach the reader about the divine signified underlying a human locution. She thus links language to revelation, even if that language requires divine illumination to be understood.

IN THE *SPECULUM,* Marguerite gestures towards a language that would transcend the need for allegorical explanation—a language that would truly express the nature of the divine but be comprehensible to humans as well. This language is the "wholly new song" that is sung by the angels and saints in her vision of paradise: "li angel et li saint . . . fant una chancon tota novella qui est si douci, que co est una granz meloudi. . . . E ycis chanz no est plus tot fenis que il en fant un autre tretot novel. Et ciz chanz durera seins fin" (the angels and the saints . . . sing a song which is all new and of such sweetness that it is a wonderful melody. . . . And this song is hardly finished when they start another one, also all new. And this song will last forever).[55] This new song, as Blumenfeld-Kosinski notes, arises out of the need for a new language in order to "fully comprehend God's goodness"—not only for Marguerite, but even for the saints, who, like her, cannot wholly understand God within the limitations of human language.[56]

53. The vision itself, of course, also comes in this form. However, it is significant that Marguerite chooses to relate the vision imagistically. She does not describe the effect of the vision upon her or her own conceptual understanding of it, but rather privileges the visual and sensory over reason and abstraction.

54. Rudd, 22.

55. *Œuvres*, 96; *Writings*, 44.

56. Blumenfeld-Kosinski, "Idea," 78.

While such a language may not exist in this world, Marguerite's text holds out the hope that one day such a new song will be sung, whether in this world or the next, and that a true understanding of God—communicable through language—will become possible.

An echo of this conviction can be found in John Bunyan's seventeenth-century dream vision narrative, *Pilgrim's Progress*, a work that adamantly espouses a plain style of writing as the most effective means of communicating truth. Bunyan expresses his conviction that the right words can convey truth when he writes in the "Apology" that prefaces the poem, "My dark and cloudy words they do but hold / The truth, as cabinets inclose the gold":[57] despite his use of allegory, he assures the reader, the substance of the poem is only truth. It is thus striking when, at the end of the poem, heaven is described as a place where angels "answered one another without intermission, saying, 'Holy, Holy, Holy is the Lord.'"[58] Paradise is imagined as a place where further language is unnecessary; the angels' utterance is essentially tautological, as they reiterate ad infinitum the equivalence of holiness and divinity. In Marguerite's vision of the "new song" that fully expresses the godhead, we might detect the desire for such language—a language that is only praise, that resounds perfectly with God.

Until that language develops, however, reading and prayer constitute the means that Marguerite proposes for obtaining an understanding of the godhead. Her visionary knowing depends upon an active return to God that, in effect, signifies the subsuming of her will to that of the divine. Marguerite's knowledge does not come to her because of the overt operation of her rational or cognitive faculties, but neither is she purely passive in its reception. Rather, she is responsible for directing her devotional thoughts and her reading practices towards God, and this forms the basis of her knowledge. In the next chapter, I will argue that Gertrude of Helfta's mysticism exemplifies a further development of this idea: her total alignment with the divine will is the grounds for both her transcendent knowledge and her intimate relationship with the divine. But for Marguerite the relationship between the inquiring intellect and divine revelation is enacted on the linguistic plane. The linguistic and textual emphasis of her visionary writings establishes a means of empowering her readers in their role as readers; revelation itself becomes a function of the prayerful encounter with the text. Both active and passive in her approach to God, she depicts a path towards visionary knowledge that is theoretically replicable for the reader or auditor of her work.

57. John Bunyan, *The Pilgrim's Progress* (New York: Penguin Books, 1981) 12.
58. Bunyan, 147.

3

The Will to Know

VOLITION AND INTELLECT IN GERTRUDE OF HELFTA

N A VISIONARY DIALOGUE, God reportedly provides the thirteenth-century Benedictine nun Gertrude of Helfta with the following assurance: "omnes spiritus angelici sic tuae subjecti sunt piae voluntati . . . ex eo quod tibi hoc ipsos facere complaceret, amodo absque dubio studiosissime conarentur adimplere" (all of the angelic spirits must submit to your pious desires . . . henceforth they will do whatever is pleasing to you. Doubtless, they are already zealously exerting themselves to carry out your will).[1] If the mystic's claim to such extraordinary favors seems audacious now, it would have appeared even more so during Gertrude's own life. In an era when women were forbidden from public teaching, and, at best, seem to have been primarily empowered to engage in theological discourse through affective visions of Christ's passion, the assertion of such volitional and intellectual powers very likely would have been suspect. Yet Gertrude does not seem to have suffered from any repression. Though never formally canonized, she was given a feast day in the seventeenth century and is customarily referred to as a saint. Her profession of an intimate knowledge of the divine and, more

1. Gertrude d'Helfta, *Œuvres spirituelles,* ed. Pierre Doyere, 5 vols., Sources Chrétiennes 127, 139, 143, 255, 331 (Paris: Les Éditions du Cerf, 1968) 4: 2.15, SC 4: 44–46; my translation. All references to the Latin text are to this edition. Some English translations of Books 1 and 2 are from Gertrude the Great of Helfta, *The Herald of God's Loving-Kindness: Books One and Two,* trans. Alexandra Barratt (Kalamazoo: Cistercian Publications, 1991), and some translations of Book 3 are from *The Herald of God's Loving-Kindness: Book Three,* trans. Alexandra Barratt (Kalamazoo: Cistercian Publications, 1999). I have also used Margaret Winkworth's translation of Books 1–3 (Gertrude of Helfta, *The Herald of Divine Love,* trans. Margaret Winkworth [New York: Paulist Press, 1993]). References to the *Legatus* will be given as follows: the book, chapter, and section will be given first, followed by the volume and page number for the Sources Chrétiennes edition (abbreviated SC); translations will be cited as Barratt or Winkworth, with the corresponding volume and page numbers. Thus, the first passage of Book 3 would be cited as follows: *Leg.* 3: 1.1, SC 3: 14; Barratt, 2: 27. Translations from Book 4 are my own.

strikingly, of the validity of her own rational faculties in obtaining some of that knowledge appear to have been accepted as legitimate within her community.

Gertrude (1256–1301 or 1302) was a nun in the convent of Saint Maria at Helfta in Saxony from the age of four, and her visions reflect the tradition of *Brautmystik*, or bridal mysticism, promulgated by Bernard of Clairvaux and current among Cistercians of the thirteenth century; many of her visions contain images of Christ as a young man and of the Lord bestowing loving kisses upon her soul.[2] Following the receipt of her first vision in 1281, at the age of twenty-five, Gertrude claims to have lived for at least two decades in the almost uninterrupted presence of God, her first vision having converted her from a preference for secular literature to an exclusive devotion to the divine. In 1289, "compulsa violentissimo impetu Spiritus Sancti" (compelled by the Holy Spirit),[3] she began recording her visions in what would become Book 2 of the *Legatus Memorialis Abundantiae Divinae Pietatis*.[4] Despite the strong influence of the *Brautmystic* tradition, however, her mysticism is not limited to affective and erotic experiences of Christ. In addition to testifying to her devotion to and special relationship with God, her texts also represent the active engagement in reflection and rational deduction that lead to her knowledge of the divine. Throughout the last twenty years of her life, Gertrude's visions granted her an ever-deepening knowledge of scripture, and she came to grasp some of this knowledge through her emotionally charged relationship with Christ.

2. The "lukewarm" disagreement, in Rosalynn Voaden's words, about whether the community at Helfta was Benedictine or Cistercian has been resolved to the satisfaction of most scholars. The Cistercian injunction against incorporating any new communities of women, passed in 1220 and reiterated in 1228, is the strongest evidence that Gertrude and her sisters, whose convent was founded in 1229, were Benedictine, although powerful Cistercian influences upon their spirituality can be detected. For more on this debate, see Miriam Schmitt, "Gertrud of Helfta: Her Monastic Milieu and Her Spirituality," in *Hidden Springs: Cistercian Monastic Women*, vol. 2, ed. John A. Nichols and Lillian Thomas Shank (Kalamazoo: Cistercian Publications, 1995) 472. See also Rosalynn Voaden, "All Girls Together: Community, Gender and Vision at Helfta," in *Medieval Women in Their Communities*," ed. Diane Watt (Toronto: University of Toronto Press, 1997) 75–76.

3. *Leg.* 2: Pr.1, SC 2: 226; Barratt, 1: 99.

4. Readers interested in the details of Gertrude's life and the convent at Helfta, which boasted at least two other important visionaries—Mechthild of Hackeborn and the beguine Mechthild of Magdeburg, who lived and wrote there during the last years of her life—may refer to Michael Bangert's article on the cloister of Saint Maria, "Die Mystikerin Gertrud die Große und das Frauenkloster St. Maria in Helfta," in *Freiheit des Herzens: Mystik bei Gertrud von Helfta*, ed. Michael Bangert (Münster: Lit Verlag, 2004) 5–21. Another helpful resource is the introduction to Winkworth's translation of Books 1 through 3 of the *Herald*. Most of the scholarship on Gertrude contains a description of her life and the history of the convent, for which reason I have not gone into great detail on these subjects here.

Gertrude's spiritual experiences are overwhelmingly structured by the cycle of the liturgy. This grounding in sanctioned church ritual, by keeping her within the bounds of orthodox practice, contributed to her authority as a mystic and to her professions of extraordinary knowledge of the divine. In this chapter, I will consider Gertrude's claims to an exceptional theological knowledge within the context of her immersion in the liturgy. Liturgical language informs and structures her experience of God; her immersion in the cycle of the liturgy enables her to achieve a union with the divine that is most vividly manifest in the union of her will with Christ's, and this volitional union is what ultimately allows her to exercise her cognitive and rational faculties as a means of gaining spiritual knowledge. That this union with God enables Gertrude not only to receive visions but to understand them suggests that the liturgy legitimized her cognitive abilities as an authentic and authoritative means of knowing—both to herself and to her broader community. By joining herself completely to the divine, she is able to grasp complex theological truths both intuitively and rationally. This model of visionary knowing locates the power to discern sacred truth in the mind of the visionary herself: intellectual activity, validated by the union of her will with God's, becomes the means by which Gertrude understands many of her visionary experiences. The power of the liturgy to create a union with God is thus essential to Gertrude's revelatory experiences. In its absence, the knowledge that she gains through her visions, being indistinct from her mere thoughts, would lack the authority of divinely revealed wisdom. As I will argue, then, the liturgy is at the root of Gertrude's visionary knowing. By requiring her volitional alignment with the divine will and the employment of her rational faculties, however, her means of knowing also comprises an active mode of visionary practice. Gertrude is emphatically not absent in her writings, and her spirituality foregrounds her own abilities alongside the divine infusion of knowledge.

I. Liturgical Practice and the Union with God

As many scholars have noted, the liturgy is a major structuring element in the *Legatus*. Most scholarship, however, has focused on how Gertrude used the liturgy to inspire and write her visions rather than on how the interpenetration of the liturgy and her spiritual life actually informed her acquisition of revealed knowledge.[5] Yet exploring the impact of liturgi-

5. Cyprian Vagaggini describes Gertrude's writings as "the most complete example" of liturgical spirituality (*Theological Dimensions of the Liturgy: A General Treatise on the Theology of the Liturgy,* trans. Leonard J. Doyle and W. A. Jurgens, rev. ed. [Collegeville,

cal practice upon Gertrude's experiences is essential to understanding her process of visionary knowing, particularly as that process is implicated in her union with the divine. A few brief examples will serve to illustrate how thoroughly Gertrude used liturgical language in her writings as well as in her encounters with God. Throughout the first-person Book 2 of the *Legatus,* the liturgy is both a catalyst for and a way of expressing her visionary experiences; Gertrude incorporates liturgical speech into the narrative of her spiritual transformation in such a way that the language of the liturgy becomes personal. She describes, for example, how reciting the prayer "Gaudete in Domino" resulted in her feeling a longed-for increase in her desire for God. Her desire gratified, she expresses her gratitude using a line from Matthew 8:8, saying, "Domine, fateor quod secundum merita mea non sum digna" (Lord, I confess that I am not worthy).[6] Similarly, she later thanks God using the words from the First Vespers of the Feast of the Holy Trinity: "Sed gratias fidelitati tuae, Deus, gratias protectioni tuae, vera, una divinitas, una et trina veritas, trina et una deitas" (But thanks to your faithfulness, Lord, thanks to your protection, truly one Divinity, one and threefold Truth, threefold and one Godhead).[7] The language of the liturgy permeates Gertrude's writing, structuring the way that she articulates her responses to her encounters with the divine. Moreover, she repeatedly uses

MN: Liturgical Press, 1976] 740). Vagaggini, however, is more concerned to establish that mystical experience and liturgical devotion can co-exist without interfering with one another than he is to undertake a thorough analysis of Gertrude's use of the liturgy. His consideration of the *Legatus* therefore primarily comprises examples of the liturgy's role in sparking her visions, or instances in which she received a vision during a liturgical ceremony. Such concerns are not exclusively Vagaggini's; in fact, references to Gertrude's use of the liturgy in inspiring and writing her visions are common. See, e.g., Patricia Demers, *Women as Interpreters of the Bible* (New York: Paulist Press, 1992); Florence Feeney, "Love's Response: The *Exercises* of St. Gertrude," *Benedictine Review* 9.2 (1954): 36–39; Maureen McCabe, "The Scriptures and Personal Identity: A Study in the *Exercises* of Saint Gertrud," in *Hidden Springs, Cistercian Monastic Women,* vol. 2, ed. Nicholas and Shank, 497–507; and Schmitt, "Gertrud of Helfta: Her Monastic Milieu and Her Spirituality." Michael Casey also touches on this issue, but his overarching project is to demonstrate that Gertrude is not a mere imitator of Bernard; the liturgical aspect of her spirituality is thus of secondary importance to him (Michael Casey, "Gertrud of Helfta and Bernard of Clairvaux: A Reappraisal," *Tjurunga: An Australasian Benedictine Review* 35 [1998]: 3–23). Much of the scholarship about Gertrude has been written for devotional purposes or to establish her exemplary status rather than as critical studies. This trend, however, may be beginning to shift. The 2004 collection of essays edited by Michael Bangert, *Freiheit des Herzens: Mystik bei Gertrud von Helfta* (Münster: Lit Verlag), indicates that Gertrude is increasingly the focus of critical scholarship.

6. *Leg.* 2: 5.1, SC 2: 248; Winkworth, 102.

7. *Leg.* 2: 11.3, SC 2: 278; Winkworth, 111. Compare the liturgical reference: "Gratias tibi, Deus, gratias tibi, vera et una Trinitas, una et summa Deitas, sancta et una Unitas," "We give thanks to you, O God, we give thanks to you, one and true Trinity, only and sovereign Godhead, holy and one Unity" (Winkworth, 147n74).

the words from the liturgical cycle to describe transformative moments in her devotional exercises. The following passage is fairly typical of her incorporation of scriptural and liturgical language into her descriptions of her experiences. The references and glosses are from Winkworth's notes (141nn39–41):

> In nocte sacratissima, quando dulcorante rore divinitatis per totum mundum melliflui facti sunt coeli [the second Responsory of Christmas: "Hodie nobis de caelo pax vera descendit: hodie per totum mundum melliflui facti sunt caeli"], vellus animae meae in area communitatis madefactum [Judges 6:37–8] attentavit meditando se ingerere et per devotionis exercitationem ministerium exhibere supercoelesti illi partui, qua sicut radium protulit Virgo filium [Cf. *Laetabundus:* "Sicut sidus radium, profert Virgo Filium"] verum Deum et hominem [The Secret of the Mass of Our Lady: "ut qui conceptum de Virgine Deum verum et hominem confitemur . . . "]. (*Leg.* 2: 6.2, SC 2: 256–58)

> (It was in the holy night, when the dew of divinity came down, shedding sweetness over all the earth, and the heavens were melting, made sweet like honey. ["Today true peace has come down to us from heaven: today throughout the whole world the heavens have dropped honey."] My soul, like a dampened fleece on the threshing-floor of the community [Judges 6:37–8] was meditating on this mystery. Through the exercise of this devotion, I was trying to give my poor services in assisting at the divine birth when, like a star shedding its ray, the Virgin brought forth her son [*Laetabundus*], true God and true man ["that we, who confess him who was conceived of a virgin to be true God and man . . . "].[8])

In the foregoing passages, she both understands and verbalizes her spiritual experiences in terms of liturgical speech. Further, her experiences themselves are informed by the ritual of the liturgy. In her first vision, Christ says to her, "Cito veniet salus tua; quare moerore consumeris? Numquid consiliarius non est tibi, quia innovavit te dolor?" (Soon will come your salvation; why are you so sad? Is it because you have no one to confide in that you are sorrowful?).[9] His words are, verbatim, the First Responsory at Matins of the second Sunday of Advent.[10] Here and throughout her text, Gertrude's visions are presented as a lived experience of the liturgy. In addition to participating in its rituals, she thoroughly incorporates it into

8. Winkworth, 104.
9. *Leg.* 2: 1.2, SC 2: 230; Winkworth, 95.
10. Winkworth, 136n7.

her experience of God; its rites and the subjective inner state that they compel are fundamental to her experience of the divine.

As I have suggested, the union with God that the liturgy promotes is what ultimately enables Gertrude's visionary knowing. The liturgy brings about this union by creating a template for an empathetic experience of Christ and his suffering. The generation of empathy is at the core of liturgical practice, which provides a model of spiritual *imitatio Christi;* reflecting in its seasonal variations all of the stages of Christ's life as well as his salvific function, it serves as a daily—even hourly—reminder of the central Christian story. The love and pity that are generated by intellectually and imaginatively re-creating the events of Christ's life help the devout to form an affective bond with God. Gertrude's attention to the events described in the liturgy frequently leads her to a heightened affective response that brings her directly to a unitive experience of the divine. In addition, the words of the liturgy themselves imbue Gertrude with a felt knowledge of God. In both of these ways, liturgical experience becomes a window onto the divine: like Marguerite d'Oingt's penetration into the meaning of *vehemens,* the visionary experiences undergone as a result of—and as a *part* of—the liturgy instill in Gertrude a profound understanding of the meanings that underlie liturgical acts and language.

In the previous chapter, I argued that Marguerite's realist understanding of language constituted an integral part of her visionary knowing. Through her implicit faith in the divine referent underlying the word *vehemens* and in the possibility of coming to know that referent through prayer and divine inspiration, Marguerite demonstrates that transcendent knowledge is available to the human understanding—and that it is accessible through language. In her incorporation of the liturgy into her visionary experiences, Gertrude's *Legatus* also exemplifies language's ability to convey knowledge of the divine. However, while both Gertrude and Marguerite embrace language as a means of knowing God, there are significant differences between the two mystics' approaches to the intersection of language and knowing. Unlike Marguerite, Gertrude does not pursue the meanings of individual words; rather, she uses liturgical acts and prayer to insert herself into eschatological history. It is this integration of Christ's life into her experience, rather than the comprehension of individual words, that enables her visionary knowing. Throughout the *Legatus*—both in Book 2, which she herself wrote, and in the collaboratively written Books 1, 3, 4, and 5—the liturgy provides her with a means of uniting with God and accessing transcendent knowledge.[11]

11. Gertrude's surviving textual output consists of two works: the lyrical *Exercitia*

Even more than an empathetic union with Christ, the acquisition of knowledge is a central purpose of Gertrude's visions. The visions chronicled in the *Legatus* usually focus upon the revelation and transmission of specific messages; while the text describes a number of affective visions, wherein, for example, Gertrude cares for the Christ child, feels great longing for Christ, and desires to be marked with his wounds, it also includes many visions that stress her comprehension of particular lessons. These instructive visions, which are more didactic in nature, usually appear in one of two forms: as directly "spoken" messages from the divine, which Gertrude "hears," and as lessons "understood" (*intellexit*) in Gertrude's soul, with no explicit spoken component. In many of her visionary encounters, God's speech is introduced directly with something along the lines of "respondit Dominus," suggesting that she "heard" the words that were somehow spoken by him. But direct speech of this kind does not always introduce her lessons. More commonly, Gertrude grasps the content of a lesson without explicit instruction. In these cases, there is no clear description of how she receives the Lord's messages; they are introduced only by phrases such as "unde intellexit" (from this she understood).[12] The verb "intellegere," "to grasp mentally" or "to understand or supply mentally,"[13]

Spiritualia, a devotional manual structured around the seven sacraments, and the five-volume *Legatus Memorialis Abundantiae Divinae Pietatis* (The Herald of the Memory of the Abundance of Divine Love). The latter work contains references to scriptural commentaries and compilations of sayings from the saints that she presumably wrote (*Leg.* 1: 7.1–2, SC 2: 152–154), but no copies of these texts are known to currently exist. (A more complete discussion of Gertrude's putative works can be found in Winkworth's introduction to her translation of the *Herald,* 10–11.) Although Gertrude only authored one volume of the *Legatus* (Book 2), it is assumed that she had a hand in the writing of Books 3 and 4, and possibly parts of 1 and 5, all of which were composed by at least one other sister (Winkworth, 12). The *Legatus* was begun in 1289, when Gertrude was moved by a sudden impulse to transcribe the visions which she had begun to experience some eight years previously, at the age of twenty-five. It chronicles the full range of Gertrude's spiritual experiences, from very personal, even homely conversations with Christ, to other nuns' visions about Gertrude and the effect of the visionary's prayers upon souls in Purgatory; such accounts comprise the bulk of Books 2, 3, and 4. Books 1 and 5, also written by other sisters at Saint Maria, center primarily upon biographical details of Gertrude's life and death.

12. This particular example is taken from *Leg.* 3: 29.1, SC 3: 130; Barratt, 2: 100, but it can be found throughout the third and fourth books of the *Legatus;* the following examples are taken at random: 3: 29.2, 3: 30.1, 3: 30.5, 3: 61.1, 3: 73.4, 4: 23.10, 4: 24.3, 4: 35.6.

13. D. R. Howlett, "Intellegere," *Dictionary of Medieval Latin from British Sources,* vol. V (I-J-K-L) (Oxford: Oxford University Press, 1997) 1423. Howlett's dictionary is based on British sources, but Lewis and Short, in agreement with Howlett, also define "intellegere" as "to perceive, understand, comprehend" ("Intellegere," *A Latin Dictionary Founded on Andrews' Edition of Freund's Latin Dictionary,* ed. Charlton T. Lewis and Charles Short [Oxford: Oxford University Press, 1984] 974). Similarly, the *Oxford Latin Dictionary* gives "to grasp mentally, understand, realize" as the primary meaning of *intellegō,* and the subsequent meanings include "to understand by inference, deduce." Examples include knowing

is applied to Gertrude with great frequency throughout the *Legatus*. As I discussed in chapter 1, the *intellectus* is the source of the mind's ability to simply grasp a revealed truth, and the use of "intellegere" references this power. What is surprising about most of the uses of this verb, however, is that there is no discussion of *how* she comes to "grasp" her mystical lessons. Unlike many other visionary writers, who specify that God speaks or shows them lessons (as, indeed, Gertrude does at some points in the *Legatus*), knowledge seems to simply appear in Gertrude as something spontaneously grasped and understood. Jane Klimisch postulates that these lessons are "heard" as "a distinct inner voice, perfectly articulated and remembered, but recognized only within the mind";[14] neither Gertrude nor her amanuenses, however, specify that this is the case. Rather, it seems that certain of her visions—or, in many cases, liturgical lessons that she hears bodily—directly instill knowledge within her without being explicitly explained or illustrated by God. And, in fact, Klimisch's phrase could itself describe the *intellectus:* the mind's recognition of knowledge that it has not actively pursued.

Gertrude's ability to access divine truth through the *intellectus* presents a model of visionary knowing that differs from what we saw in Marguerite's pursuit of the meaning of *vehemens*. Where Marguerite was incapable of understanding *vehemens* through her own efforts and required an allegorical vision to grasp its meaning, Gertrude's private intellectual reflection upon spiritual questions leads her to the answers that she seeks. Gertrude thus seems to have a greater degree of independence, a validation of her own intellectual activity—which is fitting, given her role at Helfta as a scholar—while Marguerite appears more dependent upon divine instruction and direct visionary experience. Yet, on a deeper level, the two accounts resonate with one another. Marguerite turns to prayer to understand *vehemens* and, as a result, is given a vision that enables her to grasp the meaning of the word in terms of its divine referent. Prayer, as I noted in the last chapter, is a means of surrendering oneself to God's will—a token that one has pledged one's soul to the divine. While Gertrude does not explicitly require prayer to settle at least some of the questions that trouble her, her knowing arises as the direct result of the union of her will with

the meaning of a word or discerning a quality such as "form, colour, taste, or other physical characteristic" ("Intellego, Defs. 1–3," *Oxford Latin Dictionary, Fascicle III* [Oxford: Clarendon Press, 1971] 936). Unfortunately, at the time of this writing, the volume of the *Mittellateinisches Wörterbuch* for words beginning with the letter "I" has not been published.

14. Jane Klimisch, "Gertrud of Helfta: A Woman God-Filled and Free," in *Medieval Women Monastics: Wisdom's Wellsprings,* ed. Miriam Schmitt and Linda Kulzer (Collegeville, MN: Liturgical Press, 1996) 254.

God's. Marguerite's prayer is a movement towards precisely such a union. In prayer, the individual will is wedded to that of the divine; Marguerite places herself at God's mercy, acknowledging him as her true teacher. Gertrude has already implicitly placed herself in this position relative to the divine by subsuming her will to the divine will, as I discuss in more detail below. The surrender of the self that Marguerite accomplishes through prayer has already been accomplished in Gertrude. And in both cases, the visionary is granted privileged knowledge as the result of her individual agency's being assimilated into God.

Union with God is central to Gertrude's account of her visionary experiences. In Book 2 of the *Legatus,* she records in detail the process that she underwent in turning from a life of secular study to one of wholehearted piety, a change that is emphatically about uniting affectively and volitionally with the divine. The transformation that takes place within her is a transformation of the will and desire: whereas formerly her greatest pleasure lay in secular study, the onset of her visionary life redirects her to a total focus on God, love for whom overwhelms her soul—and her intellectual pursuits—thenceforth.[15] In the words of her biographer, "Unde exhinc de grammatica facta theologa omnes libros divinae paginae quoscumque habere vel acquirere potuit infastidibiliter ruminans" (No longer a student of literature [grammarian], then, she became a student of theology [theologian] and tirelessly ruminated on all the books of the Bible which she could obtain).[16] Union with Christ characterizes her transformation, as illustrated by the redirection of her scholarly interests.

15. In Book 1, Gertrude's biographer describes her youthful devotion to the liberal arts, which, though initially a virtue in that it kept her from "childish aberrations," gradually became excessive attachment (*Leg.* 1.1–2, SC 2: 139). Education, both classical and theological, appears to have been greatly valued at Helfta. Although no library catalog exists for the convent, the importance of learning at Helfta is attested by the references—implicit and explicit—to theological texts throughout the *Legatus.* Laura Grimes argues that it is likely that the Helfta library would have contained copies of Augustine's *De Doctrina Christiana* and *Confessiones;* Doyère believes that the *Confessiones* and Bernard's sermon on the Song of Songs were known to the Helfta nuns (Laura Marie Grimes, "Gertrud of Helfta and Her Sisters as Readers of Augustine" [Ph.D. diss., University of Notre Dame, 2004], 80–81). The authors of the *Legatus* also freely quote Richard of Saint Victor (although they attribute many of these quotes to Hugh of Saint Victor).

16. *Leg.* 1: 1.2, SC 2: 120; Barratt, 1: 39. Aware that she is taking liberties with the text, Winkworth translates the first clause of this sentence as, "Hence her love of learning now became desire for knowledge of God" (53). She defends her choice on the grounds that "it seems impossible to translate this phrase literally without giving a misleading impression as to its meaning," and that she has "attempted to give the correct meaning by use of a paraphrase," which she explains through a discussion of the trivium and quadrivium (88n5). The allusion to Leclercq's *The Love of Learning and the Desire for God* can hardly be accidental.

Her first vision dramatically foregrounds the central problem that many of her early visions are meant to rectify: namely, the disharmony between her will and God's. In the beginning of the vision, Christ appears to her in the guise of an attractive youth of about sixteen. Immediately after his appearance, Gertrude feels herself to be spiritually in a place different from that occupied by her physical body: "Haec cum diceret, quamvis me corporaliter scirem in praedicto loco, tamen videbar mihi esse in choro, in angulo quo tepidam orationem facere consuevi, et ibi audivi sequentia verborum, scilicet: *Salvabo te et liberabo te, noli timere*" (although I knew that I was really in the place where I have said [in the dormitory], it seemed to me that I was in the Choir, in the corner where I usually say my tepid prayers; and it was there that I heard these words: "I will save you. I will deliver you. Do not fear").[17] This description evokes the transformation that is to occur within Gertrude by locating it in physical space. In the very place where she formerly said her "tepid prayers"—incapable of living within her soul the devotion that her Benedictine habit expresses—she receives a direct message from Christ himself. This vision's shift from her actual location in the dormitory to her habitual spot in the Choir graphically illustrates the importance of this reconfiguration of her interior practice: the very spot in which her lukewarm religiosity is most in evidence becomes the site of her first stirrings of profound spiritual feeling. The spatial shift is followed by a vision of a high hedge separating her from the young man. "[D]esiderio aestuans et quasi deficiens starem" (Burning with desire and almost fainting), she hesitates until he "seize[s]" ("apprehendens") and "lift[s]" ("levavit") her across the hedge to place her beside him. At this moment, she recognizes Christ from the "vulnerum illorum praeclara monilia," the "bright jewels, his wounds," on his hand.[18] Her reflection upon this vision is telling: "Nam ex tunc nova spiritus hilaritate serenata in suaveolentia unguentorum tuorum procedere coepi, ut et ego jugum tuum suave et onus tuum leve reputarem, quod paulo ante velut importabile judicavi" (From that hour, in a new spirit of joyful serenity, I began to follow the way of the sweet odor of your perfumes, and I found your yoke sweet and your burden light which a short time before I had thought to be unbearable).[19] The vision has changed her: formerly a nun in name only, more concerned with secular study than godly things, she now lives joyfully under Christ's "yoke." Her transformation is figured in the image of her physical union with Christ, as she is lifted over the hedge to join him, as well as in the affective union indicated by her intense desire to be with him.

17. *Leg.* 2: 1.2, *SC* 2: 230; Winkworth, 95.
18. Ibid.
19. *Leg.* 2: 1.2, SC 2: 232; Winkworth, 96.

Gertrude's subsequent visionary experiences, like her first, are over-whelmingly about union with God. This union is sometimes articulated in abstract terms, but it is also communicated through images of physicality, such as when she describes herself as mirroring Christ's wounds in her spir-itual body or uses fluid imagery to suggest the complete intermingling of her soul with the divine. Among her most vivid representations of physical identification and union with Christ are the image of her soul as wax melt-ing in the heat of God's love;[20] her desire to be swaddled with Jesus, "ne vel tenui panni medio mihi subtrahereris" (lest you should be separated from me by even so much as a thin piece of cloth);[21] and, most strikingly, her desire to be imprinted with Christ's wounds in her heart ("Scribe . . . vul-nera tua in corde meo pretioso sanguine tuo").[22] Her wish for the imprint of Christ's wounds is granted seven years later.[23] She writes, "ecce tu aderas velut ex improviso infigens vulnus cordi meo cum his verbis: 'Hic confluat tumor omnium affectionum tuarum verbi gratia: summa delectationis, spei, gaudii, doloris, timoris, caeterarumque affectionum tuarum stabiliantur in amore meo'" (Suddenly you appeared, inflicting a wound in my heart, and saying: "May all the affections of your heart be concentrated here: all pleasure, hope, joy, sorrow, fear, and the rest; may they all be fixed in my love").[24] The inner wound, which relates all of her affective states back to Christ, is a powerful sign of physical identification with Jesus that signifies the subjection of her emotional life to the divine.

Although the wound does not appear exteriorly, on the flesh, the con-cept of the spiritual body as a site of divine marking is a common trope in medieval visionary literature. A spiritual event that "wounded" one in the soul and not in the body could signify a special relationship between the recipient of the spiritual wound and God, even if that wound was invisible.

20. *Leg.* 2: 8.4, SC 2: 266.

21. *Leg.* 2: 16.5, SC 2: 296; Barratt, 1.142.

22. *Leg.* 2: 4.1, SC 2: 242.

23. Barratt's translation gives the interval between her prayer and the reception of the divine wounds as six years, but the Latin text specifies "septimo"; Margaret Winkworth translates this as seven years (101) and Doyère's French translation also gives seven years (SC 2: 249).

24. *Leg.* 2: 5.2, SC 2: 250; Winkworth, 102. Barratt translates this passage as follows: "Suddenly you were there unexpectedly, opening a wound in my heart with these words: 'May all your emotions come together in this place; that is may the sum total of your delight, hope, joy, sorrow, fear and your other emotions be fixed firmly in my love'" (1: 113). While Barratt's version is true to the meaning of the passage, Winkworth's choice of "inflicted" and "concentrated" (against Barratt's "opening" and "come together") more effectively capture the intensity of the Gertrude's experience as related in the Latin text. In general, Winkworth's translation is more fluid and evokes the ebullient style of Gertrude's writing more effectively than Barratt's, although the latter's translation is accurate in its representation of the text's literal sense.

As Caroline Bynum argues, interior markings and woundings of the sort described by Gertrude were often seen as valid indicators of divine favor: "the point was the pain of stigmata or of the wound in the heart, not the visibility of the scars."[25] Visionary experience was often figured in terms of bodily images and described as having a physical, though only internally apprehended, effect;[26] bodily marks of divine favor therefore included signs or wounds on the spiritual body that were perceptible only to their recipient. Such marks on the spiritual body typically both evoked and indicated identification with Christ's pain: by sharing in Christ's suffering, the recipient of the physical or spiritual wound identifies with and thus more fully understands his passion. But in Gertrude's text, where we might expect sharing the wounds to stand for her suffering with Christ—as it does in the works of so many medieval mystics, such as Julian of Norwich—her focus is not on sacrifice or suffering but on union and joy. Bynum writes,

> Although there are suggestions of affective identification with Christ's sufferings and suggestions that pain and illness are cleansing, Gertrude's stress on the heart and wounds is not primarily a stress on sacrifice; it is a stress on the blood that Christ feeds us in our most intimate union with him or a stress on the union itself.[27]

Physical identification is both a sign of and a *cause* of Gertrude's transformation to a life lived in perfect union with God. Even in this visceral scene, union, not compassion, is at the core of Gertrude's theology.

The wound's ability to bring Gertrude more closely into harmony with the divine resonates with Augustine's image of divine wisdom as a healer come to treat the wounds of humanity. In *De Doctrina Christiana,* Augustine figures the receipt of wisdom and the subsequent transformation of the sinning human into a redeemed soul as the treatment of an illness or injury. "Wisdom," he writes, "adapted her healing art to our wounds by taking on a human being, curing some of our ills by their contraries, others by homeopathic treatment." The incarnation is thus a cure for the fallen state of humanity. In his formulation, such figurative wounding seems a necessary prerequisite to knowledge, which comes to "restore sinners to complete

25. Caroline Walker Bynum, *Holy Feast and Holy Fast: The Religious Significance of Food to Medieval Women* (Berkeley: University of California Press, 1987) 212.

26. See Amy Hollywood, "Inside Out: Beatrice of Nazareth and Her Hagiographer," in *Gendered Voices: Medieval Saints and Their Interpreters,* ed. Catherine M. Mooney (Philadelphia: University of Pennsylvania Press, 1999) 91.

27. Caroline Walker Bynum, *Jesus as Mother: Studies in the Spirituality of the High Middle Ages* (Berkeley: University of California Press, 1982) 192.

health."[28] Similarly, Gertrude's inner wounding prepares her to receive the knowledge that will enable her to love God more completely. The inner wound clears the way for a joyful unification with the divine that would not otherwise be possible.

Gertrude's identification with Christ falls under the guiding influence of the liturgy, which, as I have noted, forms the structural basis of the *Legatus*. The powerful affective experience of being marked with Christ's wounds, like nearly all of her other visions, is subsumed within the cycle of liturgical ritual. Gertrude and her amanuenses almost always foreground the liturgical context for her spiritual experiences, as in the introduction to her first vision: "Dum in vigesimo sexto aetatis meae anno in illa saluberrima mihi secunda feria ante festum Purificationis Mariae castissimae matris suae, quae feria secunda tunc fuit sexto kal. Februarii, in hora exoptabili post Completorium, quasi in initio crepusculi" (I was in my twenty-sixth year. The day of my salvation was the Monday preceding the feast of the Purification of your most chaste Mother, which fell that year on the 27th of January. The desirable hour was after Compline, as dusk was falling).[29] In addition to providing Gertrude with the language to describe her spiritual experiences and the temporal context in which she records them, the liturgy also prompts Gertrude's encounters with Christ and provokes many of her visions. On the day of the nativity, for example, she lifts the infant Christ from his crib;[30] in this act, her spiritual experience enacts the devotional promptings of the liturgical feast. Rather than simply meditating on this moment in Christ's life, she lives it. Similarly, in the following passage, she witnesses in her soul the scene that the words of that day's Mass describe:

> In secunda ergo dominica dum ad missam ante processionem cantaretur responsorium *Vidi Dominum facie ad faciem,* etc., mirabili quodam et inaestimabili coruscamine illustrata anima, in luce divinae revelationis apparuit mihi tamquam faciei meae applicata facies quaedam. . . . Ex hac melliflua visione cum solares oculi tui oculis meis directe oppositi viderentur, qualiter tu suavis dulcedo mea tunc afficeris non solum animam meam, verum etiam cor meum cum omnibus membris, cum tibi soli sit notum,

28. Augustine, *Teaching Christianity (De Doctrina Christiana)*, trans. Edmund Hill, *The Works of Saint Augustine: A Translation for the 21st Century,* vol. I.11 (Hyde Park, NY: New City Press, 1996), I: 13, pp. 11–12.

29. *Leg.* 2: 1.1, SC 2: 228; Winkworth, 94–95. The contextualization of her visionary experiences within the liturgical year is especially apparent in Book 4, which is organized entirely around the liturgical calendar rather than through the chronological ordering of her encounters with God. Thus, events are said to have happened on particular days without regard for the passing of years between them.

30. *Leg.* 2: 16.1, SC 2: 290.

proinde quoad vixero tibi persolvam famulatum devotum. (*Leg.* 2: 21.1, SC 2: 322)

(On the second Sunday in Lent, before Mass, as the procession was about to start and they were singing the Response, "I saw the Lord face to face," my soul was suddenly illuminated by a flash of indescribable and marvelous brightness. In the light of this divine revelation there appeared to me a Face as though close to my face. . . . In this sweetest vision in which your eyes, shining like the sun, seemed to be gazing straight into mine, how you, my dearest and sweetest, touched not only my soul but my heart and every limb, is known to you alone and as long as I live I shall be your devoted slave.[31])

The Responsory plainly coincides with her experience of the words being sung. As Jean Leclercq puts it, "[w]hat was objective and universal becomes subjective and personal":[32] the communal invocation of the scriptural passage is thoroughly interiorized, vividly enacted within her spirit.

So far, I have sought to establish that the liturgy is the vehicle for Gertrude's visionary knowing: it initiates her visions and, crucially, is what enables her to unite her will to God's. The wound, normally an image of identification with Christ's suffering, is, for Gertrude, emblematic of her union with him and the complete reorientation of her affect towards the divine. As I will argue, this union is essential to Gertrude's ability to make sense of her visions and to use her own reflective and cognitive abilities to reach a greater understanding of God's mysteries. In order to understand this union, however, we must first consider the way in which the liturgy itself operates upon the practitioner, and specifically how it transforms the relationship between the world and the divine. The liturgy's ability to fundamentally change the practitioner's relationship to God is what creates the possibility of her visions and her enhanced knowledge of the divine.

To begin, we might ask why the liturgy is so important for Gertrude: what makes it such an effective catalyst for her transformative experiences? Catherine Bell's theory of ritualization helps to explain the liturgy's effect upon Gertrude's devotional practice. Ritualization, Bell argues, "temporally structures a space-time environment through a series of physical movements . . . thereby producing an arena which, by its molding of the actors, both validates and extends the schemes they are internalizing."[33]

31. Winkworth, 125–26.
32. Jean Leclercq, "Liturgy and Mental Prayer in the Life of Saint Gertrude," *Sponsa Regis* 32.1 (1960) 4.
33. Catherine Bell, *Ritual Theory, Ritual Practice* (New York: Oxford University Press,

The repetition of the liturgy creates a self-reinforcing sphere of practice, instilling in its participants a greater sense of the reality of that which the practice itself invokes. Importantly, this reality is created within the bodies of the participants: the ritualized body enacts and incorporates what the ritual expresses. Bell writes,

> the molding of the body within a highly structured environment does not simply express inner states. Rather, it primarily acts to restructure bodies in the very doing of the acts themselves. Hence, required kneeling does not merely *communicate* subordination to the kneeler. For all intents and purposes, kneeling produces a subordinated kneeler in and through the act itself. . . . [W]hat we see in ritualization is not the mere display of subjective states or corporate values. Rather, we see an act of production—the production of a ritualized agent able to wield physically a scheme of subordination or insubordination.[34]

Gertrude's use of the liturgy reflects a similar application of ritual practice. By participating in the liturgical cycle, Gertrude becomes a visionary: liturgical language initiates many of her visions while also providing her with the means of understanding them. Most importantly, it is through her engagement with the liturgy that Gertrude, bodying forth the events that it describes, becomes a site of the union between God and humankind.

Actually experiencing what is described in the liturgy is related to another devotional practice current in the Middle Ages. Like the liturgical ritualization of the worshipper's body, visualizing events from Christ's life was a common feature of medieval devotion and could lead to "lived experiences" of these events. Meditative techniques that centered upon actively visualizing scriptural events, such as Christ's crucifixion, "created a sensitivity to visualization and a receptivity to visionary perception as a way of expressing insights into the sacred."[35] This is certainly the case for Gertrude, as pressing the Christ-child to her breast she feels his "infantilium necessitatum . . . intimis meis expressius propinaretur" (childish needs . . . quench the thirst of the most intimate longings of my soul):[36]

1992) 109–10.

34. Ibid., 100.

35. Kerrie Hide, *Gifted Origins to Graced Fulfillment: The Soteriology of Julian of Norwich* (Collegeville, MN: Liturgical Press, 2001) 20. For more on the deliberate cultivation of visionary experiences, see Denise Despres, *Ghostly Sights: Visual Meditation in Late-Medieval Literature* (Norman, OK: Pilgrim Books, 1989), and Barbara Newman, "What Did It Mean to Say 'I Saw'? The Clash between Theory and Practice in Medieval Visionary Culture," *Speculum* 80.1 (2005): 1–43, esp. page 15.

36. *Leg.* 2: 16.1, SC 2: 290, Winkworth, 115.

by undergoing the Biblical event in her spiritual vision, she has a heightened affective response to the liturgical rite and enjoys a moment of divine union. Similarly, when she actually lives the words from Genesis 32:30 ("Vidi Dominum facie ad faciem") as they are being sung, she is moved to an overwhelming sense of God's greatness and her indebtedness to him. The concluding words of the passage from *Leg.* 2: 21.1, "as long as I shall live I shall be your devoted slave," indicate a radical renewal of her pledge to serve the divine. Through Gertrude's absorption in the liturgy, a matter of faith and abstract devotion becomes a lived reality, deeply felt in the core of her spiritual being.

In addition to structuring her visions and exemplifying the interpenetration of church ritual with her inner spiritual life, the intermingling of the liturgy with her visionary experiences also demonstrates the power of liturgical speech to grant to Gertrude knowledge of divine matters. In the following example, which is fairly typical of the visionary events described in the *Legatus,* the words of the Mass lead directly to an increase in Gertrude's understanding:

> Cum cantaretur Responsorium: *Vocavit Angelus Domini,* etc., intellexit quomodo agmina Angelorum quorum subsidia plene possent sufficere, circumdant electos ad protegendum eos. Sed Dominus paterna providentia quandoque suspendit eamdem protectionem, ut permittat electos in aliquo tentari, unde tanto gloriosius remunerentur, quanto magis sibi quasi subtracta angelica custodia et protectione, sua virtute triumphant. (*Leg.* 3: 30.20, SC 3: 146)

> (While the response "An angel of the Lord called" was being chanted, she understood how the hosts of angels, whose help can be more than sufficient, surround the chosen to protect them. But the Lord in his fatherly foresight sometimes suspends that protection to allow the chosen to be tempted in something. By this means they would be rewarded the more gloriously, the more they triumph through their own strength, the angelic guard and protection being withdrawn.[37])

Or, again, in the subsequent passage:

> Item, per consequens quo canitur: *Vocavit Angelus Domini Abraham,* intellexit quod, sicut deus Abraham . . . vocari meruit ab Angelo, sic electus, cum ad aliquod opus sibi difficile propter Deum mentem flectit, integram

37. Barratt, 2: 110.

adjungendo voluntatem, statim in instanti, arridente sibi suavitate divinae gratiae, testimonio propriae conscientiae meretur consolari. (*Leg.* 3: 30.21, SC 3: 146–148)

(Again, when they subsequently chant, "The angel of the Lord called Abraham," she understood that just as holy Abraham . . . deserved to be called by the angel, so when a chosen person applies his mind because of God to some task difficult for him and brings to bear his whole will, in an instant the delight of divine grace smiles on him and he deserves to be consoled by the testimony of his own conscience.[38])

In these passages, *intellegere* is the operative verb in Gertrude's visionary knowing. Listening to the words being sung or chanted at Mass, she gains a heightened knowledge of their signification; she "understands" them through the *intellectus* without any explicit instruction.

The practice of *lectio divina* parallels the way that Gertrude acquires knowledge through the words of the Mass. In *lectio divina,* attentively reading and rereading words from the Bible enables the reader to consciously internalize them, allowing their meaning to unfold within her soul.[39] In the Middle Ages, such reading was often performed aloud, resulting in a "muscular memory of the words pronounced and an aural memory of the words heard": the reader's body became involved in the process of reading scripture. Inseparable from this process is *meditatio,* which "consists in applying oneself with attention to this exercise in total memorization," while *lectio* inscribes "the sacred text in the body and in the soul."[40] Gertrude's repetition of the liturgy is similar to *lectio divina* in its use of language to instill a knowledge that reaches beyond the literal meaning of its words to a deeper truth. Strictly speaking, she is not reading; yet the nature of liturgical practice as repeated speech acts, performed again and again as part of a continued cycle, suggests that the liturgy could provide the same opportunity for internalized meditation as the repeated reading of scriptural passages. The ritualized, repeated recitation of the liturgy, performed with the proper degree of devotion and concentration, is a practice very like that of *lectio.* Through this practice, as through *lectio,* the devout could come to experience eschatological events in their spirits. Interiorizing scripture in this way, notes Christopher Abbott, "is understood to bring

38. Ibid.

39. Mary Carruthers, *The Book of Memory: A Study of Memory in Medieval Culture* (Cambridge: Cambridge University Press, 2001) 163.

40. Jean Leclercq, *The Love of Learning and the Desire for God,* trans. Catherine Misrah (New York: Fordham University Press, 1962) 78.

the human subject into a personal, existential relation to the mysteries of faith, thus making these mysteries really present in their spiritual meaning and power."[41] This is precisely the relation with the divine that Gertrude's visionary experiences bring about. Given her total immersion in the cycle of the liturgy, it is no surprise that it should form the foundation of her knowledge of God.

The role of the liturgy in Gertrude's visionary knowing underscores a further similarity between her liturgical spirituality and *lectio divina*. Emphasizing the role of concentrated attention to the Mass in her spiritual practice, Leclercq argues that it is Gertrude's close attention to the words of the Mass that leads to the visionary experiences that imbue her with profound spiritual understanding. In the example of the Nativity cited above, Gertrude "'tries to render herself present, by meditation, to this divine birth,' and to devote herself to it 'by an attentive piety.' And this effort is rewarded by grace: suddenly she 'understands,' that is, she realizes and then she analyzes the content of this instantaneous experience."[42] Gertrude's *Exercitia Spiritualia* even more explicitly develops the theme of *lectio divina* as a means of approaching God. Remarking upon a passage from the *Exercitia* in which Gertrude describes God's instructing her in the "alphabet" of his love, Mary Forman notes that "a study of the smallest *iota* of scripture . . . entered into under the guidance of the Spirit, leads to contemplative union with the divine."[43] In this exercise, Gertrude highlights the spiritual opportunities presented by minutely studying scripture in the devotional spirit required for real understanding. While the *Legatus* does not contain such clear instances of Gertrude's meditation upon the scriptures, the close attention to the words of the liturgy that is evident throughout the *Legatus* indicates a similar kind of contemplative activity focused upon the individual words of the Mass. It is not merely hearing the words that triggers her experiences; rather, her focused attention upon those words enables her to live the events of Christ's life within her soul. These experiences, in turn, generate her visionary knowledge.

The liturgy is intended to both represent and reveal the divine order of the universe. In the thirteenth century, writes Éric Palazzo, "l'ordre de l'univers est métaphoriquement représenté" (the order of the universe is metaphorically represented) in the liturgy.[44] Vagaggini argues further that

41. Christopher Abbott, *Julian of Norwich: Autobiography and Theology* (Rochester: D. S. Brewer, 1999) 55.

42. Leclercq, "Liturgy," 2.

43. Mary Forman, "Gertrud of Helfta's *Herald of Divine Love:* Revelations through *Lectio Divina,*" *Magistra: A Journal of Women's Spirituality in History* 2.2 (1997) 12.

44. Éric Palazzo, *Liturgie et société au Moyen Âge* (Paris: Aubier, 2000) 35; my translation.

liturgical speech expresses and manifests reality. It follows, he contends, that in order to properly understand the liturgy and its function, one must believe that every sign is capable of signifying its fundamental referent.

> To enter fully into the world of the liturgy, we must be convinced that under the veil of the signs, of every sign, we really reach the thing signified, and that, conversely, the reality comes to us through this sensible veil. We must admit that the sign is the means which permits the invisible reality to be present for us and permits us to enter into contact with it.[45]

While this view is not uncontroversial, Gertrude's experience is aligned with Vagaggini's position. Just as Marguerite believed that the word *vehemens* could lead her to a direct understanding of divine power, so does the Helfta mystic gain, through the words of the Mass, a thorough knowledge of the theological meanings for which they function as signs. The idea that the liturgy can enact what it says entails a realist model of language: ritual speech both creates and refers to a divine reality in which the participant may share. It is explicitly liturgical language—repeated and inhabited— that leads Gertrude to her transcendent knowledge.

Gertrude's experience of God through the liturgy is in harmony with its function: liturgical speech effects what it signifies. This is most obviously true of the Eucharistic sacrament, in which the words of the priest transform bread and wine into the body and blood of Christ. Palazzo calls the consecration of the Eucharistic host the site of "l'efficacité sacramentelle de la parole" (the sacramental efficacy of speech):

> Le "ceci" de la formule de consécration . . . peut désigner le pain tout en signifiant que ce sera le pain-corps du Christ. . . . Le langage apparaît comme un instrument qui permet de signifier, d'exprimer ses pensées mais aussi d'agir sur les choses, comme de procurer la causalité des sacrements.

> (The "this" of the consecration can designate the bread even as it signifies that this will be the bread-body of the Christ. Language becomes an instrument that enables one to signify, to express one's thoughts, but also to act upon things—to produce, for example, the causality of the sacraments.[46])

In the Eucharist, language not only signifies the divine, but it affects matter, both designating Christ's body and causing the sacrament to occur. Com-

45. Cyprian Vagaggini, *Theological Dimensions of the Liturgy*, trans. Leonard J. Doyle, abr. ed. vol. 1 (Collegeville, MN: Liturgical Press, 1959) 24.

46. Palazzo, 32; my translation.

munion is an important part of Gertrude's spirituality, as is plainly attested by the number of references to visions that occur during or immediately before or after she communicates; moreover, she is frequently called upon to reassure other sisters at the convent that they are fit to receive the Eucharist. Its centrality to her spiritual practice indicates her faith in it as a means of physically encountering God—which is, of course, only to be expected. But Palazzo's suggestion that this instance of liturgical speech is a type of "Parole en Acte"[47] that acts sacramentally upon the world in a significant way can be applied to Gertrude's visionary experiences more generally. As in the example of the Nativity service above, the words of the Mass allow Gertrude to experience in her soul the events from Christ's life that they describe. The power to enact what it signifies linguistically is vividly manifested in her spiritual response to liturgical speech.

Gertrude's spiritual life is thus thoroughly intertwined with the liturgy. The liturgical focus of her spirituality indicates an identification, if not necessarily with Christ (although there are elements of such an identification in her work), then with the events of his life. This identification is most often described in terms of union: rather than feeling Christ's wounds with him, Gertrude sees those wounds as a means of being united with Christ in his suffering humanity and, in turn, in his divinity. This union and the liturgical practice that enables it are fundamental to her visionary knowing. It is through the liturgy, in her moments of union with Christ, that Gertrude "understands" ("intellexit") the truths underlying scriptural language. But how does she actually acquire this transcendent knowledge? In the cases where her understanding is introduced only with "intellexit"—and these are, again, numerous—there is no description of what this means; she does not witness an allegorical scene, as Marguerite does in her enquiry into the meaning of *vehemens,* nor is it clear that Christ is verbally articulating his messages to her. Leclercq posits that Gertrude's knowledge comes about through a kind of unspoken experience: "what had been . . . a matter of faith, became, in a certain way and to a certain extent, a matter of experience; . . . what had belonged to the field of ideas entered into the field of 'realization' by feeling and by thought."[48] This is an apt summary of Gertrude's experience—the knowledge, once held by faith, is "realized" in her soul—but, again, this does not help to explain how the knowledge came to be there. Indeed, Leclercq's circumlocution ("in a certain way and to a certain extent") underscores the mysterious quality of this process. Implicit in both Gertrude's text and Leclercq's description is the understanding that

47. Ibid.
48. Leclercq, "Liturgy," 2.

Gertrude comes to know through the working of the divine in her soul. How this working occurs is unexplained. But what we can discover is *why* Gertrude is able to obtain her extraordinary knowledge.

II. The Role of the Will: Validating Intellectual Enquiry

For the most part, Gertrude seems untroubled by the origins of her knowledge. There are, however, two instances in which she questions the source of her privileged understanding, expressing the concern that it is the working of her own mind, rather than God himself, that leads her to her revelations. Both instances occur in Book 4 and were therefore written by one of the anonymous co-authors (or co-compilers) of the *Legatus*. The first occurs after a spiritual experience in which God did not respond to her initial prayer for understanding; her own efforts, coupled with "divine inspiration" ("divinitus inspirata"), finally provide her with the knowledge that she desires. Subsequently, she fears that this understanding is not valid. I quote this passage at length:

> Hinc timere coepit, ut moris est humani, hunc se intellectum non ex divino spiritu, sed ex proprio hausisse sensu. Ad quod divinae consolationis accepit responsum: "Noli timere, quia eo quod voluntas tua tam plene divinae voluntati meae unita est quod nihil velle potes quam quod ego volo, et per consequens in omnibus laudem meam summe desideras, omnes spiritus angelici sic tuae subjecti sunt piae voluntati, quod si antea non orassent pro vobis, secundum quod eos facere per spiritum intellexisti, ex eo quod tibi hoc ipsos facere complaceret, amodo absque dubio studiosissime conarentur adimplere; immo, quoniam tu a me imperatore imperatrix effecta es, omnes principes mei caelestes ita obsecundant tuae voluntati, quod sit tu aliqua eos facere diceres quae nondum fecissent, statim ad verificandum verba tua summopere beneplacitum tuum studerent cum summa festinatione complere." (*Leg.* 4: 2.15, SC 4: 44–46)

> (She began to fear, in accordance with human custom, that this thought did not come to her through divine inspiration, but was, rather, drawn up through her own mind. To this, she received this answer of divine consolation: "Do not fear; your will is unified so completely with my divine will that you cannot wish for anything other than what I will; and, because you desire my highest glory in all things, all of the angelic spirits must submit to your pious desires, to the point that if, previously, they did not pray for you, as you just understood spiritually, henceforth they will do whatever is

pleasing to you. Doubtless, they are already zealously exerting themselves to carry out your will. What's more, since I, the emperor, have made you the empress, all of my heavenly princes comply so well to your will that, if you were to say that they were doing something that they had not yet done, immediately, to authenticate your words, they would strive with the greatest haste to satisfy your pleasure."[49])

God comforts Gertrude with the assurance that her will is sufficiently wedded to his that her scrutiny into religious matters will yield only the truth and that even the angelic hosts will conform themselves to her will. Most significantly, Gertrude's intellectual processes and investigations into theological questions are divinely sanctioned as ways of reaching transcendent knowledge.

If such an assertion appears potentially dangerous to modern readers, it seemed no less so to Gertrude herself. In a later passage, her amanuensis records a visionary dialogue in which the mystic asks God how she can confirm that it is he who instructs her, given that her own desire is what pushes her to request further spiritual lessons. The Lord answers:

> Cur, inquit, ob hoc debet donum meum parvipendi, si cum sensibus tuis, quos ad serviendum mihi creavi, diligentiori studio illud perfeci, cum tamen magis commendetur et acceptetur quod facturus hominem consilio deliberato dixi: *Faciamus hominem ad imaginem et similitudinem nostrum,* quam quod alia creando dixi: *Fiat lux, fiat firmamentum,* etc.

> ("Why then," he said, "should one make little of this gift which, in accordance with your own sentiment, I created to be of service to me? Did not I, myself, with diligent eagerness, perfect it [Gertrude's desire]? Moreover, was it not committed and received that, in the moment of creating man, I uttered this resolution: *Let us make man in our image, after our likeness,* rather than saying, as I did for rest of creation: *Let there be light, let there be a firmament,* etc.?")

The Lord's explanation here is little more than a reiteration of his earlier reassurance with some scriptural support tacked on. Gertrude does not find this satisfactory and brazenly pushes her line of questioning further: "Si ego hanc introducerem auctoritatem, possent et alii sensu proprio laborando adinventiones diversas introducere et eas quasi pro auctoritate defendere, quamvis ea non percepissent per efficacem gratiae tuae influxum" (If I were

49. My translation.

to introduce this kind of authority, would not others, through the labors of their own minds, be able to introduce various inventions, and to defend them as if they were authoritative, although they were not gained through the influx of your grace?). The Lord replies:

> Adjunge hanc discretionem. Si quis homo finaliter in corde suo experitur quod voluntas ejus ita per omnia meae divinae sit unita voluntati, quod nullo in minimo unquam prospero sive adverso possit a meo complacito aliquatenus discordare, et insuper in omni quod agit vel patitur ita pure laudem vel gloriam mei solius desiderat, quod in omnibus propriae totaliter abdicit utilitati et mercedi, ille secure potest affirmare *quodcumque boni sensuum suorum exercitio* apprehenderit cum interno sapore, quod tamen Scripturae sacrae testimonio non videatur carere, ac proximorum posit utilitati congruere. (*Leg.* 4: 14.5, SC 4: 158–60; my emphasis)

> (Add this condition: if someone demonstrates, finally, in his heart, that his will is united in everything with my divine will, so that he is unable to diverge from my good pleasure in a single detail—neither in good nor in bad fortune—and if, moreover, he similarly desires only my praise and glory in all that he does or endures, always absolutely renouncing his own advantage and interest; that person can affirm without fear all the goods which, *through the exercise of his faculties,* it comes to him to know and savor in the depths of himself, so long as they are not seen to lack the testimony of sacred scripture, and can be profitable to his neighbors.[50])

The dialogue ends here, and Gertrude does not take up the question again.

As the only passages in which Gertrude explicitly questions the origin of those revelations that are not transmitted through direct discourse or allegorical visionary experience, these dialogues establish the conditions and criteria by which she may be considered a legitimate receptacle of divine wisdom. Relying on these two passages from Book 4 may appear risky; after all, they are a small part of an enormous work and they were not written by Gertrude herself. But while it is important to bear in mind that these passages were not directly authored by Gertrude and that we cannot know the degree of control that she had over these portions of the *Legatus,* the unity of the whole work legitimates their role as indicators of Gertrude's and the other sisters' understanding of the requisite basis for revelation of this kind. Because so much of the *Legatus* centers upon the visionary's intuitive or "realized" knowledge of scripture, the justification

50. My translation; my emphasis.

of her knowing is highly significant. These passages establish her privileged knowledge as a function of her intimate union with God—a union that is grounded not only in her affect or her internal mirroring of Christ's wounds, but in her cognitive faculties as well.

In both of his explanations (4: 2 and 4: 14), the Lord emphasizes the union of Gertrude's will with his own. It is the purity of her will, which was created in his image and is no longer subject to worldly distraction, that prepares the ground for her revealed knowledge. In Book 1, her biographer stresses this quality of Gertrude's, citing a vision in which God explains why she is a suitable recipient of his favors: "Nam singulis horis donis meis apta invenitur, quia nunquam permittit cordi suo inhaerere aliquid quod me impediat" (For hour by hour she is found fit for my gifts, as she never allows anything to find a place in her heart which could be an obstacle to me).[51] Elsewhere in Book 1, she is described as "omni humana affectione abstractum" (purified of all human affection).[52] This detachment from the material world, her biographer suggests, is what enables God's will to be manifest within her; without the obstruction of worldly attachment, Gertrude's will is wedded to that of the divine. She is therefore granted something startlingly akin to infallibility. The dialogue of 4: 14 implies that, owing to the perfect harmony between her will and God's and the purity of her intentions in seeking to answer doctrinal and scriptural questions, Gertrude's reflections upon matters theological will consistently yield correct, divinely sanctioned truth. The alignment of her will with God's frees her intellect from error: the workings of her mind can and will lead her to transcendent knowledge.

The use of the intellect in *meditatio* provides a context for Gertrude's cognitive activity. *Meditatio,* which is a part of the process of *lectio divina,* involves bringing a degree of intellectual agency to bear upon the practice of devotional reading, as the twelfth-century Hugh of Saint Victor suggests. Meditation, he writes in the *Didascalicon,* "delights to range along open ground, where it fixes its free gaze upon the contemplation of truth, drawing together now these, now those ideas, or now penetrating into profundities, leaving nothing doubtful, nothing obscure."[53] Clearly, giving free rein to one's intellect will not always yield divine truth, and Hugh is in no way implying that it does. Rather, *meditatio* is the culmination of *lectio*; it is gathering together what has been learned by reading of scripture and coming to a deeper understanding of the meaning latent within the text.

51. *Leg.* 1: 11.7, SC 2: 178; Barratt, 1: 73.
52. *Leg.* 1: 2.6, SC 2: 132; Barratt, 1: 44.
53. Hugh of Saint Victor, *The Didascalicon: A Medieval Guide to the Arts,* trans. Jerome Taylor (New York: Columbia University Press, 1961) 3. 10, pp. 92–93.

Lectio and *meditatio* lead to *sapientia,* or wisdom, rather than *scientia,* a distinction that underscores the differences between the kinds of knowledge to be obtained via devotional reading and those accessible through rational enquiry. Thus Arnoul of Bohériss, a Cistercian writing in the early thirteenth century, advises monks to "seek for savor [*saporem*], not science [*scientiam*]" in their reading.[54] Reading in the spirit of *meditatio,* like the devotional reading advocated by Augustine, could help the reader to immerse him or herself in the mysteries of the divine. But, as we have seen, Gertrude's enquiry into divine matters at times goes beyond meditation to actually granting her new knowledge. While the knowledge imparted directly by God could conceivably be received as authoritative by contemporary audiences, the understanding that she reached through her own reasoning would have been more problematic. God's reassurances validate the authority of her understanding—but, beyond that, they address an issue that was prominent in twelfth- and thirteenth-century monastic culture and that would very likely have been at the forefront of Gertrude's mind during the composition of her *Legatus.*

When Gertrude asks the Lord how she knows that her answers are God-given, what she seems to be asking is, in effect, how she can distinguish *intellectus* from *ratio.* Aquinas posits that *intellegere* is "simply to apprehend an intelligible truth, and to reason is to advance from one thing to another, so as to know an intelligible truth."[55] To exercise the *intellectus* is to grasp truths without having to go through the process of rationally proving them. Gertrude's anxiety to distinguish her knowing from ratiocination and her consequent worry that her knowledge proceeds purely from her own mind reflect monastic anxieties about the proliferation of scholastic learning in the twelfth and thirteenth centuries. Scholasticism, which often involved the pursuit of knowledge of God by means of rational enquiry, was thought by some to threaten the primacy of devotional reading and contemplation in monastic communities. Moreover, the trappings of universities—with their emphasis upon literary, as opposed to devotional,

54. "Post lectionem est orandum: et si ad legendum accedat, non tam quæret scientiam, quam saporem. Est autem Scriptura sacra puteus Jacob, ex quo hauriuntur aquæ quæ in oratione funduntur. Nec semper ad oratorium est eundum, sed in ipsa lectione poterit contemplari et orare." Arnulfi Monachi de Boeriis, "Speculum Monachorum," in *Patrologiae Latinae* 184, ed. J.-P. Migne (Turnhout: Brepols, 1981) 1175. Translation from Leclercq, *Love,* 79.

55. Thomas Aquinas, *The Summa Theologica of Saint Thomas Aquinas,* vol. 1, trans. Fathers of the English Dominican Province (Chicago: Encyclopaedia Britannica, 1952) I: 79.8, p. 421. "Intelligere enim est simpliciter veritatem intelligibilem apprehendere. Ratiocinari autem est procedere de uno intellecto ad aliud, ad veritatem intelligibilem cognoscendam" (Thomae de Aquino, *Summa Theologiae,* vol. 1, ed. Institutum Studiorum Medievalium Ottaviensis [Ottawa: Commissio Piana, 1953] 488b).

studies; their honors and awards; the distraction of teaching—were incompatible with the contemplative life required of most monastics.[56] Perhaps most importantly, however, total confidence in the human powers of cognition was associated with excessive pride. Learning based upon profane texts was thought by many monastics to be the learning that "puffs up"—an egotistical form of learning that was not properly subordinated to love for God.[57] Gertrude may well have been concerned about being aligned with this kind of learning, as her past suggests a disproportionate attachment to profane texts. According to her biographer, she was an outstanding student in her youth: "Nam cum ad scholas poneretur tanta sensuum velocitate ac intellectus ingenio praepollebat, quod omnes coaetaneas et caeteras consodales in omni sapientia et doctrina longe superabat" (When she started school she was distinguished by such quickness of perception and such natural understanding that she outstripped all her other contemporaries and other companions in all wisdom and instruction),[58] and her interest in non-scriptural literature persisted until she received her first vision at the age of twenty-five. It is entirely possible that she feared that her visionary knowledge was, either in appearance or in fact, little more than the workings of her own rational mind and not reflective of God's will. By asserting that her reasoning is validated through the union of her will with God's, she effectively overcomes this tension even as she recognizes its presence within her text. This means that her solution to this problem is not one that can readily be adopted by others, and it acknowledges the difficulty of discerning between intellectual enquiry and divine revelation. Through the overwhelming evidence of her union with God, however, the *Legatus* suggests a way for one individual to use her rational intellect in the service of transcendent knowledge.

Throughout the *Legatus,* the liturgy is the medium of Gertrude's union with Christ at every level—affective, intellectual, and even (in a sense) physical, through such events in her spiritual body as the marking of his wounds upon her. Thus the liturgy, as the vehicle for the union that is necessary for Gertrude's visionary knowing to occur, enables her to receive her knowledge of transcendent truths. Beyond the affective dimension of her union with Christ, which is characterized by feelings of pure love and pity for his suffering, the union brought about by Gertrude's liturgical devotion leads directly to knowledge. Strongly reminiscent of the *meditatio* that follows *lectio divina*, the mystic's intellectual questioning is fruitful only because she has allowed herself to be absorbed so completely

56. Leclercq, *Love,* 207.
57. Ibid., 206.
58. *Leg.* 1: 1.1, SC 2: 118–120; Barratt, 1: 38.

into the divine. This happens through liturgical practice: understanding—"intellegere"—is prompted by, *and* enabled by, the liturgy. Finally, Gertrude's active enquiries into spiritual mysteries find their validation through her volitional union with the divine. By subordinating her will to God's, she acquires the ability to employ her own intellectual agency—an agency that is an essential tool in her visionary knowing.

GERTRUDE'S VISIONARY knowing is highly specialized: her involvement in the liturgy creates a union with Christ that enables her to use her own mental faculties to reach an understanding of the divine. But, while this path might not be open to everyone, what it demonstrates is the vital relationship between the visionary's will and her powers of *intellectus* and *ratio.* Through her volitional union with Christ, Gertrude is able to use her reason to arrive at inspired conclusions about theological issues. Although much of her knowledge is instilled in her understanding through divine inspiration, her visionary knowing is not a passive process, depending as it does upon her volitional and affective orientation and her constant, intentional immersion in the liturgy. In the *Legatus,* then, we get a picture of how visionary knowing can be an active process despite the apparent passivity of the visionary herself. In the next chapter, I will consider a rather different case. Julian of Norwich's active reflection on her visions is apparent throughout the *Showings;* meditating upon and reasoning through her visions is often essential to her fully understanding them. In Gertrude's text, we have a more subtle but still compelling portrait of the visionary's active engagement in her visions. As will become clear, both the volitional engagement exemplified in Gertrude's case and the rational reflection that Julian exhibits are means of visionary knowing that appear in all kinds of vision literature, and are thus heavily implicated in the medieval understanding of the vision.

4

The Vision Is Not Enough

ACTIVE KNOWING IN JULIAN OF NORWICH

HE LONG TEXT version of the *Showings* of the English anchorite Julian of Norwich contains a lengthy parable that is absent from the earlier Short Text.[1] The parable tells of a majestic lord who sends his servant, clad in tattered clothes, off on an errand, but the servant's enthusiasm to perform his lord's will causes him to fall into a ditch. There, the servant "groneth and moneth and walloweth and writheth," unaware that his lord is gazing lovingly upon him from above. His ignorance of the lord's gaze is "the most mischefe" of his plight, "[f]or he culde not turne his face to loke uppe on his loving lorde, which was to him full nere, in whom is full comfort" (LT 51.13–17).[2] Julian observes that the servant has no "defaute" (51.29); in fact, the lord acknowledges that he has fallen only through "his good will" (51.31) in desiring to perform his master's wishes and vows to transform his suffering into bliss: "and so ferforth that his falling and alle his wo that he hath

1. Julian (1342–ca. 1416) wrote two versions of the text that documents the visions she received in an illness at the age of thirty. The first version is often referred to as the Short Text; the second, often called the Long Text, was written about twenty years later and is a significantly expanded version of the first. Together, these texts are typically referred to as the *Showings* (as I call them here) or the *Revelations of Love*. In Watson and Jenkins' edition of Julian's works, which I use in this chapter, the "Short Text" is given the title "A Vision Showed to a Devout Woman" and the Long is "A Revelation of Love"; each of these titles comes from the texts' introductory passages: "Here es a vision, shewed be the goodenes of God to a devoute woman" introduces the rubric at the start of the earlier text, and "This is a revelation of love that Jhesu Christ, our endles blisse, made in sixteen shewinges" is the first sentence of the later text (Jullian of Norwich, *The Writings of Julian of Norwich: A Vision Showed to a Devout Woman and a Revelation of Love,* ed. Nicholas Watson and Jacqueline Jenkins [University Park, PA: Pennsylvania State University Press, 2006], ST [Pol.] 1 and LT 1.1–2, respectively). For the sake of simplicity, I will use the terms "Short" and "Long" to identify them.

2. All citations from the *Showings* refer to Watson and Jenkins' edition. Whether they come from the Short or the Long Text will be indicated by citing them as ST or LT, followed by chapter and line numbers.

taken thereby shalle be turned into hye, overpassing wurshippe and end-
lesse blesse" (LT 51.49–51).

The Parable of the Lord and the Servant dramatically rearticulates
Adam's fall, giving Julian a new understanding of human sin and sug-
gesting a model of humanity in which the spiritual and the corporeal are
capable of reintegration and redemption. The servant represents Adam,
Julian learns, whose original fall is the cause of humanity's need to work,
here described as the search for a treasure that is of great value to the lord.
Contrary to traditional representations of Adam and Eve's labor, this work
is presented in positive terms: while it is "the grettest labour and the hard-
est traveyle that is," when the treasure is found, "he shulde take [it] . . . and
bere it full wurshiply before the lorde" (LT 51.163–4, 169–70). The reason
for the servant's fall is unusual, as well; it occurs because of his great love
for the lord and his desire to accomplish his will "in gret hast" (LT 51.11).
Eve is entirely absent from the vision, a fact that removes the feminine as
the cause of Adam's fall and creates a neat parallel between the first and
second interpretations of the vision—the servant is both Adam and Christ.
Following the wishes of the Father, Christ similarly "fell" from heaven
into humanity through Mary's womb. Christ's fall is explicitly linked with
Adam's through the double signification of the allegory, as Julian explains:
"When Adam felle, Godes sonne fell" (51.185–6). The parable encapsu-
lates the core of Christian salvation history as well as its prefiguration in
the Old Testament.

Three aspects of Julian's parable are important to an understanding of
her visionary knowing. First, Eve's absence from the story of the fall shifts
the responsibility for humankind's sinful state away from the female body.
Gender is absent from the parable, and effacing the link between female
corporeality and sin has profound implications for the production of a
female-authored text that presents original theological insights. Second, the
reconfiguration of sin suggested by the parable is essential to Julian's belief
in the possibility of a redeemed, complete human subject. This subject is
free from the gendered associations between body and mind that are so
prevalent in medieval discourse. And third, the twenty-year delay between
Julian's initial writing of her visions (the Short Text) and the Long Text,
where she records the parable for the first time, demonstrates the impor-
tance of her intellectual understanding to the creation of her work. The gap
between the writing of the two versions and the reasons that she gives for
excluding the parable from the first indicate the centrality of Julian's inter-
pretive processes to the acquisition of transcendent knowledge.[3] Julian's

3. Despite the prominent role that Julian plays in the interpretation of her visions, the

model of visionary knowing, then, depends not only upon her affective visionary experience but upon cognitive work in the form of interpretation and reflection, as well—two means of knowing that have frequently been seen as antithetical. All too often, critical scholarship on Julian has fallen on one or the other side of this dichotomy, arguing either that the *Showings* is a work of intellectual theology or that Julian's theology is a theology of the body, centered upon physical experience and vivid images of blood, wombs, and the suffering body of Christ. Ironically, critical scholarship that espouses this dichotomy threatens to re-inscribe the gendered mind (male)/body (female) distinction that hindered women's participation in public discourse in the Middle Ages. In fact, however, Julian's text shuttles back and forth between these two modes, depending upon a constant return to each. Both reasoning and revelation are necessary for her to obtain her knowledge; *ratio* and *intellectus* are both implicated in her epistemology.

Julian's *Showings* illustrates a need to use a variety of tools in visionary knowing. Rather than depending solely upon the experiential knowledge that comes with an acutely physical, affective encounter with the divine, Julian takes her affective experiences and develops their meanings through sustained cognitive work. Deploying both *intellectus* and *ratio* as interdependent means of uncovering the meaning of her visions, she nonetheless conserves the importance of the physical experience that lies at their origin. Yet the *Showings* is intended as a text for *all* Christians, a devotional work to be read or heard and meditated upon by those who have not received such visions themselves. Without downplaying the importance of her affective experience, then, Julian's emphasis upon meditation, *lectio divina,* and interpretation as paths to knowledge suggests a universal approach to God. Personal, embodied visions of Christ are not necessary for one to know what Julian has learned. By shifting the emphasis of her later text to the

details of her life are obscure. Born in 1343, Julian experienced her visions in May of 1373, when she was thirty years old. We do not know anything about her life prior to her visionary experience; what is known is that she was an anchorite, attached to the church of St. Julian in Norwich, later in her life. At what point she became an anchorite—whether before her visions, immediately after, or later—is unknown. Likewise, we cannot be sure of her real name (it is possible that she adopted the name "Julian" after the church to which she was attached), or whether she took orders prior to her visionary experience: Benedicta Ward has argued that Julian was a widowed mother, questioning the once-common assumption that she spent her early life as a nun (Benedicta Ward, "Julian the Solitary," in *Julian Reconsidered,* ed. Kenneth Leech and Benedicta Ward, 2nd ed. [Oxford: SLG Press, 1992] 11–29). We know, based on the introduction to the Short Text of her *Showings,* that she was still alive in 1413 (ST 1.Prol.), although we do not know when she died, and Margery Kempe describes a visit that she paid to the anchorite in the course of her wanderings (Margery Kempe, *The Book of Margery Kempe,* eds. Stanford Brown Meech and Hope Emily Allen, EETS vol. 212 [Oxford: Oxford University Press, 1940] 42–47).

mental faculties that are possessed by all of her "even Christians" and stripping these faculties of their gendered implications, the anchorite indicates a path to knowing that anyone, male or female, can follow, with or without the singular visions granted her by God.

I. Un-Gendering Knowledge: Affect and Intellect

In chapter 1, I briefly discussed which mental powers were believed to be involved in knowing in the Middle Ages. As I noted, *intellectus* and *ratio* are the powers that many medieval thinkers saw as being most important in the acquisition of knowledge. Designating the sudden apprehension of truth in a single "movement," *intellectus* enables us to understand things in flashes of insight, perceiving as self-evident what may be clouded and obscure to the *ratio*. *Ratio,* on the other hand, approximates what we term the reason. To know something through ratiocination is to understand it through logical argument. When, in the preceding chapter, Gertrude's flashes of insight into the divine are described by the verb *intellego,* she is exercising her *intellectus.* All humans are possessed of both *intellectus* and *ratio.* Nonetheless the *intellectus,* by virtue of its association with angelic knowing, is "higher" than the *ratio.* That Gertrude arrives at much of her knowledge by means of the *intellectus* rather than the *ratio* locates her means of understanding in the higher sphere; she can see the truth without having to progress through the cumbersome and earth-bound process of rational argumentation. But *ratio* and *intellectus,* though distinct, come from the same inner power. While understanding (*intellegere*) is angelic, unqualified, and immediate, reasoning is human, sequential, and "in motion."[4] It allows one to advance from step to step towards truths that the *intellectus* might perceive instantaneously and without the deliberation required in the rational progression through argument.

Julian's use of both *ratio* and *intellectus* signifies a move away from the gendered associations adhering to these faculties and their related means of knowing. *Ratio,* in particular, was considered to be a predominantly masculine capacity in the Middle Ages. The erasure of gender from the story of the fall in the Parable of the Lord and the Servant therefore has significant implications for the depiction of cognitive activity in Julian's text. As any student of gender in the Middle Ages knows, women were often portrayed as intrinsically incapable of rational cognitive work, an attitude concisely

4. Thomas Aquinas, *The Summa Theologica of Saint Thomas Aquinas,* ed. Daniel J. Sullivan, Fathers of the English Dominican Province, vol. 1 (Chicago: Encyclopædia Britannica, 1952) I: 79.8.

summarized by Philo of Alexandria, who writes that "mind corresponds to man, the senses to woman."[5] This sentiment was repeated by Augustine and Ambrose and restated, in one form or another, for the following thousand years.[6] The notion that women were aligned with physicality, sexuality, and the carnal body, while men and masculinity were associated with reason, rationality, and the soul exemplifies medieval attitudes towards the role of sex and the mind/body distinction.[7] For a woman producing a text that documents her own interpretive and rational processes, the inhibiting effects of this attitude would not have been easy to ignore. Julian's parable suggests a way of negotiating these potentially restrictive societal attitudes. By erasing gender from the story of the fall and making it a drama between God and Adam alone, Julian implies that the responsibility for sin and death—humankind's fallible, physical nature—can be found in both men and women. And if this is so, spirit and mind must inhere in women as well as men.

Julian's model of visionary knowing supersedes gendered approaches to knowledge by embracing both affective experience, which instills knowledge via the *intellectus,* and the *ratio,* which she uses when she reflects upon and interprets her visions. The overall structure of the *Showings,* as it develops from the Short Text to its later incarnation in the Long, reflects the importance of a continual process of enquiry into the meaning of her visionary experiences. This process foregrounds her rational interpretation and analysis and is especially evident in the inclusion of the Parable of the Lord and the Servant. At the same time, however, Julian resists prioritizing rationality above sensory and affective experience, instead validating "feminine" approaches to knowledge, as well, and proposing an approach to visionary knowing that incorporates affective understanding along with reason into the acquisition of knowledge.[8] Julian's knowledge and authority

5. Philo, "On the Account of the World's Creation Given by Moses (De opificio mundi)," in *Philo,* trans. F. H. Colson and G. H. Whitaker, Loeb Classical Library, 2 vols. (1929 reprint, Cambridge: Harvard University Press, 1949) 49. Quoted in Denise Nowakowski Baker, *Julian of Norwich's* Showings: *From Vision to Book* (Princeton: Princeton University Press, 1994) 124.

6. Baker, *Julian,* 124.

7. Two concise summaries of medieval misogyny can be found in Laurie Finke, *Women's Writing in English: Medieval England* (London: Longman, 1999) 12–14, and Joan M. Ferrante, *To the Glory of Her Sex: Women's Roles in the Composition of Medieval Texts* (Bloomington: Indiana University Press, 1997) 4. For a discussion of the particular trope of women as inherently physical (rather than spiritual or intellectual) beings and its relationship to Julian's text, see Nicholas Watson, "'Yf wommen be double naturelly': Remaking 'Woman' in Julian of Norwich's *Revelation of Love,*" *Exemplaria* 8.1 (1996) 6–8, as well as Baker, *Julian,* 123–25.

8. Although a part of my project is to disavow affective knowledge as essentially or nec-

arise out of both the "feminine" sensual and affective path to knowledge, which hinges upon the use of the *intellectus,* and the rational and interpretive understanding prominent throughout the *Showings.*

Affective understanding is inarguably important to Julian's visionary experience, as her visions are explicitly presented as the result of a wish to engage in compassionate identification with Christ. Such identification, she believes, will lead her to a fuller understanding of his passion and of divine grace. In her youth, she writes, she had three desires: first, to experience Christ's passion in her spirit, as a witness; second, to undergo a bodily sickness that would bring her to the point of death; and third, to receive three "wounds": the wound of contrition, the wound of compassion, and the wound of longing for God (ST 1.1–3, 41–42; LT 2.1–4, 34–36). She emphasizes that she only desires the first two gifts if they are in accordance with God's will (ST 1.32–33) and that her wish to see Christ's passion does not mean that she lacks faith in church doctrine:

> Notwithstandinge that I leeved sadlye alle the peynes of Criste as halye kyrke shewes and teches, and also the paintinges of crucifexes that er made be the grace of God aftere the techinge of haly kyrke to the liknes of Cristes passion, als farfurthe as manes witte maye reche—noughtwithstondinge alle this trewe beleve, I desirede a bodilye sight, wharein I might have more knawinge of bodelye paines of oure lorde oure savioure, and of the compassion of oure ladye, and of alle his trewe loverse. . . . (ST 1.9–15)

Her desire is not to generate faith or to be converted as such, for she already believes in the church's teachings. Maria Lichtmann remarks that Julian's wish for a vision is grounded in a conviction that bodily experience will result in a deepened understanding: "Julian seeks to move . . . from faith to experience, from mere belief to vision, and from a doctrinal, second-hand knowledge to her own inner authority. And the passage from an intellectual, non-integral faith to a thoroughly grounded experience is through bodiliness."[9] Lichtmann argues that Julian's theology depends upon the body as a vehicle for divine union with God, and that she "sees her body as the *locus* for spiritual enlightenment."[10] Julian's wishes reflect the body's

essarily "feminine," it is true that, for women, affective visionary experience was generally more available as a means of gaining social and religious authority and visionary knowledge than was other intellectual work. I therefore use "feminine" as indicative of socially constructed expectations and understandings rather than of essential nature.

9. Maria R. Lichtmann, "'I desyrede a bodylye syght': Julian of Norwich and the Body," *Mystics Quarterly* 17 (1991): 14. Lichtmann is using "intellectual" in its modern meaning, not in the sense of the *intellectus.*

10. Ibid., 13.

role in divine union, implying that first-hand, bodily experience will result in a more thorough knowledge of Christ's incarnation. She forms these desires because she wishes to know Christ's passion—not, importantly, because she wishes to believe in it, as she already has "trewe beleve." Julian does not necessarily want to know more; she wants to know *better.* Affective, compassionate experience is the route to the deepened knowledge that she craves.

In the visions that Julian receives, affective experience conveys knowledge in a way that suggests the infusion of divine revelation through the *intellectus.* Her physical suffering is interwoven with visions of Christ's passion, indicating the extent to which experience, coupled with a spirit of devotion, can open the visionary to a greater understanding of the incarnation. Her visions occur during an illness in which her body is paralyzed from the waist downwards and she is thought to be dead or dying. "After this the overe partye of my bodye began to die, as to my felinge. . . . Than wende I sotheley to hafe bene atte the pointe of dede," she writes (ST 2.33–36). In the extremity of her illness, her pain leaves her suddenly and she recalls her third wish, to have "felinge of his [Christ's] blessede passion. . . . For I wolde that his paines ware my paines, with compassion and afterwarde langinge to God" (ST 3.3–4). The suffering brought about by her sickness, apparently in fulfillment of her second wish, initiates the devotional "wounding" desired in the third. This wounding is the compassionate suffering and identification that form the crux of her affective knowledge. Compassionate experience, brought about through the pain of her own illness—which mimetically becomes Christ's pain—is intrinsically linked to a deepened understanding and awareness of Christ's passion. The interdependence of her illness and her unitive experience is summarized by Denise Baker, who argues that Julian's visions help her "to achieve an identification . . . [through] both a physical *imitatio Christi* through the pain of bodily sickness and a psychological participation in his suffering."[11] Sickness and compassionate suffering merge in Julian's visions: focusing on the crucifix brought before her during the reception of the Last Rites, she sees the figure of Jesus begin to bleed from under his crown of thorns (ST 3.10ff). The actual experience of the vision, born out of bodily suffering and generative of compassion, is the affective, physical ground of her visionary knowing.

As her youthful desires suggest, Julian sees compassionate suffering as a means of identifying with Christ's passion and ultimately gaining a greater understanding of theological truth.[12] Her text plays out this dynamic.

11. Baker, *Julian,* 21.

12. Baker argues that Julian's experiences and the sequence in which she undergoes them reflect a more or less standard "program" of affective spirituality and meditation on Christ's wounds that was popularized in England by the Franciscan movement (*Julian,* 23–32).

Julian's compassion for Christ, which is activated through her vision of his suffering body, gives her a greater awareness of the depth of sacrifice represented by the incarnation and crucifixion. This increased awareness is evident in revelation 1, when Julian sees the blood from the crown of thorns pouring over Jesus' face:

> . . . I saw the red bloud trekile downe from under the garlande, hote and freshely, plentuously and lively, right as it was in the time that the garland of thornes was pressed on his blessed head. Right so, both God and man, the same that sufferd for me. I conceived truly and mightly that it was himselfe that shewed it me, without any meane. (LT 4.1–5)

The structure of this passage reveals the prominence of the *intellectus* in her visionary knowing. Following upon the visual description, Julian "truly and mightly" grasps the reality underlying the vision. Her conviction that Christ "himself" is showing it to her and that in him are wed divinity and humanity comes directly out of her visual experience of his suffering. Further, she sees that she herself is implicated in the passion narrative, viscerally appreciating that her salvation is entailed by the crucifixion of Jesus. Affective experience triggers understanding, bringing Julian into a close relationship with the divine and giving her a deeper, felt knowledge of the incarnation.

Beyond simply gaining an appreciation for the reality of the crucifixion, Julian's sensory and affective experience of Christ's suffering and death initiates further insights. Immediately following the passage quoted above, for example, Julian describes how, "in the same shewing, sodeinly the trinity fulfilled my hart most of joy." Through this sudden influx of happiness she "understode [that] it shall be [thus] in heaven without end, to all that shall come ther." The joy of heaven immediately follows the pain of Christ's bleeding, as the drama of suffering and redemption is enacted in Julian's affect, reinforcing the unity of the human Christ and the divine Trinity: "the trinity is our endlesse joy and our blisse, by our lord Jesu Christ and in our lord Jesu Christ. . . . For wher Jhesu appireth the blessed trinity is understand, as to my sight" (LT 4.6–12). In these cases the vision leads to an infusion of knowledge through the *intellectus* by enabling Julian to viscerally identify with the events of Christ's death. Lichtmann terms Julian's emphasis upon the suffering humanity of Christ a "full-blown theology of 'sensualyte.'"[13] "[U]ntil she knows with her body," Lichtmann argues, "she

13. Maria R. Lichtmann, "'God fulfilled my bodye': Body, Self, and God in Julian of Norwich," in *Gender and Text in the Later Middle Ages,* ed. Jane Chance (Gainesville: University Press of Florida, 1996) 263.

will have no basis for knowing Christ at all."[14] Bringing Christ's experience into her body instills in Julian a comprehensive, lived understanding of his passion, granting her a depth of theological knowledge presumably inaccessible to the reason.

While the experience of Christ's suffering grants Julian an understanding that implies the infusion of knowledge through the *intellectus,* however, many of the revelations described in the Long Text are actually understood through the exercise of her *ratio.* Julian's need for a long period of inward reflection guided by divine instruction in order to comprehend her visions presents a model of cogitation as a valid, even necessary, tool in the acquisition of visionary knowledge. Far from being inspired with a ready understanding of what she witnesses in her visions, often Julian must actively work to interpret her revelations in order for their meanings to become clear. The cognitive work in which she engages includes interpreting the symbolic content of her visions and meditating upon and developing that content. These activities, as largely rational processes, indicate Julian's active mental engagement in the comprehension and elucidation of her experience.

The differences between the two versions of the *Showings* most clearly expose the importance of the *ratio* to Julian's visionary knowing. She first recorded her visions in what is known as the Short Text of the *Showings,* and, while the exact date of this text's composition is unknown, we do know that she composed the second version—the significantly expanded Long Text—about twenty years later (LT 51.73).[15] In brief, the Short Text highlights the affective experience of the visions, while the additions included in the Long Text feature her interpretive and cognitive work. The degree to which reflection and interpretation were essential to Julian's understanding is suggested, first, in the fact that she found it necessary to rewrite her text at all, and, second, in the types of changes that she makes in the second version of the *Showings.* The Long Text amplifies many of the explanations of her revelations and adds visual details and even whole episodes. The Parable of the Lord and the Servant, for example, is absent from the Short Text but forms a major part of Julian's soteriology in the Long. Julian omits the parable from the Short Text because, she says, she did not properly under-

14. Ibid., 267.
15. Until recently, it was held that Julian wrote the Short Text in 1373, immediately following her visions. However, Nicholas Watson has argued that the Short Text was actually written significantly later, perhaps as late as 1388 or shortly before that year (Nicholas Watson, "The Composition of Julian of Norwich's *Revelation of Love,*" *Speculum* 68.3 [1993]: 642). While we cannot say for certain when the text was composed, it is possible that Julian reflected upon her visions for some time prior to initially writing them down.

stand it when she first recorded her revelations. It was only after twenty years of meditation and "teching inwardly" that she came to recognize its significance (LT 51.73–4). The existence of the Long Text thus testifies to the role of reflection and interpretation in Julian's visionary knowing.

In other respects, too, the Long Text exhibits a broader perspective upon the visionary experience than would have been possible in the Short Text, when the experience was still relatively new and her concomitant insights had not yet been fully explored.[16] This is superficially reflected in the addition of a table of contents at the beginning of the Long Text and the more frequent cross-referencing between the numbered revelations;[17] in addition, Julian's memory, imagination, and descriptive abilities assume a more prominent role in the later redaction, resulting in the more vivid descriptions of Christ's sufferings in the Long Text.[18] Finally, the greater thematic unity of the visions, in which issues such as the purpose of sin and the prevalence of divine love are repeatedly stressed, suggests that the twenty years between the composition of the Short and the Long Texts were spent in active reflection upon her revelations.

By documenting her interpretive process, the Long Text vividly illustrates the cognitive processes that Julian engaged in as she developed a full understanding of the visions, thereby demonstrating the necessity of supplementing affective visionary experience with reflection and interpretation. The Long Text elaborates a complicated soteriology that seeks to explain the purpose of sin and the implications of the incarnation. In her later text, Julian repeatedly questions God in scenes that are absent from or shorter in the Short Text and actively works out the interpretive difficulties of her visions. The process of amplification and the intellectual development of her visions' content can be seen, for example, in a comparison between the two versions of the third revelation. Both accounts of this revelation begin in roughly the same way, with Julian seeing that God "doth alle that is done," but wondering, "'What is sinne?' For I saw truly that God doth alle

16. Christopher Abbott describes Julian's expansion of the visions into the Long Text as "mak[ing] public theological sense of her private visionary experience" (Christopher Abbott, *Julian of Norwich: Autobiography and Theology* [Rochester: D. S. Brewer, 1997] 7). He attributes the development of a more theologically complex account in the Long Text to a split between Julian's participating and remembering selves. In the Long Text, he writes, "Julian evokes her own passage through a process of spiritual education. The presentation of such a process is predicated on a disjunction between the remembered and the remembering self, the latter understood to have a certain spiritual understanding which enables it to discern patterns of meaning, a grace of interpretation which the remembered self did not have, or not equally" (10–11).

17. For examples of this cross-referencing, see, e.g., LT 10.53, 34.19, 35.15, 52.30–1, 57.45, 77.26.

18. Baker, *Julian,* 55.

thing, be it never so litile" (LT 11.4–5).[19] After this introduction, however, the Short Text contains only a few sentences of explanation, while the Long Text expands for several pages upon the significance of sin's absence from the vision. In the Short Text, Julian remarks on her puzzlement when "it semed to [her] that sinne is nought," concluding, "And I walde no lenger mervelle of this, botte behalde oure lorde, whate he wolde shewe me. And in another time God shewed me whate sine es nakedlye be the selfe, as I shalle telle afterwarde" (ST 8.17–19). In this account, Julian defers the explanation of sin to a later part of the text. In the Long Text, by contrast, although she does, again, defer her full explanation of sin until later (returning to it in revelation 13), she nonetheless lays out her understanding of sin as "no dede," adding that the perception of an act as good or evil comes from humankind's limited comprehension, not from God (LT 11.14–41). While the Short Text is primarily concerned with the documentation of the vision, the Long Text expands upon the theological insight that it provided her.

Julian's analysis of the Parable of the Lord and the Servant most fully reveals the centrality of reflection and interpretation to her visionary process. She does not include the parable in the Short Text, she notes, because she could not "take therein full understanding to my ees in that time" (LT 51.56): her understanding of the parable was incomplete.[20] Along with comprehension came the ability to record and describe her revelation. In a fundamental sense, Julian's vision of the parable was not complete until she had accomplished the cognitive work necessary to understand it; only then could it be written. In fact, Julian's process of comprehension is inscribed into the account of the vision. After relating the parable, she describes her initial ignorance of its meaning and the manner in which she came to understand it:

> And thus in that time [when she received the vision] I stode mekille in unknowinge.[21] For the fulle understanding of this mervelouse example was

19. The wording is virtually identical at ST 8.12–13.

20. One could also surmise that she was apprehensive about including what Brad Peters calls a "powerful critique of her culture's accepted teachings about sin" (Brad Peters, "A Genre Approach to Julian of Norwich's Epistemology," in *Julian of Norwich: A Book of Essays,* ed. Sandra J. McEntire [New York: Garland Publishing, 1998] 141). The parable suggests that Adam's fall into sin was not accomplished through any fault of his, but through love alone. In her comments surrounding the parable's account in the Long Text, however, Julian claims that she did not wish to record a vision whose meaning she did not understand.

21. Baker's edition of the text gives "thre knowynges" instead of "unknowing" (Julian of Norwich, *The Showings of Julian of Norwich,* ed. Denise N. Baker [New York: Norton, 2005], LT 51, p. 72. Watson and Jenkins' notes on this passage point out that the Paris manuscript, on which Baker's edition is based, does indeed read "thre knowynges"; they hypoth-

not geven me in that time, in which misty example the privites of the rev-
elation be yet mekille hid. . . . For twenty yere after the time of the shew-
ing, save thre monthes, I had teching inwardly, as I shall sey: "It longeth to
the to take hede to alle the propertes and the condetions that were shewed
in the example, though the thinke that it be misty and indefferent to thy
sight." (LT 51.58–61, 73–76)

Julian was inwardly guided to observe with utmost attention the details of
her vision, which were to lead to a fuller understanding of its meaning and
significance. She thus returns to the vision in her mind, "seeing inwardly,
with avisement, all the pointes and the propertes that were shewed in the
same time, as ferforth as my wit and my understanding wolde serve" (LT
51.76–8). Careful meditation upon the details of the vision enables Julian
to perceive the allegorical meanings concealed within them; thus, for
example, she pays attention to the way that the lord sits, the servant's posi-
tion with respect to him, the clothes that they both wear, and so forth. Every
attribute of the allegorical personages becomes significant in her interpre-
tive practice. The fact that she includes her reflections upon such details
in the account of her vision underscores the central role that contemplation
plays in the unfolding of her revelations.

Implicit in Julian's account of her interpretive process is the fact that
such interpretation is required to understand the vision—to such an extent
that it becomes, in a sense, a part of the visionary experience itself. The
vision cannot be understood without allegorical exegesis; close attention
to the details of the vision enables Julian to perceive the meanings under-
lying them. On the Lord's response to the servant's fall, for instance, she
writes that "The rewth and the pity of the fader was of the falling of Adam,
which is his most loved creature. The joy and the blisse was of the fall-
ing of his deerwurthy son, which is even with the fader" (LT 51.114–6).
Initially, however, she is not aware of the necessity of performing such
exegetical work. Her ignorance of the vision's meaning prior to beginning
this work implies that she does not know how to approach its signification,
or, indeed, what interpretive practice it requires. Again, it is only with the
divine instruction to carefully consider every characteristic and detail of
the parable that she begins her interpretive process. Yet this process is inex-
tricable from the meaning of the vision itself. Julian states that the vision
has three aspects: "The furst is the beginning of teching that I understode

esize that "perhaps the scribe read 'onknowynge' as 'one knowing' and thought her exemplar
had made a mistake." The Sloane manuscript's use of "unknowing," however, "makes better
sense in context, since the point of the passage as a whole is to stress how slowly Julian
understood the exemplum" (Watson and Jenkins ed., 405n58).

therin in the same time. The secunde is the inwarde lerning that I have understonde therein sithen. The third is alle the hole revelation, fro the beginning to the ende. . . ." Her initial understanding, her later allegorical understanding, and the vision itself are all "propertes" of the revelation. But these properties cannot be separated from one another; they are, she specifies, "so oned . . . that I can not nor may deperte them" (LT 51.64–8). Thus the interpretation of the parable, along with its original significance to her and the sequence of the vision itself, is an essential part of the revelatory experience as a whole. The visionary experience, in other words, does not end with the vision. It is only through sustained cognitive work that its meaning becomes apparent.

As is indicated by Julian's references to "inwarde lerning" and "teching inwardly," the process by which she comes to understand the parable is figured as an internal one. The impetus for this internal process is apparently divine, but the process itself depends upon Julian's paying close attention to, and reflecting upon, the details of the vision. She is instructed to "take hede to alle the propertes and the condetions that were shewed in the example, though the thinke that it be misty and indefferent to thy sight" (51.74–76). She then rehearses mentally "all the pointes and the propertes that were shewed" in the vision (51.77) in order to understand their meaning. The comprehension of the parable that she derives from this process depends in large measure upon her own mental activity. Inspired by God and under his direction, Julian examines each point of the vision until she comes to recognize its allegorical significance.

Julian's questioning of those aspects of her text that seem to her *un*reasonable implicitly associates her analysis of the parable with the *ratio*. Of the servant's ragged kirtle, for instance, she thinks, "This is now an unsemely clothing for the servant that is so heyly loved to stond in before so wurshipful a lord" (LT 51.145–46). In light of the servant's importance to the lord, she finds his clothing unsuitable and is struck by the apparent discrepancy in the vision. Yet later this very discrepancy reveals the greater truth underlying the image: the tattered clothing of the servant represents Adam's fall and, consequently, the humanity of Christ. "By the pore clothing as a laborer, standing nere the left side, is understode the manhode and Adam, with alle the mischefe and febilnesse that foloweth. For in alle this, oure good lorde shewed his owne son and Adam but one man" (LT 51.193–5). The perception of the discrepancy is dependent upon a process of rational deduction: it is unreasonable for a beloved servant to wear indecent clothing; thus, the fact that he is wearing rags indicates that there is a deeper meaning underlying his appearance—a meaning that is one of the cornerstones of Julian's theology.

Despite the apparently orthodox assumption that women's physicality made them largely incapable of rational intellection, then, cognitive work is essential to the understanding of at least some of Julian's revelations, and the value of affective and sensory experience to her visionary knowing does not undercut the importance of such work. For this reason, I do not fully agree with Lichtmann when she argues that Julian "does not identify the person with the strictly rational dimension" and that her text presents "[f]eminine awareness as an alternative way of understanding and engaging reality, as an epistemology . . . [in] her constant recourse to the depth and concreteness of experience."[22] Although Lichtmann's emphasis on the affective and the bodily is apt, her interpretation of Julian's epistemology reiterates the body-mind dichotomy that the *Showings* undercuts. While it is true that Julian's text does return, again and again, to the concrete facts of her experience, her epistemology involves far more than the repetition of that experience. Her understanding of transcendent reality develops out of her experience *alongside* meditation, reflection, and the interrogation of that experience. The Parable of the Lord and the Servant most clearly illustrates this fact, as Julian's subsequent interpretation of her vision, during which she pays minute attention to its details, brings her to an understanding of its meaning that was totally inaccessible to her during the experience of the original showing. That arguably her most significant and controversial theological ideas come out of the parable further supports the importance of intellectual enquiry and reflection to Julian's visionary practice.

II. "And yet I merveyled": Reason's Inadequacy and the Limits of Revelation

Evident in the parable is the interdependence of the *ratio* and the *intellectus*. Repeatedly, Julian is seen to grasp a truth that had been obscure to her in a flash of insight that nonetheless comes out of the reasoning process described above. The knowledge apprehended by the *intellectus* seems to arise simultaneously out of her observations, *ratio,* and divine inspiration. For example, before the realization of the unity of Christ and Adam in the figure of the servant, Julian chronicles a point of uncertainty about the vision:

> And yet I merveyled fro whens the servant came. For I saw in the lord that he hath within himselfe endlesse life and all manner of goodnes, save the

22. Lichtmann, "'God,'" 266.

tresure that was in the erth [and that the servant would henceforth strive
to uncover for his lord]. . . . And I understode not alle what this exampil
ment, and therfore I marveyled from wens the servant came. (LT 51.172–4,
177–8)

Her uncertainty, however, gives way to a sudden flash of insight:

In the servant is comprehended the seconde person of the trinite, and in the
servant is comprehended Adam: that is to sey, all men. And therfore whan
I sey "the sonne," it meneth the godhed . . . and whan I sey "the servant," it
meneth Cristes manhode, which is rightful Adam. (LT 51.179–82)

There is no intervening text between these two passages; from uncertainty
and "marveling" Julian shifts into an authoritative voice, expounding in
definite, unwavering terms what had hitherto been incomprehensible to
her. These passages comprise a striking example of a process that occurs
frequently in Julian's text when she sees or hears something and, from this,
understands a previously obscure truth. Understanding functions in Julian
as *intellegere* functions in Gertrude, but with the difference that the *Show-
ings* also stresses a preliminary process of rational deduction and exegesis.
Julian's work of reasoning through the allegory of her vision has prepared
her for the flash of insight characteristic of revelation. In the case of the
parable, neither *intellectus* nor *ratio* is sufficient on its own: both faculties
must be engaged for Julian to understand her vision in its entirety.

The shift from *ratio* to *intellectus* indicates the limits of reason, the
point where the truth must simply be apprehended. Julian's puzzling over
the meaning of the servant's distance from his lord or the state of his cloth-
ing can lead her no further than she has already come; these details point
to paradoxes and inconsistencies within the rational structure of the vision.
The insight of the *intellectus,* presumably reached with the guidance and
aid of the divine, thus exceeds the limits of rational understanding. The
impossibility of fully understanding God without exceeding these limits is
consonant with Julian's reflections upon reason's inadequacy to behold the
divine in all things. Explaining the cause of humankind's inability to rest
continuously in the "beholding" of God, she writes, "the use of oure reson
is now so blinde, so lowe, and so simple, that we can not know the high,
marvelous wisdom, the might, and the goodnes of the blisseful trinite"
(LT 32.11–13).[23] Divine wisdom simply surpasses the knowable reaches

23. The idea of the *intellectus* as a continual beholding, or resting, is also found in Aqui-
nas (*ST* I: 79.8) and Dante (*Paradiso* XXIX.70–81).

of human reasoning. Without *intellectus,* this wisdom is unattainable, and *ratio* alone cannot lead us to the apprehension of divine truth. But the necessity of the *intellectus* does not diminish the role of the *ratio.* Without the use of her *ratio,* Julian would not have been suitably prepared for her final insights; nor would she be capable of understanding them.

Julian's failure to comprehend—or even describe—the parable prior to undergoing a long period of rational and inspired contemplation underscores the interdependence of these two modes of knowing. This interdependence resonates with an important characteristic of Gertrude's text: divine revelation alone is not always sufficient for understanding. Julian's knowledge is generated in part through cognitive work of her own. That God authorized and initiated this work does not invalidate her intellectual agency; on the contrary, it validates its importance in her understanding of the revelations. Knowing, in Julian's text, is achieved partly through direct divine instruction and partly through her own interpretive, exegetical abilities, as the foregrounding of her analytic process demonstrates. Remarkable for its requirement that Julian interpret her vision as a part of the process of achieving her revelation, the Parable of the Lord and the Servant strongly suggests that cognitive work is a legitimate and, at times, necessary means of comprehending divinely revealed truths. By only being included in the *Showings* after Julian has had the opportunity to meditate at length on its meaning, the parable demonstrates the importance of her own mental activity to the account of her visions: clearly, it is not enough simply to record what she saw.

The foregrounding of Julian herself as the witness to her visions, moreover, highlights the importance of her rational and cognitive faculties even in the moments where she receives knowledge through revelatory insight. Repeatedly in the *Showings,* she frames seeing and knowing as almost a part of the same action, implicating the development of knowledge within the visionary experience. At the beginning of revelation 3, for instance, she writes, "I beheld with avisement, seeing and knowing in that sight that he doth alle that is done" (LT 11.2–3). This blending of perceptual and cognitive actions reflects the process that Julian undergoes in explaining and, indeed, understanding her visions, as her accounts often combine descriptions of the visions with her thoughts about them. For example, a dialogue with Christ is followed by a vision of a three-tiered heaven:

> In this feling, my understanding was lefted uppe into heven, and ther I saw thre hevens. Of which sight I was gretly merveyled, and thought: "I see thre hevens, and alle of the blissed manhed of Criste. And none is more, none is lesse, none is higher, none is lower, but even like in blisse." (LT 22.6–9)

The vision itself is not enough: Julian's observations lead her to the conclusions necessary for her to understand the showing. Julian's text incorporates the sudden illumination of the *intellectus* with the knowledge attained through the exegetical interpretation of her visions.

Of course, such observations can be attributed in part to the minimal perceptual capacities that would seem to be necessary for one to receive a vision in the first place; a hopelessly obtuse visionary, incapable of perceiving even the equality of the three heavens before her, would be of little use to anyone. But Julian's inclusion of herself as observer highlights the importance of the observing faculty. She could have written, simply, that she saw three heavens, of which no one was more nor less, higher nor lower, than the others; instead, however, she focuses on her reactions, her "marveling" and reflecting upon what she sees. In this way, her understanding is stressed almost as much as the vision itself. This is far from the "typical" visionary that Stephen Russell describes, who "generally disappears from his own text . . . the vision has nothing special to do with him—there is ideally no 'him' for the vision to have to do with—but a special communication to the world from God that merely uses this person as a medium."[24] Julian is a medium for God's message, but a medium that changes, adapts, and in part creates the message as it passes through her. By reflecting upon what she sees and then describing the results of that reflection, she emerges as something akin to a co-author of the *Showings* (and of the showings), striving to re-create for her readers both the passive (visual) and active (cognitive) aspects of the experience that she has undergone. This role is also a far cry from that suggested by the idea of woman as aligned with the physical body, incapable of working competently in matters of the intellect.

In Julian's treatment of her sex, in fact, the Long Text suggests that the interval between the production of the short and long versions of the *Showings* gave her a greater degree of confidence in her intellectual abilities. The effacement of gender from the parable of Adam's fall implies

24. J. Stephen Russell, *The English Dream Vision: Anatomy of a Form* (Columbus: The Ohio State University Press, 1988) 48. See also Karen Scott's discussion of Raymond of Capua's representation of Catherine of Siena, which indicates the propensity of at least some medieval writers to figure visionary women as passive vessels filled by God. Scott writes: "Raymond's repeated depiction of Catherine as a 'dead' body and as an empty vessel filled entirely with divine grace was meant to convince his audience that she was indeed a saint. To that end it was more important for him [Raymond of Capua] to show her [Catherine of Siena] in moments worthy of 'admiration' than of 'imitation'" (Karen Scott, "Mystical Death, Bodily Death: Catherine of Siena and Raymond of Capua on the Mystic's Encounter with God," in *Gendered Voices: Medieval Saints and Their Interpreters,* ed. Catherine M. Mooney [Philadelphia: University of Pennsylvania Press, 1999] 143). Raymond's practice clearly has significant implications both for the visionary's agency and the possibility that others might emulate her.

this development as well, corresponding to her disregard for the gendered implications of the intellectual and rational faculties. In the Short Text, Julian's brief apology for writing as a woman implicitly undermines whatever cognitive contribution she may have made to her text. She writes,

> Botte God forbede that ye shulde saye or take it so that I am a techere. For I meene nought so, no I mente nevere so. For I am a woman, lewed, febille, and freylle. Botte I wate wele, this that I saye I hafe it of the shewinge of him that es soverayne techare. . . . Botte for I am a woman shulde I therfore leve that I shulde nought telle yowe the goodenes of God, sine that I sawe in that same time that it is his wille that it be knawen? And that shalle ye welle see in the same matere that folowes after, if itte be welle and trewlye taken. Thane shalle ye sone forgette me that am a wreche, and dose so that I lette yowe nought, and behalde Jhesu that is techare of alle. (ST 6.35–45)

Julian's apology is an acceptance of her society's view that under normal circumstances women should not take it upon themselves to instruct others. Although she expresses the conviction that she should "tell . . . the goodenes of god" despite her sex, she explicitly states that she is not to be taken as a "teacher." Notably, this passage is absent from the later Long Text. In fact, there is in the Long Text no mention of her sex at all. There are several possible reasons for this omission. It could be that, by the time she wrote the Long Text, Julian had enough support from the Church and her community that she did not feel the need to protect herself from the charge of behaving in a manner inappropriate to her sex. It is also possible that the years of divinely sanctioned meditation and cognitive work increased her confidence in her role to the point where she felt certain enough of her message that she chose not to bother with such prefaces. Whatever the reason, the effect of this omission is that the author of the Long Text seems aware of the central role that her powers of interpretation play in the explanation and comprehension of her transcendent knowledge and does not denigrate those powers by apologizing for writing as a woman.

A similar change in Julian's self-presentation is evident in the Short and Long Text descriptions of the three ways that she received her visions and of her role in transcribing them. Late in the Long Text, she explains that her showings came to her in three different guises:

> Alle this blessed teching of oure lorde God was shewde by thre partes: that is to sey, by bodely sight, and by worde formed in mine understanding, and by gostely sighte. For the bodely sighte, I have saide as I sawe, as truly as I can. And for the words, I have saide them right as oure lorde shewde them

me. And for the gostely sight. . . . I am stered to sey more, and God wille
geve me grace. (LT 73.1–6)

The "more" that she is "stered to sey" is her elaboration upon various theo-
logical points that were illuminated for her in the course of her revelations.
The differences between this passage and the corresponding one in the
Short Text indicate a dramatic shift from the Short to the Long Text in terms
of where Julian locates the agency that enables her readers to comprehend
her experiences. The corresponding explanation comes much earlier in the
Short Text, shortly before the account of revelation 3. She writes,

Alle this blissede techinge of oure lorde God was shewed to me in thre
parties: that is, be bodilye sight, and be worde formede in mine understand-
inge, and be gastelye sight. Botte the gastelye sight I maye nought ne can
nought shewe it unto yowe als oponlye and als fullye as I wolde. Botte I
truste in oure lorde God allemighty that he shalle, of his goodnes and for
youre love, make yowe to take it mare gastelye and mare swetly than I can
or maye telle it yowe. And so motte it be, for we are alle one in love. (ST
7.1–7)

In the Long Text, Julian stresses her role in describing the three different
types of vision, noting that some were easier to relate than others and that,
in order to recount the ghostly sights, she must rely to some extent upon
God's grace. She even concedes that she "may nevyr fulle telle" these par-
ticular visions. Nonetheless, the focus is upon her role in producing the text
of her visions and in leading her readers to as full an understanding of them
as she can. In the Short Text, on the other hand, God is responsible for the
reader's understanding her ghostly sights. In this earlier version, she says
merely that she cannot reveal what she understood in these visions as fully
as she would like and surrenders herself—and the reader—to God's will,
hoping that he will illuminate devout readers regarding the substance of
these revelations. In the twenty years between the composition of the Short
and the Long Texts, Julian seems to have realized that her role in elaborat-
ing upon the visions is greater than she originally assumed. Her new role,
moreover, foregrounds her interpretive ability, as she strives to translate the
ephemeral quality of her ghostly visions into comprehensible, communi-
cable language.

Julian plays a major role in her visionary knowing. Her attainment of
knowledge involves the constant engagement of her *intellectus* and *ratio,*
and throughout the *Showings* her moments of inspired understanding are
followed by active questioning and interrogation. As Abbott argues, Julian

"does not merely bask . . . in a delicious state of mystical illumination."
When, for example, she suddenly "see[s] and know[s]" that God "doth alle
that is done" (LT 11.2–3), she follows her revelation with an interroga-
tion of the vision. Notes Abbott, "Beholding stimulates seeking, and her
response to the third showing is a questioning one . . . as she thinks to her-
self, 'What is synne?'"[25] Alternating between *intellectus* and *ratio,* Julian
moves ever closer to knowledge of the divine mysteries. Even the pairing
of these two powers, however, is not sufficient for full understanding. The
faculties of reason and intuitive apprehension are united with the sensual,
bodily experience of Christ's suffering. All of these aspects of her body
and mind work together to allow the fullness of her knowledge to develop.
Julian thus articulates a theory of knowing that melds the corporeal and the
spiritual. This melding enables the affective visions that initiate her rev-
elations and the cognitive processes used to comprehend those visions to
merge into a single process of knowing that includes external and internal,
bodily and "ghostly" experience, mirroring the union of divine and human
in the figure of Christ.

III. Knowing and the Body

Fundamental to Julian's conception of knowing is her view that the physical
and the spiritual are not inherently in opposition. Rather, she sees human-
kind as being made up of two parts, the "higher," which she calls the "sub-
stance," and the "lower," or "sensual." The substance of the soul "never
assented to sinne, ne never shall," while the lower part is subject to the
drives and desires of the flesh (LT 53.9–10). Nicholas Watson argues that
this splitting of the human subject into two parts effectively shifts the blame
for sin from the higher to the lower part, leaving the "substantial" soul
blameless and perfect.[26] But Julian envisions a future perfection in which
the two halves of the human subject will be united in a single, fulfilled
entity. "And thus," she writes, "in our substance we be full and in oure
sensualite we faile; which failing God wille restore and fulfil by werking of
mercy and grace, plentuously flowing into us of his owne kinde goodhede"
(LT 57.6–8). When considered alongside her understanding of sin as the
fault of the inherently fallen "sensual" part of the soul, what emerges is
a simultaneous validation of both aspects of humanity. This point is rein-
forced in the Parable of the Lord and the Servant, where Adam's fall into

25. Abbott, 84.
26. Nicholas Watson, "'Yf wommen be double,'" 20.

sin is accomplished, paradoxically, through love and entails no lessening of God's love for him. While the "substance" is already blameless and perfect, the "sensuality," whose falling is inevitable and therefore effectively blameless, will be itself perfected by God, restoring humankind to an unfallen and sinless state.

Julian's understanding of the corporeal as preordained for union with the spiritual contrasts with the suppression of the physical commonly found in contemplative mysticism. Denise Baker argues that the anchorite's vision of wholeness "reaffirms the original integrity of self, the sacredness of sensuality as well as substance," positing sin "as a division between the two parts of the soul as well as a temporary separation from God."[27] But this is not to say that the corporeal is nothing more than an impediment to leading a devout life prior to its final perfection. By virtue of being the part of Christ that suffered for humanity's salvation (LT 55.38–43), sensuality is naturally imbued with positive and even salvific characteristics. It is the sensual part of the soul that is "grounded in kinde, in mercy, and in grace, which ground ableth us to receive giftes that leed us to endlesse life" (LT 55.18–19). It is impossible to read this passage without recalling Julian's experiences at the beginning of the *Showings,* when her compassionate experience of Christ's suffering and death, along with her illness, prepared the ground for the visions and transcendent knowledge that she henceforth dedicates much of her life to propagating for the benefit of her fellow Christians. Moreover, the fallible flesh that caused Adam to fall into the "ditch" is what enables him to work for God's "treasure" in the soil (and, allegorically, the soul) (LT 51.163–8). Despite its shortcomings, Julian depicts corporeality as a necessary facet of the human soul's movement towards the divine.

Rather than positing corporeality as irrevocably averse to visionary knowing, then, Julian shows the two working together, ultimately leading to a fuller understanding of Christ's incarnation and the other theological insights that she gains through her visionary and meditative experiences. Julian's visionary knowing relies upon a constant movement of interpretation that not only concerns the divine content of her visions but that also returns to the physical experience that prompted those visions. In the Long Text of the *Showings,* the constant circling back to the original bodily visions and experience of Christ's suffering highlights the interdependence of corporeality and theological insight in Julian's visionary knowing.

Julian's use of the techniques of *lectio divina* is an emblem of the interdependence of the corporeal and the abstract, the affective and the rational, in her visionary knowing. *Lectio divina* is clearly important to her under-

27. Baker, *Julian,* 130–31.

standing of her visions;[28] the fact that the visions are not literally "read" is unimportant. Julian returns again and again to the "text" of the visions, constantly seeking a greater comprehension of them. Re-visualizing the visions, repeating Christ's words to herself, and expanding upon the meanings of those words leads the anchorite to an ever-deepening knowledge of their meanings. Her deepened understanding of the content of the visions can be seen in her amplifications of Christ's message, as in the following passage:

> And with this same chere of mirth and joy, our good lord loked downe on the right side, and brought to my minde where our lady stode in the time of his passion, and said: "Wilt thou see her?" And in this swete word, as if he had said: "I wot welle that thou wilt se my blessed mother, for after myselfe she is the highest joy that I might shewe the, and most liking and worshipe to me. And most she is desired to be seen of alle my blessed creatures."
> (LT 25.1–6)

Expanding Christ's locutions with the phrase "as if he said," Julian moves beyond the superficial text of her visions to penetrate the mysteries lying within. The "as if" functions dually, attributing the new words to Christ while distinguishing them from what he actually said. Peters calls these additions "rejoinders," noting that such phrases lead to the practice of *lectio divina*. Julian's *lectio*, he argues, is grounded in the "dialectical principle" of her converse with Christ and "helps Julian systematically to expand the rejoinders, allowing her to explore ever more profoundly the knowledge that Christ imparts to her."[29] The insight of the *intellectus*, the progression of dialogue and *ratio*, and meditation upon the effects of both are thereby wedded in Julian's visionary knowing.

The process of *lectio* has the further effect of implicating Julian's body into the visionary process. As I noted in the previous chapter, *lectio divina* is often described as a physical process that impresses the sacred text upon the mechanisms of the body, resulting in "a muscular memory of the words pronounced."[30] Furthermore, *lectio* helps the reader or speaker to internalize the text, bringing it into a kind of somatic relationship with the body. Joan Nuth elaborates upon the internalizing effect of Julian's meditations upon the showings:

28. See Edmund Colledge and James Walsh, "Introduction," in *A Book of Showings to the Anchoress Julian of Norwich,* ed. Colledge and Walsh, vol. 1 (Toronto: Pontifical Institute of Medieval Studies, 1978) 131–32.
29. Peters, 129.
30. Jean Leclercq, *The Love of Learning and the Desire for God,* trans. Catherine Misrah (New York: Fordham University Press, 1962) 78.

In the context of prayer, Julian returns over and over again to the images and words of her revelations[,] allowing them to become part of her, through the memorization of detail that characterizes the *meditatio,* and through the relishing of the sudden insights given her in moments of contemplation.[31]

To appreciate the physical implications of this practice, we must remember that Julian's visions are, for the most part, overwhelmingly about Christ's incarnation and his fleshliness; moreover, they were prompted by a physical illness. Returning to the visions again and again, Julian is not simply recalling the messages that she received, but the whole visionary experience. By continually circling back to the original experience of the sickness and visions, the anchorite maintains the primacy of the physical aspects of her experience as a means of meditating upon and delving into their meanings. Physicality is inextricable from the cognitive processes that are nonetheless necessary for her attainment of transcendent knowledge. For Julian, analytic reflection and interpretation, the cognitive work that gives rise to the fullest understanding of her visions, are interdependent with physicality. In the Long Text, affective and rational mysticism—*intellectus* and *ratio*—converge, creating a synthesis that gives rise to a fundamentally altered understanding of Christ's incarnation and of theology.

The treatment of Julian's cognitive processes in the *Showings* demonstrates her ability to interpret and explain her visions, and her interpretive and cognitive work is ultimately a part of her visionary experience. Julian's concern with re-creating her revelations for the benefit of her "even Christians" reinforces the usefulness of her path to transcendent understanding, and that path includes reflecting upon her visions as well as the visions themselves. By describing the process by which she came to understand her visions—inscribing it into her account of them—she emphasizes the utility of this process for the reader or auditor who seeks the same knowledge that Julian has acquired. In its totality, the visionary experience is both the reception of the visions and the process of meditating upon and coming to understand them. Julian thus expresses the conviction that intellectual and cognitive processes are an essential aspect of visionary knowing. In so doing, she emerges as an active participant in the generation of her revelatory knowledge and as a striking counter-example to the image of the visionary as a passive recipient of divine knowledge.

31. Joan M. Nuth, *Wisdom's Daughter: The Theology of Julian of Norwich* (New York: Crossroad, 1991) 38.

THE *SHOWINGS* illustrates Julian's ability to bring her rational and inter-pretive abilities to bear upon the content of her visionary experience, as she employs both affective and intellectual means of understanding the vision's message. Her use of her rational faculties, however, is divinely sanctioned: God instructs her to meditate upon the content of her visions, and the "inward teaching" that she receives during her reflections upon the Parable of the Lord and the Servant imply that divine guidance has helped her to understand its content. Moreover, the visions themselves are precipitated by an illness—a much-desired illness—that enables her to identify affec-tively with Christ as she experiences his sufferings mimetically in her own body. In chapter 3, I argued that Gertrude of Helfta's volitional union with Christ forms the basis for her visions; it is the union of her will with that of the divine that validates her intellect and enables her to arrive at an under-standing of God's mysteries through reflection and meditation. Likewise, Marguerite d'Oingt's prayer for understanding—her acknowledgment that she needs God's help to understand the meaning of *vehemens*—indicates that submitting herself to the divine is requisite for her visionary knowing. In much the same way, Julian's physical and affective union with Christ is what permits her visionary experience to occur. In short, none of these three visionaries exercises her cognitive faculties upon divine matters out of nowhere. All of them express a union with God and receive validation of their reflection and reasoning.

These three chapters illustrate a mode of visionary knowing that was available to women in the later Middle Ages. The writings of Marguerite, Gertrude, Julian work within the same basic understanding of the vision and its ability to convey knowledge. Their diversity—of geographic origin, intent, audience, and even temporality (Julian having written rather later than Gertrude or Marguerite)—suggests a continuity in medieval concep-tions of the vision despite obvious differences between particular visionary texts. These texts also indicate that the vision provided a space in which medieval women could—and, at times, had to—engage in a discourse that reflects the philosophical discourses of their time. Julian's text perhaps best exemplifies the union of affective and intellectual visionary modes, dem-onstrating the congruence of bodily and rational knowing; both Gertrude and Marguerite, however, also illustrate the possibility that visions with a strong physical or affective element were not adverse to reason and medita-tive contemplation. The gendered assumptions about knowing, reason, and the body are complicated and even challenged by these three texts, whose very diversity suggests a deeper complexity regarding such issues in later medieval Europe.

In the next few chapters, I will change tack. Where I have hitherto read the works of three fairly different visionary women from different contexts, I will consider a much narrower range of works: three male-authored dream vision poems all written in England at the end of the fourteenth century. These three poems demonstrate a remarkable similarity in their interrogation of the vision's viability as a source of knowledge, although each takes a different approach to this issue. What I would like to suggest is that, while a definable account of what went into visionary knowing seems to have circulated within mystical vision texts of the late Middle Ages both on the Continent and in England, something starts to happen to the vision in late medieval England. In the epilogue, I will discuss some of the possible reasons for the troubled status of the vision in these English poems. The next three works, however, and *The Book of Margery Kempe,* which I discuss in chapter 8, stand apart from these vision texts in the uncertain stance that they take on the vision's efficacy. And yet the version of the vision that they critique shares many characteristics with the women's visionary texts discussed in these last three chapters. What all of this suggests is the extent to which some medieval women—typically thought to have been excluded from dominant discourses—actively participated in a tradition of vision writing of which these English poets were aware and to which they responded in their dream poetry.

In the next two chapters, I turn to dream vision poems that depict dreamers who struggle with their visions of the divine. *Pearl,* the subject of chapter 5, features a dreamer who does not particularly want a divine vision; his interest is in the dead maiden who attempts to turn his attention from her towards God. Her success in deflecting him away from the worldly desire for reunion with her physical being and towards the beatific vision of Christ has been much debated. Reading *Pearl* as a response to the visionary tradition, however, offers some insight into the reasons for the Maiden's merely partial success. In chapter 6 I turn to *Piers Plowman,* which depicts a dreamer named Will who actively desires an affective, intuitive knowledge of Christ, but cannot seem to achieve it. Unlike the *Pearl*-dreamer, who does not particularly want a vision of God, Will goes to great (if occasionally misguided) lengths throughout his dreams to witness and understand the divine. But despite the dreamer's intentions, the ending of *Piers,* too, is the subject of controversy, as it is ultimately unclear whether Will ever achieves the knowledge that he seeks. What these two poems have in common is the ambiguity of their visions' conclusions. And the basis of that ambiguity, I will argue, is the dreamers' lack of preparation for their visionary experiences. Unlike Marguerite, Gertrude, and Julian, who all receive some kind of divine sanctioning for their quests for knowledge,

Will and the *Pearl*-dreamer are singularly unprepared. The *Pearl*-dreamer is still obsessed with the dead Maiden and actively resists seeing his vision as pertaining to the divine, while Will is—among other things—mistaken in his fundamental approach to Christ, whom (despite his protestations) he attempts to know rationally rather than by turning inwards to examine his own conscience and behavior.

Dream visions, then, have the capacity to show us visionaries who are *not* equipped to engage appropriately with their visions. Their fictionality means that their authors are free to represent hapless and misguided dreamers whose paths to visionary knowing are troubled and confused, but who nonetheless persist in their efforts to understand their visions. In their depictions of troubled dreamers, moreover, *Pearl* and *Piers Plowman* also indicate the importance of active engagement with the visionary experience. The reason that Will and the *Pearl*-dreamer run into such trouble is that they do not know the proper way to engage with their visions. Merely witnessing the vision is not enough; neither dreamer is simply imbued with knowledge. Instead, their minds actually get in the way, as when the *Pearl*-dreamer tries to rewrite the Maiden's message in material and worldly terms and Will argues bitterly with Scripture. These texts, then, demonstrate the importance of the visionary's active cognitive and interpretive work. When that work is misguided, they suggest, the vision can go wrong—leaving the visionary unsettled, confused, and perhaps no closer to God. These misguided dreamers demonstrate the possibility that the visionary knowing practiced by Marguerite, Gertrude, and Julian might fail.

5

Worldly Attachment
and Visionary Resistance in *Pearl*

HE CONCLUSION of the fourteenth-century English dream poem *Pearl* has long been something of a puzzle. Critics are divided on the question of whether the dreaming Jeweler— who has been described both as "hopelessly literal-minded"[1] and as an "Everyman" whose difficulties mirror the human mind's inability to comprehend the divine[2]—achieves a real spiritual transformation at the end of his vision. The expectation that the dreamer will undergo such a transformation comes from our understanding of how dream visions work. As Margaret Bridges remarks, the anticipated closure brought about by the dream, be it "love's consummation" in the love vision or the "mystic marriage to the Lamb" in the apocalyptic, is usually "the cue for the dreamer . . . to wake to the reality of the initial setting."[3] Whether we read *Pearl* as a religious vision or, as some have suggested, as a love vision, its expected closure seems thwarted: the poem's troubled dreamer neither achieves union with Christ nor manages to rejoin his love, the Pearl-Maiden.[4] After the dreamer awakens, instead of the unitive experience that we might anticipate,

1. A. C. Spearing, *The Gawain-Poet* (Cambridge: Cambridge University Press, 1970) 152. Spearing has since revised his view, but he remarks that such rather judgmental language was commonly used against the dreamer in earlier criticism of the poem (A. C. Spearing, *Textual Subjectivity: The Encoding of Subjectivity in Medieval Narratives and Lyrics* [Oxford: Oxford University Press, 2005] 160).

2. Theodore Bogdanos, *Pearl: Image of the Ineffable. A Study in Medieval Poetic Symbolism* (University Park, PA: Pennsylvania State University Press, 1983) 94.

3. Margaret Bridges, "The Sense of an Ending: The Case of the Dream-Vision," *Dutch Quarterly Review* 14 (1994): 83. Similarly, Denise Despres agrees that *Pearl* resists the expectations built into its genre; she cites the dreamer's "exasperatingly" literal attitude as the source of readers' frustration (Denise Despres, *Ghostly Sights: Visual Meditation in Late-Medieval Literature* [Norman, OK: Pilgrim Books, 1989] 104).

4. A summary of readings of the poem that postulate a romantic or sexual relationship between the Jeweler and the Maiden can be found in Jane Beal, "The Pearl-Maiden's Two Lovers," *Studies in Philology* 100.1 (2003): 1–21.

the dreamer's acceptance of his consignment to the sublunary world seems little more than a resigned acquiescence to God's law. The tenor of his return to the waking world stands in marked contrast to the edifying joy depicted in most purportedly authentic visionary texts or to Dante's euphoric vision at the end of *Paradiso.*

To read *Pearl* with the expectation that it will show the dreamer achieving *unio Christi,* however, may not be appropriate. While the poem is plainly focused upon the Jeweler's encounter with a representative of the divine, it also echoes the conventions of secular love visions, and its treatment of the mystical component of the vision is accordingly ambiguous.[5] The Jeweler is not, in fact, unequivocally invited into a unitive experience of the divine; the Maiden is encouraging him to surrender to God's will, and their dialogue concerns his difficulty in comprehending and accepting her message. Understood thus, the apparent limitations of the dreamer's visionary experience are not a failure of the poem, but rather the poem's point. Instead of focusing upon what message the dreamer "should have" received from the Maiden—a reading that underscores his shortcomings and implies that a vision "fails" if the dreamer is not converted to the point of view of his otherworldly interlocutor—I will argue in this chapter that the poem stresses the limitations on visionary understanding inherent in the human mind itself. *Pearl*'s primary concern is not the heavenly vision, but rather the difficulty of transcending worldly attachment in order to gain knowledge of the divine.

Pearl thematizes a major theological issue of its time: the incompatibility of human love and total absorption in Christ. Roughly contemporary theological writings, such as *The Cloud of Unknowing,* Meister Eckhart's sermons, and Gertrude of Helfta's *Legatus,* make it clear that to obtain divine knowledge (and, eventually, union) one must subordinate all merely human loves to the love for God. This stricture has its origins in Biblical tradition and is elaborated in Augustine's *De Doctrina Christiana,* a work that was highly influential throughout the Middle Ages. But although mystics such as Gertrude are shown to have hearts unfettered by the bonds of mortal attachment, *Pearl* suggests that the ordinary layperson cannot easily renounce such human loves—even at the bidding of a heavenly messenger. The Jeweler's unwillingness to abandon his love for the Maiden— his persistent attachment to her physical form—illustrates the difficulty of

5. See María Bullón-Fernández, who argues that *Pearl* is characterized by the fusion of mystical and courtly love and that romance and religion cannot be separated in the poem (María Bullón-Fernández, "'By3ond þe Water': Courtly and Religious Desire in *Pearl,*" *Studies in Philology* 91.1 [1994]: 37).

following this injunction. Through the opposing figures of the Jeweler and the Maiden, *Pearl* dramatizes both the importance of renouncing worldly attachment and the near impossibility of doing so. The poem thus questions revelation's ability to instill knowledge, as the Jeweler's revelatory experience does more to illustrate the obstacles in the way of his visionary knowing than to clarify the Maiden's transcendent message.

To compare *Pearl* to the *Commedia,* then, is not really apt. Where Dante's poem presents the reader with a vision of heaven, *Pearl* is concerned with the obstacles that our all-too-human will and affections place in the way of visionary knowing. This argument does not, however, depend upon the *Pearl*-poet's having known the visionary and mystical works mentioned above. The concern with non-attachment evident in these texts—and in late medieval mystical literature more generally—indicates a widespread understanding of worldly renunciation as an essential step on the way to knowledge of the divine and as a key component of visionary knowing. Reading *Pearl* alongside visionary literature of the period, as a work that interprets and comments on the standards of that literature, illuminates both the Jeweler's situation and the outcome of his vision. Rather than concerning itself exclusively with the success or failure of the dreamer's transformation, *Pearl* exposes the limits of such a transformation's possibility. The Jeweler's revelatory experience leads to a conversion that is only partial and does more to illuminate the obstacles in the way of his visionary knowing than to illuminate the Maiden's transcendent message. The poem thus articulates a response to the necessity of mystical non-attachment by illustrating the obstacles to knowing that arise from the dreamer's love for the Maiden.

The likelihood that the Jeweler's love for the Maiden is familial rather than sexual is significant. As we saw in chapter 1, *Le Roman de la rose* illustrates the capacity of lust to lead the dreamer away from reason and the potentially edifying effects of the vision, but this is not obviously the problem in *Pearl*. The precise nature of the relationship between the Jeweler and the Maiden has been a source of debate since at least the nineteenth century, and I have no hopes of resolving the issue here. Like many readers, however, I favor the view that their relationship is a family connection and that they are probably father and daughter. The relationship between the two characters is couched in familial terms—she is "nerre þen aunte or nece" (233)—and the girl seems to be quite young—she "lyfed not two ʒer in oure þede" (483).[6] While these passages have been used in arguments

6. All references to *Pearl* are from Malcolm Andrew and Ronald Waldron, eds., *The Poems of the Pearl Manuscript: Pearl, Cleanness, Patience, Sir Gawain and the Green Knight* (Berkeley: University of California Press, 1979) 52–110. References to the poem appear in

both for and against the Maiden's familial relationship to the dreamer, most critics agree that the Maiden is most likely a child, and probably the child of the dreamer;[7] there is little strong evidence to suggest that the Maiden is the Jeweler's lover or wife.[8] Centering the text upon a filial relationship allows the poet to explore the way that attachment to another person can obstruct the dreamer's relationship with the divine without implicating the problem of sexual love. The poem thus indicates that even a seemingly benign attachment can impede visionary knowing, as a father's love for his daughter inhibits his ability to surrender to the divine will. Nevertheless, the Jeweler's love for the Maiden and his concomitant attachment to the material reality of her body ultimately inhibit his visionary capability, as his unwillingness to renounce his desire for her physical presence prevents him from realizing—or even desiring—a unitive experience of the divine. His desires are therefore in conflict with the Maiden's wish that he abandon his grief over her death and surrender himself to Christ. The poem exposes this conflict in the dreamer's word play, which reveals his determination to keep the Maiden at the center of his dream by reconfiguring the terms of her discourse. In this chapter, I will first analyze the dreamer's attachment to materiality and its reflection in his linguistic play. I will then argue that, in its exploration of the conflict between worldly renunciation and visionary experience, *Pearl* presents a response to mystical texts such as Gertrude's *Legatus,* Eckhart's writings, and *The Cloud of Unknowing,* all of which stress the incompatibility of earthly love and divine union.

the text parenthetically by line number.

7. More recently, Lynn Staley has raised the question of whether the Maiden is actually dead, arguing that she may represent a girl who has entered a convent and that the poem commemorates her death to the world rather than her literal death (Lynn Staley, "*Pearl* and the Contingencies of Love and Piety," in *Medieval Literature and Historical Inquiry: Essays in Honor of Derek Pearsall,* ed. David Aers [Cambridge: D. S. Brewer, 2000] 83–114). Even if she is only figuratively dead, however, she is as fully removed from her earthly existence as though she had died.

8. The most commonly accepted interpretation of the Jeweler's relationship to the Maiden is that he is the girl's father. Jane Beal ("The Pearl-Maiden's Two Lovers") and Mother Angela Carson ("Aspects of Elegy in the Middle English *Pearl*," *Studies in Philology* 62 [1965]: 17–27) argue that the Maiden is the dreamer's beloved, but few critics adhere to this view. Other interpretations have included the theories that the Maiden is an illegitimate child or a "heathen" bride who converted to Christianity two years before her death; criticizing these speculations, René Wellek argues that they "cannot be deduced" from the text (René Wellek, "The *Pearl:* An Interpretation of the Middle English Poem," in *'Sir Gawain' and 'Pearl': Critical Essays,* ed. Robert J. Blanch [Bloomington: Indiana University Press, 1966] 21). While the question is not definitively resolved, the father-daughter reading is generally accepted as the most plausible.

I. Materiality, Desire, and the Limits of Reason

The Jeweler's vision functions dually: it is intended to correct his percep-
tion that the Maiden is lost and also to instruct him in the importance of
abandoning his grief and believing faithfully in God's justice. The vision
itself is *not* the site of a mystical union, as it becomes evident that the
Jeweler will not be able to remain in the heavenly garden while he is alive:
"Þur3 drwry deth boz vch man dreue, / Er ouer þys dam hym Dry3tyn
deme," the Maiden says (323–24). But the vision does seek to alter his
relationship with the divine. When the Maiden enjoins him to "forsake þe
worlde wode" (743), she is entreating him to demonstrate "a willingness
to live in uncertainties and darkness,"[9] accepting his distance from her and
thereby assenting to God's will. Yet the Maiden also emphasizes the impor-
tance of the Jeweler's renouncing worldly attachment. Her advice resonates
with the *Cloud*-author's instruction to "put a cloude of for3etyng bineþ
þee, bitwix þee & alle þe cretures þat euer ben maad."[10] Only by leaving
behind—indeed, forgetting—all created beings can one hope to attain true
love for and knowledge of God. Similarly, the Jeweler is called to engage
in a gradual movement towards the divine by leaving behind his attachment
to worldly love-objects and living more fully a life of faith and renuncia-
tion.

The Jeweler's difficulty in understanding the Maiden's message can
be seen as a conflict between educative and revelatory modes of visionary
understanding, both of which are apparent in the poem. This conflict reveals
the limits of the *ratio* in comprehending divine truth, but also presents the
ratio as a rhetorical tool that the dreamer can use against his visionary
interlocutor. By adhering to a debate structure that is inconsonant with the
revelatory aspect of the vision, the Jeweler resists those sides of the Maid-
en's message that do not cohere with his desires. Yet the vision is clearly
revelatory. The conclusion of the poem depends upon a revelatory moment:
the sudden unveiling of the kingdom of heaven and the apocalyptic vision
of the Lamb surrounded by his adoring brides, images that are drawn from
Revelations. This is the part of the vision that has a significant emotional
impact on the dreamer; the "gret delyt" that overwhelms him as he watches
the procession of the Lamb (1128) contrasts with his intellectual grappling
with the Maiden's earlier speeches. Despite his resistance, the glimpse of

9. J. Allen Mitchell, "The Middle English *Pearl:* Figuring the Unfigurable," *The Chau-
cer Review* 35.1 (2000): 96.

10. Phyllis Hodgson, ed., *The Cloud of Unknowing and the Book of Privy Counseling,*
EETS, vol. 218 (London: Oxford University Press, 1944) 24. All quotations from the *Cloud*
are from this edition.

the heavenly city transforms him emotionally in a way that her discourse does not. The contrast between these two modes of instruction reflects the differences between educative visions that rely upon the *ratio* and revelatory visions that lead to a sudden understanding and are characterized by the use of the *intellectus*. The poem's culmination in a revelatory moment that prompts the climax of the narrative reinforces revelation's presumed effectiveness as a means of immediately transforming the dreamer in contrast to the earlier, instructive passages.

The revelation is disrupted, however, by the Jeweler's insistence upon the vision's confirming his own desire for the Maiden's presence rather than upon the lesson that she intends him to learn. Up until the revelatory moment, the poem is largely didactic, with the dreamer arguing with the Maiden over various points of Christian eschatology. This didactic section of the narrative focuses on an educative mode of visionary instruction that bears a structural resemblance to Boethius's *De Consolatione*. First, the appearance of a consoling figure of authority in the dreamer's moment of distress recalls the arrival of Lady Philosophy;[11] the poem also draws on Boethian models, Michael Cherniss argues, in the central place that it accords to the narratorial consciousness. Because the poem is centered upon the narrator's consciousness, Cherniss asserts, following the Jeweler's development is essential if we are to grasp the meaning of the poem as a whole.[12] In other words, we cannot understand *Pearl* without understanding the Jeweler—at least, insofar as any changes in his perception and character are revealed to us through the first-person narrative. Both Cherniss and Kathryn Lynch take Boethius' text as the prototypical dream vision, and *Pearl* at least superficially conforms to the Boethian model in its use of the first person, the presence of a single figure of authority, and the frame story of a narrator who is initially distressed by a psychological problem but who is "cured" through the experience of the dream. While the narrator of *Pearl* bears a surface relationship to the protagonist of *De Consolatione,* however, he does not fit neatly into this model. Most importantly, his development is not linear and does not culminate in a true understanding of the vision's lesson.[13] Gregory Roper notes that the dreamer slips back into sin almost immediately following the penance performed in his dream; *Pearl,* Ropes argues, shows "what happens *after* the sinner emerges from confession."[14] While there is some critical dispute regarding whether the

11. Michael D. Cherniss, *Boethian Apocalypse: Studies in Middle English Vision Poetry* (Norman, OK: Pilgrim Books, 1987) 151.

12. Ibid., 157.

13. Ibid., 163.

14. Gregory Roper, "*Pearl,* Penitence, and the Recovery of the Self," *The Chaucer Review* 28.2 (1993): 179.

Jeweler does in fact fall short of a full understanding of his vision, nearly all critics seem to agree that the ending is ambiguous and that the Jeweler's path to visionary knowing is anything but straightforward.[15] In contrast, the narrator of *De Consolatione* follows a clear, well-ordered philosophical trajectory, progressing through a structured and linear argument to achieve the knowledge towards which Lady Philosophy wishes to guide him. But the Jeweler appears to misunderstand the Maiden's words (e.g. 744, 780), accuses her of exaggeration and falsehood (e.g. 423–44, 471–74), and argues that her claims are "vnresounable" (590). While the broad outlines of *Pearl* parallel those of a Boethian dream vision whose narrator attains the desired level of understanding, within those parameters it troubles the ascent to knowledge by foregrounding a narrator who cannot seem to keep to the path laid before him by his visionary guide.

The Jeweler's problem is not thick-headedness, however, but an unwillingness to let go of his attachment to the girl he loves. His difficulty in achieving the spiritual transformation desired by the Maiden is not the result of her message's obscurity or of his inability to comprehend it but of his refusal to accept her terms. Throughout the poem, he resists moving beyond the material being of his daughter and renouncing the world in favor of divine union, and his unwillingness is reflected in his insistence upon regarding the Maiden's argument in secular, worldly terms. The Jeweler reframes the Maiden's words, which she intends to signify heavenly matters, so that they refer only to their earthly meanings: to borrow Augustine's phrase, he is "enslaved under signs," unwilling to move beyond the literal signification of the words that she utters.[16] Far from being incapable

15. To cite just a few examples of critics on both sides: Cherniss argues that the dreamer achieves at least some measure of enlightenment by the end of his vision, characterized by a "new mood . . . of positive resignation rather than despair" (162). More optimistically, Jane Chance states that "The 'vision' *has* educated the dreamer away from his literalism: he understands *figura*, a non-literal sign, in the communion wafer as pearl" (Jane Chance, "Allegory and Structure in *Pearl:* The Four Senses of the *Ars Praedicandi* and Fourteenth-Century Homiletic Poetry," in *Text and Matter: New Critical Perspectives of the* Pearl-*Poet,* ed. Robert J. Blanch, Miriam Youngerman, and Julian N. Wasserman [Troy, NY: Whitston Publishing Company, 1991] 48). On the other side of the debate, Steven Kruger declares that the dreamer's "naïve, uncomprehending questions prevent the poem from ever fully transcending earthly perspectives" (Steven F. Kruger, *Dreaming in the Middle Ages* [Cambridge: Cambridge University Press, 1992] 129). Spearing feels that the dreamer is changed by his vision, but that the change is "precarious" (*Gawain-Poet,* 168), and Bridges sees the poem's ending as "pervaded by a feeling of disappointment and loss" due to the dreamer's "frustration that the vision was so incomplete" (86–87). Bullón-Fernández puts this perspective bluntly: by the end of the vision, "the dreamer has not learned much" (48).

16. Augustine, *Teaching Christianity (De Doctrina Christiana),* trans. Edmund Hill, The Works of Saint Augistine: A Translation for the 21st Century, vol. I.11 (Hyde Park, NY: New City Press, 1996) III.9.13.

of recognizing figurative language, however, the Jeweler insistently misunderstands her lessons, reinterpreting her words so that they refer back to the reality that he prefers—the reality in which he can enjoy the living presence of his daughter. Both of these behaviors stem from his affectionate attachment to the Maiden, which binds his heart and prevents him from dedicating himself fully to Christ. These traits are an impediment to the visionary process; fundamentally, it is his attachment to a material form—the living Maiden—that prevents him from comprehending the salvific message of his vision. The Jeweler's grappling with these obstacles is the overriding concern of *Pearl,* and their merely provisional resolution at the end of the poem reflects the difficulties of that struggle.

The Jeweler's commitment to the workings of the sublunary world and his reliance upon rational argumentation indicate his attachment to the Maiden as a living, physical being. Throughout much of the poem, he implicitly privileges what is reasonable in *this* world, and this inhibits his ability to understand either the salvific message of his vision or the Maiden's current status in Heaven. By insisting on understanding the Maiden's lessons in earthly terms and maintaining a narrow view of the signifying possibilities of her speech, he strives to situate her within the worldly realm. His constant recourse to earthly reasoning, perception, and mores signifies his refusal to grasp her transcendent message.

The Jeweler's insistence on material perception and worldly reasoning is pointed out, in fact, before he even has a chance to act on it. The Maiden notes his perceptual problem and develops its implications early in the poem when she articulates three errors in the Jeweler's understanding (291–99). The first of these, that he "leuez noþynk bot [he] hit sy3e[s]" (308), or that he depends too much upon his senses, explicitly accuses him of excessive reliance upon material evidence in the discernment of divine truth. To require the testimony of the senses for belief, she adds, is a

> . . . poynt o sorquydry3e,
> Þat vche god mon may euel byseme,
> To leue no tale be true to try3e
> Bot þat hys one skyl may dem. (309–312)

The Maiden conflates sight and "skill," or the ability to reason. By relying upon the evidence of his eyes, she suggests, the Jeweler is also relying on his mental faculties and refusing to consider that some truths might lie beyond his sensory and rational discernment. In other words, he has too much confidence in his rational capabilities, and depending too much on one's own reason is, in effect, the sin of pride. In the passage above, the Maiden is

quite clear in her condemnation of those who would depend on their reason alone to tell them what is true. Though this is just one of the three ways in which the Jeweler has erred in his speech, it is the first, suggesting that it lies at the root of his later inability to understand the lessons that she would impart to him. Its primacy underscores the fallacy of adhering too closely to human understanding and perception. Like Gertrude in the *Legatus,* the Maiden is skeptical of the faculties' ability to discern transcendent truth without the assistance of the divine, suggesting that revelation will be necessary for the dreamer to truly understand his vision.

In spite of the Maiden's warnings, however, the Jeweler persists in using *ratio* in his attempts to understand his vision, and this can be seen in his insistence upon worldly standards in his interpretation of the Maiden's speech. When he argues that the Maiden's share of heavenly bliss is too great, for instance, he calls her position in Heaven "vnresounable" (590), highlighting the disharmony between divine rule and what passes for reasonable in the mortal world. Despite her lengthy disquisition on the parable of the vineyard, the Jeweler protests that two lines from the Psalter contradict all of her explanation (595–96) and implies that, moreover, the proposition that "þe lasse in werke to take more able, / And euer þe lenger þe lasse þe more" (599–600) is frankly unjust. His inability to transcend his worldly understanding of justice and merit prohibits him from grasping the workings of divine reward. What appears materially unfair to him—that a man who works for only an hour should be paid as much as one who has worked all day—cannot, as far as he is able to judge, have any deeper allegorical meaning or justice; his logic remains bound to a narrow set of assumptions that are grounded in the rules of human society. This disagreement between the Maiden and the Jeweler suggests that a commitment to mortal standards can prohibit the individual from recognizing those truths that lie beyond the human sphere.

The dreamer's insistence upon interpreting the Maiden's parable in terms of earthly justice enables him to continue conceiving of the dead girl in worldly terms and is thus an aspect of his attachment to her physical being. In applying earthly logic to the parable of the vineyard, he is refusing, one could argue, to encounter the transcendent meanings offered by the Maiden—thereby effectively refusing to see her as having moved beyond the worldly realm. Such an interpretation of this passage is tricky, however, as various other interpretations also suggest themselves; for example, it seems at least as likely (if not more so) that this part of their dialogue is used to highlight the differences between divine and human justice and to point out the incomprehensibility of the divine. Moreover, the apparent

conflict between the vineyard parable and the passage from the Psalms quoted by the Jeweler ("Þou quytez vchon as hys desserte, / Þou hy3e Kyng ay pertermynable," 595–96) underscores a very real doctrinal conflict and is pertinent to the debate over whether works are necessary for the soul to reach heaven—a question that is central to the Maiden's dialogue with the dreamer. Thus, the example of the parable cannot be used conclusively to demonstrate the dreamer's desire to re-inscribe the Maiden within the worldly sphere.

His misunderstanding of her use of the term "queen," however, does suggest such an interpretation. When he accuses her of setting herself "in heuen ouer hy3" by making herself "quen þat watz so 3onge" (473–74), his incredulity stems from an understanding of "queen" in terms of its earthly referent—that is, as the woman of highest status within a particular group. A child could never be queen of heaven, he reasons, because there are so many other worthy women who should, by rights, be placed above her. The Jeweler retains this interpretation of the word despite the Maiden's explanation that everyone who arrives in heaven is either a king or a queen (447–48). By ignoring her explanation of the meaning of queenship in the heavenly sphere and insisting instead upon its earthly signification, the Jeweler seems to be retaining an image of the Maiden within *this* world that resists her inscription into the transcendent terms that she describes.

Yet his attachment to the terms of this world and the rational process that it entails need not prevent the Jeweler from understanding the Maiden's speech. Reason is not inherently averse to visionary knowing, as we have seen. At the beginning of the poem, moreover, the Jeweler presents reason and faith as two different but equally viable routes to consolation for the Maiden's death. The Jeweler's acknowledgment of reason's proper use occurs in an early stanza, where he sees himself as incapable of consoling himself for the Maiden's loss. In the last stanza of group 1, he reflects,

A deuely dele in my hert denned,
Þa3 resoun sette myseluen sa3t.
I playned my perle þat þer watz penned,
Wyth fyrce skyllez that faste fa3t.
Þa3 kynde of Kryst me comfort kenned,
My wreched wylle in wo ay wra3te. (51–56)

Reason, according to the Jeweler, is not opposed to Christian comfort: it is in fact perfectly in accord with it. While it has been argued that this passage indicates the Jeweler's belief that reason alone is inadequate to pro-

vide him with comfort,[17] it is not clear that the narrator is making any such distinction. Instead, by presenting reason side by side with Christ—and implying no causal or contrasting connection between the two—he seems to be saying, quite simply, that *neither* reason nor Christ could comfort him in that moment, though either one should have sufficed. The implied equivalence between human intellectual faculties and faith is important, for it suggests that at this early point in the poem the Jeweler is neither aware of their proper hierarchization nor willing to accept that either one can provide him with the comfort that he craves. The Jeweler believes that both reason and Christ ought to be able to provide him with the solace that he desires, but his will remains opposed to both. The reasonable thing to believe, in other words, is Christian doctrine—that the pearl is now in God's hands and that death is necessary for life to begin anew. The change in the representation of reason from a possible means of consolation to a tool for refuting the Maiden's arguments suggests that his use of the *ratio* can be willful and intentional: by using his reason to argue with the Maiden, the dreamer is able to persist in his attachment to her physical form. The proper use of reason would be to affirm the Maiden's permanent absence from the physical world, but instead the dreamer uses it to argue against his separation from her. This initial recognition that reason should be able to effect consolation for her death thus establishes the conflict between the *proper* use of reason and his use of it in his vision.

The Jeweler's suggestion that reason and faith are simply two alternate means to the same end gestures towards a connection between the two modes of understanding that would enable them to work together for the dreamer's enlightenment. The possibility of *ratio*'s working *with* faith rather than against it is touched on in Jane Chance's analysis of the poem: rather than positing the Jeweler's investment in rationality as simply a hindrance to his spiritual development, she sees it as pointing him along the proper path to spiritual transformation—as containing "the seeds," in her words, "of his own spiritual edification and faith." Similarly, the "rational understanding of his loss," whose absence he perceives at the beginning of the poem, "suggests the spiritual direction he must now pursue." In order to come to terms with his loss he must absorb and understand the lesson that his rational mind teaches him—namely, that he ought to accept the Maiden's death as a part of the higher order of both the natural and spiritual

17. See Despres, who writes, "The poet stresses that humankind's intellectual faculties, 'resoun' alone, cannot provide the comforting knowledge of spiritual regeneration beyond empirical proof. The dreamer must have faith before he . . . can interpret those vestiges of God's order in nature" (102).

worlds.[18] Chance's reading of *Pearl*'s opening stanza group provides a way of looking at the Jeweler's development along the lines of the educative/revelatory schema. The problems that he encounters in his attempt to reconcile the Maiden's lessons with worldly logic may arise at least in part from the absence of any figure of authority who can connect the revelatory message of his vision to his usual way of thinking. Dante, we should recall, was not afforded a vision of Beatrice until he had spent considerable time with Virgil undergoing an education in those elements of the afterlife that are comprehensible to human reason. Perhaps the Jeweler's difficulties in understanding the Maiden stem in part from the absence of any identifiable Virgilian figure in the poem. He has not been adequately prepared for the eschatological vision before him; his mind, entrenched in worldly ways of knowing, cannot readily make the leap from the limited perspective of rational logic to symbolic and faith-based understanding.

II. The Jeweler's Language of Resistance

The Jeweler's refusal to move beyond the logic of the human world and to accept the difficult message offered him by the Maiden can be seen most clearly in his attitude towards language. Throughout the poem, he persists in understanding the Maiden's words in terms of their mundane rather than their transcendent referents. One illustration of this problem is the Jeweler's flawed understanding of the heavenly court. In his persistent challenging of the Maiden's new position as queen, the Jeweler insists upon the worldly referents underlying her speech, thereby keeping the physical body of the girl at the center of their discourse. It may be that this misunderstanding is inevitable, the inescapable outcome of using human language and imagery to describe the transcendent. As Stephen Russell argues, "*Pearl* attempts to bring human discourse to bear on a subject, only to discover human discourse to be inadequate as a medium."[19] When the Maiden describes what it means to be royalty in heaven—that everyone who arrives in the "reme" is a king or queen under Christ (448)—the dreamer seems incapable of grasping her meaning, repeating his protest that she is too young to be exalted so highly (474), as I have discussed above. Committed to earthbound notions of what it means to be a queen, he cannot conceive of a land in which everyone holds the position of greatest power and glory. Understood in earthly terms, her language is meaningless to the dreamer,

18. Chance, 39.
19. J. Stephen Russell, *The English Dream Vision: Anatomy of a Form* (Columbus: The Ohio State University Press, 1988) 160.

who can only muster objections which are equally meaningless from her perspective.

On Russell's view, this meaninglessness is essential. The poem, he claims, "undermine[s] the discourse of eschatology through an exposition of its dependence on human language and human reason," which in turn "encourage[s] in place of such notional comprehension of Heaven a simple relationship with God based on faith and trust, not on thoughts and words."[20] If Russell's contention is correct, then we must ask whether the poem succeeds in conveying to the Jeweler its intended challenge to a language-based understanding of the divine. I would argue that, at least in the middle section of the poem, it does not.[21] Throughout this section, the dreamer retains a materialist (as opposed to transcendent) understanding of the Maiden's declaration that she is a queen; this is evident in his assumption that the Maiden's status as queen is in conflict with Mary's position in heaven (421–28) as well as his assertion that she is too young to be queen—"[þ]ou lyfed not two 3er in oure þede. . . . And quen mad on þe fyrst day!" (483, 486). Even when he does absorb the fact of the Maiden's new stature, Spearing notes, he misunderstands its source, seeing it in terms of a disparity in their respective social, rather than spiritual, positions.[22] His newfound sense of the social distance between them can be detected in the contrast between his plainspoken protest against the parable of the vineyard—"Me þynk þy tale vnresounable" (590)—and the deferential tones in which he addresses her three hundred lines later: "I schulde not tempte þy wyt so wlonc, / To Krystez chambre þat art ichose" (903–4). The latter lines indicate his acceptance of her position as Christ's bride and queen. But this change in his reaction to her claims of royalty does not mean that he truly understands how she is using the title "queen." Indeed, he retains a conception of "queen" that applies to worldly courts and social stature; his deference reveals his perception of a difference in their respective social standings which does not acknowledge the Maiden's insistence that everyone who is admitted to heaven becomes a king or a queen (448). In this instance, at least, the Jeweler seems bound to a notional interpretation of the Maiden's words. Although the Jeweler's understanding of what the Maiden means by "queen" shifts and the problems that he encounters

20. Ibid., 161.

21. This is not to disagree with Russell's primary thesis. As far as the reader is concerned, the poem may still promote the type of relationship with God that he proposes, at the expense of a reliance on the language of eschatology. But the reader's understanding of this message in no way entails the Jeweler's grasping it, and it is the Jeweler's understanding of language that interests me here.

22. Spearing, *Gawain-Poet*, 154–55.

vary, he is caught in the image: he cannot escape its earthly signification or see it as having alternate meanings deriving from heavenly discourse.[23]

The word play that recurs throughout the poem reveals the Jeweler's unwillingness to relinquish his attachment to the Maiden. It is this unwillingness, in turn, that prevents him from achieving the spiritual transformation that she describes. His failure to fully grasp her message is not the result of the obscurity of her speech or his inability to comprehend it but of his refusal to accept her terms. Contrary to critics who have cited the Jeweler's difficulties in understanding the Maiden's transcendental message as evidence of his thick-headedness, I do not believe that the Jeweler is irredeemably literal-minded in his understanding and use of language.[24] His word play suggests a measure of sophistication when it comes to metaphorical linguistic usage, as throughout the poem he toys with the Maiden's words, refusing to adhere to the meanings that she attaches to them. His reworking of the Maiden's speech demonstrates a knowing unwillingness to interpret her words and phrases in the Christological sense that she intends. The difficulties that he encounters in grasping her meaning are not, therefore, due to an inability to understand metaphor but to his attachment to a particular, different set of meanings—perhaps reminiscent of Amant's renunciation of Raison in the *Roman de la rose*. The Jeweler's insistent reconfiguration of the Maiden's language is a vivid illustration of his willful resistance to her transcendent message.

The Jeweler's appropriation of the Maiden's words indicates his determination to stay focused on her, not God, in a way that emphasizes her physicality and his proprietary relationship to her. Examples of such appropriation can be found in many of the concatenating link words that are repeated from stanza to stanza within each of the poem's twenty stanza

23. Bullón-Fernández attributes the Jeweler's inability to understand the transcendent signified behind the Maiden's mundane signifiers to the Maiden herself: "Throughout the poem the maiden tries to appropriate the language of courtly love and to give it an exclusively religious meaning. However, the end of the dreamer's vision is witness to her failure" (49). I find this reading to be a bit less charitable than is perhaps called for; like accusing the dreamer of being too dense to understand the Maiden's discourse, placing the blame for the breakdown in communication squarely on one party neglects the fact that, inadequate though it may be, this was the kind of language used (and still used today) to talk about things divine. Russell's interpretation strikes me as being more apt in that it acknowledges the necessity of using human language to describe otherworldly matters, despite its limitations.

24. Numerous critics have stated or suggested that the dreamer is too obtuse to understand his vision; for example, in addition to the rather blunt assessments cited above, Frances Fast calls the dreamer "a bit of a fool," adding that he represents "the human inability to comprehend or express the heavenly" (Frances Fast, "Poet and Dreamer in *Pearl*: 'Hys Ryche to Wynne,'" *English Studies in Canada* 18.4 [1992]: 371).

groups.[25] As he repeats the Maiden's words, the Jeweler frequently invests them with a new meaning, usually one that is more congenial to his desires. When, for example, he concludes a speech to the Maiden with a description of himself as a "joylez juelere" and begins the following stanza with a reference to her as a "juel" (252–53), or when the Jeweler picks up on the Maiden's phrase, "[þ]ou art no kynde jueler," to again refer to her as a "juel" (276–77), he emphasizes his sense of their relationship through the play on words: they are naturally linked to one another, the jewel being rightfully the property of the jeweler. As Heather Maring notes, however, jewels do not remain the property of jewelers; although they are shaped by jewelers, they ultimately pass out of their hands and into the hands of others.[26] Yet the Jeweler "wants to hoard his jewel"[27]—in his insistence upon his relationship to the girl, he sacrifices the implications of his own metaphor. Elsewhere in the poem, his linguistic play is clearly used to keep the Maiden at the center of their discourse. In the thirteenth stanza group, he echoes her use of the word "maskelles"—which she utters in reference to the "pearl of price" and to the pearls in which Christ has clothed her (744 and 768)—but employs the word to describe her purity (745 and 769). Echoing her terms in this way has the effect of conflating the Maiden with her message and foregrounding her as the subject of their dialogue. Such play enables him to elide her intended message, maintaining his focus upon the presence of the Maiden and, importantly, on her close relationship to him.

The dialogue following the parable of the "pearl of price" most clearly demonstrates the Jeweler's determination to adapt the Maiden's language and to bring it back to his preferred meaning. This example is particularly telling because the Maiden makes it quite clear what she means by the "maskelles perle" at the center of the story, and yet the Jeweler reinterprets this phrase as referring to the Maiden herself. He thus reconfigures the lesson of her parable so that it coincides with his interest in reuniting with her. The Maiden first relates the story of the jeweler who "solde alle hys goud, / boþe wolen and lynne, / To bye hym a perle watz mascellez" (731–32). She is fairly explicit about what she means by this "perle":

25. The word play in the poem is, of course, actually the product of the poet, who plays with the link words on a larger scale throughout the text. However, the Jeweler serves as the mouthpiece for much of this word play, working like the poet to invest the imagery of heaven with the earthly meanings that suit his desires.

26. Heather Maring, "'Never the Less': Gift-Exchange and the Medieval Dream-Vision *Pearl*," *Journal of the Midwest Modern Language Association* 38.2 (2005): 1–15, esp. 5–8.

27. Maring, 7.

This makellez perle, þat boȝt is dere,
Þe joueler gef fore alle hys god,
Is lyke þe reme of heuenesse clere—
So sayde þe Fader of folde and flode—
For hit is wemlez, clene, and clere,
And endelez rounde, and blyþe of mode,
And commune to alle that ryȝtwys were.
Lo, euen inmyddez my breste hit stode:
My Lorde, þe Lombe, þat schede Hys blode,
He pyȝt hit þere in token of pes.
I rede þe forsake þe worlde wode
And porchace þy perle maskelles. (733–44)

Although the meaning that the Maiden ascribes to the pearl is complex, she clearly articulates the basic concepts to which it refers: it is the realm of heaven, it belongs to those who live rightly, and it is a spotless token of peace—in short, it signifies the renunciation of worldly living (the "forsak[ing of] þe worlde wode") and the pure, virtuous life of worship. Some critics have read the Maiden's explanation of the parable as her imposition of a transcendental interpretation upon her hapless father. O. D. Macrae-Gibson argues that this stanza is a part of the Maiden's attempt to correct her father's original misunderstanding of the meaning of the pearl-image: while the Jeweler thinks of the child's body as a pearl—a material object to be possessed—the true pearl is the soul, which can only be possessed by God.[28] Edward Wilson makes a similar argument, noting that throughout *Pearl* the Maiden "take[s] the narrator's imagery and give[s] it different referends, supernal for earthly." The progressive increase in the Jeweler's understanding of her discourse can thus be measured by his "giving heavenly referends to images which earlier had earthly ones," as he does in his use of the image of the rose in lines 905–6.[29] Like Macrae-Gibson, Wilson sees the Maiden as controlling the terms of the dialogue, infusing the Jeweler's earthly language with transcendent signification.[30]

Macrae-Gibson's and Wilson's readings make sense until we consider the lines that follow the Maiden's explanation, where it becomes apparent

28. O. D. Macrae-Gibson, "*Pearl*: The Link-Words and the Thematic Structure," *Neophilologus* 52.1 (1968): 56.

29. Edward Wilson, "Word Play and the Interpretation of *Pearl*," *Medium Aevum* 40.2 (1971): 124.

30. Spearing implicitly asserts the Maiden's role as a corrector of the dreamer's mistaken ideas when he notes that "the Pearl Maiden meticulously unpicks and corrects the dreamer's misunderstandings about the nature of the heavenly kingdom and the means of gaining it" (*Textual Subjectivity*, 161).

that this is more than a one-way correction. When the Jeweler responds to the Maiden's parable, he makes no reference to the transcendent content of what she has said. Instead, he takes the phrase "perle maskelles" and applies it, not to the heavenly kingdom to which the Maiden refers, but to the Maiden herself: "O maskelez perle in perlez pure, / Þat beres . . . þe perle of prys," he begins (745–46). In the stanza that these lines introduce, he dwells on the beauty of her form and asks who created her to be so radiant, clearly appropriating the key phrase of her speech in order to subvert her meaning. By referring to her as the "maskelez perle" of the parable, he suggests that *she,* not heaven, is the prize to be won. In fact, the Maiden's use of the metaphor of the pearl opens the way for the Jeweler's willful reinterpretation. She is wearing pearls, and she has been given the perfect pearl "inmyddez [her] breste," making the Jeweler's return to materiality—to the pearls on her clothing (746), to her clothing itself (748), and finally to her own beauty (749)—altogether natural. That he turns the conversation away from transcendent matters and back to the physical body of the girl he loves, then, need not be a sign of stupidity or literal-mindedness, but indicates his unwillingness to renounce his attachment to her.[31]

Second, Wilson's argument that the Jeweler's use of the rose image indicates his newfound understanding of the transcendent referends underlying the Maiden's speech does not hold up to scrutiny. The image of the rose first appears early in the poem, when the Maiden uses it to signify her mortal body: "For þat þou lestez watz bot a rose / Þat flowred and fayled as kynde hyt gef," she says (269–70). She sets the rose in opposition to the pearl, which signifies the immortality of her soul. Wilson sees the dreamer's later use of the rose image as evidence of his increasing facility with symbolic language. However, the Jeweler's use of the image actually suggests that he does not fully understand the Maiden's meaning: "I am bot mokke and mul among, / And þou so ryche a reken rose, / And bydez here by þys bylsful bonc / Þer lyuez lyste may neuer lose" (905–08). Where the Maiden uses the rose as an image of temporality and the impermanence of the flesh that contrasts with the purity of the pearl, the Jeweler still sees her as the rose. His use of the image is indicative not of his acceptance of her meaning but of his persistence in identifying her with her physical form. The mere fact that he is employing her imagery, then, does not mean that he has absorbed—or consented to—the meaning with which she has tried to imbue it.

31. It is, moreover, strange to consider him "literal-minded" when even the fact of his associating the pearl with the Maiden is evidence of his metaphorical inclinations.

At other points in the poem, as well, the Jeweler illustrates his unwillingness to relinquish the Maiden in his repetition of the link words, which enables him to shift the terms of her discourse away from God and the heavenly kingdom and back to the girl herself. His linguistic play allows him to create meanings that are congenial to his desires by keeping the Maiden at the center of their discourse. For instance, in the sixth stanza group, the dreamer adapts her use of "deme," or judgment, to foreground *her* judgment of *him,* rather than the divine judgment to which she refers. The Maiden emphasizes the impossibility of the Jeweler's remaining on the far bank with her before he has suffered death and earned God's permission when she says, "Þur3 drwry deth boz vch man dreue, / Er ouer þys dam hym Dry3tyn deme" (323–24). She stresses God's judgment as that which will determine the Jeweler's fate. His response to this, however, is to ask, "Demez þou me . . . ?" (325). His words echo the terminal "deme" of the preceding line but apply it to the Maiden, shifting the focus of the discussion from God's judgment to the girl's. His appropriation and reinterpretation of her speech evoke his ongoing preoccupation with the Maiden rather than an engagement with the content of her speech and the submission to God's will that she continually enjoins him to undergo. Again, later in the poem, the Maiden's description of the company of virgins in which she finds herself—"þe meyny þat is withouten mote" (960)—gives way, in the Jeweler's reply, to the singular figure of the Maiden herself: "Motelez may so meke and mylde," he addresses her in the subsequent line (961). The dreamer's insistence on her singularity, rather than on the blessed collectivity that she is trying to evoke, keeps her in the foreground of their conversation. The Jeweler thus repeatedly borrows from the Maiden's speech not to affirm her message but to deny it. With his appropriation of her language, he insists upon her presence when she wishes him to think of God and reduces the company of virgins to the single figure of the girl. In each of these examples, he inverts her meaning, interpreting her transcendent messages as reflections of his worldly desire.

III. The Will as Obstacle

The Jeweler is an active participant in the visionary dialogue. By reinterpreting the terms of the Maiden's speech, he insists upon his ongoing attachment to her physical form and her relationship to him despite her insistence that he leave these behind. From the beginning of the poem, it is evident that this resistance to her instructions is a function of his will. "A

deuely dele in my hert denned / Þa3 resoun sette myseluen sa3t. . . . Þa3 kynde of Kryst me comfort kenned, / My wreched wylle in wo ay wra3te" (51–52, 55–56), he laments, indicating the dominance of his will. Theodore Bogdanos asserts that the poem depicts "a violent splitting of the self into two antithetical voices": reason and the "kynde of Kryst" on the one hand and the dreamer's will on the other.[32] Where fourteenth-century mystical texts stress the importance of subordinating one's will to the divine will as a necessary step on the way to divine union, the Jeweler's willful attachment to the Maiden illustrates the difficulty of following this injunction, and his unwillingness to accept her terms is ultimately the greatest obstacle to his fully understanding her message.

Although the Jeweler's resistance to the Maiden comes from the stirrings of his will, the fact that he is not in control of his vision prohibits him from fully acting upon his desires. Potentially, it would seem that the Jeweler could fall into the trap to which Amant succumbs in the *Rose:* his will, rebelling against both reason and religion, could lead him down a path that is in harmony with his desire to remain with the Maiden. And that is what he attempts to do when he resists the Maiden's transcendent meaning in his word play. But an essential difference between *Pearl* and the *Rose* prevents this from coming to fruition: where the *Roman de la rose* is populated with conflicting authorities—Raison and Amor prominent among them—in *Pearl* there is only the Maiden. No alternative path presents itself; the dreamer is compelled to obey the Maiden and, through her, Christ. Moreover, the Maiden is not a mere player in the world of the dream—as Raison is in the *Rose,* where she competes on equal terms with Ami, Amor, and the others—but is a part of the controlling force behind the vision. As a God-given revelatory experience, the vision limits the courses of action that are available to the dreamer; it is, for example, implausible that the Jeweler could have snuck across the river while the Maiden's eyes were turned.[33] His behavior within the dream is constrained by the rules dictated by Christ and voiced through Christ's mouthpiece, the Maiden. The problem of the wayward will is not, therefore, as pernicious as it is in the *Roman de la rose.* Because it cannot result in successful action, the Jeweler's resistance to the Maiden's speech is largely internal and manifests in his linguistic play.

But the Jeweler's unruly will hinders his acceptance of the Maiden's terms, preventing him both from drawing comfort from God and from absorbing the spiritual message of his vision. That his will continues to struggle despite his seeming awareness of the consolatory powers of both

32. Bogdanos, 29.

33. Were this the Jardin de Déduit, however, we might expect precisely such an occurrence.

reason and Christ ("My wreched wylle in wo ay wra3te") demonstrates his reluctance to abandon his grief regardless of the distress that it causes him. This attitude, which is made explicit at the outset of the poem, illustrates his commitment to a material attachment to the Maiden as a living girl—an attachment that will undermine his visionary experience, impeding him in his understanding of the divine message that it is intended to transmit. Further, this attachment entails his inability to truly experience Christ's presence. As Cynthia Kraman argues, lines 51–56 reveal the Jeweler's purely intellectual understanding of Christ; he is not yet capable of genuinely "feeling Him as a presence." She writes, "The narrator is tied to the literal body, longing for the supernal one, but unsure of the ultimate transference of self that will happen when he surrenders to the comfort of Christ. This possibility of Christ's comfort, and the willful dismissal of it, is captured" in lines 55–56.[34] The Jeweler's attachment to the Maiden is an attachment to the world and represents his alienation from the comforting presence of the divine.

The Jeweler's attachment to the material form of the Maiden is even reflected in the material terms in which he understands the visionary landscape. From the outset of the vision, the poem establishes him as vividly interested in the concrete elements of the world, and his reaction to the dreamscape—his preoccupation with visual details and the emotional effect that these details have on him—demonstrates that he is unprepared to turn away from the physical in favor of the supernal. Upon finding himself in the otherworldly landscape of his dream, the Jeweler compares many of its features to ordinary things, such as weaving (71), music (91–94), jewels (82), and precious metals (77, 106). The use of mundane items to describe the supernatural may signify nothing more than the necessity of employing images of the familiar to describe the new. However, the second stanza group's link word—"adubbement" and its variations—indicates a preoccupation with physical adornment and beautification. This preoccupation exposes the Jeweler's significant investment in materiality. Moreover, the capacity of his setting's physical beauty to console him ("The dubbement dere of doun and dalez, / Of wod and water and wlonk playnez, / Bylde in me blys, abated my balez, / Fordidden my stresse, dystryed my paynez," 121–24) demonstrates its power over the dreamer. What the thought of Christ could not do in the earlier stanza is achieved by the beauty surrounding him. Far from being prepared to renounce the world, the Jeweler is thoroughly entrenched in its beauties, comforts, and temporal rewards. This

34. Cynthia Kraman, "Body and Soul: *Pearl* and Apocalyptic Literature," in *Time and Eternity: The Medieval Discourse,* ed. Gerhard Jaritz and Gerson Moreno-Riaño (Turnhout: Brepols, 2003) 359.

preoccupation with the material limits his ability to look beyond the Maiden's physical form. His focus on the beauty of the vision's setting, argues Jim Rhodes, "indicate[s] his attachment to the physical world and point[s] to his sensitivity to human finitude, change, and the problem of death."[35] Where there is physicality, there is its demise: indeed, the Jeweler's attachment to the Maiden is first introduced in the description of her body moldering underground. In the second stanza of the poem, prior to the onset of his vision, the Jeweler reflects on the physical reality of her dead body, introducing a theme that will resurface—albeit in less literal terms—throughout the work: "To þenke hir color so clad in clot! / O moul, þou marrez a myry juele, / My priuy perle withouten spotte" (22–24). The dreamer's preoccupation with her physical presence attains its most striking realization in the poem's final sections, when it contrasts with the extravagance of the heavenly procession. At the height of his apocalyptic vision, the Jeweler persists in thinking of the Maiden in terms of her worldly relationship to him: she is a queen, but remains "my lyttel quene" (1147). Even at this stage he retains his attachment to her.[36] Pervading the poem is the narrator's longing to rejoin the physical body of the girl even after he has come to understand that she is now a queen in heaven.

Finally, the Jeweler's impetus for crossing the stream clearly evinces his ongoing desire for physical proximity to the girl that he loves, indicating that even by the end of the vision he has not renounced his desire to be with her again. The timing of his decision to attempt the crossing strongly suggests that it is not Christ but the Maiden that the Jeweler wishes to reach. At the end of the procession of the Lamb, he sees his "lyttel quene" rejoicing in the presence of Christ (1147). It is explicitly this sight that prompts him to consider crossing the stream: "Þat sy3t me gart to þenk to wade / For luf-longyng in gret delyt" (1151–52). The "love longing" that he feels is not for Christ, but for the Maiden. It is she that he is drawn to rejoin, she—not Christ—for whom his soul yearns.[37] Significantly, his delight is expressed in terms of sensory (and therefore physical) pleasure— "Delyt me drof in y3e and ere, / My manez mynde to maddyng malte" (1153–54)—phrases that underscore the physical quality and origin of his

35. Jim Rhodes, "The Dreamer Redeemed: Exile and the Kingdom in the Middle English *Pearl*," *Studies in the Age of Chaucer* 16 (1994): 130.

36. Cherniss, 162.

37. Sarah Stanbury makes a similar argument, noting that the Jeweler "yearns to join not the Lamb, not Christ, but his Pearl." His focused attention on her, and the description of himself as perceiving the Lamb and the Maiden, is a reminder of the fixity of his body in space, and of its distance, perhaps, from the divine. (Sarah Stanbury, *Seeing the* Gawain-*Poet: Description and the Act of Perception* [Philadelphia: University of Pennsylvania Press, 1991] 24.)

pleasure, even in the face of the heavenly scene before him.[38] The reference to the physical senses and his "man's mind" recall, as well, the Maiden's first criticism of him—that he depends too much on his faculties of reason and perception—as well as the words with which she introduces her criticism of his speech: "Wy borde 3e men? So *madde* 3e be!" (290; my emphasis). The thematic and verbal echoes between these two passages suggest that the Jeweler has not progressed at all since that first rebuke. That it is the overwhelming of his mind and senses that pushes him to cross the stream graphically illustrates the physical terms in which he experiences his vision. He cannot, or *will* not, perceive it in any way other than through human eyes. To the very end, his desire remains fixed upon the Maiden, driving him to the madness ("maddyng") that leads him to plunge into the stream despite the knowledge that he will not be able to cross. By fixing his will upon the Maiden and essentially refusing to abandon his attachment to her, the Jeweler remains almost static: his emphasis upon her physical body and his desire to possess it hinder his understanding of the content of even the most revelatory moment of his vision.

IV. Mystical Renunciation and the Jeweler's Desire

The idea that attachment to created things prevents one from uniting with the divine is not new. An obvious Biblical root of this sentiment is found in Luke 14:26: "If any man come to me, and hate not his father, and mother, and wife, and children, and brethren, and sisters, yea, and his own life also, he cannot be my disciple." In *De Doctrina Christiana,* Augustine provides an elaborated theological explication of the renunciation of loving attachment, as his careful distinction between "use" (*usi*) and "enjoyment" (*frui*) is explicitly applied to the love between human beings. He writes,

> *Praeceptum est* enim nobis *ut diligamus inuicem;* sed quaeritur utrum propter se homo ab homine diligendus sit an propter aliud. Si enim propter se, fruimur eo; si propter aliud, utimur eo. Videtur autem mihi propter aliud diligendus. Quod enim propter se diligendum est, in eo constituitur beata uita, cuius etiam si nondum res, tamen spes eius nos hoc tempore consolatur.[39]

38. Stanbury notes that this passage shows that the Jeweler's crossing the stream is "a response to sensory and especially visual stimuli" (*Seeing*, 13), underscoring his attachment not simply to the physical, but to the specifically visual.

39. Augustine (Sancti Aurelii Augustini), *De Doctrina Christiana. De Vera Religione,* Corpus Christianorum, vol. 32 (Turnhout: Brepols, 1962) I.22, 20; italics in original.

(We have been commanded . . . to love one another; but the question is whether people are to be loved by others for their own sake, or for the sake of something else. If it is for their own sake, then they are things for us to enjoy; if for the sake of something else, they are things for us to use. Now it seems to me that they are to be loved for the sake of something else, because if a thing is to be loved for its own sake, it means that it constitutes the life of bliss, which consoles us in this present time with the hope of it, even though not yet in its reality.[40])

The objective of earthly love, according to Augustine, is not love of the particular individual, but love of God. Being attached to the corporate being, the human love-object, is tantamount to being "enslaved under signs" ("sub signo . . . seruit")[41]—that is, failing to recognize the divine referent that underlies the signifying word. Love, for Augustine, follows much the same rules as language in that in its proper manifestation it points beyond its earthly incarnation and towards the divine.

The fourteenth-century *Cloud of Unknowing,* an English text roughly contemporaneous with *Pearl,* articulates a similar view of affective attachments to created beings as an obstacle to the soul's union with God. A work of apophatic mysticism,[42] *The Cloud of Unknowing* repeatedly enjoins its readers to forsake worldly attachment—to "for3ete alle þe creatures þat euer God maad & þe werkes of hem"[43]—in order to truly love God. The *Cloud* resonates with Augustine's prohibition on "enjoying" the love-object rather than properly "using" it as a means of reflecting on and honoring God; indulging in an affectionate attachment to another human being is an impediment to knowing the divine. Thus the *Cloud*-author directs the reader to "Lift up þin herte vnto God wiþ a meek steryng of loue; & mene himself, & none of his goodes . . . so þat þi þou3t ne þi desire be not directe ne streche to any of hem, neiþer in general ne in special."[44] One should orient one's loving attention towards God, in other words, and not towards his "goods"—which includes human beings as well as material objects.

The terms of the Jeweler's attachment to the Maiden imply a rejection of the detachment advocated by the *Cloud. Pearl*'s ending does not depict the translation of a previously worldly dreamer into a state of spiritual

40. Augustine, *Teaching Christianity,* 114.
41. Augustine, *De Doctrina Christiana,* III.9.13.
42. See Gallacher's comments in the introduction to the TEAMS edition of the *Cloud* for a lengthier discussion of the author's treatment of Pseudo-Dionysian apophatic mysticism. Patrick J. Gallacher, ed., *The Cloud of Unknowing* (Kalamazoo: Medieval Institute Publications, 1997) 4–9.
43. Hodgson, ed., *Cloud,* 16.
44. Ibid.

enlightenment, as the Jeweler's declaration that "my joye watz sone tori-
uen, / And I kaste of kythez þat lastez aye" (1197–98) indicates a confu-
sion between his attachment to the Maiden and his desire to comply with
God's will. Given that it was the sight of the Maiden, and not of the Lamb,
that spurred him to attempt to cross the river, it seems clear that his "joye"
is her, not Christ. In the same stanza, his professed submission to God's
will is also confused: his desire to obey God is intermingled with his love
for the Maiden. The lines "To þat Pryncez paye hade I ay bente, / And
3erned no more þen watz me geuen. . . . To mo of His mysterys I hade ben
dryuen" (1189–90, 1194), so often cited as evidence that he has undergone
a spiritual transformation,[45] suggest a failure of understanding: there is
no indication that he would have been allowed to cross the stream in his
mortal lifetime even if he had been obedient to Christ's will, as the Maiden
makes clear ("Þur3 drwry deth boz vch man dreue, / Er ouer þys dam
hym Dry3ten deme," 323–24). Moreover, given that his attachment to the
Maiden remains the motivating force behind his desire to stay in the world
of his vision, there is something disingenuous about his stated interest in
following the strictures laid down by God.

The obstacles to divine knowledge raised by the Jeweler's love for the
Maiden situate *Pearl* within a broader tradition of mystical literature that
posits the renunciation of worldly attachment as necessary for divine union.
A major proponent of non-attachment is Meister Eckhart (1260–1328), a
Dominican preacher and scholar who taught laypersons and religious alike
in Germany and France. Eckhart's theology emphasizes the importance of
emptying oneself of all forms of attachment, including the attachment to
images and divine favors such as visions, as a prerequisite for true knowl-
edge of God. The divine, argues Eckhart, is present in the *grunt* (ground)
of the soul, which is of the same nature as God. But union with God is pos-
sible only if the soul is free of all worldly attachments—in what he calls a
juncvröuwelich, "virgin" state. A virgin soul is a soul that "von allen vrem-
den bilden ledic ist, alsô ledic, als er was, dô er niht enwas" (is free of all

45. In his 2005 study, Spearing argues that this conclusion shows that the Jeweler "subse-
quently recognized that he must submit to God's will and commit her to God with a father's
blessing" (*Textual Subjectivity,* 152). This conclusion coincides with his 1966 argument that
this passage reveals that "the Dreamer's visionary experience has a significant effect on his
life in the waking world. . . . [S]ubmitting to God's will, he now accepts positively the loss of
the pearl" (A. C. Spearing, "Symbolic and Dramatic Development in *Pearl*," in Sir Gawain
and Pearl: *Critical Essays,* ed. Robert J. Blanch [Bloomington: Indiana University Press,
1966] 118). Gregory Roper has also noted that by the end of the poem the dreamer "realizes
that it is his own attitude towards God's grace that opens or closes the door to higher things,"
teaching him "to give even his closest possessions . . . to God" (Roper, 183).

foreign images, as free as he was when he was not).[46] Conceding that this state of total detachment is not easy to attain, Eckhart nonetheless insists that it is a necessary precondition for union with Christ, who, being innocent and free himself, can only join with a soul that is equally so. The Jeweler's soul is not, in Eckhardian terms, *juncvröuwelich*. Resisting the Maiden's injunction to surrender her to the afterlife, he remains focused on material attachments and the corporeality of her body. Until he gives her up, Christ cannot be "born" in his soul—he cannot enjoy true union with, or knowledge of, the divine. The Jeweler's inability to remain in the city with the Maiden is consistent with Eckhart's theology of non-attachment: by repeatedly turning away from the Maiden's transcendent message and towards the Maiden herself, he consigns himself to a worldly existence.

In contrast, a lived example of the Eckhardian "virgin" soul can be found in Gertrude of Helfta, who, in her *Legatus Memorialis Abundantiae Divinae Pietatis,* similarly asserts the necessity of uniting one's will with God's. Twice, the Lord tells Gertrude that her knowledge of divine matters is predicated upon her volitional union with Christ.[47] The basis for this union is her freedom of the heart, or *libertas cordis*: her renunciation of all attachment to ideas, affections, and even the self. By emptying the soul of earthly attachments, *libertas cordis* "make[s] room for the in-dwelling of the divine."[48] According to her biographer, it is because Gertrude manifests this quality that Christ chooses to grant her his favors.[49] Like Eckhart's concept of spiritual virginity, *libertas cordis* entails a detachment from the world that enables the divine to manifest itself in the soul and leads to the union of one's will with God's. The *Legatus* repeatedly emphasizes this characteristic as the trait that makes Gertrude's visionary experiences possible and enables her to understand the transcendent knowledge that those experiences reveal.

The fact that such disparate works as the *Cloud,* Eckhart's sermons, and Gertrude's *Legatus* all stress detachment from worldly ideas, desires, and other creatures as an essential prerequisite for the soul's union with Christ suggests the idea's widespread purchase in thirteenth- and fourteenth-

46. Eckhart, "Predigt 2," in *Die deutschen und lateinischen Werke* vol. 1, ed. Josef Quint (Stuttgart: W. Kohlhammer Verlag, 1986) 25; my translation.

47. Gertrude of Helfta, *Legatus Abundantiae Memorialis Divinae Pietatis,* in *Œuvres spirituelles,* 5 vols., ed. Pierre Doyere, Sources Chrétiennes vols. 127, 139, 143, 255, 331 (Paris: Les Éditions du Cerf, 1968) 4: 2.15 and 4: 14.5, SC 4: 44–46 and 4: 158–60. See chapter 3 for a fuller discussion of Gertrude's volitional union with the divine and its relationship to her visionary knowing.

48. Gertrud Jaron Lewis, *"Libertas Cordis:* The Concept of Inner Freedom in St Gertrud the Great of Helfta," *Cistercian Studies* 25.1 (1990): 69.

49. Gertrude of Helfta, *Leg.* 1: 11.5, SC 2: 174–76.

century Christian thought.[50] Based upon a consideration of even these few sources, it becomes clear that the Jeweler is incapable of fully comprehending the transcendent knowledge imparted by his vision. He does not renounce the Maiden by the end of the poem; clinging to her as much as he ever did, he openly regrets that his hasty impulse has prevented him from remaining with her in paradise. The lesson that he was meant to learn— to let go of his attachment to the Maiden and submit himself entirely to God—has not been fully absorbed even by the closing lines of the poem. But this ending need not be read in an entirely pessimistic light. *The Cloud of Unknowing* provides a way of interpreting worldly attachment as a common but surmountable obstacle to mystical union. Understood thus, the closing stanzas of *Pearl* suggest that the Jeweler has learned something— even if it is not the whole of the lesson that was intended for him—and that his plight is not altogether hopeless.

Several passages in the *Cloud* acknowledge that worldly renunciation is not easy to accomplish and that an attachment to another created being does not irrevocably prevent one from knowing the divine. In fact, the author suggests, even the purest souls occasionally find themselves embroiled in loving attachments to other creatures:

> I say not bot he schal fele som-tyme—3e! ful ofte—his affeccion more homely to one, two, or þre, þen to alle þees oþer; for þat is leueful to be for many causis, as charite askiþ. For soche an homly affeccion felid Criste to Ihonn, & vnto Marye, & vnto Petre bifore many oþer. Bot I say þat in þe tyme of þis werk schal alle be iliche homly vnto hym; for he schal fele þan no cause bot only God. So þat alle schul be louyd pleinly & nakidly for God, & as wel as him-self.[51]

In this passage, the author admits that even Christ sometimes developed powerful attachments to specific individuals. Such "homly affeccion" is not to be taken as an irremediable failing; it is human and natural for even the holiest to experience it. The mere fact that the Jeweler feels a particular love for the Maiden—a love that distracts him from his love for God—does not mean that he is hopelessly obtuse, or irredeemably bound to the things of this earth.

50. These three texts are by no means the only examples of medieval Christian literature that emphasize the importance of renouncing earthly attachment in order to obtain a perfect knowledge of the divine. The theme is, in fact, quite prevalent; Walter Hilton's fourteenth-century *Scala Perfectionis,* for example, repeatedly underscores the necessity of detachment from the world and its creatures in the ascent to divine union.

51. *Cloud,* 60.

But even these attachments must be overcome through a combination of individual striving and divine grace. Although the *Cloud*-author recognizes the inevitability of developing the occasional affectionate tie to an individual creature, the text emphasizes that surmounting such affections is the work, or "travayle," of the virtuous soul:

> Sekirly þis trauayle is al in tredyng doun of þe mynde of alle þe creatures þat euer God maad, & in holdyng of hem vnder þe cloude of for3etyng namyd before. In þis is alle þe traueyle; for þis is mans trauayle, wiþ help of grace. & þe toþer abouen—þat is to sey, þe steryng of loue—þat is þe werk of only God. & þerfore do on þi werk, & sekirly I behote þee it schal not fayle on hym.[52]

The author thus enjoins the reader to "do þi werk": to strive continually for the suppression of earthly attachments and ideas and by such renunciation to move ever closer to God. Importantly, however, the soul's movement towards God is not the work of the soul alone. This "steryng of love" is "þe werk of only God." It is our task, in other words, to place the things of this world into a cloud of forgetting—a continual work, as new attachments will inevitably rise up throughout our lives—and leave the development of love for God at least partially in God's hands. This depiction of the soul's progress towards God is similar to that laid out by Eckhart, who describes the emptying of the soul and its return to a "virgin" state as characterized by constant vigilance, work, and activity. The realization of God's love in the soul then comes from God, who is "fruitful through" the soul ("vruht-bærlich in im").[53] The soul is not, therefore, wholly responsible for its movement towards the divine. Grace explicitly plays a part in the development of one's loving relationship with the godhead.

In *Pearl,* the vision can be read as a part of the Jeweler's education, pushing him towards the work of renunciation that may eventually lead to divine knowledge. Applying to the poem the *Cloud*'s joint stress on human labor and divine grace therefore yields a more forgiving interpretation of his spiritual trajectory. It is true that his attachment to the Maiden impedes his progress towards Christ by disrupting his vision and, more importantly, distracting him from love for the divine. But by the end of the poem he seems to be on the road to understanding. Recognizing that "ay wolde man of happe more hente / Þen mo3te by ry3t upon hem clyuen" (1195–96), he sees, at least, that grasping at more than he has been granted by trying

52. *Cloud,* 61–62.
53. Eckhart, 28.

to remain with the Maiden before his time is not in harmony with God's will. Whether this means that he has begun suppressing his attachment to the Maiden is unclear, but the lesson that he *has* learned—that he must renounce the pursuit of pleasure for its own sake and subjugate himself to the will of God—suggests that he has at least a theoretical understanding of the work that lies before him if he is ultimately to achieve union with Christ. In the absence of an unfettered heart and mind, the Jeweler cannot truly conform to God's will, but he can understand what he needs to do to live a virtuous—if perhaps unexceptional—life.

Like the *Roman de la rose,* then, *Pearl* illustrates how the human will can interfere with visionary knowing. In *Pearl,* however, the will is not an agent of lust, as it is for Amant, but rather follows the dictates of a presumably familial love. The Jeweler cannot truly learn what his vision aims to teach him because his heart is clouded by earthly attachment. Yet he is nonetheless able to amend his life, and the final stanzas of the poem suggest that he has at least begun to recognize that he has clung too fiercely to the Maiden's physical presence. In this sense, the vision has achieved its aim. Because the Jeweler's initial failing is his continued attachment to the Maiden as a living girl, it makes sense that one of the poem's major themes is how such attachment interferes with the soul's union with and knowledge of Christ. *Pearl* can therefore be read as an exemplum of the *Cloud*'s theology of detachment. By failing to put the Maiden behind a "cloud of forgetting," as the *Cloud*-author instructs, the Jeweler is prevented from reaching Christ or the heavenly city and of learning what greater truths his vision might have imparted had he been more patient.[54] The sense of regret that pervades the poem's ending suggests that the Jeweler at least recognizes this, although it is less clear whether he understands the whole cause of his failure. His refusal to accept the Maiden's terms seems to have abated as he recognizes the futility of persisting in his attempt to regain her presence.

One further point bears mentioning in a consideration of how a loving attachment to another human interferes with the possibility of divine rev-

54. Spearing argues that his plunge into the stream excludes the dreamer from the culminating moment of the vision, in which, perhaps, "the Lamb and the pearl would be identified, and the Dreamer would see in the precious stone the ground of its own preciousness; or, to put it differently, would recognize in the human soul the image of God" (*Gawain-Poet,* 170). In his more recent study, he supports this earlier reading when he posits that the dreamer's inability to resist joining the Maiden "brought the vision to a premature end" (*Textual Subjectivity,* 152). Although Spearing's reading is largely speculative, it is possible that—within the world of the narrative—the vision would have continued had he refrained from attempting to cross the stream; the fact that his attempt at crossing is what wakes him up supports this theory.

elation: such love can, in fact, enable divine revelation to occur. Two lines in the final stanza point to a surprising turn away from the *via negativa* that is implied by the Jeweler's need to renounce his love for the Maiden. In the narrator's final summing-up of his vision, he notes, "Ouer þis hyul þis lote I la3te, / For pyty of my perle enclyin" (1205–06). In these words, he reminds the reader that the vision came about through "pyty"—a usage of the word which the *Middle English Dictionary* glosses as "Sorrow, grief; misery, distress; also, remorse."[55] While pity can be an attribute of God, in this instance its quality of expressing grief makes it a human emotion stemming from a loving attachment to another human being.[56] And this pity is the source of his vision. His love for the Maiden is what enables him to have the vision of divine truth; attachment therefore *can* lead to a glimpse of the divine. Such a use of earthly love is, in Augustinian terms, a form of *usi,* whereby one's thoughts are turned to God by means of an appreciation of and love for another created being. The Jeweler's "use" of the Maiden, while it is problematic in that he does not initially consent to it, focusing on her instead of the divinity that is perceptible through her, suggests one way that love for another human can both impede and enable visionary knowing.

Yet the dreamer remains limited—by his corporeality, by the difficulty of transcending his attachment to earthly beings while still in the living world. Gazing upon the heavenly city, the dreamer remarks that it is such a great marvel that "No fleschly hert ne my3t endeure" its sight (1082). This phrase has particular resonance in the context of his attachment to the dead girl's material presence. His love for the Maiden—for her physical body— cannot endure the detachment necessary for a true union with the divine. And his heart, which continues to love the girl despite her repeated injunction that he turn away from her and contemplate the divine alone, cannot make the movement of renunciation that his heavenly vision demands of him. As a fleshly being, a purely human being who remains attached to the loves and pleasures of the world, the sight is not his to endure. Perhaps, as a result of his overwhelming desire to remain with the girl that he loves, the Jeweler did awaken before his vision had revealed the totality of its apoca-

55. "Pitē, Def. 3a," *Middle English Dictionary,* ed. Sherman M. Kuhn, vol. P.4 (Ann Arbor: Univeristy of Michigan Press, 1983) 974.

56. It is significant that the Jeweler's compassionate feeling for the Lamb arises out of a similar feeling of pity—"Alas, þo3t I, who did þat spyt?" he wonders when he sees the wound in his side (1138). This echo of the pity that he feels for the dead Maiden unifies the two figures in his affective response to them, further implicating the Maiden in his understanding of Christ's suffering; it also emphasizes the predominance of this very human response in the dreamer's emotional state.

lyptic message, but the conclusion of the poem leaves us with the sense that he has learned all that he can learn at this point in his spiritual development. Understanding that he must submit himself to God's will despite his ongoing love for the dead girl is enough for now—and is, perhaps, the limit of what his "fleshly heart" can endure in this life.

6

The Critique of Revelation in
Piers Plowman

 RECURRING CONCERN in the texts that I have discussed so far has been the role of the will in revelatory experience. This faculty is obviously important to Gertrude of Helfta and is evident in *Pearl,* but it also crops up in Marguerite d'Oingt's reliance on prayer, Amant's rejection of Raison, and Julian of Norwich's interpretive process. The union of the human will with that of the divine is important at many stages of the visionary experience: it prepares one for a vision; it ensures the proper interpretation of the visionary message; and it enables the dreamer or visionary to use his or her new knowledge to increase in his or her love for God and to disseminate the revealed message. Improperly directed, however, the will presents a significant obstacle to visionary knowing, as I argued in my discussion of *Pearl.* Given its primacy in visionary literature, it is only fitting that I should next consider a work whose main character is actually named Will.

As many critics have remarked, it is almost impossible not to regard Will, the protagonist of *Piers Plowman,* as to some extent an allegorical representative of the will.[1] In a world populated by creatures named Conscience, Reason, Shame, Holy Church, Truth, and Mercy, it is reasonable to expect that a man called Will will have something to do with his namesake faculty. While he is clearly a character, with a body, thoughts, wishes, desires, and dreams, and is also presumably a figure of the poem's author William Langland, Will nonetheless evinces many of the qualities

1. For a more thorough discussion of Will as the will, see, e.g., Mary Carruthers, *The Search for St. Truth: A Study of Meaning in* Piers Plowman (Evanston: Northwestern University Press, 1973) 93; James I. Wimsatt, *Allegory and Mirror: Tradition and Structure in Middle English Literature* (New York: Western Publishing Company, 1970) 106; John Bowers, *The Crisis of Will in* Piers Plowman (Washington, DC: Catholic University of America Press, 1987) 48–49; and J. A. Burrow, *Langland's Fictions* (Oxford: Oxford University Press, 1993) 49.

associated with the volitional faculty. His primary activities in the poem are seeking and desiring: he wishes for "kynde knowing," he wants to understand Truth, he quests after Dowel, and he pursues Piers the Plowman. These are activities that depend upon the will's investment in and pursuit of a particular aim. In the Middle Ages, as we have seen, the will was commonly thought to be "the object of instructive agents such as reason and conscience,"[2] and indeed, Will actively seeks the counsel of such inner faculties. At several points in the poem, moreover, the dreamer is ambiguously identified as either a person named Will or as the will itself. Thought is the first to name him in the B-text: "Thanne Thoght in that tyme seide thise wordes: / 'Wher Dowel and Dobet and Dobest ben in londe / Here is Wil wolde wite if Wit koude teche hym.'"[3] The verbal echo between "Wil" and "wolde" suggests an identification between Will the dreamer and the faculty that wills.

Interpreting the dreamer as at least partly representative of the faculty of the will places *Piers Plowman* within the tradition of allegorical dream poems, such as *Le Roman de la rose,* that dramatize the inner workings of human psychology. More importantly, however, it allows the poem to indicate a generalizable path towards transcendent knowledge. By presenting as its protagonist a figure of one of the inner powers that everyone shares rather than a specific individual, the poem can illuminate the ways in which anyone might strive towards knowledge of the divine.[4] The possibility of generalizing Will's experience makes *Piers* a poem about the journey of both an individual character (Will) and an "Everyman," represented by one of the faculties with which the human subject was most identified. Not incidentally, this faculty is instrumental in the soul's preparation for divine union and visionary experience. In *Piers Plowman,* Will proceeds, in a halting and at times erratic fashion, through encounters with such other faculties as Conscience, Reason, Wit, Kynde Wit, Inwit, Thought, and Ymaginatif; engages in conversation with Study, Clergy, Scripture, and

2. Bowers, 182.

3. William Langland, *The Vision of Piers Plowman,* ed. A. V. C. Schmidt (London: Everyman, 2001) B.8.124–27. All citations refer to this edition of the B-text. I have found a happy echo of my own reasons for selecting this edition in William Rogers' *Interpretation in* Piers Plowman: "I am talking about the B-text . . . because the B-text is what most critics talk about. I quote from the edition of A. V. C. Schmidt because that edition is inexpensive, accessible, and good" (William Elford Rogers, *Interpretation in* Piers Plowman [Washington, DC: Catholic University of America Press, 2002] 29).

4. Several of Chaucer's dream poems, such as *The Book of the Duchess* and *The House of Fame,* expressly focus on a named individual ("Geffrey") rather than a common faculty, characteristic, or human type. These poems do not as readily yield the "universal" messages that can be found in, for instance, *Le Roman de la rose* (whose protagonist, Amant, could be a figure of any lover, or the sexually desiring part of a person).

Holy Church; and witnesses the antics of the sins. In these sections of the poem, Will's journey represents a series of confrontations with the various aides and obstacles that the will faces on the way to a significant relationship with the divine. These essentially educative moments in the narrative sometimes help and sometimes hinder him in his quest for the revelatory experience that he desires.

Piers Plowman implicitly advances a theory of visionary knowing, exploring several paths towards a deeper understanding of the divine— specifically language and the use of the rational faculties—to ultimately demonstrate that each is in itself inadequate to provide the "kynde knowing" that Will seeks. While Will seems to meet with repeated failure in his search, however, he nonetheless retains the hope that revelation will occur and visionary knowing be achieved. It is only by recognizing the limitations of linguistic reference and of the rational faculties as paths to divine knowledge, by abandoning his conviction of these tools' efficacy and becoming a "fool," that the dreamer is able to approach a true understanding of the divine.

In this chapter, I will consider several aspects of Will's quest for knowledge. First, I will examine the way in which the poem questions the stability of linguistic reference as exemplified in the search for Dowel that spans roughly Passus 8–14. Will's search implies that it might be possible to know God through language, but the definitional explanations of Dowel that Will receives do not lead to the kind of knowledge that he desires. The search for Dowel demonstrates the limitations of definitional knowledge and *scientia,* as the dreamer's desire to understand Dowel as a person and as a concept brings him to the limits of language as a means of accessing divine truth. In this way, the quest for Dowel echoes the major issues in Marguerite d'Oingt's search for the meaning of *vehemens.* Second, I will consider the limitations of the individual faculties of the human mind as they emerge in the poem and their implications for the educative approach to divine knowledge. Much of Will's search for Dowel concerns his interrogation of the faculties and their representatives; these dialogues demonstrate the insufficiency of Thought, Wit, and the others to provide a complete picture of the concept that they attempt to explain. The inadequacy of their answers suggests the fallibility of the model of visionary knowing that can be found in Julian of Norwich, where the interpretive activity of the visionary is the key to understanding her visions. The limitations of linguistic definition and of the faculties ultimately present a series of obstacles that the will must confront and overcome if the dreamer is to obtain a greater understanding of the divine. These aspects of Will's journey have important implications for the role of the will in visionary

knowing. The dreamer, as a figure of the will, follows its vagaries through-
out his quest; as his will becomes increasingly focused, its movements
prepare him for the eschatological visions of Passus 18. Unlike Gertrude
of Helfta, Will is not volitionally united with Christ, but his long quest—
through the search for Dowel and the disputations with the faculties—grad-
ually refines his will, intensifying his desire for an understanding of God's
works. It is this intensification, the focusing of his desire upon the divine,
that finally brings him fleetingly into harmony with God and enables him
to achieve his brief moment of visionary understanding. *Piers Plowman*
thus explores the obstacles along the dreamer's way to visionary knowing,
but without rejecting the possibility that such knowing can occur.

I should note that I will deal only briefly with the question of whether
Will gains knowledge in his final eschatological vision; my focus in this
chapter is on what enables him to have this particular vision in the first
place. *Piers Plowman* is constructed as a series of visions, but only the
visions in Passus 18—of the passion and the harrowing of hell—are of the
sort that most eschatological and mystical vision texts usually describe. It
is therefore worth considering how the dreamer gets from his initial vision
of the field of folk and the trial of Lady Meed to the vision of Christ's
death—how he moves, in essence, from a largely educative mode to revela-
tion. How is knowing figured in his earlier visions, and what knowledge
does he gain in preparation for the later visions? Exploring these questions
will yield a more complete sense of the treatment of visionary knowing
in the poem, by establishing the necessary grounds for that knowing, than
would an analysis of his response to the visions of Christ alone. Yet, in
order to clarify my approach to the poem as a whole, I will explain my take
on the poem's resolution, since this is an area that has generated consider-
able critical controversy and because my interpretation of the concluding
sections of the poem informs my reading of the earlier Passus.

I believe that Will's journey is, finally, successful, if not resoundingly
so. Will's reaction to the vision of Christ that he receives in Passus 18, when
he awakens and implores his wife and daughter to join him in church—
"Ariseth and go reverenceth Goddes resurexion, / And crepeth to the cros
on knees, and kisseth it for a juwel!" (18.429–430)—represents a real con-
version to a deeper faith in and understanding of Christ's passion that is
brought about through visionary revelation.[5] At this point, for the first time

5. Many critics do not share the view that Will obtains visionary knowledge or reaps any
real spiritual benefit from his vision. To give just two examples: in his analysis of *acedia*, or
sloth, as Will's besetting sin, Bowers asks whether the vision "represent[s] a natural extension
of Will's meditation on the meaning of the Mass, or . . . [whether it comes] unexpectedly as a
gift of grace to a man who may not have deserved it?" (156). Arguing from a different angle,

in the poem, Will is moved to actually perform a devotional act. Although that act may not be performed in an ideal manner (he does, after all, immediately fall asleep again), his action nonetheless indicates a new urgency in his devotional impulse. The fact that this experience does not lead to a permanent and *static* change, as is evident from the siege of Unity Holy Church in Passus 19 and 20, does not invalidate the transformative effect of the revelatory experience. In *Piers Plowman,* the path to knowledge is not a straight line but a continuous process that constantly circles back to its beginning. The poem concludes with Conscience's vow to "walken as wide as the world lasteth, / To seken Piers the Plowman" (20.382–83). This decision, which echoes Will's earlier pilgrimages in search of Dowel and Piers, suggests that the transformation achieved through the vision of Christ is neither permanent nor complete and that the quest for kynde knowing must continue beyond the epiphanic moment of visionary understanding. But Conscience's decision to embark on a new pilgrimage at the end of the poem does not negate the transformation that occurs at the end of Passus 18. It signifies, instead, the inconclusive nature of revelatory experience. Following the vision is a return to the difficulties and trials of waking life: the vision does not mark the end of Will's spiritual journey, but his return to the difficult task of leading a life in harmony with God's will.

The overarching concerns of *Piers Plowman* are consistent with the interpretation of Conscience's pilgrimage as a continuation, rather than an invalidation, of the effects of Will's eschatological vision. The poem as a whole is about the difficulties of approaching God in this life, not about the bliss of divine union. Mary Davlin contends that having Will rest in the comfort of a visionary experience of God would be at odds with the purpose of the poem as a whole:

> the poem does not end with an arrival at the place of God. Where God is
> in *Piers Plowman* does not provide a comfortable ending to the narrative;
> it cannot, since the poem is about faith in this world, not sight in the next;
> and Will returns from his great Paschal vision of Christ to the problems of
> his contemporary world.[6]

David Benson, addressing the multiplicity of "authoritative" voices in the poem, notes that even Christ's words cannot ultimately be taken as the "direct authorial message of the poem" (C. David Benson, "What Then Does Langland Mean? Authorial and Textual Voices in *Piers Plowman,*" *The Yearbook of Langland Studies* 15 [2001]: 11); Benson develops this argument further in *Public Piers Plowman: Modern Scholarship and Late Medieval English Culture* (University Park, PA: Pennsylvania State University Press, 2004) 99–107. Both critics see Will's quest as inherently flawed and its conclusion accordingly suspect.

6. Mary Clemente Davlin, *The Place of God in* Piers Plowman *and Medieval Art* (Aldershot, UK: Ashgate, 2001) 34.

Similarly, Steven Kruger argues that the poem's ending underscores "the tension between Christian ideals and the hard, corporeal facts of life," a tension that has eschatological implications in that it "pulls the church— the marriage of abstract doctrine with the fallible custodians of doctrine— apart."[7] While they differ in the details of their arguments, both Davlin and Kruger share the view that the end of the poem highlights a contrast between the rarefied world of the revelatory moment and the tensions and problems of day-to-day life. David Benson's argument that the poem's conclusion shifts the responsibility for salvation out onto the reader, that Conscience's pilgrimage "must be undertaken by the poem's readers themselves,"[8] similarly posits the ending as a continuation of the vision, which seeks to confront the necessity—and challenge—of living a truly Christian life. Like *Pearl,* the conclusion of *Piers Plowman* exposes the difficulty of bringing the transcendent back into the mundane.

The transience of Will's moment of divine union acknowledges that the effects of a revelatory experience were usually fleeting. In mystical and visionary literature, the divine revelation is typically brief: "Mystics and theologians testify that even when faith blazes into moments of the loving communion of *sapientia* (wisdom or 'kynde knowyng'), these moments are partial and passing."[9] Visionary experience is often followed by moments of what has been called "spiritual dryness," a phrase that describes the anticlimactic return to the ordinary world following the temporary, fleeting experience of the vision. As John Bowers writes, "The vision eventually fades, the feeling of intimate union with God cannot last, and even the most accomplished mystic must descend from the mountain." Bowers cites evidence from Walter Hilton, Bernard of Clairvaux, Teresa of Jésus, and Julian of Norwich to illustrate the range of forms that post-visionary lassitude could take.[10] Although Gertrude of Helfta claimed to have lived for most of her life in a continual enjoyment of the divine presence, avowals of long-lasting inspiration seem to have been rare.[11] More common were the

7. Steven F. Kruger, "Mirrors and the Trajectory of Vision in *Piers Plowman,*" *Speculum* 66.1 (1991): 92–93.

8. Benson, *Public Piers Plowman,* 125.

9. Mary Clemente Davlin, *A Game of Heuene: Word Play and the Meaning of* Piers Plowman *B* (Cambridge: D. S. Brewer, 1989) 119.

10. Bowers, 67–69.

11. Even Gertrude reports that the Lord was once absent from her for a period of eleven days—although she remarks that she "had to such an extent taken leave of my senses as to fail to notice the loss of such a treasure. For I do not remember feeling any sorrow, nor any desire to find it again. I cannot understand," she concludes, "what madness had taken hold of my mind" ("videns me tam deperditae dementiae quod non attenderem talem perdidisse thesaurum, non enim recordor me pro eo doluisse, vel aliquo saltem parvo desiderio reoptasse, quod nunc miror quae vesania mentem meam detinuerit," *Leg.* 2: 3.3, SC 2: 238–40; Winkworth, 98).

fleeting revelations, the brief moments of clear vision and deepened faith, which are echoed in Will's vision of Christ and the harrowing of hell. The ending of the poem does not, then, necessarily invalidate what has come before, and I believe that Will at least partly achieves the visionary experience and consequent knowledge that he craves.

Reading the poem through the lens of mystical visionary literature can help us to account for the apparent setbacks and reversals that haunt Will's journey towards that knowledge. Contained in the poem are elements of all of the aspects of visionary knowing that I have discussed earlier in this book: Marguerite d'Oingt's view of language as a bearer of revelation is problematized by the obscurity of Dowel as a linguistic referent; the importance of a volitional union with Christ, which is exemplified in Gertrude of Helfta and examined in *Pearl,* is interrogated through the use of a character named Will who seems incapable of finding a convincingly authoritative figure to guide and direct him; and the role of interpretation and intellectual engagement with the vision found in Julian of Norwich is challenged by the fact that neither Reason, Thought, nor Wit seems fully competent to guide Will on his quest. Yet the overall structure of the poem, which follows Will's journey through each of these modes of visionary knowing, eventually leads to an eschatological vision and a resolution, however short-lived these may be. The end of the poem implies a repetition of the beginning, a circular movement that demands the constant renewal of the quest for divine union.[12] To achieve an understanding of the divine, *Piers* suggests, requires working through *all* of the preceding approaches to God, none of which is in itself adequate for the ordinary seeker. Will is no saint, and his path to God is not the purified devotion of a Gertrude. As an ordinary person, he must muddle his way through the sometimes contradictory and

12. Critics differ on whether to read the poem as a linear sequence with a clear *telos* or as following a circular, recursive structure. Elizabeth Kirk argues that the poem does follow a linear—albeit spiraling—sequence (Elizabeth D. Kirk, *The Dream Thought of* Piers Plowman [New Haven: Yale University Press, 1972] 11). I am inclined to agree with Kirk's reading, although it is not universally accepted. Pamela Raabe, for example, claims that *Piers* is not at all linear, but describes "a quest whose end is in its beginning, and vice versa." Her argument rests upon the observation that the "trinitarian vision of each part as an expression of the whole underlies every allegory in the poem from beginning to end"; that is, that the poem constantly prefigures and "expresses" its overarching dynamic in each of its individual parts (Pamela Raabe, *Imitating God: The Allegory of Faith in* Piers Plowman B [Athens: University of Georgia Press, 1990] 57–58). While Raabe's analysis can help us to understand the mode of allegorical signification apparent in the poem, I find that the poem as a whole, though often self-referential and reiterative, can be mapped onto a plan that is at least loosely linear, and that its circling back upon itself is nonetheless part of a forward momentum. This can be seen, for example, in the way that the kind of visions Will has progressively changes from estates satire through the interrogation of the faculties to eschatological vision.

always insufficient recommendations of his inner faculties to arrive, finally, at a glimpse of an understanding of God. *Piers Plowman* thus provides an elaborate commentary on the inadequacies and problems associated with applying the methods of visionary knowing described in the earlier chapters to the experience of an unexceptional human being.

I. Language and *Sapientia* in the Quest for Dowel

One of the major obstacles to understanding in *Piers Plowman* is the polysemy of language. Puns, word play, and other instances of semantic confusion abound in the text, and Langland's complex treatment of language is vividly enacted in Will's quest for Dowel. The multiplicity of meanings which accrue to Dowel and Will's apparent misapprehension of how the word functions linguistically point out language's instability as a signifying system.[13] Whereas "Dowel" initially does not appear to be a complicated or ambiguous term, its appearance sparks a dramatic change in the poem's direction. The first mention of Dowel occurs in the pardon scene, when the priest translates *Et qui bona egerunt ibunt in vitam eternam; / Qui vero mala, in ignem eternum* (7.110a–10b) as, "'Do wel and have wel, and God shal have thi soule,' / And 'Do yvel and have yvel, and hope thow noon oother / That after thi deeth day the devel shal have thi soule!'" (7.112–14). Following the priest's words, Piers tears the pardon up in a rage; he vows that he will stop sowing, and "swynke noght so harde, / Ne aboute my bely joye so bisy be na moore; / Of preieres and of penaunce my plough shal ben herafter, / And wepen when I sholde slepe, though whete breed me faille" (7.118–21). The precise meaning of this episode has been much debated, but, whatever one makes of it, Piers' tearing of the pardon and the introduc-

13. In this section, I focus on only a single example of linguistic difficulty in *Piers*. The quest for Dowel, however, is one of the organizing patterns of the entire poem. I have therefore chosen to examine its relation to linguistic stability in the poem rather than considering more of the individual episodes that reveal problems of interpretation and signification. (For a thoughtful and thorough analysis of the thematization of linguistic and interpretive problems in the poem, see Davlin, *Game*.) A further reason for foregrounding this particular sequence is that it has a significant effect on Will's consciousness. Most of the other verbal battles and interpretive puzzles in the poem—such as the definition of the king in the Prologue (139–45) and the argument between the four sisters in Passus 18 (125–228, 410–419)—are merely *watched* by the dreamer, but the search for Dowel fundamentally concerns him and his development. In a consideration of the process by which the dreamer or visionary comes to gain transcendent knowledge, tracking such a motif is more fruitful than would be a summary of the various instances of linguistic play throughout the poem. And finally, considerations of space limit me to this one example. A comprehensive study of linguistic referentiality and interpretation in *Piers Plowman* would quickly overwhelm this book.

tion of the concept of Dowel initiate a major change in the dreamer's activity and in the action of the poem as a whole.[14] From this moment on, Will is less of a passive viewer—as he was during his initial visions of the trial of Lady Meed, of the rats and the mouse, of the repentance of the seven sins, and of the plowing scene—and becomes a much more active participant in his visions. The quest for Dowel is one of the major motivating events of the following seven Passus (8–14). But the question of what Dowel actually *is* is never quite answered—at least, not to Will's satisfaction. Part of the problem with Dowel is that it is never entirely clear how the word "Dowel" is intended to signify: whether it represents an allegorical figure, an action, or a state of being.

The grammatical ambiguity of the term "Dowel" generates a sense of language's instability, as what initially seems to be a self-evident verb (to "do well") transforms into an elusive character. This transformation first comes out of an apparent category mistake on Will's part. Following the reading of the pardon, in which "Do well" is given as an imperative, and Piers' destruction of the document, Will rather incongruously ventures forth "for to seke Dowel, / And frayned ful ofte of folk that I mette / If any wight wiste wher Dowel was at inne, / And what man he myghte be of many man I asked" (8.2–5). Will is looking for Dowel as though it were a person, located in physical space. At this point, in the beginning of his search, Will believes that he understands what "Dowel" is, as can be seen in his encounter with the friars early in Passus 8. His confidence in his own understanding is reflected in the bravado of his retort to the friars: "'*Contra!*' quod I as a clerc, and comsed to disputen" (8.20). When the friars claim that Dowel lives among them, he argues back, "'whoso synneth,' I seide, 'dooth yvele, as me thynketh, / And Dowel and Do-yvele mowe noght dwelle togideres'"

14. The significance of the pardon scene has been the focus of considerable study. Critics differ greatly in their interpretations of the meaning of this scene and why Piers would tear up a pardon that is little more than a quotation from the Athanasian Creed. Some scholars see the "pardon" as no real pardon at all. James Simpson, for example, contends that the scene demonstrates a rejection of paper pardons—"there *is* no pardon but 'Dowel,' and . . . paper pardons are, in consequence, of limited value." Piers' tearing of the pardon is therefore a "simultaneous affirmation of true pardon, and criticism of paper 'pardons'" (James Simpson, "The Transformation of Meaning: A Figure of Thought in *Piers Plowman*," *The Review of English Studies* 37.146 [1986]: 179). Others have seen the pardon scene as emblematic of the debate regarding the relative importance of works and grace. Denise Baker argues that Piers' rejection of the pardon signifies his rejection of the idea that works alone are sufficient for salvation and his reliance on the concept of grace. "Piers' change from plowman to penitent is a repudiation of the Nominalist claim that man can do good without grace. His affirmation of faith indicates that grace is operating in him; his vow to pray and do acts of penance demonstrates that he is cooperating with grace" (Denise N. Baker, "From Plowing to Penitence: *Piers Plowman* and Fourteenth-Century Theology," *Speculum* 55.4 [1980]: 721).

(8.23–24). Will begins from a place of assumed knowledge: he believes that he knows what it is that he is looking for and that all he needs is an address in order to embrace Dowel in the manner that the pardon prescribes. But Will and the friars have mutually exclusive understandings of what Dowel is. The friars understand Dowel as a characteristic or a verb, while Will sees it as a substantive noun. Writes Britton Harwood, "For the friar, 'dowel' is an attribute. . . . To the contrary, when the dreamer objects 'that dowel and do yuele mowe no3t dwelle togideres' (8.23), he means that one substance—for example, one person—cannot be another."[15] Will has apparently confused an attribute for a substance. Will might also be said to be displaying realist tendencies: taking an abstract term for a concrete substance, he is engaging in what William of Ockham would have called "a fallacy of a figure of speech." When he invests the abstract "do well" with "an independent reality"—an error that Ockham attributed to the diversity of language rather than "being" or "God"[16]—Will is fundamentally misunderstanding the object of his quest; from a nominalist perspective, it is no surprise that his quest is doomed to fail. Will's struggle to understand even how Dowel signifies underscores the conflict between these two views of language.

Will's conviction that Dowel is a substance rather than an attribute is most apparent in his assumption that Dowel can be located in space. Will's search for Dowel is initially figured as a search for a specific location: when Thought asks Wit to tell Will "Wher Dowel and Dobet and Dobest ben in londe" (8.125), "a question of meaning ('What was Dowel') is recast as a question of place . . . as if the two questions were identical or as if place is a basic clue to identity."[17] This grammatical confusion leads to a deeper misunderstanding of what it is that Will is seeking. Instead of trying to discover a quality or an action, his focus is outward as he attempts to find Dowel in the physical world, both within the dream and when he is awake. Will's belief that Dowel has an independent, external existence, exemplified in his assumption that Dowel is a man who can be found at an "inne" (8.4), reflects a confusion about the grammatical function of the word and thus of its signification. The dreamer's misunderstanding of what kind of word "Dowel" is—and it is, to some extent, an understandable misunderstanding, given the

15. Britton J. Harwood, "Langland's 'Kynde Knowyng' and the Quest for Christ," *Modern Philology* 80.3 (1983): 252. Similarly, Bowers argues that Will "confuses the verbal with a nominal" (34).

16. Gordon Leff, *The Dissolution of the Medieval Outlook: An Essay on Intellectual and Spiritual Change in the Fourteenth Century* (New York: New York University Press, 1976) 70.

17. Davlin, *Place*, 18.

allegorical world in which he finds himself[18]—leads him to seek a person outside of himself where he should be looking inward, correcting his own behavior.

The wealth of apparently divergent meanings that Will's quest for Dowel yields and his resulting confusion arise from this initial misunderstanding of Dowel's grammatical function. Most of the definitions that Will receives do not give him clues to the location of an external being, but suggest ways of effecting an inner change. Will's assumption that Dowel exists outside of himself means that such definitions cannot satisfy his curiosity, as the terms in which they are given conflict with his own interpretation. First, Thought defines Dowel, Dobet, and Dobest as "thre faire vertues. . . . / Whoso is trewe of his tunge and of his two handes, / And thorugh his labour or thorugh his land his liflode wynneth, / . . . / And is noght dronkelewe ne deynous, Dowel him folweth" (8.79–83). Under Thought's definition, Dowel is a network of conscientious behaviors that become a virtue, a way of being. Will is dissatisfied with this explanation, wishing for "more kynde knowynge . . . / How Dowel, Dobet and Dobest doon among the peple" (8.110–11). Where Thought's definition prescribes a series of behaviors that must be followed if one is to possess Dowel—attributes and actions, in other words, that could transform the dreamer—Will persists in seeking an external creature, someone outside of himself and "among the peple." Again, his problem is that he is focusing on what is external, rather than turning inwards to amend his own behavior. This error is repeated in his subsequent encounters with various interlocutors who attempt to define Dowel for him. Wit, for example, suggests that Dowel is, in fact, a person; Wit's Dowel, however, is not a character like Will or Piers, but an allegorical attribute that lives in the flesh, with Anima (9.1–9). Wit goes on to define Dowel as an action: "Dowel, my frend, is to doon as law techeth," he says (9.200). Although this answer appears straightforward, it does not conclude Will's quest. Instead, Will collects more definitions, some of which he only partly understands; for example, Scripture's discourse leads him to believe that Dowel and Dobet are "*dominus* and knyghthode" (10.330–31). Scripture responds that this is not so and, when she explains that salvation can be reached by loving God above all others, counseling Will on the importance of embracing charity and avoiding sin (10.346–70), Will responds with impatience: "This is a long lesson . . . and litel am I the wiser! / Where Dowel is or Dobet derkliche ye shewen" (10.371–72). Throughout these encounters, Will persists in believing that Dowel can

18. One might argue, in fact, that Will's assumption that Dowel is a person arises from exactly the same impulse that leads critics to argue that Will is representative of the will—a similarity that makes me, at least, more inclined to sympathize with him in his troubles.

be located in physical space and is therefore an entity external to himself. This is only a partial list of the wealth of definitions that Will collects in his search, and these accumulated explanations do not lead to Will's enlightenment; as late as Passus 15, he muses that "it was wonder longe / Er I koude kyndely knowe what was Dowel" (15.1–2).[19] His protracted search for an explanation of a term whose meaning initially appears self-evident yields only confusion, as every faculty clamors with a different definition.

It is tempting to claim that such confusion simply could not occur in a mystical vision text that claims a basis in lived experience and that Will's misguided quest marks a point of radical divergence from the visionary tradition. But Marguerite d'Oingt's desire to understand the word *vehemens* suggests that she and Will share a related attitude towards knowledge and understanding. Like Marguerite, Will is motivated by a desire for a profound knowledge of the meaning of a single word—a desire that expresses a belief in the transformative power of linguistic signification. The phrase "kynde knowing," which acts as a refrain throughout *Piers,* is applied to Will's desired understanding of Dowel. The word "kynde" means, roughly, "nature," and "kynde knowing" has usually been interpreted to mean knowledge that is both in accord with one's nature[20] and that goes deeply into one's "nature": an intuitive or experiential knowledge. Davlin's definition of the phrase as "a personal, loving, deep knowledge of Truth or Christ or God"[21] is typical. Although some controversy over the precise meaning of the phrase remains, it generally has been understood to signify a kind of knowing that is not rational or deductive—knowledge that is sapiential as opposed to scientific.[22] For example, Gillian Rudd describes the kind of knowledge of Dowel that Will seeks as "affective knowledge," or an understanding that cannot be attained through the "deductive faculties" of

19. Mary Carruthers offers a useful chart delineating many of the various definitions of Dowel that Will receives. See Carruthers, *Search,* 7.

20. Ibid., 82.

21. Mary Clemente Davlin, "Kynde Knowyng as a Major Theme in *Piers Plowman* B," *The Review of English Studies* 22.85 (1971): 2.

22. Part of the controversy over this term stems from Piers' use of the word "kynde" when he says, in his first appearance in the poem, "I knowe hym [Truth] as kyndely as clerc doth his hise bokes" (V.538). This line, writes Rogers, suggests that "kynde knowing" "is not *absolutely* opposed to book knowledge. . . . Thus we have Piers' own word for it that the relationship a cleric has with books can be described at least metaphorically as 'kynde knowynge.' Possibly, then, for some people (intellectuals?) 'kynde knowynge' comes at least initially through intimacy with texts or through reading the world as a text" (105). This line could be interpreted differently, however, to mean that clerks know their books in virtue of their (the clerks') nature: it is "natural" for a clerk to know his books well, since, by definition, clerks know books.

Thought, Wit, and Reason.[23] Will's frustration with the many definitions of Dowel that he receives can be explained by their failure to provide him with the kind of knowledge that he desires.

In several important ways, Marguerite's quest for the meaning of the word *vehemens* parallels Will's search for Dowel, revealing a similar faith in language's ability to reveal or express truth. Like Will, Marguerite is attracted to a word whose meaning she doesn't fully understand; also like Will, she goes in search of its meaning, asking a number of people what it might signify. Like him, she is not content with the simple answers that she receives and continues striving to comprehend the word in its fullest signification. Unlike Will, however, she ultimately turns to God for understanding, and her subsequent vision gives her a satisfactory, divinely-granted knowledge of the word's meaning that puts an end to her quest. Marguerite prays—asking that God "ostat" the word "dou cuor"—and receives a vision that allegorically expresses its meaning.[24] The standard definition of *vehemens* having proven inadequate, she is finally satisfied by a vision that grants her an affective understanding of its signification. The sudden rush of understanding that she experiences as a result of the vision and that puts an end to her quest is like kynde knowing. Her vision—the result of her prayer—is as unlike the simple definition "fort" as Will's interlocutors' definitions of Dowel are unlike his desired understanding of the word.

Yet Will seems to have gone somewhat astray in his quest for a kynde knowing of Dowel. Although he insists that he seeks a knowledge of Dowel that is "kynde" (sapiential, affective, experiential), his conviction that the answer can be found outside of himself—that Dowel is a substantive, not an attribute—suggests a fundamental paradox at the very heart of his quest. To understand Dowel "kyndely" would mean to acquire an *internal* sense of what Dowel means, within himself; by seeking Dowel outside of himself, however, he remains alienated from it. He does not understand that Dowel is an imperative, something in which he must engage, and kynde knowing therefore remains out of his grasp. Davlin sees the contradiction in Will's quest as evidence of a misapplication of the word "kynde." She argues that, in the *Vita de Dowel* (Passus 8–14),

> [Will] comes to use *kynde knowyng,* or *kenne me kyndeli,* in a polite, super-
> ficial way, meaning "Kindly tell me" or "I want a thorough (though theo-
> retical) knowledge," though by using the phrase at all he is still nominally

23. Gillian Rudd, *Managing Language in* Piers Plowman (Cambridge: D. S. Brewer, 1984) 25.

24. Marguerite d'Oingt, *Œuvres,* ed. Antonin Duraffour, Pierre Gardette, and Paulette Durdilly (Paris: Les Belles Lettres, 1965) 146.

seeking a deep loving knowledge or wisdom. That is, while still using the same words that Holy Church and Piers used—*kynde knowyng*—and thus reminding the reader of the glorious goal he set out to find, Will actually begins to deviate from the goal by seeking only a theoretical definition of Do Well, in the absurd hope that such a definition can satisfy him.[25]

The nominal definitions that Will has been collecting and his persistent attempts to apply them to an entity outside of himself reflect the "theoretical" level at which he seeks to understand Dowel. Yet he remains conscious of the gulf between the knowledge he has gained and the knowledge that he seeks, as is evinced in his continued dissatisfaction with the answers that Thought and the others give him. This dissatisfaction, in turn, drives him ever onward in his quest. Despite his confusion about the very nature of the knowledge that he craves, then, Will retains the hope that an understanding of Dowel is accessible—accessible, moreover, through language.

What, then, is the status of linguistic reference, if not in the poem as a whole, at least in the long quest for Dowel? Although I have been arguing that *Piers Plowman* shares Marguerite's confidence in the ability of linguistic understanding to ultimately yield kynde knowing, the differences between these two texts must be addressed. Most obviously, Will's bewildering wealth of definitions is given to him in a series of visions. Marguerite's unsatisfactory answer, on the other hand, is the product of a conventional human definition; her single vision yields an immediate and visceral understanding of the concept of *vehemens*. But it is not clear that Will's visions are of divine provenance, and the apparently conflicting information that his interlocutors give him is strong evidence that they are the products of his own mind rather than of God's will. They are therefore more closely analogous to Marguerite's interactions with human interlocutors, as the knowledge that they provide is limited by the capacities of the human mind rather than instilled from above. In his dialogues with Thought, Wit, Conscience, and the others, Will remains engaged in a process of deductive and analytic interpretation that produces a series of discrete definitions of Dowel. These definitions are not necessarily incompatible and could in fact be different aspects of a single concept, but their presentation—and Will's understanding of them as somehow referring to an entity outside of himself—keep them separate. His desire for knowledge, therefore, remains unsatisfied. Similarly, Marguerite initially attempts to understand *vehemens* by asking various people what they think the word means. Just as Marguerite is not content with these definitions, neither is Will; he contin-

25. Davlin, "Kynde," 3.

ues searching, even when he has accumulated an impressive list of answers and it is no longer clear what exactly he wants to learn.

There is something fundamentally inadequate, then, about Will's approach to Dowel. Bowers attributes this inadequacy to the insufficiency of language: "the three Do's," he argues, "are never meant to be thoroughly knowable through the words used to describe them."[26] Although verbal definitions of Dowel cannot be sufficient to grant Will kynde knowledge, however, Dowel itself nonetheless points to an underlying reality that can be grasped by the dreamer. Yet, in part because of Will's interpretation of Dowel's grammatical function, the word in itself cannot give him the understanding that he craves. In much the way that Marguerite's vision was necessary for her to understand *vehemens* fully, Will must have an affective, non-discursive experience in order to grasp Dowel. Language, in *Piers,* can refer to divine concepts—but not without a revelatory experience that synthesizes and points beyond the definitions given by the faculties.

Both Marguerite and Will obtain an affective understanding of the concepts that interest them through an experience that does not rely on definitional meaning or rational analysis. Marguerite is only satisfied with her understanding of *vehemens* once she has had her divine vision of the overturned tree. The vision, a non-discursive, allegorical scene that has a visceral effect on Marguerite, satisfies her search for meaning in a way that mere definitions could not. Will requires a similar experience in order to understand Dowel, and this experience occurs in his encounter with Haukyn, the Actif Man. In this episode—which, I will argue, is comparable to Marguerite's vision—the dreamer has a sudden, affective response that alters his perception of his relationship to Dowel.

The affective impact of Will's encounter with Haukyn is predicated on an emotional identification between the two characters that culminates in Will's powerful response to the other's repentance for his sins. Passus 14 concludes when Haukyn's demonstration of contrition awakens the dreamer: "'I were noght worthi, woot God,' quod Haukyn, 'to werien any clothes, / Ne neither sherte ne shoon, save for shame one / To covere my careyne,' quod he, and cride mercy faste, / And wepte and wailede—and therwith I awakede" (14.329–32). The introduction to Passus 15 makes it clear that Will has been profoundly affected by Haukyn's grief. "Ac after my wakynge it was wonder longe / Er I koude kyndely knowe what was Dowel. / And so my wit weex and wanyed til I a fool weere" (15.1–3). In a short space of time, Will has come a long way from the proud debater of the

26. Bowers, 34.

earlier Passus. What explains his response to Haukyn's repentance, when he had, as recently as Passus 13, argued so confidently with the Doctor on the subject of Dowel?[27] Will's admission that he has lost his "wit" and that he does not know Dowel suggests that Haukyn's grief has somehow undone the knowledge that he previously supposed himself to possess.

I propose that Will's vision of and identification with Haukyn enable him to see that he himself falls short of Dowel, as what was a matter of disputation, explanation, and intellectual understanding becomes a matter of emotional knowledge. In short, as a consequence of the scene with Haukyn, *ratio* gives way to *intellectus* and Will confronts the vast gulf separating him from the Christian ideal. As the opening lines of Passus 15 make clear, it is not the case that Will ever finds—in his words, kyndely knows—Dowel. Following the encounter with Haukyn, however, it is precisely the knowledge of Dowel's *absence* that is important. The process of self-perfection, of doing well, becomes an ever-renewing quest, a constant self-improvement, much as Conscience must begin the quest for Piers again at the very end of the poem. Will's apparent misunderstanding of the grammatical nature of Dowel therefore serves a purpose. If he had understood the meaning of Dowel from the outset, there would have been no quest and hence no striving. But in order to complete his quest, Will must turn inward and consider his own actions rather than continue to pursue a discursive understanding of Dowel. Prior to his encounter with Haukyn, he was only concerned with gaining a definitional understanding of the word. Haukyn becomes a vivid exemplar, a living example, of Will's own way of living and of its remoteness from the Christian ideal.[28]

The similarities between Will and Haukyn have been noted often.[29] Haukyn is a "mynstrall" although he cannot do anything related to the minstrel's art (13.225–35), and the uselessness of his creative activity is a reminder of Ymaginatif's denigration of Will's literary ambitions: "And thow medlest thee with makynge—and myghtest go seye thi Sauter" (12.16). More strikingly, Haukyn is "Yhabited as an heremyte, an ordre by hymselve" (13.285), recalling Will's early self-description: "In habite as an

27. See 13.78–118 and ff. for the scene between Will and the gluttonous Doctor.

28. Benson argues that Haukyn, with his sin-bespotted baptismal coat and his notion that it is impossible (or at least impractical) to live a truly Christian life, is "the most poignant example of how imperfectly ordinary laypeople live their faith" (*Public Piers Plowman,* 141). Will's "everyman" qualities, which I discuss above, support this reading, lending even more pathos to Will's grief over Haukyn's failures.

29. Carruthers stresses their similarities, arguing, "Haukyn is the fullest mirror image that Will encounters in the poem; thus, to understand Haukyn is to understand *kyndelich* Will's own deficiencies and faults" (*Search,* 115). Carruthers' use of "kyndelich" stresses Haukyn's relationship to nonrational, affective ways of knowing.

heremite unholy of werkes" (Pr.3). These echoing descriptions both sym-
bolically link the two characters and reinforce the fact that neither one of
them participates in the activities of any sanctioned religious order, each
roaming about the countryside on his own quasi-spiritual quest. These
similarities immediately tie the two together, suggesting a relational bond
between them. In Passus 14, Haukyn even becomes a sort of parodic echo
of Will, taking up his interrogation of Patience on the whereabouts of Char-
ity (14.97), the comparative merits of patient poverty and riches (14.101–
2), and the meaning of patience (14.275). Furthermore, although Haukyn
is specified as being "active," in contrast to Will, who is primarily engaged
in a quest for knowledge (and, of course, in dreaming), the object of Will's
quest indicates a way of reconciling even this difference. Haukyn is the
man who "does," while Will is trying to find a way of "doing" in the world.
The affinities between the two characters and the emphasis on Haukyn's
activity suggest that Haukyn is a possible Will, a vision of the dreamer's
active self.

Given the analogical relationship between Haukyn and Will, it is only
reasonable that the latter should respond powerfully to the former's grief.
When Haukyn realizes the magnitude of his sins, lamenting how "hard it
is . . . to lyve and to do synne" and that "Synne seweth us evere" (14.322–
23), Will's grief stems from his recognition of himself in the other's lapses.
Haukyn's plight also emphasizes the attributive (rather than substantive)
nature of Dowel. Haukyn is a man who does, but does not *do well,* and
who embodies the difficulty of consistently doing well. The stress on the
verb "do" in the narrator's summary of Haukyn's penance—he "weyled the
tyme / That evere he *dide dede* that deere God displesed" (14.324–25; my
emphasis)—underscores the importance of his actions and implies a verbal
echo with Dowel. Haukyn thus vividly depicts the failure of doing well
along with the grief that comes from a self-conscious understanding of that
failure.

What I would like to stress here is the non-discursive nature of the
Haukyn episode. In contrast to the lengthy conversations that Will has
had with Thought, Conscience, Reason, and the others, the encounter with
Haukyn has a profound effect on the dreamer that is neither analyzed nor
explained. Like Marguerite's vision of the overturned tree, Will's encounter
with Haukyn transforms his awareness of his quest and launches him into
a new stage in his search for a redeemed life. After this point, he becomes
a "fool" who can no longer follow the dictates of the world: "And leten me
for a lorel and looth to reverencen / Lordes or ladies or any lif ellis. . . . /
That folk helden me a fool," he claims (15.5–6, 10).[30] The episode with

30. Will's transformed, foolish state persists through Passus 18. The beginning of that

Haukyn has had the unbalancing effect that his discourse with the allegorical faculties did not. He is disoriented, thrown off course. Unlike his verbal sparring with Reason and the others, which leads only to disagreement and the continuation of his quest, Haukyn's acknowledegment of his sinful nature and his subsequent repentance effect a profound transformation in the dreamer, bringing him closer to the knowledge that he craves.

The Haukyn episode pushes Will closer to the kynde knowing that he seeks, not by giving him definitions but by undoing his intellectual moorings, instilling in him the sense of his *un*knowing. By his own admission, the episode does not give Will kynde knowledge of Dowel, as we have seen: "it was wonder longe / Er I koude kyndely knowe what was Dowel" (15.1–2). Yet this very ignorance leads to a transformation in Will's sense of himself and of his rational capabilities. He goes on: "*And so* my wit weex and wanyed til I a foole weere" (15.3; my emphasis). The "waxing and waning" of his wits and his transformation into a fool are the result of the difficulty of discovering what (not, importantly, where) Dowel is in the world. While Dowel remains elusive, therefore, Will has in an important sense gained an understanding of it. First, he no longer seeks Dowel as a person, but as an attribute—he wishes to know *what* it is. Second, his lack of an intimate knowledge of Dowel (which means, perhaps, his recognition that he does not do well in his own life) leads him to reject the world, reflecting an awareness of the impossibility of truly doing well—in the Christian sense—while remaining attached to worldly things. Despite his protestations, then, in the example of Haukyn, Will does have an adequate representation of what it is to do well—or, at least, to *fail* to do well. The encounter has shown him his ignorance—and left him a fool.

Will's quest for knowledge shifts at this point from an educative to a revelatory mode. By recognizing himself and his failings in Haukyn and mourning those failings, he sees that his quest for a definitional meaning of a single word or allegorical figure is not sufficient. The encounter with Haukyn leads Will to recognize that his search for *scientia,* or rational knowledge, is misguided, and it propels him on to the eschatological visions of Passus 16–18. The change in the direction of his search is cemented in the vision immediately following his encounter with Haukyn, in which Anima warns him that his desire to know all things "kyndely" is, in fact,

Passus sees him "Wolleward and weetshoed . . . / As a recchelees renk that of no wo recdheth, / And yede forth lik a lorel al my lif tyme" (18.1–3). The dreamer's repeated description of himself as a fool in this section sustains the impression that he has effectively separated himself from the cares of the world. Finally, in Passus 20, Conscience's calling all the "fooles" to come together in Unity Holy Church (20.74–75) aligns this characteristic with a deeper understanding of spiritual truth, suggesting that Will, as a fool, is ready to enter Unity. I discuss the significance of Will's foolishness at greater length below.

"ayeins kynde" (15.53). Anima criticizes Will's intellectual pursuits, discoursing at length upon the dangers of learning, which at its worst leads to the sin of pride and distracts the seeker from the pursuit of virtue. Anima quotes Bernard of Clairvaux: *Sciencie appetitus hominem immortalitatis gloriam spoliavit* (15.63a). It would be more fruitful, Anima suggests, for Will to pursue self-understanding; "from Anima's perspective, one's understanding of salvation depends on the proper understanding of one's own consciousness."[31] The encounter with Haukyn has indicated to Will the fact that he has inadequately considered the state of his own soul; consequently, his goal must shift from the pursuit of Dowel to a more concentrated search for personal salvation. This shift is reflected in the nature of Will's visions from this point on. The next three Passus (16–18) are thematically different from those chronicling Will's search for Dowel. They trace the dreamer's search for Piers (16.167 ff.), his encounters with the Old Testament figures of Moses and Abraham, and finally the incarnation and the harrowing of hell. Overtly eschatological themes are far more evident in these Passus than they are in the earlier sections, tracking the shift in Will's curiosity from his obsessive quest for Dowel to his desire for a greater understanding of salvation history. Will's encounter with Haukyn thus acts as a catalyst, providing him with an affective experience that accomplishes what his discursive encounters with the faculties could not.[32] The Haukyn episode suggests that the search for linguistic meaning, by orienting the dreamer's desires towards a particular conceptual goal, can lead to his transformation. And that transformation occurs not through definitional understanding but through direct experience with a mirroring exemplum.

All of this does not mean that Dowel *as a word* ceases to signify. Will's quest for Dowel has brought him to Haukyn, a figure of the sinful, active man, which leads him to abandon the quest for a discursive understanding of Dowel and begin to recognize where he himself has fallen short of doing well. The word still signifies—but not through the partial, merely verbal definitions provided by the different faculties, each of which is too limited to convey its meaning in the "kynde" sense that Will desires. The quest itself—not the answers to the questions he has actually posed—brings him to the point of kynde knowing. The problem with language as a tool

31. Rogers, 128.

32. Although Anima also prompts this change, it is important to remember that Anima, too, is representative of Will's inner faculties, and Will's conversation with him can therefore be read as an internal change. Haukyn, however, is not clearly symbolic of Will's inner workings, but is rather a vision of an alternative self. The qualitative difference between the two figures shapes their different functions: the vision of Haukyn changes Will's orientation and the conversation with Anima develops and explains that change.

of visionary knowing in *Piers* is not, then, that language cannot point to divine reality or lead one closer to transcendent knowledge. The problem is that the faculties with which we are equipped—Thought, Reason, Conscience, Kind Wit—are never adequate to provide a fully developed understanding of a word's deeper signification. This point is driven home by the enormous range of possible signifying systems that the poem depicts: each faculty, in effect, has its own way of defining Dowel. Where Marguerite only receives one mundane definition for *vehemens* ("fort"), *Piers* provides an overwhelming multitude of meanings for Dowel. *Piers* thus complicates the notion of linguistic signification as a possible route to God by showing the many pitfalls that lie between an individual's consciousness and a true understanding of the signified. While language does not necessarily fail to point towards the divine reality underlying it, that reality is not accessible from the comfortable route of verbal definition. Instead, experience must be sought—experience and exempla—that will illustrate, through allegory and the sudden flash of insight brought about by divine grace, the theological truth that lies hidden within a single word.

II. Allegories of the Faculties: The Trouble with Reason

The problem of Dowel can be reframed as a problem of how the faculties lead—or fail to lead—the dreamer to transcendent knowledge. In light of the cognitive faculties' involvement in the visionary experience of mystics such as Julian of Norwich, this issue has considerable significance. In the *Showings,* I argued, interpretation and meditation are essential to Julian's visionary knowing; without performing her own cognitive work, she would not have understood much of her visions' content. The importance of Julian's intellect to her visionary experience is evident in her decision to exclude the Parable of the Lord and the Servant from the Short Version of the *Showings* because she could not "take therein full understanding to my ees in that time" (LT 51.56). Will's quest for Dowel, however, throws into doubt the faculties' ability to ever arrive at an adequate understanding of the divine.

Framing the different faculties' approaches to understanding as discrete interpretive systems, William Rogers argues that Will's quest for the meaning of Dowel reveals a great deal about how we know:

> the metaquestion, so to speak, that comes up again and again in the long middle of the poem is an epistemological question: "How do we know what something is?" Different interpretive systems produce different answers to

that question. . . . One way of separating the faculties of the human soul, in fact, is to say that wherever we have a distinct way of knowing what something is, there we have a distinct faculty. Langland is therefore also showing us the implications of various ways of interpreting (that is, analyzing) the human soul.[33]

Each of the faculties inherently produces a different way of seeing Dowel. When Conscience states that Dowel is contrition, Dobet is the will to amend oneself through grace, and Dobest is the satisfaction that follows repentance, we should not be surprised. It makes sense that Conscience would see Dowel as contrition rather than as the virtuous right living that Thought makes him out to be, because Conscience is concerned with contrition, repentance, and pardon. What Rogers' "metaquestion" suggests is that the search for Dowel is not only a search for knowledge but is also a search for *knowing.* By pursuing Dowel, Will is also exploring the variety of ways that the mental faculties approach a single concept and the kinds of knowledge that they provide.

One reason that the faculties fall short of fulfilling Will's desire is that by and large they are concerned with a deductive approach to knowledge that is not consonant with kynde knowing.[34] Thought, Clergy, Wit, Reason, and Study are emblematic of the rational cognitive faculties and the tools that they might employ. These faculties are prominent in Will's search for a definitional knowledge of Dowel, and initially they appear to be appropriate aides along his journey. Given the purported object of his quest—a definition of Dowel—it seems reasonable that these faculties and methods should lead him to the knowledge that he seeks. Deductive knowledge, or *scientia,* is consonant with the process of defining Dowel rationally and arises from the exercise of the *ratio.* Furthermore, as Rudd notes, Will's initial ignorance suggests that both *ratio* and *scientia* could be useful in his quest for Dowel:

> since he starts his quest lacking in knowledge he is surely right in selecting the form of learning which requires no prior knowledge, viz. the deductive approach and indeed his ability to engage in debate and judge the quality

33. Rogers, 210–11.

34. Admittedly, I am using "faculties" rather loosely. The allegorical figures that Will consults are not only the mental faculties, but also their tools, methods, and representatives; for example, Clergy and Study connote a reliance on authority and textual learning and stress ordered, rational approaches to knowledge. For the sake of brevity and convenience, I have sometimes considered all of these interlocutors together as "faculties," since they are related to the faculties.

of the arguments put forward increases throughout the poem. Given his apparently correct procedure, it is reasonable to expect that he should find what he is seeking in some degree. Yet his encounters with the deductive faculties are always in part unsatisfactory.[35]

These encounters are unsatisfactory because, despite his ignorance, Will's real goal is not merely definitional knowledge, and so the use of *ratio* alone must ultimately fail. As we have seen, what Will truly seeks is a kynde, or experiential and affective, knowledge of Dowel, and this type of knowledge is inherently inaccessible through the rational faculties. The experiential knowledge that is the real object of Will's quest is, Rudd states, "usually communicated through figurative and emotive language, not exacting argument."[36] Above, I suggested that the reason that the faculties must fail to provide Will with a thorough understanding of Dowel is that they are inherently partial and incomplete. For example, Conscience's view of Dowel as contrition (14.18–18a) and Study's understanding of Dowel as being accessible through Clergy (10.218–19) represent the logical concerns of these two figures. What Rudd's argument makes clear, however, is that the problem runs deeper than the partiality of their definitions. Instead, the very attempt to reach kynde knowing through these faculties is flawed because they can only arrive at knowledge through a deductive method that is fundamentally at odds with experiential and affective understanding.

In *Piers,* the allegorical figures that rely upon deductive argumentation are generally associated with those faculties that are involved in rational understanding. Their limitations thus have serious consequences for the role of the dreamer's cognitive faculties in interpreting his visions and arriving at an understanding of the divine. Aquinas' taxonomy of the psychological faculties emphasizes their role in both understanding and action. First, Kind Wit, a major character in Will's search for Dowel, is the "natural understanding of the first principles of the speculative as well as the practical intellect."[37] In Thomist psychology, Kind Wit is necessary for the movement of the *ratio,* which builds upon first principles to arrive at comprehensive understanding.[38] Reason, another major figure in Will's quest, obviously represents the rational powers; it is the faculty that is most

35. Rudd, 25.
36. Ibid.
37. Gerald Morgan, "The Meaning of Kind Wit, Conscience, and Reason in the First Vision of 'Piers Plowman,'" *Modern Philology* 84.4 (1987): 352–53.
38. Thomas Aquinas, *The Summa Theologica of Saint Thomas Aquinas,* ed. Daniel J. Sullivan, trans. Fathers of the English Dominican Province, vol. 1 (Chicago: Encyclopædia Britannica, 1952) 1: 79.8.

in operation when engaging in ratiocination and constructing deductive arguments. Finally, according to Aquinas, the conscience is the faculty that determines how one acts, and acts are what "connect knowledge to things." Conscience's relation to knowledge, Aquinas states, is reflected in its etymology (from *cum alio scientia,* that is, knowledge applied to something).[39] Several of the major allegorical figures who provide Will with definitional explanations of Dowel are therefore fundamentally implicated in cognitive processes. By questioning the cognitive faculties' suitability as counselors, Langland suggests that a rational approach to transcendent truth is bound to be limited and result only in unsatisfactory, partial knowledge. It appears that Will cannot arrive at kynde knowing through the use of these faculties.

The dreamer's allegorical significance—as the will, the guiding volition behind actions—casts an ironic light on these faculties' inability to provide him with meaningful guidance or knowledge. Medieval scholastic philosophers argued that the will was guided by the intellectual faculties; if these faculties are not capable of properly instructing Will/the will, the dreamer is at risk of being left without a reliable inner counselor. Conventionally, Reason, Conscience, and Kind Wit are seen as counselors of the will.[40] Gerald Morgan articulates their relationship to the will in more detail: "Kind Wit appoints the end, and Reason determines the means through counsel and judgment and executes it through command. Conscience is the fallible act of judgment."[41] Within the intellectualist model of faculties psychology advanced by Aquinas, then, Kind Wit, Reason, and Conscience are the cognitive faculties that are to direct the will and determine its course of action. Aquinas believed that the intellect was the prime faculty and that the "natural (i.e., innate, instinctive) orientation of the mind is or should be toward truth, knowledge, rational comprehension": when the rational intellect has decided on a course of action, the will simply follows along.[42] The failure of Will's interrogation of these figures therefore undermines the Thomist view of knowing and volition. Will is turning to authorities that no longer work correctly and that cannot, by their very nature, provide him with the type of understanding that he seeks.

The Franciscan voluntarists, on the other hand, believed the will to be prime and ideally oriented towards love and compassion; on this view, the will chooses a course of action which the intellect then supports.[43] Will's

39. Ibid.
40. Wimsatt, 106.
41. Morgan, 358.
42. Lois Roney, *Chaucer's Knight's Tale and Theories of Scholastic Psychology* (Tampa: University of South Florida Press, 1990) 22.
43. Ibid.

pursuit of the rational faculties' advice in his quest suggests a superficial adherence to the intellectualist, Thomist view—however, the inability of Reason, Thought, Kynde Wit, and the other faculties to provide him with sufficient information to change his course of action indicates the failure, or at least the limits, of this model.[44] Langland's apparent rejection of the majority of the faculties as suitable advisors to Will and his stress upon visionary experience indicate that his poem draws at least partly upon the Franciscan conviction that subjective experience is more suitable than the rational intellect to guide the movements of the will.[45] Fourteenth-century English Franciscans were deeply interested in affective experience, popularizing participatory visual meditation as a devotional technique. By meditating on the events of Christ's life, the Franciscans believed, one could gain an affective and even experiential understanding of the divine.[46] Along with this interest in affective experience, many Franciscans shared a strong belief in the importance of the will to human subjectivity. The roles of experience and of the will were intertwined in Franciscan thought, which invoked the effects of personal experience as a controlling measure over the volitional powers. As Bowers notes, Franciscans believed that by "subject[ing] all arguments to the test of personal experience . . . we can feel within our consciousness the will stirring itself to action and asserting complete volitional control over the other functions of the soul."[47] In contrast to a Thomist emphasis on the role of reason, kind wit, and conscience in the directing of the will, the Franciscans stressed the importance of affect and of experience. The faculties' failure to provide Will with an adequate knowledge of Dowel, then, could be construed as a rejection of Thomist principles in favor of a turn to the subjective and affective.

In the fourteenth century, the clash between Aquinas' Aristotelian, intellectualist model of the psychology of the faculties and the voluntarists'

44. As I discuss below, Conscience does play some part in the significant Haukyn episode and thus exerts an influence upon Will's behavior. In contrast to the other rational faculties, Conscience seems to be associated with the impact of affective experience upon the dreamer's consciousness.

45. Langland's apparent rejection of Thomist psychology and his interest in affective, subjective experience resonate with Lawrence Clopper's argument that Langland was himself a Franciscan. See Lawrence M. Clopper, *"Songes of Rechelesnesse": Langland and the Franciscans* (Ann Arbor: University of Michigan Press, 1997). The most commonly adduced evidence against Langland's Franciscanism are the virulent attacks on the friars that are scattered throughout *Piers;* in response, Clopper contends that these criticisms constitute a sort of insider's attack on the Franciscan order and that the poem also contains numerous "images of mendicant perfection" largely ignored in the critical literature (10).

46. See Denise Despres, *Ghostly Sights: Visual Meditation in Late-Medieval Culture* (Norman, OK: Pilgrim Books, 1989), especially chapter 2.

47. Bowers, 49.

privileging of the will and its orientation towards love and charity gave rise to a stress on the epistemological importance of personal experience. Ockham's insistence that valid inferences could only be based upon experience led him to abolish the notion of universal laws; what was known through experience he called "intuitive knowledge" and claimed was "the foundation of all knowledge."[48] Writes William Courtenay, "In place of the process of extracting or abstracting the universal focus from the particular, Ockham asserted that the mind intuited the particular and knew it directly and immediately."[49] An initial result of his innovations and the Franciscans' adoption of a voluntarist outlook was to indicate the limits of logic as an explanatory and deductive tool. Another consequence of this conflict was to destabilize the conception of universal knowledge and hence to privilege subjective experience. During this time, Lois Roney notes, there was "a growing tendency to question the possibility of universal certitudes and to focus instead on pastoral concerns, mysticism, and personal experience, all areas that foreground the subjective and the individual."[50] The foregrounding of personal experience shares the Franciscan stress on the subjective and affective above rational intellection. In the move from his dialogue with the faculties to the affective experience of Haukyn's repentance and, later, the vision of Christ's death, Will's experience maps this conflict. Where the wisdom imparted by Reason, Thought, Conscience, and the others is partial and imperfect, the vision of Haukyn impels Will into a new stage of his search, one that causes him to turn inward to examine his own conscience and prompts him to seek Piers, the figure of Christ.

While the faculties are not in themselves capable of granting Will sapiential or kynde knowing, however, they are able to help push him along in his quest. This is particularly true of the faculties that are not explicitly associated with deductive argumentation and scholarship: Conscience and Ymaginatif. (Although the conscience also figures into Aquinas' intellectualist model, it is concerned with will and action rather than deduction.) These faculties help to articulate between *scientia* and *sapientia;* accordingly, they appear at key moments in Will's quest. Conscience is among the last figures with whom Will speaks prior to his encounter with Haukyn, and it is Conscience—along with Patience—who counsels Haukyn, as well. Both Conscience and Patience play prominent roles in Passus 13 and 14,

48. Gordon Leff, *Medieval Thought from Saint Augustine to Ockham* (Harmondsworth, UK: Penguin Books, 1958) 281–82.

49. William J. Courtenay, "Nominalism and Late Medieval Religion," in *Covenant and Causality in Medieval Thought: Studies in Philosophy, Theology, and Economic Practice*, ed. Charles Trinkaus with Heiko A. Oberman (London: Variorum Reprints, 1984 [1974]) 44.

50. Roney, 51.

through the meal with the Doctor and the encounter with Haukyn. The fact that these figures appear between the dialogues with Reason, Thought, Clergy, and Study and the change in Will's consciousness that follows his vision of Haukyn positions the conscience as a point of articulation between the Thomist model of knowing and the Franciscan model of affective experience as the necessary grounds for knowledge. It is Conscience who gives Haukyn (and, therefore, Will) the definition of Dowel, Dobet, and Dobest as Confession, Amendment, and Satisfaction (14.18–22), and Haukyn's repentance at the end of the Passus (14.320–32) suggests that he has started along the path set forth by Conscience. The affective vision of Haukyn weeping, in turn, pushes Will's quest away from definitional knowledge and towards sapiential understanding. Conscience thus acts not as a counselor to the will, but rather as a driving force of change, a force that prompts a development in Will's consciousness that it is beyond Reason's power to initiate.

The role of Reason is further trumped by Ymaginatif, who, in an earlier Passus, provides a model of knowing that relies upon love instead of intellectual hunger. Ymaginatif's stress upon love is suggestive of voluntarist psychology: when one acts with love, one acts from the will rather than the intellect. As we might expect, Ymaginatif's theory of knowing is consistent with the role of the psychological faculty of the imagination. In medieval faculties psychology, the function of the imagination is to help the mind assimilate disparate bits of information. John Chamberlin, tracking the role of the *imaginatio* in Hugh of St. Victor, argues that imagination and reason work together to create a comprehensible view of the world: "The faculty of imagination (*imaginatio*) functions at the intersection of sense and spirit; it configures the data of sense experience, makes it susceptible to comprehension. . . . It is reason that is able to define and name what *imaginatio* presents to it."[51] True to this definition, Ymaginatif helps Will make sense of his conversation with Reason (11.411–32). Rudd notes that Ymaginatif is instrumental in changing Will's understanding of the knowledge that he received previously, making him more aware of the disparity between the knowledge that he craves and the knowledge that he seeks. The encounter with Ymaginatif, she argues, "shake[s] the dreamer out of his blinkered acceptance of the authority of knowledge as *scientia*."[52] Will's visions change in register from this point on, reflecting the shift in his understanding. Instead of the lengthy debates that characterized the preceding Passus, his visions become more allegorical and less didactic as he dines with the

51. John Chamberlin, *Medieval Arts Doctrines on Ambiguity and Their Place in Langland's Poetics* (Montreal: McGill-Queen's University Press, 2000) 114.
52. Rudd, 115.

gluttonous Doctor and encounters Haukyn. The move from predominantly didactic to increasingly allegorical visions reflects the change in the kind of knowledge to which Will has access following his encounter with Ymaginatif.

Ymaginatif's success in pushing Will towards a more appropriate understanding of the divine is grounded in his articulation of a balance between knowledge and faith. His conversation is scattered with reprimands; it is he who criticizes Will for "medl[ing] . . . with makynge" (12.16), chastises him for complaining about Reason (11.418–20), and, most importantly, makes it clear that Will's search for knowledge has been flawed: "Adam, the whiles he spak noght, hadde paradis at wille; / Ac whan he mamelede aboute mete and entremeted to knowe / The wisedom and the wit of God, he was put fram blisse," he declares (11.415–17). Early in the following Passus, he embarks on a lengthy diatribe against vain knowledge, quoting *Sapientia inflat* (12.57a) and *Nescit aliquis unde venit aut quo vadit* (12.69a). The knowledge attained through Clergy, he states, is an impediment to grace: "Ac grace is a gras therfore, tho grevaunces to abate. / Ac grace ne groweth noght but amonges gomes lowe" (12.59–60). Even more strongly, he says, "Ac grace is a gifte of God, and of greet love spryngeth; / Knew nevere clerk how it cometh forth, ne kynde wit the weyes" (12.68–69). These lines clearly criticize Clergy and Kynde Wit as inadequate— indeed, misguided—approaches to God. Up to this point, Ymaginatif seems to be arguing that knowledge is unnecessary and that it can even be an impediment to salvation. Not long thereafter, however, he adds that knowledge *is* important: using the analogy of two men drowning in the Thames, he asks, "Which trowestow of tho two in Themese is in moost drede— / He that nevere ne dyved ne noght kan of swymmyng, / Or the swymmere that is saaf by so himself like . . . ?" (12.164–66). On the surface, he presents two irreconcilable positions—one, that knowledge is not necessary for (and may, indeed, hinder) the reception of grace, and two, that knowledge can give one a distinct advantage. How can these two positions be reconciled, and what do they mean for Will's quest?

The answer can be found in Ymaginatif's image of the mirror as a figure of both Kind Wit and Clergy. This image suggests that, if properly applied, knowledge—and the pursuit thereof—can be used to amend one's life. The image appears in the middle of his discourse, between his condemnation of striving for excessive learning and his acknowledgement of the usefulness of knowledge:

Forthi I counseille thee for Cristes sake, clergie that thow lovye,
For kynde wit is of his kyn and neighe cosines bothe

To Oure Lorde, leve me—forthi love hem, I rede.
For bothe as mirours ben to amenden oure defautes,
And lederes for lewed men and for lettred bothe. (12.92–96)

Ymaginatif counsels Will to use Clergy and Kind Wit as tools for self-improvement. They can be "lederes" for both educated and uneducated alike, steering them towards betterment—but they are not ends in themselves. Like Marguerite's image of Christ's life as a speculum that provokes her to strive for self-perfection, Ymaginatif's analogy indicates a path towards the reconciliation of knowing and grace. By turning his knowledge inwards and using it to amend his life rather than enjoying it as an end in itself, Will's knowing may move him closer to the divine. In order for knowledge to aid in self-perfection, however, it must be directed by love. Ymaginatif specifies that knowledge should be pursued "for Cristes sake," and that Will must "love" Clergy and Kind Wit as Christ's "cousins." Ymaginatif thus functions as a reminder to Will that love is to be the guiding principle of his quest for knowledge, and that he must use what he has learned to amend his failings, rather than simply resting in the pride and vanity of knowledge for its own sake. This view represents a conviction that the proper orientation of the will is essential to right knowledge and, consequently, right action.

III. Becoming a Fool: Unknowing to Know God

In his conversations with the various faculties, Will's quest is not properly motivated. The fact that Will is not yet able to pursue knowledge with the appropriate measure of love or to apply that knowledge to the amendment of his faults marks a clear difference between Will's use of the faculties and Julian's. Julian uses her reason and cognitive abilities to better understand the messages hidden in her visions. She is guided by the faith that she had in Christ prior to her visionary experience ("I leeved sadlye alle the peynes of Criste as halye kyrke shewes and teches," ST 1.9–10) and also by God's injunction that she continue to meditate upon her visions (her "teching inwardly," LT 51.73–74). Her use of *ratio* to understand the mysteries buried in her vision of the Parable of the Lord and the Servant is sanctioned by God and informed by her preexisting faith. Moreover, the existence of the Short Text as a precursor to the Long indicates that she had already processed the surface content of her visions prior to using her cognitive faculties to penetrate their deeper meanings. Will, on the other hand, has not yet (at Passus 12, where he discourses with Ymaginatif) received his

eschatological vision. Indeed, up to this point, God has not been overtly manifest in his visionary experience. Other than Holy Church, Will's interlocutors primarily have been worldly representatives of the church (such as the friars), allegorical figures of the sins, representatives of the various classes of humankind, and his own inner faculties. For most of his quest, then, he has been trying to understand the divine through fundamentally worldly means, lacking a divine "text," such as Julian's visions, to use as the subject of his interrogation. His intellectual pursuit does not have the divine sanction or motivation necessary to bring him to a true knowledge of God.

Nonetheless, in teaching him precisely this lesson, the quest for Dowel and Will's dialogues with the various faculties do serve a purpose in furthering his search for a kynde knowing of Christ. Will learns that the faculties cannot provide him with the knowledge that he seeks. His realization of their inadequacy is most apparent in his descriptions of himself as a fool; such descriptions appear twice, and both times, the tenor of his journey shifts dramatically. The first occurs after his vision of Haukyn: "And so my wit weex and wanyed til I a fool weere; / And some lakkede my lif—allowed it fewe— / And leten me for a lorel and looth to reverencen / Lordes or ladies or any lif ellis" (15.3–6). This self-description is echoed at the beginning of Passus 18, shortly before Will receives his vision of Christ's passion and the harrowing of hell. Following his vision of the Samaritan in Passus 17, Will awakens, and "Wolleward and weetshoed wente I forth after / As a recchelees renk that of no wo reccheth, / And yede forth lik a lorel al my lif tyme, / Til I weex wery of the world and wilned eft to slepe . . ." (18.1–4). The phrase "al my lif tyme" suggests that, in the second instance, Will has become even more fully a fool, separating himself from the demands of the world and wandering in a state of increasing disorientation and desperation.

Will's lapses into foolishness occur at significant moments in the development of his visionary knowing, when his path shifts most visibly from educative to revelatory. Both of these passages follow scenes in which Will's prior attempt to obtain discursive knowledge from the faculties is trumped by a vision of an allegorical figure, Haukyn in the first instance and the Samaritan in the second. As I argued above, the first of these two passages marks the beginning of Will's renunciation of the world, and its placement after the vision of Haukyn indicates that his renunciation is prompted by the allegorical, non-definitional understanding of Dowel that this vision gives him. The affective vision of Haukyn leads Will to understand his relationship to Dowel in a way that his definitional quest for Dowel's meaning could not, and this brings him closer to the state of being a

holy fool, regretting his sins and ignoring worldly convention. The second passage follows Will's vision of the Samaritan, who attempts to explain to Will how God can be three people in one (17.125–350). The Samaritan begins his discourse with the observation that Conscience and Kynde Wit may contradict his requirement to "lovye / Thyn evenecristene evermoore eveneforthe with thiselve" (17.134–36), thereby suggesting that these faculties cannot be wholly relied upon to properly understand the mysteries of faith. He proceeds to offer two images of the Trinity that, being allegorical, are better grasped intuitively than rationally. The first is of the Trinity as a hand (palm, finger, and fist) (17.137–203), the second is of a torch or taper (17.204–51). These similes work like Marguerite's vision of the overturned tree, employing images that do not necessarily make discursive sense in order to instill an intuited understanding of a complex or abstract concept. Finally, the Samaritan concludes his monologue with a discourse on sin and repentance, emphasizing the fallibility of the flesh (17.329–34) and the importance of amending one's life in order to receive God's mercy (17.343–50). Like the vision of Haukyn, this episode reminds Will of the importance of examining and rectifying his own faults rather than seeking external knowledge. It is from this vision that Will awakens "like a lorel." In both cases, Will becomes a fool after an encounter in which knowledge is presented non-discursively and in which the rational faculties are not dominant. Nonrational understanding, presumably acquired through the *intellectus,* convinces him of the importance of self-examination and changes his relationship to the concepts that he seeks to understand. The effectiveness of this nonrational knowing undermines Will's confidence in his own reason and understanding and prepares him for the vision of Christ. He is thereby made ready for the eschatological vision and the knowledge of the divine that he craves.

In these encounters, Will's consciousness is transformed through allegory. In both cases, a vivid allegorical experience has an affective impact on the dreamer that the faculties' discourse has failed to achieve. Allegory has revelatory potential: in Suzanne Akbari's words, it "conveys meaning that cannot be expressed directly through ordinary language." Allegory's ability to express meaning "directly" comes from its capacity to circumvent the limitations of direct discourse. "[B]y avoiding the limitations inherent in literal language," Akbari writes, "allegory creates meaning *within* the reader, bypassing the inevitable degeneration of meaning as it passes through the obscuring veil of language."[53] In the Haukyn episode and the

53. Suzanne Conklin Akbari, *Seeing through the Veil: Optical Theory and Medieval Allegory* (Toronto: University of Toronto Press, 2004) 9.

Samaritan's images for the Trinity, *Piers Plowman* exploits allegory's ability to create meanings that go beyond literal comprehension. These allegorical moments, in contrast to the discursive arguments advanced by the cognitive faculties and their representatives, undo Will's presuppositions and lead him to a place of unknowing. His intellectual pride is replaced by disorientation and detachment from the things of the world. Allegorical visions, by providing Will with an affective experience and using visual imagery to circumvent the limitations of language, bring him closer to the knowing that he desires—but at the expense of his confidence in his rational powers.

In the end, Will's unsatisfactory conversations with the faculties channel his will towards the proper kind of understanding and knowledge by leading him away from his reliance upon reason. Linda Clifton has argued that Will's encounters with Thought, Wit, and Study are what allow him to progress in his quest, maintaining that these faculties enable Will's progress by channeling his will away from the "jangling" and sloth that characterize the dreamer's early preoccupations.[54] To some extent, I believe that this argument is correct. The faculties do help to hone Will's quest and push him further along in his mission. At the same time, however, the realization of their limitations—which occurs in his two moments of "foolishness"— are also instrumental to the development of Will's knowing. Overcoming his attachment to his rational capabilities is essential to the dreamer's visionary knowing. While I agree with Clifton, then, that the will must be properly directed in order to achieve visionary knowledge, I would add that in Will's case its proper channeling entails its direction not only away from the world but away from a reliance upon his own abilities, as well. That this is so is reflected in the timing of Will's eschatological vision, which follows hard upon his encounter with the Samaritan and his description of himself as "lik a lorel" whose "wit" has left him (18.3, 1). By acknowledging the limitations of his intellect, Will can adopt the kind of attitude towards knowledge advocated by Ymaginatif in Passus 12.

Piers Plowman depicts visionary knowing as an achievable goal. The path to such knowing, however, is fraught with difficulties and calls into question both linguistic understanding and the use of the faculties as epistemological tools. The quest for Dowel illustrates the inadequacy of definitional understanding as a means of achieving kynde knowing, or intuitive knowledge, of the divine; it is the living example of Haukyn as an Active Man who does *not* do well that finally enables Will to understand, if not

54. Linda J. Clifton, "Struggling with Will: Jangling, Sloth, and Thinking in *Piers Plowman* B," in *Suche Werkis to Werche: Essays on* Piers Plowman *B in Honor of David C. Fowler*, ed. Míceál F. Vaughan (East Lansing: Colleagues Press, 1993) 50–51.

the precise meaning of Dowel, at least what it is that he has been seeking all along. His inner faculties—of Reason, Thought, Kynde Wit, and so forth—are also revealed to be limited by their own restricted abilities and by the fact that Will's interrogation of the faculties is not divinely informed. Despite these obstacles, however, Will's will is, finally, brought into harmony with God's, but only by the rejection (or, less strongly, the realization of the limitations) of human interlocutors and the human faculties as ways of gaining a true understanding of the divine. By losing his orientation upon a particular goal—that is, going forth "Wolleward and weetshoed" rather than feverishly questing for answers to specific questions—he opens himself up to the possibility of receiving a divine vision and, with it, the movement of faith that prompts him to "Arise[] and go reverence[] Goddes resurexion" (18.429). In the end, his long quest has led him to *shed* confidence in the faculties and definitional understanding and rendered him capable of receiving a divine vision.

7

Discrediting the Vision
THE HOUSE OF FAME

 S I HAVE ARGUED in the preceding chapters, successful visionary knowing—the effective communication of knowledge of the divine through a vision or a dream—depends upon a number of factors. The visionary or dreamer must be volitionally united with his or her divine interlocutor and, in many cases, must engage in both passive and active epistemological practices. In addition to passively receiving the vision, that is, he or she may need to reason through and interpret it in order to fully comprehend its message. The volitional and rational orientations that make such comprehension possible are at least partly under the visionary's control. But the dream or vision itself must also meet certain criteria if it is to meaningfully convey knowledge to its recipient. Chief among these criteria is the presence of an authoritative figure within the vision. Dante's Beatrice, Boethius' Lady Philosophy, and even Raison in *Le Roman de la rose* all assume this role, transmitting knowledge to the dreamer through demonstration and discourse. The Pearl-Maiden, who speaks from a position of divine authority to instruct the dreaming Jeweler, fulfills this function, as well; her authority is confirmed by the fact that the dream ends when the Jeweler disobeys her in his attempt to cross the stream. These figures' messages are validated within the texts and, in most cases, the dreamers are changed by them. The presence of a clearly marked figure of authority seems to be necessary in dream vision narratives: without the validation of the dream's merit that this figure's presence implies, the dream is confused and the dreamer awakens without a clear understanding of its content. Such confusion occurs in *Piers Plowman,* where the proliferation of authorities—none of whom seems capable of granting Will the "kynde knowing" that he desires—troubles the assumption that a single figure of authority is adequate for the transmission of transcendent knowledge. But *Piers* continues to express the hope that visionary

experience is available and can transform the dreamer. Will's vision of the passion at least begins the process of bringing him into a potentially transformative relationship with the divine.

Where *Piers Plowman* undercuts the authority of the visionary interlocutor, however, *The House of Fame* annihilates it. Nothing in *Fame* can be pinned down as an unambiguous source of truth. This annihilation of authority is most radically realized in the poem's last lines, when Chaucer apparently abandons his poem immediately after the appearance of the "man of gret auctorite" (line 2158), cutting off the work's promise of visionary revelation.[1] Fame herself, the other seemingly authoritative figure in the poem, is openly fickle in her judgments, suggesting that she cannot reliably convey truth. Finally, Geffrey's vision is all about the uncertainty—even impossibility—of discerning the true from the false, as he witnesses "tydynges" "of fals and soth compouned" (1027, 1029) and sees both lies and true stories willingly "medle . . . ech with other" (2102). The ambiguity of all forms of visionary authority is thus a major issue in the poem. Chaucer's satirical take on the dream vision tradition suggests the arbitrariness of dreams and the unlikelihood of their effectively revealing truth.

The House of Fame's pervading characteristic is its debunking of the systems that help the individual to understand his or her world. As Kathryn Lynch has argued, Chaucer's text "parodies the logical systems that attempt to organize and give meaning to worldly diversity." Positing that Chaucer's satire of these systems is related to a late medieval skepticism regarding the accessibility of divine knowledge, Lynch concludes that *Fame* "multipl[ies] rather than simplif[ies] truths, possibilities, perspectives."[2] This multiplication of truths, as I will demonstrate, has particularly disturbing repercussions for the vision, a potentially privileged purveyor of knowledge. While the implications of *Fame*'s spoofing *Le Roman de la rose* and even the *Divina Commedia* remain within the context of a literary conversation, reading the poem as a commentary on visionary texts that claim a basis in lived experience suggests a broader view of the vision as an unreliable means of gaining knowledge. In addition, *Fame* exposes the limits of the dreamer's or visionary's ability to successfully discern the truth-content of a vision. As I have argued, the visionary must often play an active role in the interpretation and comprehension of the vision, a role that is fundamental to its transmission of knowledge. *Fame*'s treatment of authority as an essentially unstable and

1. All references to *The House of Fame* are from *The Riverside Chaucer*, ed. Larry D. Benson (Boston: Houghton Mifflin, 1987): 348–73.
2. Kathryn L. Lynch, *Chaucer's Philosophical Visions* (Cambridge: D. S. Brewer, 2000) 63–64.

ambiguous intermixing of truth and falsehood ultimately leaves us with no authority but the dreamer's—and Geffrey is anything but reliable. In this chapter, I will argue that *The House of Fame* destabilizes the possibility of visionary authority and, hence, of visionary knowing itself. The only potential authorities that emerge in *Fame* are Geffrey and the reader, and the vision as a potential source of knowledge deconstructs when these voices, rather than the voice of revelation, emerge as the primary sites of textual authority. Moreover, the centrality of the reader's role in establishing the value of the text parallels the foregrounding of the reader's response that is apparent in many purportedly authentic vision texts, in which the value of the visionary experience is determined by the visionary's impact and how the visionary is received by a broader audience. In Chaucer's pseudo-apocalyptic poem, the vision emerges as a bankrupt genre in which what knowledge that can be transmitted is unreliable and the transmission itself deeply flawed.

I. Unstable Authority: The Revelation that Never Comes

The House of Fame is in tension with the expectations of visionary literature, promising a revelation that it never reveals and featuring an inexperienced narrator more suited to one of the Canterbury Tales than to a heavenly vision. This tension is the crux of the poem. Chaucer satirizes the visionary tradition by depicting a vision that is epistemologically meaningless and that, in fact, thematizes meaningless speech. His dreamer is a parodic figure of the visionary: he makes hyperbolic claims to having experienced marvels but is almost too heavy to be borne up into the heavens. And while Geffrey says that, like Paul, he does not know whether his vision occurred in the spirit or in the flesh (981–82), his bodiliness is made evident when the eagle accuses him of being "noyous for to carye" (574). He is thus dramatically unlike those visionaries whose privileged relationship with God results in otherworldly bodily phenomena, such as Christina Mirabilis (1150–1224), whose sanctity gives her a kind of supernatural lightness that enables her to live in the treetops when the presence of other humans grows too oppressive.[3] While Christina is hardly typical, Geffrey's corpore-

3. "Christina fled the presence of men with wondrous horror into deserts, or to trees, or to the tops of castles or churches or any lofty structure. Thinking her to be possessed by demons, the people finally managed to capture her with great effort and to bind her with iron chains. . . . One night, with the help of God, her chains and fetters fell off and she escaped and fled into remote desert forests and there lived in trees after the manner of birds" (Thomas de Cantimpré, *The Life of Christina Mirabilis,* trans. Margot H. King [Toronto: Peregrina

ality suggests his distance from such models of extreme holiness,[4] and it is clear that his vision was received very much in the flesh. In the absence of any consistently authoritative frame, both the visionary experience and the visionary author are exposed as unreliable and earthbound, kept within limits that are determined by their corporeality. The wholesale undermining of any authoritative frame of reference within the poem—in the vision, in the narrator, and in the figure of authority who never quite appears—presents the vision as an unstable site of epistemic confusion.

The opening lines of *The House of Fame* forecast the epistemological ambiguity that will become a running current throughout the poem. In the Proem to Book 1, Geffrey expresses the difficulty of differentiating between truth-bearing and somatic dreams:

> For hyt is wonder, be the roode . . .
> Why that is an avision
> And why this a revelacion,
> Why this a drem, why that a sweven,
> And noght to every man lyche even;
> Why this a fantome, why these oracles,
> I not. . . . (2, 7–12)

In this passage, Geffrey questions the perceived boundaries between "visions" and "dreams," between "phantoms" and "oracles." The categories of dreams articulated by Macrobius[5]—for example, the hypnagogic *visum* and the prophetic *oraculum* ("fantome" and "oracle," 12)—are shown to be indeterminate, difficult if not impossible to tell apart in actual practice. Geffrey's confusion might not be simply the result of his own obtuseness; in fact, it points out a very real tension within the Macrobian categories that were so often used to organize and assess dreams. As Stephen Russell confirms, Macrobius' categories can seldom be kept discrete; for example, an apparent *visio* might also be a wish-fulfillment dream and hence an *insomnium*. Even within Macrobius' parameters, Russell argues, "the possibility that a dream might have originated in the waking concerns of the dreamer is, in and of itself, sufficient to raise questions about its authenticity."[6]

Publishing, 1989] 15).

4. See Caroline Walker Bynum, *Holy Feast and Holy Fast: The Religious Significance of Food to Medieval Women* (Berkeley: University of California Press, 1987) for more on bodily manifestations of sanctity.

5. These categories, which Macrobius describes in his *Comentarii in Somnium Scipionis,* were highly influential throughout the Middle Ages. For a more detailed discussion of the Macrobian categories, see chapter 1, footnote 31.

6. J. Stephen Russell, *The English Dream Vision: Anatomy of a Form* (Columbus: Ohio

Although Geffrey does not tell us about his "waking concerns" prior to the dream, his musings underscore the permeability of Macrobius' seemingly discrete categories. While the theoretical distinctions between a nightmare brought on by overeating and a prophetic dream of future catastrophe are well and good, then, such distinctions are hard to make in practice. Geffrey's interrogation of the boundary between "authentic," externally granted visions and meaningless, internally generated ones hints at the breakdown of the categorical distinctions between the different kinds of vision.

The narrator's blurring of the boundaries between truth-bearing and somatic visions also serves as an upfront declaration of *this* vision's ambiguous status. Although the epistemological status of the dream vision was a "much-debated topic" in the Middle Ages, Katherine Terrel notes, "the narrator's disparagement of dreams sheds doubt on the credibility of this work—and, indeed, of the entire genre of literature which claims to be based upon a dream or vision of the author."[7] Geffrey's questioning of the status of his vision contrasts with the corresponding declarations in *Piers Plowman* and *Le Roman de la rose,* where discussions of the problems of dream interpretation are coupled with assurances of the validity of the particular dreams described in the narratives.[8] *The House of Fame* goes further than both of these works in its effacement of the boundaries between the different kinds of dream: as far as Geffrey is concerned, at least, it is impossible to know whether a dream will be truthful, and the reasons that one person has a prophetic dream while another does not are obscure.

Despite his ignorance of what makes one dream true and another false, Geffrey is nonetheless invested in his dream's capacity to convey knowl-

State University Press, 1988) 163.

7. Katherine H. Terrel, "Reallocation of Hermeneutic Authority in Chaucer's *House of Fame,*" *The Chaucer Review* 31.3 (1997): 282–83.

8. Compare, for example, Will's remarks in *Piers Plowman,* where he draws from Cato to explain his uncertainty about the usefulness of interpreting dreams but then cites Biblical examples to provide evidence of prophetic dreams: "Ac I have no savour in songewarie, for I se it ofte faille; / Caton and canonistres couseillen us to leve / To sette sadnesse in songewarie—for *sompnia ne cures.* / Ac for the book Bible bereth witnesse / How Daniel divined the dremes of a kynge . . ." (William Langland, *The Vision of Piers Plowman,* ed. A. V. C. Schmidt [London: Everyman, 2001] B.7.149–53). Because the latter examples (he provides several more) draw from the Bible, they are by implication more authoritative than Cato's dismissal of the dream's potential. Guillaume de Lorris expresses the conviction that his dream is true even more strongly in the opening lines of the *Rose:* "Maintes genz cuident qu'en songe / N'ait se fable non et mençonge. / Mais on puet tel songe songier / Qui ne sont mie mençongier, / Ainz sont après bien aparant. / . . . / Quiconques cuit ne qui que die / Qu'il est folece et musardie / De croire que songes aveigne, / Qui ce voudra, por fol m'en teigne, / Car androit moi ai ge creance / Que songe sont senefiance / Des biens au genz et des anuiz, / Que li plusor songent de nuiz / Maintes choses covertement / Que l'en voit puis apertement" (Guillaume de Lorris and Jean de Meun, *Le Roman de la rose,* ed. Armand Strubel [Paris: Librairie Générale Française, 1992] 1–5, 11–20).

edge. This investment in his dream's potential is first hinted at in his understanding of prophecy. Geffrey's discussion of prophetic dreams implies a kind of backwards causality whereby the dream becomes prophetic once it has come true rather than foreshadowing a predestined event by virtue of being prophetic. He wonders "why th'effect folweth of somme, / And of somme hit shal never come" (5–6): why, he asks, are some dreams followed by the actual events that they foretell, and others not? While his question introduces the ambiguity of dreams—it is hard to know ahead of time whether a dream is prophetic—it also implies that a dream only becomes "true" after the fact, when what it has foretold has come to pass. On this understanding, the truth value of a dream can be changed—perhaps even manipulated—depending on what happens after the dream has taken place. This understanding implicitly places a high priority on the events that follow the dream: It is these events that determine the vision's value. If its prophetic nature cannot be apprehended in anything within the dream itself, but only in its consequences, then Geffrey will need to concern himself with the way that the dream is treated and interpreted following its narration. Already in the first lines of the poem, Chaucer suggests that the vision might draw its authenticity from something outside of itself and, as we will see, that Geffrey's vision's authority is similarly dependent upon external events for its validation.

Perhaps unsurprisingly, then, Geffrey is deeply concerned to control the consequences of his dream, and this concern is revealed in his anxiety over its interpretation. In the Proem and Invocation to Book 1, he expresses two convictions: first, that a dream can be meaningful, and second, that his dream may not be. The tension between these convictions is apparent in his uncertainty about what makes a dream true and in his general wish that all dreams might yield positive results ("God turne us every drem to goode!" (1); "the holy roode / Turne us every drem to goode," 57–58). But Geffrey is specifically concerned with the reception of his own dream. In spite of his uncertainty regarding prophetic dreams, he believes his dream to be of tremendous importance, remarking that it is as wonderful a dream as any man has ever had (59–62). And he is intent on conveying that wonder to his readers: despite his admission that he does not know what makes one dream true and another false, he is deeply invested in his dream's merit. But Geffrey sees the dream's value primarily in terms of its effects, rather than in any worth inherent in the dream itself. Those effects arise from the reader's response to the dream-narrative.[9]

9. For the sake of simplicity, I am using "readers," here, to designate Chaucer's audience in general: not just those who physically read the words on the page, but also those who heard it performed or had it read to them.

Early in the poem, Geffrey indicates the importance of the reader's properly appreciating his dream, declaring his hope that those who interpret it favorably will be rewarded:

> . . . shelde hem fro poverte and shonde,
> And from unhap and ech disese,
> And sende hem al that may hem plese,
> That take hit wel and skorne hyt noght,
> Ne hyt mysdemen in her thought
> Thorgh malicious entencion. (88–93)

This prayer could be nothing more than a courtly gesture towards his readers, expressing the hope that they will find favor with his poem. The next few lines, however, make it clear that something else is going on. In this hyperbolic passage, Geffrey expresses the wish that those who interpret his dream poorly or regard it with disfavor may be punished with every awful fate imaginable:

> And whoso thorgh presumpcion,
> Or hate, or skorn, or thorgh envye,
> Dispit, or jape, or vilanye,
> Mysdeme hyt, pray I Jesus God
> That (dreme he barefoot, dreme he shod),
> That every harm that any man
> Hath had syth the world began
> Befalle hym therof or he sterve. . . . (94–102)

In these two passages, the narrator produces a paradoxical situation for his readers, at once enjoining them to interpret the vision and severely limiting the interpretations that they are allowed to make. He essentially threatens the readers in an attempt to ensure that his dream will be well received— and, as Karla Taylor points out, he neglects to tell them what would constitute an acceptable reception.[10] Moreover, the passage's stress on the reader's inner state implies that there is a *morally* correct way to read and interpret the dream. Those who "take [the dream] wel" are those who do not misunderstand it as the result of "malicious entencion"; those who arrive at an unfavorable judgment of the poem do so through presumption, hate, scorn, or envy. Immoral readers, lacking in virtue, read badly, and good readers—

10. Karla Taylor, *Chaucer Reads 'The Divine Comedy'* (Stanford: Stanford University Press, 1989) 38–39.

that is, virtuous readers—are the only ones who are capable of properly understanding the dream. The narrator creates a bind for the reader, who cannot help but "take hit wel"; to do otherwise would be to admit to immorality and bad interpretive practice.

Implicit in Geffrey's threat to the reader is the assumption that the dream's effects constitute its meaning—a view that reflects medieval methods of assessing the origins of apparently divine visions. His concern with the effects of the vision are similar to the criteria used in *discretio spirituum,* or the discernment of spirits, a process that medieval clerics used to determine whether a vision was divinely inspired, demonically inspired, or simply fraudulent. The criteria for assessing a vision's legitimacy usually centered upon enquiries into its consequences, and in most accounts of the principles of *discretio,* the vision's effect is one of four major categories of evidence used to determine its validity. As Rosalynn Voaden notes, these four categories are typically "the virtue of the recipient, the circumstance of the apparition, the orthodoxy of the revelation, and the 'fruits' of the experience—that is, striving after goodness or succumbing to temptation."[11] For example, Alfonso de Jaen, whose treatise on *discretio,* the *Epistola Solitarii ad Reges,* was translated into Middle English,[12] lists seven criteria for determining the authenticity of a vision. Two of Alfonso's criteria concern the vision's effects: first, the visionary's soul must be inflamed by love for God following the vision, and second, the vision's "fruits" must be to the increase of God's glory.[13] That these "fruits" are largely undefined is consistent with the rather vague understanding of how *discretio* worked; some of its major medieval theorizers, such as Peter d'Ailly, expressed doubts that inquisitors could determine the veracity of visions at all.[14] Further evidence of a vision's authenticity could be found in the status of its prophecies, but this, too, was an uncertain method. If a prophecy came true, it was probably divinely inspired; however, the devil could also prophesy truthfully. In his remarks on the differences between divinely and demonically inspired visions, Augustine notes that visions brought on by evil spirits make their recipients "into demoniacs or fanatical enthusiasts or false prophets" while a good spirit "makes them faithful speakers of mysteries or true prophets."[15]

11. Rosalynn Voaden, *God's Words, Women's Voices: The Discernment of Spirits in the Writing of Late-Medieval Women Visionaries* (Woodbridge, UK: York Medieval Press, 1999) 48.

12. Ibid., 159.

13. Ibid., 50.

14. See Dyan Elliott, *Proving Woman: Female Spirituality and Inquisitional Culture in the Later Middle Ages* (Princeton: Princeton University Press, 2004) 257–63.

15. Augustine, "The Literal Meaning of Genesis," in *On Genesis (De Genesi),* trans. Edmund Hill and Matthew O'Connell, *The Works of Saint Augustine: A Translation for the*

At the same time, however, Augustine notes that demons are perfectly capable of granting true visions and prophecies.[16] In fact, only false prophecies can really contribute to the determination of a vision's truth, as prophesying incorrectly is proof that a vision was demonically, not divinely, inspired.[17] Geffrey's meditation upon the different kinds of dream and vision mirrors the ambiguity contained in the doctrines of *discretio spirituum,* echoing the links between effect and authenticity that arise in hagiographic and mystical literature. Although it was uncertain whether any particular outcome could definitively prove the authenticity of a vision, the vision's effect nonetheless contributed to the determination of its validity, and hence of the perceived truth of its content.

With a poetic text, the "effect" is, in large part, its reception. Geffrey makes it clear that he wants to secure a favorable reception for his dream, and his interest in controlling its interpretation suggests that his vision is valuable not for its intrinsic content but for the response that it receives. Like divine visions, whose effects are seen as a manifestation of their origins, the dream relies upon its aftereffects for its validation, and Geffrey's command shifts his vision's importance from its content onto the reader's interpretive responsibility. The problem is that Geffrey is concerned more with the reader's intention than with the correctness of his or her interpretation. As Frank Grady points out, "The effect of a dream is . . . tied not to correct interpretation but to the moral state and intention of the reader."[18] Framing the validity of the reader's interpretation in terms of his or her moral state also glosses over the question of whether the dream is of divine or somatic origin. Its significance "is not to be traced to the predispositions, obsessions, or digestion of the dreamer but to the ways in which readers are moved to respond and to act."[19] The vision itself ceases to be the site of authority, as the reader is made to bear responsibility for its meaning.

By foregrounding the interpretation of the vision, Chaucer highlights the importance of cognitive and interpretive work to the proper understanding of its content. In *Fame,* however, this work is to be performed not, as we have seen in texts such as Julian's *Showings,* by the dreamer, but by the reader. This emphasis on the reader's role stresses the importance of interpretive activity, but suggests further that the dream's meaning—its status

21st Century, vol. I.13, ed. John E. Rotelle (Hyde Park, NY: New City Press, 2002) XII.19, 41, p. 486.

16. Ibid., XII.13, 28, p. 478, and XII.17, 34, p. 482.

17. Elliott, 262; see also Nancy Caciola, *Discerning Spirits: Divine and Demonic Possession in the Middle Ages* (Ithaca: Cornell University Press, 2003) 290.

18. Frank Grady, "Chaucer Reading Langland: *The House of Fame,*" *Studies in the Age of Chaucer* 18 (1996): 17.

19. Ibid.

as "good" or "bad"—is malleable and subject to the shaping influence of its audience. Yet his threat indicates his determination to maintain control over his vision even after its written transmission takes it out of his hands. The poem thus takes an ambivalent stance on the intersection of interpretation and authority, as well as on what finally takes precedence: the reader's interpretation or the dreamer's authority as the dreamer of his dream and the author of his tale. On the one hand, the reader's response is acknowledged to be the locus of authority: the reader determines the text's value and meaning. On the other, Geffrey is unwilling to relinquish his controlling influence over its reception. And finally, the repeated prayer that God "turne us every drem to goode" suggests that the real determinant of the dream's value lies with neither the reader nor the dreamer-narrator but with the divine, and that it may ultimately be beyond anyone's control. In its construction of a triad of potential authorities—the dreamer-narrator, the reader, and God—*The House of Fame* presents the locus of visionary authority as indeterminate, shifting between the dreamer and the interpreting reader, with a nod to the final authority of the divine. But God never makes an appearance in the poem, and Geffrey's acknowledgement that some dreams are meaningless implies that the divine simply may not be relevant to his dream. The triad is more accurately seen as a dyad: authority lies with the reader and/or the narrator, neither of whom is necessarily objective or even equipped to properly understand the vision.

Consistent with its shifting locus of authority, the poem alternates between promising revelation and disavowing its possibility. Both implicit and explicit connections between this vision and the mystical visionary tradition are made throughout the poem. First, despite Geffrey's uncertainty about the provenance of his dream, he implies that his vision will convey marvels when he says, "no man elles . . . / Mette, I trowe stedfastly, / So wonderful a drem as I" (60–62). The eagle who sweeps Geffrey up into the heavens also indicates the dream's supernatural provenance. The eagle is sent from Jupiter, a god—albeit a pagan god—and the vision is therefore endowed with supernatural promise (608–09). Geffrey's lament that he is neither "Ennok, ne Elye, / Ne Romulus, ne Ganymede" (588–89) further implicates him within the revelatory tradition: while his comparisons are negative, his anxiety about his unlikeness to these Old Testament and classical figures, all of whom were granted glimpses of the heavens, suggests that his vision is comparable to theirs.[20] In spite of these thematic links with

20. Geffrey's remark also echoes Dante's words at the beginning of his vision: "Ma io, perché vinirvi? o chi 'l concede? / Io non Enëa, io non Paulo sono" (But I, why do I come there? And who allows it? I am not Aeneas, I am not Paul) (Dante, *The Divine Comedy,* trans. and ed. Charles S. Singleton, 3 vols. [Princeton: Princeton University Press, 1980], *Inferno*

the eschatological vision tradition, however, Geffrey's moment of revelation never arrives. The poem itself is apparently unfinished, and its concluding lines—"Atte laste y saugh a man, / Which that y [nevene] nat ne kan; / But he semed for to be / A man of gret auctorite" (2155–58)—terminate the vision at the precise moment when its visionary potential seems about to be fulfilled. Yet even if Chaucer had finished the poem, it is not certain that the unnamed man would have fulfilled the dream's revelatory promise. Geffrey cannot name the man, who only *seems* to be "of gret auctorite." While the poem toys with the expectations of visionary literature, then, its defining moment never arrives and perhaps never would have arrived at all.

The blurred boundaries between somatic and truth-bearing visions and the poem's ambiguous, unfulfilled promise of revelation undermine the authority of Geffrey's vision *as a vision.* Whatever implicit claims to authority it may have had by virtue of its belonging to the dream vision genre and its similarity to divine visions have been seriously troubled by the narrator's professed uncertainty regarding the provenance of his vision (and visions in general), as well as by the unstable relationship between the dreamer's control over his text and his audience's interpretation of it. By undermining these aspects of the dream vision, Chaucer also troubles the genre of vision literature more broadly. If the line between somatic and divinely inspired visions is called into question, and if the power to determine the merits of a vision might lie either with the reading audience or with the dreamer's ability to control that audience's interpretation, then what possible truth-value can the vision have? Both the origin and the reception of the vision are called into doubt.

The similarities between *Fame* and eschatological visions implicate the vision tradition more broadly within Chaucer's satirical take on the dream vision genre. In his appropriation and subversion of the characteristics of eschatological vision texts, the poet undermines the authoritative status of the genre itself. A number of scholars have examined *The House of Fame*'s satirical relationship to traditional eschatological visions like Revelations and the *Visio Pauli,* which detail otherworldly matters such as the Second Coming and the punishment of sinners in hell. Geffrey's startling ascent in the claws of an eagle, the appearance of Fame, and the apocalyptic fervor of Fame's court lend themselves to such a comparison. In his appropriation of the eschatological vision, however, Chaucer reinterprets the tradition in a way that divests it of its revelatory authority. Eschatological tropes are rearranged and misrepresented, thwarting readers' expectations for a

II.31–32). Numerous scholars have commented on the relationship between the *Commedia* and *Fame;* see note 29 below.

conventional visionary text. Robert Boenig notes that, while many of the "apocalyptic details" from Revelations appear in *Fame,* they are "arranged oddly, almost as if Chaucer had cut them out and put the fragments together in the wrong way."[21] One such "apocalyptic detail" is Lady Fame herself, whose seven lamps are the seven stars of Revelations 1:16[22] and who is covered with the multiple eyes that, in Revelations, belong to the worshipers.[23] Other details that Chaucer plays with include the trumpet of Eolus as a substitution for the trumpet of the last judgment, the smoke that emerges from both the Apocalyptic and the Eolean trumpets, and the scattering to different sections of the poem of the four beasts that symbolize the evangelists.[24] Through this rearrangement, Boenig argues, *Fame* suggests that reading— that is, interpretation—*is* fragmentation, as the interpreting readers "set themselves up as authors, as critics, as gods."[25] In addition to the elements that Boenig describes, the structure of *Fame* encourages the poem's identification with the eschatological tradition while simultaneously undercutting it. David Jeffrey notes that its tripartite structure, by hearkening to the "three-stage ascent toward understanding" common in eschatological visions, "invites careful reading according to that traditional framework, and in almost every respect encourages the reader to anticipate such an intellectual journey as he or she might find in Augustine, Bonaventure, [or] Dante." Yet, Jeffrey argues, the narrator's actual "ascent" thwarts such a reading, as his trajectory does not lead in a smooth arc towards the knowledge that he is presumably intended to acquire.[26] In both its details and its overall structure, *The House of Fame* invokes the traditional elements of the otherworldly vision but ultimately plays with those elements in a way that distances it from the tradition that it purports to mimic.

The poem's reconfiguration of its eschatological content has important implications for the work's meaning. Lisa Kiser argues that one of the major differences between *The House of Fame* and eschatological visions is that *Fame* deals, not with the afterlife of souls, but with "the afterlife of words."[27] Instead of describing the specific rewards and punishments that

21. Robert Boenig, "The Fragmentation of Visionary Iconography in Chaucer's *House of Fame* and the *Cloisters Apocalypse*," in *So Rich a Tapestry: The Sister Arts and Cultural Studies,* ed. Pam Hurley and Kate Greenspan (Lewisburg: Bucknell University Press, 1995) 184.

22. Ibid.

23. Ibid., 187.

24. Ibid., 184.

25. Ibid., 197.

26. David Lyle Jeffrey, "Sacred and Secular Scripture: Authority and Interpretation in *The House of Fame,*" in *Chaucer and Scriptural Tradition,* ed. David Lyle Jeffrey (Ottawa: University of Ottawa Press, 1984) 207.

27. Lisa J. Kiser, *Truth and Textuality in Chaucer's Poetry* (Hanover: University Press of

individual souls undergo after death, Chaucer focuses upon the ultimate fate of language. In concerning himself with words rather than souls, he disclaims the visionary tradition while also establishing it as a source: "he clearly avoids the normative theological content of the religious vision, yet he nonetheless depends heavily on the conventions of the genre."[28] By borrowing from the eschatological tradition, Chaucer is able to underscore the difference between his text and the traditions inhering in both purportedly authentic visionary writing and literary dream visions, which are invoked throughout the poem.[29]

Chaucer's appropriation and reconfiguration of the eschatological vision tradition enables him to propose a radically different understanding of his poem's subject. Chaucer plays upon the characteristic elements of eschatological material in order to create new meanings, focusing on words rather than souls and using the revelatory mode to undermine the authority of language. The subversion of authoritative source material is a part of Chaucer's method of appropriation. By simultaneously acknowledging and disavowing his source material—as he does openly in his retelling of the Dido and Aeneas myth in Book 1, which I discuss in the next section—Chaucer problematizes the very genres to which his poem belongs. His satire of the eschatological tradition invests that tradition with new meaning, deliberately shifting it away from its customary implications.

II. Uncertain Meanings: The Power of the Reader

By investing traditional literary structures with new meaning, Chaucer subverts the basis of authority in his poem. Far from being an authorizing technique, the narrator's emphasis upon his own meanings—rather than traditional, received authority—calls into question the poem's ability to convey truth. While the interpretive instability that the poem highlights justifies Geffrey's concern with the reception of his dream, at the same time his own reading practices point out the difficulty of controlling a wayward reader and makes his preoccupation with the reader's judgment of his text all too appropriate. Geffrey's retelling of the story of Dido and Aeneas par-

New England, 1991) 27.

28. Ibid.

29. The influence of other literary visions, especially the *Divina Commedia,* on Chaucer's poem has been explored by a number of scholars. For an analysis of the relationship between *Fame* and the *Commedia,* see, for example, Karla Taylor, *Chaucer Reads 'The Divine Comedy'*; Roberta L. Payne, *The Influence of Dante on Medieval English Dream Visions* (New York: Peter Lang, 1989); and Suzanne Conklin Akbari, *Seeing through the Veil: Optical Theory and Medieval Allegory* (Toronto: University of Toronto Press, 2004) 203.

allels Chaucer's reconfiguration of the apocalyptic tradition and illustrates how narrative appropriation can undermine the narrator's credibility as a truthful, authoritative speaker: his fluid reworking of the myth demonstrates the reader's ability to effectively re-author his source material.

Early in his vision, Geffrey finds himself in Venus' temple, reading the story of Troy that is inscribed upon its walls. He initially collapses Virgil's and Ovid's mutually incompatible interpretations of Aeneas' abandonment of Dido: where Virgil praises Aeneas' actions as an inescapable part of his heroic fate, Ovid emphasizes the dishonor of his leaving the woman who loved him.[30] Instead of focusing on one of these interpretations, Geffrey blends the two together, using elements from both in his narrative. In doing so, he points out the conflict between them without privileging one interpretation over the other: Aeneas cannot be both heroic *and* dishonorable, but Geffrey seems to be trying to include both readings in his narration.[31] Faced with this contradiction, he ultimately provides his own reading of the tale. His original additions to the story are signaled rhetorically by the sudden absence of references to the text that he has been reading. While the bulk of his account is peppered with variations of the phrase "I saw,"[32] Geffrey's contribution to the narrative lacks these authorizing claims. Instead, it includes such editorializing asides as, "Allas! what harm doth apparence, / Whan hit is fals in existence!" (265–66) and "browke I wel myn hed, / Ther may be under godlyhed / Kevered many a shrewed vice" (273–75), and even explicit references to his authorial originality, as when he adds, "Al this seye I" (286). By shifting from "saw I" to "say I," the narrator installs himself as an author of the legend. Writes Terrel, "Geffrey usurps interpretive control of the story from both sources and instead forges his own account of Dido's situation, ostensibly relying solely upon his own imaginative powers,"[33] as he himself implies when he declares, "Non other auctour alegge I" (314). Terrel sees this proclamation as Geffrey's "tak[ing] full responsibility for this portion of the tale,"[34] but the shift from received

30. Sheila Delany, *Chaucer's* House of Fame: *The Poetics of Skeptical Fideism* (Gainesville: University Press of Florida, 1994 [1972]) 50; Terrel, 285; Rosemarie P. McGerr, *Chaucer's Open Books: Resistance to Closure in Medieval Discourse* (Gainesville: University Press of Florida, 1998) 77. Karla Taylor further maintains that "Chaucer does not merely rewrite Virgil into Ovid" but also "adds new material" (29).

31. See Delany, 51.

32. "First sawgh I" (151); "next that sawgh I" (162); "And I saugh next" (174); "Ther sawgh I" (193); "Ther saugh I" (209); "Ther saugh I" (212); "Ther saugh I" (219); "Ther saugh I" (221); "Ther sawgh I" (253). Following his interjection, he resumes the authorizing technique of the earlier part of his telling: "Thoo sawgh I" (433); "also sawgh I" (439); "When I had seen al this syghte" (468).

33. Terrel, 284.

34. Ibid.

authority to individual interpretation also suggests the breakdown of any stable point of reference. Even his introduction to his retelling of the tale—"I wol now synge, yif I kan" (143)—indicates Geffrey's departure from accepted authority, as the qualification of his abilities opens up the possibility of inaccuracy.[35] Given multiple possible interpretations, no one perspective can be fully embraced—especially when (as in this case) we are given no particular reason to favor any single interpretation. As Taylor notes, "he does not attempt to reconcile his sources, but instead stitches them together with such obvious seams that they are shown to be irreconcilable." This juxtaposition, she argues, suggests that the conventional versions of the story and his invented additions are "equally fictive."[36] Geffrey's retelling of Dido's story, like Chaucer's reinvestment of the eschatological tradition, ultimately authorizes neither the tradition nor its reinterpretation. Instead, it points out the multiplicity of possible meanings and interpretations latent within the original tradition without providing the basis for selecting any one over another.

When Geffrey confronts the conflict between Virgil and Ovid with a detour through his own interpretation of the Dido myth, he posits himself as a co-author of the text that he is purporting to reproduce. Significantly, the myth appears in the poem as a text, and Geffrey is in the role of the reader. By moving away from the story as it is told in that text—"alegg[ing]" "non other auctour" but himself—Geffrey suggests that the reader can narrate with as much credibility as the poets whose works he or she reads. But Geffrey is not only a reader: he is also the dreamer and the author of his account, subject to the vision that he receives but controlling its representation in his narrative. His imaginative retelling of the Aeneas and Dido story implies that he might be treating his vision with imaginative fluidity, as well. How are we to know whether he is accurately relating the events of his dream or, alternatively, investing them with original interpretations and adding details to his narrative? But while this incident might undermine Geffrey's authority as a reliable narrator, it also recalls the concern about interpretation articulated in his threat to the reader. For if Geffrey, as the reader of the story of Troy, is free to craft his own interpretation of that story, then the reader of his vision may be equally free to interpret *it* as he or she chooses, as well. Geffrey's attempt to control the reader's interpretation of his dream-narrative is a response to the flexibility of interpretive authority, which he enacts in his retelling of the myth.

35. Taylor observes that this line "is distinctly un-Virgilian; indeed, it is characteristically Chaucerian" in its "almost personal signature of new authorship" (28).

36. Ibid., 29.

Interpretive authority is presented as a problem throughout the text. The eagle who carries Geffrey to Fame's house observes that all speech, once it has left its speaker's mouth, becomes essentially the same phenomenon, suggesting that no particular speech act is any more authoritative than any other. Explaining how sound reaches Fame's palace, he tells Geffrey,

> Soun ys noght but eyr ybroken:
> And every speche that ys spoken,
> Lowd or pryvee, foul or fair,
> In his substaunce ys but air;
> For as flaumbe ys but lyghted smoke,
> Ryght soo soun ys air ybroke. (765–70)

That he is speaking of language as well as noise is clear in his explanation of the shared fate of *all* sounds: "every speche, or noyse, or soun . . . Mot nede come to Fames Hous" (783, 786), he says. Sound, in other words, is radically democratized: each utterance, no matter how meaningful (or meaningless) it might seem, is ultimately reduced to the same physical phenomenon. These sounds mix and blend together, "fals and soth compouned" (1029)—and indeed, even the tidings of love that the eagle has promised Geffrey will be "Both sothe sawes and lesinges" (676), calling into question the legitimacy of the promised visionary message itself. This democratization of sound, argues Suzanne Akbari, "underlines the contingent nature of all knowledge, as coherent images give way to noisy confusion."[37] No speech act is inherently authoritative; no utterance retains its privileged place in the "afterlife." In contrast to Dante's hierarchically arranged paradise, in the House of Fame, even the loftiest statements are on the same plane as the meaningless squeaks of a mouse (785).

The democratization of speech undermines the notion of a single, privileged source of authority. In addition, the fallibility of all speech is highlighted by the fact that at Fame's house some words are represented by the forms of their human speakers (1076–77). By reincarnating speech in the image of its speaker, the disembodied authority of a given utterance is reduced to its human, and hence imperfect, source. Laurel Amtower sees the presence of commonplace speech within Fame's palace as evidence of *"humanized* authority, authority granted by humanity itself," as words achieve "immortality and grandeur" from having "traveled so far from their fallible source."[38]

37. Akbari, 209.

38. Laurel Amtower, "Authorizing the Reader in Chaucer's *House of Fame," Philological Quarterly* 79.3 (2000): 279; italics in original.

But humanized authority threatens to be no kind of authority at all. In the world of Fame, a word's "fallible source" reappears as its representative, reducing even the esteemed authority of Homer's speech to the utterance of a subjective human being: an unnamed bystander asserts that Homer was too partial to the Greeks to be considered reliable ("Oon seyde that Omer made lyes, / Feynynge in his poetries, / And was to Grekes favorable; / Therefor held he hyt but fable," 1477–80). This anonymous accusation meets with no rebuttal: it is left on its own, as a possible truth, and Chaucer's reader is given no further basis upon which to assess Homer's poetic virtue. Taylor argues that this indicates "a radically different means of truth: not the imaged truth of historical events . . . but the truth of the teller." Authority is the authority of the reporter, not of the events themselves.[39] As a result, the hearer has no immediately discernible way of discriminating historically true tales from false ones or of weighing the merits of one teller against another's. When language is represented by its human speaker, it becomes as fallible as that speaker and its authoritative status dissipates. In contrast to divinely authorized speech, human speech is subject to interpretation, bias, and misunderstanding. The democratization of the clamoring sounds in Fame's house yields no coherent basis for choosing one utterance over another, and the hierarchy inherent in the very notion of authority is dissolved.

The proliferation of conflicting meanings is further reflected in Lady Fame's judgment of her petitioners. Her treatment of the nine groups that petition her illustrates the seeming arbitrariness of her judgment, which apparently hinges only upon her own fickle preference and is at least twice determined merely by her inclination, as she freely admits when she gives "me lyst hyt noght" (1564) and "for me list" (1665) as the reasons for her verdicts. The first three groups comprise people who have performed good deeds and desire the appropriate measure of renown; to the first group she gives no fame, to the second, good fame, and to the third, a bad reputation (1527–1665). The fourth and fifth groups also performed good deeds, but want these to be hidden; she grants the fourth group's request, but not the fifth's, commanding her servant Eolus to make that group's goodness known (1690–1721). The sixth and seventh groups are both made up of idle people who wish to have good fame; she grants the request of the sixth group but accords the seventh evil fame (1727–99). The last two groups of petitioners comprise people who have performed evil deeds; the eighth group wishes for good fame, and the ninth wants a bad reputation that accurately represents its wickedness. Fame grants the ninth group's request

39. Taylor, 33–34.

but denies the eighth's (1811–38). The result of her vacillating favors is an unpredictable hodgepodge of decrees that lacks any discernible order. "In her arbitrary responses," remarks Carolynn Van Dyke, "Fame flaunts her absolute power like a would-be nominalist god":[40] her arbitrary judgments defy any possible link between reality and merit. The implicit consequence of her "system" of judgments is to cast doubt upon received constructions of authority, as we are given no basis for distinguishing merited from unmerited fame.

Yet Geffrey still tries to control the kind of fame that he will receive. He responds to the indeterminacy of Fame's judgment by proposing an alternate course, one that lies outside of the predetermined routes that are before him. He will avoid petitioning Fame altogether, he says, being satisfied with his own judgment:

> I cam noght hyder, graunt mercy,
> For no such cause, by my hed!
> Sufficeth me, as I were ded,
> That no wight have my name in honde.
> I wot myself best how y stonde;
> For what I drye, or what I thynke,
> I wil myselven al hyt drynke,
> Certeyn, for the more part,
> As fer forth as I kan myn art. (1874–82)

Denying that he is seeking any kind of reputation from Fame's palace—and, indeed, he came there for knowledge, not personal glory—Geffrey insists that he is the best judge of his own actions and that he will be content to keep that judgment to himself. Ironically, this expressed desire for anonymity is written into a text in which Chaucer explicitly names and describes himself.[41] By framing his commitment to remaining anonymous within a text that clearly references the author, Geffrey/Chaucer maintains the illusion of control over his narratorial/authorial persona. Like his request that his dream be interpreted by its readers—but only if this results in a favorable interpretation—the narrator's stated wish for anonymity in a poem that

40. Carolynn Van Dyke, *Chaucer's Agents: Cause and Representation in Chaucerian Narrative* (Madison: Fairleigh Dickinson University Press, 2005) 47.

41. See Helen Cooper, "The Four Last Things in Dante and Chaucer: Ugolino in the House of Rumour," in *New Medieval Literatures* III, ed. David Lawton, Wendy Scase, and Rita Copeland (Oxford: Oxford University Press, 1999) 60. See also Lynch, *Chaucer's Philosophical Visions;* remarking on the paradoxical nature of this moment in the text, Lynch argues that while this moment "brings us closest to Chaucer 'the man'" it also "snatches away the cozy confidence that had existed between Dreamer and Eagle" (65).

contains a self-conscious representation of its author reveals the tension between authorial self-representation and the reader's interpretive freedom. Geffrey's ostensible decision not to seek fame reflects the narrator's authority; he is free to represent himself however he chooses within the confines of his own narrative and can refuse to participate in the petitioning of Fame that makes up the central action of his dream. Nonetheless, within this assertion lies an obvious contradiction. Can we take this claim at face value? Or is Chaucer deliberately undermining his own narrative self-representation? It is an odd moment in the text, as Geffrey appears to be declaring the very opposite of what he is, in fact, doing.

The House of Fame points out the limits of the narrator's interpretive control over his tale. On the surface, Geffrey appears capable of determining his course of action, opting not to petition Fame, penning his own interpretation of the Dido and Aeneas story, and trying to force his readers to interpret his dream favorably. In the final analysis, however, his agency is only partial. Not only are his actions constrained by the events of the dream—the eagle's unceremoniously sweeping him up into the sky is a vivid illustration of Geffrey's lack of control—but even the interpretive authority that he seeks to command eludes him, as his hyperbolic threat to the reader reveals. Geffrey's alternation between control and powerlessness is echoed in Chaucer's relationship to his text and readers. Geffrey's attempts at poetic self-determination ultimately expose the limits of *Chaucer's* control over *his* self-representation. To the extent that Geffrey functions as the author's mouthpiece, his professed desire for anonymity is obviously a sham. But Chaucer seems aware of this irony, constructing a satirical self-portrait that allows him to control, to some extent, the terms of his authorial persona. And yet, full control of that persona is impossible. It is only within the text itself—as Geffrey, who refuses to engage with Fame—that Chaucer is able to control his self-representation. Just as Fame metes out her judgment on no other basis than her own whims and as Geffrey cannot truly control the interpretation of his dream, the reception of the poem is out of its author's hands. In the end, the readers are left to determine the outcome and interpretation of the text, both in how they respond to Chaucer and in how they choose to interpret Geffrey's dream. Authority over the text is elusive, constantly slipping into and out of authorial control and threatening to become wholly subject to the readers' interpretation. Like Fame, readers can dispose of the poem and its author as they wish. Geffrey's anxiety about his dream's interpretation highlights the importance of the reader's response, and Fame's seemingly arbitrary judgments emphasize the impossibility of an author's exerting control over his text's

reception. Ultimately at issue in the poem's emphasis upon interpretive and authoritative instability is the afterlife of the text itself.

III. Anxieties of Interpretation in *Fame* and the Visionary Tradition

In the first two sections of this chapter, I argued that *The House of Fame* is a poem about interpretation and authority: about how an author might seek to control the reception of his text but also recognize that it is the audience's interpretation that finally determines its afterlife. I would now like to suggest that a similar tension can be found in medieval mystical literature and hagiography, whose authors were often very concerned with the reception of their texts. Geffrey's uncertainty regarding the future of his narrative echoes contemporary mystics' and hagiographers' concerns about the possibility of communicating divine messages, and these writers respond to their texts' uncertain futures by stressing the appropriate ways of reading them, often explicitly seeking to control their works' reception by stipulating that they should only be read by individuals who have the proper spiritual and emotional orientation. Thus, for instance, the author of the fourteenth-century *Cloud of Unknowing* includes a prologue that describes the work's proper audience in terms of how well they love and follow Christ:

> I charge þee & and I beseche þee . . . neiþer þou rede it, ne write it, ne speke it, ne ȝit suffre it be red, wretyn, or spokyn, of any or to any, bot ȝif it be of soche one or to soche one þat haþ (bi þi supposing) in a trewe wille & by an hole entent, purposed him to be a parfite folower of Criste, not only in actyue leuyng, bot in þe souereinnest pointe of contemplatife leuing þe whiche is possible by grace for to be comen to in þis present liif of a parfite soule ȝit abiding in þis deedly body. . . . For elles it acordeþ noþing to him.[42]

The author's detailed delineation of exactly what kind of audience is suited to his text emphasizes the importance of the reader's moral state to the reception of the work: the work will be meaningless—it will "acord[] nothing"—to a reader who is not striving to be a perfect follower of Christ. In a

42. Phyllis Hodgson, ed., *The Cloud of Unknowing and the Book of Privy Counseling*, EETs vol. 218 (London: Oxford University Press, 1944) 1–2.

sense, the text's intended message is safeguarded by the restrictions placed upon who may or may not understand it, as it will only be comprehensible and useful to someone who is spiritually prepared to encounter the work.

Many hagiographies include similar admonitions to their audiences. These prefatory remarks tend to construct the reader as devout and faithful, thereby enforcing a particular kind of interpretive practice. The prologue to the *Vita* of Beatrice of Nazareth provides a striking example of an author's seeking to construct a particular kind of reader. Her hagiographer writes,

> the devout reader may expect that our whole story has flowed, not from some dark mendacious hiding place, but from the bright shining font of truth. Who would be so insane as to think that the venerable Beatrice would proffer or write something false or fabricated by herself, for she read and learned in the book of experience everything which she later wrote with her own hand in a manner as truthful as it was faithful?[43]

This passage clearly constructs the "good" reader of Beatrice's *vita* as devout, sane, and accepting of the text's authority. Indeed, it is a necessary outcome of the reader's sane devotion that he or she will accept Beatrice's word and recognize her sanctity. More typical are instructions that aim to increase the reader's devotion through an encounter with the text, such as Mechthild of Magdeburg's direction to "read [her book] through nine times in faith, humility, and devotion."[44] These prefaces make it clear that only readers who are prepared to engage with the texts in the proper spirit of devotion should read them. Like Geffrey's threat, such caveats alert the reader to the proper interpretation of the spiritual work and designate some readers as more suited to interpreting the text than others. By implication, these prefaces limit the possible interpretations of the text. If readers criticize its content or fail to find the work edifying, they expose their own lack of proper spiritual preparation: it is not that the text is flawed, but that the reader was not reading it in the right spirit.

This construction of the reader's responsibility to the text resonates with Gertrude of Helfta's anxiety that her mode of visionary knowing may be undertaken by individuals whose intentions are not grounded in a love

43. " . . . [D]euotus lector attenderet, non ex mandaciorum tenebroso latibulo, sed ex luculente veritatis fonte perspicuo, totan narrationis nostre seriem emanasse. Quius enim vel insani capitis estimet venerabilem beatricem aut falsum aliquid aut confictum de semetipsa proferre vel scribere potuisse, que totum in experientie libro legit et dedicit quod, eo veratiori quo fideliori stilo, suis postea minibus exarauit?" Roger De Ganck, ed. and trans., *The Life of Beatrice of Nazareth, 1200–1268* (Kalamazoo: Cistercian Publications, 1991) Pr. 5.

44. Mechthild of Magdeburg, *The Flowing Light of the Godhead*, trans. Frank Tobin (New York: Paulist Press, 1998) 36.

for God—of individuals who are, in effect, unauthorized. As I discussed in chapter 3, Gertrude is capable of employing her cognitive faculties to apprehend divine truth because of her volitional alignment with God. In Book 4 of the *Legatus,* she twice asks God why it is that she can trust her own reason to lead her to truth when contemplating divine matters. The second time that she does so, God responds that her desire is sufficiently wedded to his that she can wish for (and therefore conclude) nothing that he would not approve.[45] Where Geffrey and the *Cloud*-author stress the relationship between the reader's spiritual orientation and his or her interpretive practice, in Gertrude knowing itself is predicated upon devotion. In these texts, not simply the transmission but even the comprehension of revealed knowledge depends absolutely on one's spiritual state.

The central role that one's inner state plays in authorizing interpretation and, indeed, in knowing itself points to an instability at the very heart of visionary knowing. If the validity of interpretation and understanding is based on one's being in a state that is not perceptible to an outside observer, how is the authenticity of the visionary's knowledge or the reader's interpretation to be discerned? In Gertrude's case, the two passages from Book 4 of the *Legatus*—penned, significantly, by another nun—contribute to the authorization of her visionary experience and subsequent literary production. Gertrude's concern reflects an awareness of her own vulnerability as a visionary authority, and the testimony of the anonymous writer of Book 4 works to legitimize that authority by implicitly providing an external validation of what only Gertrude—and God—could really know. But Geffrey, whose voice is the sole locus of authority within *The House of Fame,* is not similarly authorized. His presence within the text, both as an actor and as an interpreter, reminds us that his role is to interpret and represent his vision for his reader. But he has no discernible basis for that role, and every assertion of authoritative presence within the poem—his declaration that "non other auctour alegge I" in his retelling of the Dido and Aeneas story, his apparent ignorance of the provenance of his vision, his unwillingness to see the stars when the eagle offers to take him to them (993–95)—highlights his inadequacy as a figure of authority. While his vision is, in a sense, divine, there is nothing to lend credibility to his interpretive and mediating role. In fact, the eagle notes, Geffrey has been granted this vision precisely because he *lacks* prior knowledge: he has been writing about love without knowing anything about it (615–27). His apparent willingness to write on a subject about which he knows nothing significantly undermines his position as an

45. Gertrude of Helfta, *Leg.* 4: 14.5 (*Œuvres Spirituelles,* ed. Pierre Doyère, Sources Chrétiennes, 5 vols. [Paris: Les Éditions du Cerf, 1968] 4: 158–60).

authoritative speaker. While the inner moral state that would guarantee Geffrey's ability to understand and communicate his dream properly might not be accessible to the reader, all of the evidence—as well as *Fame*'s concern to trouble the very idea of authority—points to his fallibility.

More powerful than Geffrey, however, are his readers, whose inner state informs not just their individual responses to the dream, but the after-life of the text itself. Like Fame, whose whimsical judgment is nonetheless absolute, the reader's judgment of the text determines its status. *The House of Fame* effectively shifts the locus of authority from any character within the text out onto the reader, whose interpretation becomes essential to the dream's public life. In a similar way, visionary women were actively con-structed by their audiences—and their public construction was vital to how they were received, determining their status as heretics or saints.[46] But, as Geffrey's hyperbolic address to the reader points out, dreamers (and their authors) cannot control their readers. The narrator's claim that he will not petition Fame, preferring to keep his own counsel—coming as it does in the very text in which Chaucer most explicitly names himself—underscores the paradox of self-representation within the poem: however the poet/nar-rator ostensibly wishes to present himself, he is *always* presenting himself, and the image that the reader takes away may not be identical to the one that he intends. Geffrey's emphasis on the moral state of his readers and the arbitrary decisions of Fame herself demonstrate Chaucer's awareness that he cannot truly expect to control the future reception of his work. Not only the effects but the very life of a text—and its author—depend upon the moral state and inner apprehension of its readers.[47]

The two potential sources of authority in *The House of Fame* are Gef-frey and the reader. Fame is fickle, the eagle's "proofs" are sprinkled with

46. See Voaden, *God's Words.* Voaden argues that women's visionary experience itself was constructed by the discourse of *discretio,* a claim that resonates with Bynum's examina-tion of how women, consciously or not, used the available imagery of corporeality and food to construct their encounters with and understanding of the divine (see Bynum, *Holy Feast*). Writes Voaden, "*discretio spirituum* supplied a pattern for self-fashioning which extended to behaviour, demeanour and modes of expression. Familiarity with, and skill in, the discourse was a vital factor in the textual—and physical—survival of the visionary. Facility with *dis-cretio spirituum* empowered medieval women visionaries and enabled them to fulfill their divine mandate to communicate revelation" (4). Whether or not one accepts the argument that experience itself was structured by *discretio,* it is very likely that many visionary texts incorporated particular discursive strategies in order to construct their subjects as divinely inspired rather than merely vain or, worse, heretical.

47. The life of the author was literally at stake in some visionary texts. In cases of can-onization, the ecclesiastical reader's response to the text determined the subject's celestial status in the afterlife, while in heresy trials—such as in the case of Marguerite Porete—a text's being interpreted unfavorably could mean the author's execution.

circular reasoning and tautology,[48] and the "man of gret auctorite" never gets a chance to speak. But neither Geffrey nor the reader provides the incontestable authority of a divine interlocutor, a Lady Philosophy, or even a Raison: both are fallible and subject to bad intentions. In the absence of a reliable figure of authority, authoritative knowledge cannot be received or transmitted through Geffrey's dream. And because the dream is always mediated by its interpreting dreamer and audience, its epistemological potential lacks the kind of authoritative basis that visionary texts require if they are to be meaningful. The model of unreliable visionary knowing portrayed in *The House of Fame* indicates a fundamental problem with the idea of the active visionary who employs his or her cognitive faculties to understand, interpret, and fully realize the contents of the divinely granted vision. Where *Pearl* and *Piers Plowman* point out the dangers of using a merely human interpreter to understand and convey divine wisdom, *The House of Fame* suggests that the reception of meaningful knowledge through the vision might never be successful. Even Homer, after all, may be too partial to the Greeks to be a reliable authority. By extension, then, Chaucer himself—as the self-conscious author of both Geffrey and his dream—highlights his own unreliability. By effectively dismantling every possible figure of visionary authority, Chaucer shows that we can rely on little more than the dreamer, the poet, and the reader for the creation of meaning. While, in the words of the eagle, this meaning may be taken "in ernest or in game" (822), it is always human, always fallible, and emerges, not from divine authorization, but from the subjective minds of human beings.

48. "From beginning to end, the Eagle's speech relies on tautology, analogy, non sequitur, reductive simplicity, abuse of the syllogism, circular argument, and 'proofs' that prove nothing," writes Sheila Delany (75).

8

Knowledge Is Power

NEGOTIATING AUTHORITY
IN *THE BOOK OF MARGERY KEMPE*

HE HOUSE OF FAME goes much further than *Piers Plow-man* or *Pearl* in challenging the vision's status as a reliable means of obtaining knowledge. While the latter poems retain some hope for the vision's success, *Fame*'s absurd narrator and unpredictable events make it clear that, in Geffrey's case at least, the vision is a site of unstable authority and eccentric experience. Of all the dream vision poems discussed in this book, it is, both in content and tone, the least similar to the mystical texts that I examined in chapters 2 through 4. *Fame* challenges the status of the vision as an authoritative source of knowledge—a status that is largely unchallenged in much mystical vision literature—and also situates its discussion of the vision within a poetic context, implicitly satirizing Dante's *Divina Commedia* while also making light of eschatological visions such as the *Visio Pauli*.

The House of Fame does, however, bear some similarities to *The Book of Margery Kempe,* an account of the life and revelations of an early fif-teenth-century English mystic. Kempe's book is, of course, very different from Chaucer's poem; where *Fame* is at least ostensibly concerned with sexual love, Margery's experiences are relentlessly focused on the divine, and we see at least as much of her engagement with the outside world as we do the details of her visions. Unlike *Fame,* which is centered upon a single dream, the *Book* is the story of an individual whose life is consumed by an active, mutual relationship with God, chronicling the many difficulties that she faces in dealing with her contemporaries as well as her own struggles to understand and accept God's addresses to her.[1] But *Fame* and the *Book*

1. I am following Lynn Staley's means of distinguishing nominally between the *Book*'s author (Kempe) and its protagonist (Margery), which Staley uses throughout *Margery Kem-pe's Dissenting Fictions* (University Park, PA: Pennsylvania State University Press, 1994). Even if Kempe's book is an autobiography, creating a distinction between the author/creator and her subject reflects the constructed nature of the text and emphasizes the fact that it is not

both interrogate issues of authenticity and authority in the visionary experience. Where *Fame* pokes fun at the trope of the vision, demonstrating its potential absurdity, Margery asserts the authenticity of her experiences in the face of skeptics and ill-wishers. This authenticity, moreover, is supported by the authority that Margery gains from her "feelings"—the revelations and prophecies that she receives in her spirit thanks to God's grace and "communication."

Rhetorically, Geffrey's and Margery's experiences are presented within the frameworks of more or less conventional genres. Chaucer uses the conventions of the literary vision to question the possibility of communicating the visionary experience; Margery attempts to operate within the conventions of the authentic vision but must repeatedly negotiate popular mistrust of her affective and visionary experience. Just as Geffrey's ambiguous fulfillment of the visionary's role is the result of his ignorance and inability to understand his vision, Margery must address challenges that stem from the persecution of Lollards and from the assumption that she is stepping outside of the bounds set by her roles as a wife and mother.[2] When Margery prevails against her challengers—as she so often does—her authority is based upon her knowledge: a knowledge that is received through the affective understanding but that is also predicated upon the at times contentious union of her will with God's. Kempe's text thus illustrates the precarious status of visionary knowing in late medieval England.

In *The Book of Margery Kempe,* we see the role of successful visionary knowing in a *public* space: Margery is empowered to speak within a hostile world because the validation of her visionary knowing both affirms and denies ecclesiastical authority. In the space that is created by this simultaneous movement of affirmation and denial—her maneuvering between acceptance and rejection of the powers that would constrain her—Margery can establish herself as a holy woman. However, given the limitations upon female spiritual activity in fifteenth-century England, this movement requires constant negotiation. Such negotiation is also required internally, as Margery periodically doubts the veracity of her revelations and requires divine reassurance to be convinced of the legitimacy of her visionary knowledge. Her visionary knowing and its validation—both public and private—

literally true to life (a distinction that may be worth making in the study of other autobiographies, as well).

2. See, e.g., the sections of the *Book* in which Margery is told by a scornful bystander that she would be better off going home to sew (129) and is shortly thereafter accused of telling women to leave their husbands (133). All references to the *Book* are to *The Book of Margery Kempe*, ed. Stanford Brown Meech and Hope Emily Allen, EETS vol. 212 (Oxford: Oxford University Press, 1940).

thus serve as the basis for a constant negotiation of authority that enables Margery to live out, albeit in an embattled state, her highly controversial spirituality.

The *Book*'s contested status as a vision text that may or may not be a work of "fiction" makes it a particularly fitting conclusion to my study. Beginning with an overview of how its genre recently has been assessed and contested, I will argue that *The Book of Margery Kempe* constitutes an articulation of the visionary knowing that serves as the basis of both the public and private authentication of Margery's experience of the divine. While Margery's mystical experience and religious practice are largely affective, they are validated through her knowledge, and the difficulties that she faces illustrate her society's skepticism regarding the authenticity of visionary knowing. In *The House of Fame,* Chaucer points out the loopholes in the vision text through humor, using a narrator who cannot be taken entirely seriously. *The Book of Margery Kempe,* in contrast, shows the effects of such skepticism upon a woman who seems to want nothing more than to be taken seriously and for whom legitimacy as a visionary could determine her social, spiritual, and even saintly status. While the concerns of the two texts are similar, then, their implications differ enormously, as Margery's account reveals the possible effects of the troubling of the vision upon a late medieval English laywoman with a call to spiritual practice.

I. Fact or Fiction: Generic Considerations

Several scholars have pointed out that the *Book,* far from being a randomly gathered collection of a would-be saint's unstructured memories, is every bit as intentionally crafted as any other hagiographic narrative. Other than what is written in the text, we know little about Margery Kempe of Lynn, but, as I noted in the introduction, Lynn Staley has argued that *The Book of Margery Kempe* is best understood as a work of fiction. Whether we read the *Book* as fact or fiction, it is, as Staley stresses, a constructed narrative. Emphasizing that considering the *Book* to be an ingenuous account of a woman's personal experience creates the impression that the text's composition is accidental and unplanned, Staley's study highlights the fruitfulness of reading it as a deliberately crafted narrative that showcases many of the tensions and anxieties of its cultural moment.[3] Cheryl Glenn's study

3. Sue Ellen Holbrook also challenges the view that Kempe's text is best described as an autobiography in "'About Her': Margery Kempe's Book of Feeling and Working," in *The Idea of Medieval Literature,* ed. James M. Dean and Christian K. Zacher (Newark: University of Delaware Press, 1992) 265–84.

of the author and audience(s) of Kempe's text further indicates the extent to which the *Book*'s structure creates a particular rhetorical effect. Arguing that Kempe creates a "heteroglossic self," Glenn notes that the *Book* "subtly implements highly sophisticated fictional techniques—an implied author, a narrator, and the author-as-character—and demonstrates the refinement of her rhetorical method."[4] Laura Howes similarly points out evidence that Kempe's text was consciously and carefully constructed when she notes the omission of references to a child that Margery seems to have borne during her pilgrimage to Rome. This omission, Howes argues, can be explained by the fact that "Margery's central concern is with events relating to her spiritual life that also have a public impact" rather than private events such as childbirth.[5] The almost complete suppression of references to her many children, the adumbrations of evidence of Margery's holiness, and the alternating stories of Margery's persecution and her triumph all indicate that the *Book* was composed with the aim of promoting its protagonist as a mystic rather than of providing a complete account of her life.[6] At an even more basic level, the assertion that the *Book* was written out of order—in the words of her scribe, "it was so long er it was wretyn þat sche had for-getyn þe tyme & þe ordyr whan thyngys befellyn" (5)—is a reminder that it is not a literal chronicling of historical events.[7] Its claim

4. Cheryl Glenn, "Author, Audience, and Autobiography: Rhetorical Technique in *The Book of Margery Kempe*," *College English* 54.5 (1992): 546. David Benson argues for a more moderate heteroglossia—or rather a dialogism—in the *Book*, asserting that Kempe's work is "multivoiced as well as multitextual" and that the *Book*, like *Mandeville's Travels* and *Piers Plowman*, "contain[s] a multitude of other voices, which express a range of opinions on diverse topics" despite the apparent primacy of Margery's own voice (C. David Benson, *Public Piers Plowman: Modern Scholarship and Late Medieval English Culture* [University Park, PA: Pennsylvania State University Press, 2004] 136).

5. Laura L. Howes, "On the Birth of Margery Kempe's Last Child," *Modern Philology* 90.2 (1992): 223. Howes also suggests that this omission could indicate Margery's repudiation of her earlier, carnal existence (223).

6. These omissions are dealt with at length by Robert Ross, who compares the *Book* to oral life-histories in order to argue that they are the normal result of a person's telling his or her life story. "Margery's moment of revelation determines the rest of her life," he writes. "We do not see any progression in her personality, merely a repetition of those characteristics by which she allows herself to be defined. . . . This is exactly the phenomenon oral life-history manifests" (Robert C. Ross, "Oral Life, Written Text: The Genesis of *The Book of Margery Kempe*," *The Yearbook of English Studies* 22 [1992]: 235). Ross' thesis does not contradict the idea that the narrative was composed with a particular rhetorical effect in mind, however, even if that effect was implicit rather than conscious: Margery's concerns are—to put it in terms of a rather crude dichotomy—religious rather than domestic. Her child-bearing does not add (and, indeed, potentially detracts) from her self-presentation as a saint and is therefore largely extraneous to her narrative.

7. For more on this feature of the narrative, see Rosalynn Voaden, *God's Words, Women's Voices: The Discernment of Spirits in the Writing of Late-Medieval Woman Visionaries* (Woodbridge, UK: York Medieval Press, 1999) 114. Voaden goes on to characterize Margery

to a basis in lived experience and its evident fictionalizing qualities make the *Book* a sort of bridge between the "genres" of "literary" and "authentic" vision text. Even the question of the relationship between the narrator and its author, which, as I suggested in the introduction, can help us to differentiate between vision texts that are based in lived experience and those that are not, does not serve us here; the relationship between "Margery" and the author of the text is impossible to determine and, given her struggles with temptation and the irritating effect that she seems to have had on others, Margery herself might only with difficulty be called "idealized." The very indeterminacy of the *Book*'s genre—whether it is fact or fiction—exposes the arbitrariness of such distinctions, emphasizing that apparent intent, rhetorical strategies, and the construction of the protagonist ought to be taken into account when dealing with *any* vision text.

The primary goal of Kempe's text is the establishment of Margery's authenticity as a visionary in response to the many critics that she encounters. This authenticity is established in part by the text's situating her experiences within a larger visionary tradition. In its references to other saints and mystical texts, the careful construction of the hagiographic subject of the *Book* is most in evidence. Kempe's text exhibits an awareness of the rhetoric of authority, particularly of visionary authority, that associates it with the category of literature that Thomas Heffernan calls "sacred biography": "First, the text *extends* the idea that its subject is holy and worthy of veneration by the faithful, and, second, the text as the documentary source of the saint's life *receives* approbation from the community."[8] While it is less clear that the *Book* fulfills the latter requirement,[9] its defense of Margery's experiences certainly strives for the former. The repeated stress upon Margery's holiness emphasizes its similarity to hagiographic literature, echoing the tropes of that genre. Indeed, both Margery and the author of the *Book* plainly were aware of contemporary vision literature. Margery is situated throughout the *Book* in relation to such noted mystics as Birgitta of Sweden, Julian of Norwich, and Walter Hilton,[10] all mystics who wrote

as the "protagonist" and the scribe as the "narrator." "Both of these 'personae,'" she argues, "are constructed within the framework of the text, and serve its purposes" (114).

8. Thomas J. Heffernan, *Sacred Biography: Saints and Their Biographers in the Middle Ages* (New York: Oxford University Press, 1988) 16. Italics in original.

9. Interestingly, Margery's claim to sainthood gains strength as the result of the criticism of her interlocutors: the challenges that she faces from her contemporaries constitute a kind of Christ-like suffering that potentially enhances her sanctity. For a discussion of how slander, in particular, contributes to the discourse of sanctity in the *Book*, see Olga Burakov Mongan, "Slanderers and Saints: The Function of Slander in *The Book of Margery Kempe*," *Philological Quarterly* 84.1 (2005): 27–47.

10. See, e.g., Kempe, 42–47, where she talks her visions over with and receives validation from Julian; 153–54, in which the priest who is her scribe gains confidence in her visions

down their experiences; in the words of A. C. Spearing, "the book of her life was shaped by the books of others' lives."[11] Spearing's comment highlights the textual nature of the *Book*'s imitative quality; not only does Margery herself apparently strive to imitate other mystics, but the record of her life is, he suggests, crafted as an echo of theirs. Moreover, the fact that the text typically articulates its comparisons between Margery and these mystics in terms of their writings stresses the translation of Margery's experiences into a text, implicitly (and sometimes explicitly) suggesting that the *Book* should be seen as equally authoritative as these other works.[12] The *Book*'s singleness of purpose and its repeated references to the tradition of which it would be a part testify to an authorial awareness of the integrity of the book's construction.

Such evidence of Kempe's awareness of the textual tradition of visionary literature attests to her efforts to fit the *Book* into the hagiographic genre, but Margery's legitimation within the text is predicated upon the privileged knowledge that she receives as a result of her relationship with the divine. Throughout the book, her visionary knowing emerges as a means of combating hostile priests, clerics, fellow pilgrims, and townspeople. It is through the validation of her knowledge—the realization of prophecies, for example, or simply the assurance of its authenticity by the clerics to whom she "shows" her "feelings"—that Margery is rendered an authentic representative of Christ's love and his will. Some of this validation is public; it is this public validation, the legitimation of her knowledge by others, that enables her to act freely and to practice the spiritual activities in which she deeply desires to engage. Much of the *Book* is in fact dedicated to the validation of Margery's "feelings"—the word that Kempe often uses to denote her knowledge and revelations—by members of a larger public, especially of the clergy. It is through this validation that she negotiates the continued hostility of many of her interlocutors and witnesses, or what Glenn calls her

through his perusal of the *Stimulus Amoris*, Richard Rolle's *Incendio Amoris,* and the treatise of St. Elizabeth of Hungary; and 39, where her revelations are favorably compared to Birgitta of Sweden's *Revelations,* Walter Hilton's *Scale of Perfection*, the *Stimulus Amoris*, and the *Incendio Amoris*. Birgitta of Sweden seems to have been one of Margery's principal models; see Ellen M. Ross, "Spiritual Experience and Women's Autobiography: The Rhetoric of Selfhood in *The Book of Margery Kempe*," *Journal of the American Academy of Religion* 59.3 (1991). 539.

11. A. C. Spearing, "*The Book of Margery Kempe*; or, The Diary of a Nobody," *The Southern Review* 38 (2002): 629.

12. Catherine Akel argues that Margery (or Kempe) expected her book to be available to an audience that would also read Hilton's, Rolle's, and, especially, Birgitta's works. "Structuring her text to appeal to an audience similar to other mystics' means that Margery deliberately directs her content to a particular writing style, a kind or genre with which she and her audience are familiar." Catherine S. Akel, "'. . . A Schort Tretys and a Comfortybl . . .': Perception and Purpose of Margery Kempe's Narrative," *English Studies* 82.1 (2001): 9.

"immediate audience"—the people with whom Margery engages within the text.[13] The validation of her knowledge is essential to Margery's establishment as a public mystic, a woman who, despite her married status, can wear white and engage in what might seem to be eccentric or excessive spiritual practices. Although some members of her immediate audience—various monks, the Bishop of Lincoln, certain priests and laypeople whom she encounters on her pilgrimages—believe in and even assert her sanctity, the repeated confrontations with skeptics and Margery's triumph over them constantly assert her privileged position.

But the validations of Margery's knowledge are also at times personal, enabling her to overcome her doubts, for example, or reaffirming her relationship with God. In the latter cases, her spiritual knowledge is confirmed internally, through prescient knowledge, visionary affirmation, and divine proofs of the accuracy of her feelings. The internal confirmation of her feelings affirms her sanctity for Margery and for the audience of the text, while their external confirmation by her immediate audience gives her the right within the text to pursue the spiritual life that she desires. Some of the accounts of external validation by other individuals within her narrative illustrate the social strictures that had the potential to confine a late medieval Englishwoman; thus, for example, Margery must get a letter from a bishop to stop the mayor of Leicester—one of her more determined enemies—from preventing her from going where she wishes (118–19). But many of her assurances, being private and divinely granted, serve primarily to affirm her confidence in her spiritual desires over and against public disparagement, while also affirming them for the audience of the *Book*. The text's ongoing concern with the validation of her knowledge underscores the role of knowing within the production of the would-be holy woman's sanctity. As I will argue in the remainder of this chapter, the public validation of her knowledge, through a dialectical movement of affirming and resisting ecclesiastical authority, enables Margery to perform her spiritual practice, while its private validation confirms her sanctity for the audience of the *Book*. The legitimation of Margery's visionary knowing is thus essential to the performance of her sanctity on two levels: both within and outside of the text.

II. "To answer euery clerke": Margery's Problems with Authority

It should hardly come as a surprise that *The Book of Margery Kempe* chronicles the public implications of private mystical experience. Late medieval

13. Glenn, 544.

England saw the rise of forms of lay spirituality that implicitly called into question the totalizing control of ecclesiastical authority. Chief among these spiritual practices was a form of meditative Franciscan piety that became widespread among the laity in late medieval England.[14] Denise Despres notes that this form of meditation encouraged participants to "examine individual spirituality" through a "creative act of revision and reordering [of] personal history in imitation of Christ's life."[15] By meditating on and vividly imagining the events of Christ's life, the penitent was able to identify with him in an intensely subjective and affective manner that almost amounted to an experience of his suffering, either as a witness or a participant. Such meditation could give rise to actual visionary experiences, and Margery's spirituality reflects these practices; as Despres writes, her "individual experience blends with scriptural scenes in dreamlike or meditative states, dissolving the boundaries of time and space."[16] Vivid mental or imaginative engagement with eschatological scenes leads to a sense of immersion in those scenes, and Despres argues further that Margery's experiences, as well as her personal spiritual development, were shaped and informed by her meditations upon Christ's life and suffering.[17] Such meditative practices therefore may have helped not only to structure but actually to generate her visions. Other evidence of a mystic's employing these techniques or their rhetoric in the development and articulation of her visions can be found in the *Showings* of Julian of Norwich, who, Denise Baker argues, was influenced by the Franciscan model of meditation.[18] The flourishing of these techniques, which essentially gave laypeople a sense of having immediate access to the divine, was a clear threat to the dominance of an ecclesiastical hierarchy. The accusations of Lollardy that she faced and the references to other "heretical" figures suggest that Margery was not seen as an isolated phenomenon, but rather as a part of a larger threat to the boundary between

14. Glenn, 541. See also John V. Fleming, *An Introduction to the Franciscan Literature of the Middle Ages* (Chicago: Franciscan Herald Press, 1977) and David Lyle Jeffrey, *The Early English Lyric and Franciscan Spirituality* (Lincoln: University of Nebraska Press, 1975) for more extensive treatment of the influence of Franciscan spirituality in England.

15. Denise Despres, *Ghostly Sights: Visual Meditation in Late-Medieval Literature* (Norman, OK: Pilgrim Books, 1989) 20. In addition, Raymond Powell discusses the similarities between Margery's spirituality and the meditation practices that circulated in the Franciscan *Meditaciones vitae Christi*, Nicholas Love's *Mirrour of the Blessyd Lyf of Jesu Christ*, and *The Prickynge of Love* (Raymond A. Powell, "Margery Kempe: An Exemplar of Late Medieval English Piety," *The Catholic Historical Review* 89.1 [2003]: 4–5).

16. Despres, 15.

17. Ibid., 62–63. Clarissa Atkinson also situates Margery's spirituality within the Franciscan tradition in *Mystic and Pilgrim: The Book and the World of Margery Kempe* (Ithaca: Cornell University Press, 1983).

18. Denise N. Baker, *Julian of Norwich's Showings: From Vision to Book* (Princeton: Princeton University Press, 1994) 23–24.

clergy and layperson.[19] Thus, the very prominence of the meditative strate-
gies that Margery employs could have cast doubt on her visions' veracity
by echoing a broader conflict over religious authority. In the end, the spread
of these techniques may have undermined the perceived status of the vision
in late medieval England and may partially account for the relative paucity
of English visionaries.[20]

What allows Margery to assert herself despite the suspicion and restric-
tions that she faces is her visionary knowing. Margery's visionary knowing
enables her to negotiate a complex relationship with representatives of the
church who are often unsure of how to deal with her. In her interactions
with clergymen, Margery works to make her particular spiritual practices
possible, despite their unconventionality. To do so, she must gain clerical
approval without submitting wholly to clerical control. Her revelations are,
of course, what allow her to do this, as her divinely sanctioned refusal to
follow some of the strictures laid upon her by representatives of ecclesi-
astical authority implicitly recognizes the power of the Church while also
designating Margery's private communion with God as superseding that
authority.

Paradoxically, Margery's negotiation of public power frequently is
enabled by the private, internal validation of her knowledge and feelings.[21]
Thus, for example, Margery is able to respond to and resist the monk who
confronts her upon her return to England from Rome by turning inward and
receiving explicit guidance from God. When the monk demands to know
what happened to the child who was "begotyn & born whil sche was owte,
as he had herd seyde," Margery responds with an assertion of her chastity:
"Ser," she replies, ". . . God knowyth I dede neuyr sithyn I went owte
wher-thorw I xulde haue a childe." But the monk is skeptical, and would
"not leuyn hir for nowt þat sche cowde sey." Nonetheless (or perhaps as a
result), the monk wishes to play a role in governing her spiritual develop-
ment. Such governance, coming from a man who has grave doubts about
her chastity, would doubtless be disastrous to Margery's purpose; it must be
with some relief, then, that she receives a message from the Lord telling her

19. Lending support to the notion that visionaries like Margery were suspected of Lollard
tendencies in the early fifteenth century is the fact that most of the *Book* takes place during
the years in which prosecution of Lollards was at its height (1409–1410 and the early 1420s).
See Sarah Stanbury, *The Visual Object of Desire in Late Medieval England* (Philadelphia:
University of Pennsylvania Press, 2008) 194. This issue is also discussed in Powell, 21.

20. For a more extensive discussion of the dearth of visionary literature in late medieval
England, see the Epilogue.

21. It is significant that, despite her troubles with figures of ecclesiastical authority,
Kempe chronicles the support of more clerics than does any other medieval woman visionary
(Voaden, *God's Words,* 123).

that it is not his will that she subject herself to the monk's authority (103). This episode clearly asserts Margery's revealed wisdom over and against the monk's authority, but also presents the monk's request as potentially legitimate. The recognition and support of such churchmen both is and is not important: while the incident exposes the extent to which privately revealed knowledge, the intimate "feelings" that she receives in her soul, trump the dictates of a mere man, Margery's engaging in dialogue with the monk, her defense of her actions before him, and her consultation with God on the matter also indicate the requirement to almost constantly negotiate her position vis-à-vis church authorities. Private confirmation of her uniqueness, of the exceptional spiritual position that she holds, has a public consequence: she can persist in the outward performance of her spirituality without submitting to the control of this particular cleric.

The attendant double movement of affirmation of and resistance to the monk's authority is in keeping with her fraught position as a laywoman. As Karma Lochrie points out, Margery's tumultuous relationship with clerical authority would have been particularly dangerous in early fifteenth-century England, where accusations of Lollardy were a continual threat. Margery "must assert her own orthodoxy as a Christian at the same time that she argues for her right to speak."[22] When speaking itself, as a possible indication of a layperson's knowledge of scripture, means risking suppression, negotiating a position from which to speak is difficult indeed. Moreover, the very nature of her holiness—depending as it does upon the world's revilement of her—creates a difficult tension between her need for the support of the church and her need to reject that support.[23] Negotiating this tension requires her both to seek the endorsement of the Church and, when necessary, to reject it, and her visionary knowledge provides a way for her to do both. By invoking her revelations before an ecclesiastical public, she gains the confidence and authority to defy the clergy when necessary.

Sometimes, however, the public confirmation of her knowledge by clergymen actually affirms clerical authority. Such episodes serve to assert Margery's orthodoxy, further making it possible for her to follow her desired spiritual trajectory. Orthodox confirmations of the validity of her knowing most often happen when she "shows" her life and revelations to initially skeptical clergymen, indicating the importance of her visionary knowing—and, significantly, its exposure—to the creation of a positive relation-

22. Karma Lochrie, *Margery Kempe and the Translations of the Flesh* (Philadelphia: University of Pennsylvania Press, 1991) 108.

23. Voaden articulates this tension as a conflict between the discourses of *discretio spirituum,* which legitimates visionaries, and of revilement, or worldly renunciation (*God's Words,* 117).

ship with the Church. Her conversations with these men and her efforts to convince them of her sanctity point out her recognition of clerical power while also highlighting her ability to sway its representatives. For instance, when she approaches William Sowthfield, the White Friar of Norwich, she "schewyd hym hir meditacyons & swech as God wrowt in hir sowle to wetyn yf sche wer dysceyued be any illusyons or not" (41). Sowthfield is explicitly designated as a "good man and an holy leuar," and Margery is commanded by God to go to him (41). The difference between this episode and the preceding example is striking: in the incident with the distrustful monk, Margery consults within herself, apparently confident that her revealed knowledge is true; here, however, she exposes that very knowledge to scrutiny, seeking confirmation that it is of God and not the devil. External validation of her revelations is apparently needed, and it comes, this time, from a male representative of a religious order.

Margery's revelation of her knowledge to Sowthfield is presented as a non-discursive act, the laying open of her experience to his scrutiny. The language of revelation in which the public exposure of her visionary knowledge is consistently couched points to the necessity of an experiential or affective response, as she does not, in these cases, seem to *describe* her visions, but rather somehow displays them. As quoted above, she "schewyd" Sowthfield her "meditacyons": the use of the verb "schew" emphasizes the non-discursive nature of Margery's knowledge. As with Marguerite, who must witness the meaning of *vehemens* in a vision in order to understand its meaning, or Will, who understands Dowel through action rather than description, Kempe's use of "schew" implies a distinction between rational knowledge and revealed wisdom. Margery displays herself to Sowthfield as though she were a book or an image, exposing her reflections and revelations for his analysis. This display is evidently effective, as Sowthfield, after listening to her in awe ("heldyng up hys handys" and saying, "Ihesu, mercy & gremercy"), assures her that "it is þe Holy Gost werkyng plentyuowsly hys grace in 3owr sowle" (41). Similar validations follow thick upon the revelation of her feelings to Sowthfield, as Margery shows Julian of Norwich " . . . þe grace þat God put in hir sowle of compunccyon, contricyon, swetnesse & deuocyon, compassyon wyth holy meditacyon & hy contemplacyon, & ful many holy spechys & dalyawns þat owyr Lord spak to hir sowle" and then proceeds to "schew[] hyr maner of leuyng to many a worthy clerke, to worshepful doctorys of divinyte, boþe religiows men & oþer of secular abyte," all of whom "seyden þat God wrowt gret grace wyth hir" (42–43). Margery's sharing of her revelations, framed in words that connote visual display, consistently results in the validation of her visions' authenticity. What I am calling the public, or external, validation of Mar-

gery's knowledge—the confirmation by a recognized spiritual guide of her revelations' legitimacy—thus occurs through non-discursive self-exposure. These episodes also confirm the clergy's and other spiritual guides' power, as their recognition is clearly important to and sought by Margery, even as, by virtue of such recognition, they allow her the space to speak and act freely.

The success of her "showing" of her knowledge implies that its truth is self-evident, provided that it is exposed (rather than, perhaps, simply described) to her interlocutors. But this exposure requires work on the visionary's part: Margery must in a sense translate God's words and her experience of his presence into a showable form. The use of the verb "schew," then, underscores Margery's role as an intermediary between the divine knowledge that she receives and the rest of the world.[24] Her "dalliance" with churchmen, writes Lochrie, "serves as Kempe's way of converting bold speech into action at the same time that it converts divine speech into showing":[25] God's words to her become a part of a narrative of revelation, coherent "feelings" that can be perceived and understood by another. This act of translation is not quite as radical as the use of the word "show" might suggest to a modern audience, however. As Staley notes, in this context "schew" means "to disclose or to make oneself known"; Kempe's use of the word is "at once utterly conventional and pointedly reflexive."[26] But as conventional as it is, it nonetheless highlights the self-exposure required by the act, creating as well an echoing link to revelation itself, shifting attention away from the content of her knowledge and onto the revealed nature of that knowledge. Margery is in essence revealing her revelations.

Such self-revelation is, moreover, an active gesture. While at first blush "showing" suggests that Margery is passively revealing herself to her interlocutor in order to have her thoughts and actions interpreted by him, the manner in which she shows her feelings indicates the tight control that she maintains over their interpretation and her consistent role as an intermediary between her revelations and her audience. In Margery's conversation

24. Gwenfair Adams argues that medieval visions functioned as windows onto the supernatural (Gwenfair Walters Adams, *Visions in Late Medieval England: Lay Spirituality and Sacred Glimpses of the Hidden Worlds of Faith* [Leiden: Brill, 2007] xvii). In this sense, Margery herself is such a window: she re-presents her visions to a larger audience so that her audience may be either edified themselves or simply awed by the evidence of God's working through her. Her role in transmitting her visions to a wider audience is not at all extraordinary; many visionaries, including Hildegard of Bingen and Gertrude of Helfta, explicitly report being commanded by God to make their visions known to the world at large, and that this broader transmission of their revelations was crucial to the revelations' purpose.

25. Lochrie, 107.

26. Staley, *Margery Kempe,* 195.

with Richard Caister, for example, Kempe follows a lengthy catalogue of the graces that Margery has received with the assertion that God has dallied in her soul "so excellently þat sche herd neuyr boke, neyþer Hyltons boke, ne [B]ridis boke, ne Stimulus Amoris, ne Incendium Amoris, ne non oþer þat euyr sche herd redyn" that showed a higher degree of love for God than what she has felt in her soul (39). Of this passage, Staley argues that Kempe "makes it clear that the act of showing involves far more than disclosure; it is also an interpretative act, one meant to validate the shower's self-awareness." Staley concludes that "Margery is both the text and its most astute translator."[27] Showing therefore is not a neutral act; it is an assertion of her inner revelations along with their proper interpretation. Moreover, the verb "show" typically is not used in cases where Margery's interlocutor remains hostile to her. When properly revealed, her feelings are perceived to be true. The success of her showings thus implicates the mystic into the visionary process: by figuratively making visible her meditations and revelations, she also exposes their divine origins—origins that are unmistakable to the men and women who witness them.

Both inner assurances and public recognition of the validity of her visionary knowing therefore serve to affirm the importance of clerical authority while also carving out a space in which Margery can perform her piety on what are more or less her own terms. But this form of self-assertion requires constant negotiation and struggle: the space that Margery creates exists somehow in between her acceptance of and resistance to the authority of ecclesiastical representatives, depending on their support while moving outside of and beyond their control. At the same time, however, she also encounters a significant number of people who refuse to be persuaded of her holiness, who will not "see" her revelations or their divine source: the clerics who criticize her for wearing white, the hostile mayor of Leicester, the fellow pilgrims who cut her dress short and make her sit at the foot of the table. Margery's relationship to the people who surround her and who have the power to limit her religious expression is thus highly ambivalent. It is characterized by her need continually to assert the validity of her revelations and by the privileging of her visionary knowledge over the strictures of conventional behavior. Susan Colón describes this as "an ever-present tension between her desire to be approved by holy men and women and her principled feeling that her peculiar call gives her an autonomous status in which the approval of others is irrelevant":[28] Margery at once

27. Ibid.

28. Susan E. Colón, "'Gostly Labowrys': Vocation and Profession in *The Book of Margery Kempe*," *English Studies* 86.4 (2005): 294. Powell, pointing out that Margery seems to have enjoyed a reasonably elevated social status (witnessed in her access to bishops and

seeks authorization and implicitly expresses the conviction that her divinely sanctioned status exempts her from the need for such approval, both affirming and denying others' control over her. As such, Margery's religious life requires that she engage in "a complex resistance to ecclesiastical norms of religious profession."[29] I would argue, however, that the first term of this tension goes beyond a "desire" for approval on Margery's part; it is, rather, a need, at once pragmatic and spiritual, and the tension itself is a byproduct of the difficult position of a religious laywoman who is both committed to her belief in her inner experiences and dependent upon being sanctioned by clerical authority.[30]

In the end, however, Margery's sense of her activities' being endorsed by God—her conviction of the truth of her inner knowing—trumps the dissent that she encounters. So long as her revelations and divinely sanctioned behavior are affirmed by the clergy, she works in harmony with its members; but her commitment to her particular form of spirituality, driven as it is by private, inner revelation, ultimately supersedes the dictates of her human superiors.[31] Margery's certainty of her behaviors' legitimacy is confirmed by Christ, who tells her that "Ther is no clerk can spekyn a-3ens þe lyfe whech I teche þe, &, 3yf he do, he is not Goddys clerk; he is þe Deuelys clerk" (158). Despite Christ's complicity in negotiating a space in which Margery can act, however, she is the one who must deal with the clergy, and she does so through the validation of her knowledge. In negotiating the tension between ecclesiastical and divine dictates, Margery's knowledge, as evidence of her sanctity in response to both her own and others' doubts, is crucial. Throughout her exchanges with skeptical bishops, priests, and monks, her feelings—the revelations that instruct her in her religious development and expression as well as the divinely granted knowledge that con-

archbishops and her apparent acquaintance with the Countess of Westmoreland and Lady Greystoke), argues that her insistence upon her persecution was less a reflection of reality than an effort to establish her cultic status, for "The scorn of others could be taken as a sign of God's approbation" (19). This argument does not, however, abolish the necessity of considering how the adversarial relationship between Margery and her fellow Christians works within the text itself.

29. Colón, 283.

30. Nona Fienberg explicitly relates this position to women's situations in medieval England, describing Margery's activity as "both challeng[ing] the patriarchy and attempt[ing] to create a place for herself within it." Nona Fienberg, "Thematics of Value in *The Book of Margery Kempe*," *Modern Philology* 87.2 (1989): 133.

31. Margery's relationship to her own visions is sometimes similarly ambivalent, as I discuss in the next section: she occasionally challenges the strictures laid upon her by God, particularly the weeping that he mandates for her. Her stress upon her unwillingness to weep but her inability to stop weeping confirms the divine origin of her "gift of tears," possibly acting as a defense against those of her contemporaries who found her effusions objectionable.

firms her status as a holy woman—are the primary means for her to express and affirm her spiritual practice.

The knowledge that allows Margery to engage in her desired spiritual praxis is implicitly affective and non-discursive, at least in how it is presented to both her immediate and actual audiences, within and outside of the text.[32] As I have noted, her knowledge is usually described as "feelings," a term that associates it with the action of the *intellectus*. The *Middle English Dictionary* glosses Kempe's use of "felinge" as "[s]piritual or mystical awareness or insight,"[33] and, as "insight," it is linked to the movement of understanding that characterizes the *intellectus*. Just as the verb "show" situates her revelations within a non-discursive sphere, so does Kempe's repeated reference to "feelings" suggest that what Margery knows is not (or not only) logically or rationally accessible. In Kempe's words, her feelings are "reuelyd to hir vndirstondyng" by the Lord (172); it is the illumination of the *intellectus,* which is typically associated with the understanding, that gives her her extraordinary knowledge of hidden things. Ellen Ross argues that the knowledge achieved through experience—and Margery's revelations are indeed a kind of experience—comprises "a deeper level of understanding" than does "[c]omprehension at an intellectual level."[34] As I have argued in earlier chapters, the knowledge that is accessible to the *ratio* is typically portrayed as limited in comparison to that available to the *intellectus;* while the *ratio* is often necessary for and instrumental to visionary knowing, it is the *intellectus* that is most often implicated in the flash of divine insight. Kempe's frequent use of words such as "feeling," "understanding," and "showing" aligns Margery's visionary knowing with the profound and intuitive knowing of the *intellectus*. To give a few characteristic examples of her use of such terms, Margery has "vndyrstondyng be felyng in hir sowle" that a young man offering to sell books to a priest will cheat him (57); "sche felt be reuelacyon" that a woman's husband, who was healthy at that time, would soon be dead (53); and she knows "be reuelacyon & be experiens" that her own weeping is not a sickness (151). The essentially experiential nature of Margery's knowledge is further seen in

32. "Immediate audience" and "actual audience" are terms that I borrow from Cheryl Glenn, who, in turn, has adapted them from Peter Rabinowitz. The "immediate audience," as I explain above, is the audience within the text—the audience with whom Margery interacts. The "actual audience" is us—the physical readers of the *Book* (Glenn, 541–44).

33. "Feling," *Middle English Dictionary online,* University of Michigan, http://quod.lib. umich.edu/m/med/. Accessed May 13, 2009.

34. Ellen Ross, "'She Wept and Cried Right Loud for Sorrow and for Pain': Suffering, the Spiritual Journey, and Women's Experience in Late Medieval Mysticism," in *Maps of Flesh and Light: The Religious Experience of Medieval Women Mystics,* ed. Ulrike Wiethaus (Syracuse: Syracuse University Press, 1993) 47.

the episodes in which experience explicitly confirms her revelations; when, for example, she finds a priest who reads to her "many a good boke of hy contemplacyon," she "knewe be experiens þat it was a ryth trewe spiryt" that had told her that she would find a person to help her increase in learning (143). Variations on the phrase "sche fond hir felyngys ryth trewe" (75) punctuate the narrative, as experience bears out the promises that are made to her in her revelations. For Kempe, "understanding" and "feeling" denote knowledge gained through direct revelation—knowing via the *intellectus*—and proven by experience.

But while Margery's knowing is primarily a function of the *intellectus,* her knowledge also comes about through direct enquiry, much like Gertrude of Helfta's thought-out revelations, and this knowledge, too, substantiates her claims to spiritual exceptionalism. It also presents Margery as playing an active role in her visionary knowing; not only is she a recipient of divine revelation, but she actually goes out and seeks it, a strategy that Voaden argues is an "assert[ion of] her power."[35] God frequently responds directly to Margery's prayers and questions and, as in the example of the monk who wishes to govern her, gives her clear instructions for how to negotiate situations in her life. Like the cases in which private revelation enables Margery to repudiate public control over her behavior, God's direct instructions and lessons allow her to simultaneously acknowledge and deny ecclesiastical authority in order to carve out a space in which she can act in accordance with divine injunctions rather than worldly restrictions. The advice and information that she receives explicitly from God help Margery to determine how best to act or to respond to an external threat, as in the case of the monk's desire to govern her, while also serving as evidence of her intimacy with the divine.

An example of divine revelation's serving as evidence of her intimate relationship with God occurs early in the *Book,* when a monk who had been skeptical of Margery's holiness begins to be converted by the "good wordys" that she utters as God inspires her. Requiring further evidence, however, he makes a request: "I pray þe telle me wheþyr I schal be sauyd or nowt and in what synnes I haue most dysplesyd God." His request is framed explicitly as a demand for proof, as he adds that "I wyl not leuyn þe but þow con telle me my synne" (26). Margery asks God what she should answer him and is given the correct answer: the monk has sinned in "letthery, in dyspeyr, & in wordly goodys kepyng" (26). The proof of Margery's sanctity lies in her privileged knowledge—not, in this case, of things divine, but of the monk's conscience; she asks for and receives an

35. Voaden, *God's Words,* 132.

inspired perspective on the state of the sinner's soul. This proof, moreover, is a *public* proof. In this case, Margery does not require divine knowledge to demonstrate to herself the reality of her visitations; nor is some particular knowledge—either of others' sins or of divine matters—the foundation of her spiritual practice. Rather, privileged information becomes evidence that can be used to convince a public that is skeptical of her gifts. Despite the overwhelmingly affective nature of Margery's spirituality, then, for the public, affective display is only the *sign* of her mysticism, not the proof. While her weeping marks her as spiritually different, it is knowledge—a heightened inner awareness—that substantiates her claims to special grace.

It is clear, then, that while knowledge and enquiry may not seem to be at the center of Margery's largely affective mysticism, they contribute significantly to others' confidence in the reality of her experiences and often provide her with the means of negotiating a position both within and outside of ecclesiastical authority. But Margery's knowing serves an internally directed function, as well, affirming her own belief in the reality of her relationship with the divine. The moments of doubt that punctuate Kempe's narrative arise, in fact, from Margery's uncertainty regarding the origins and validity of her knowledge. Most essential to her is the knowledge that she is indeed in an intimate, loving relationship with God—not the knowledge of coming storms, of others' sins, or of which spiritual counselors to consult or avoid. In addition to convincing others of the truth of her feelings, then, the visionary herself must learn to have faith in her own understanding. Staley describes this transformation as "Margery's inner development, a process that culminates in her ability to trust her own 'feelings' and to need no external proof that God speaks through her." This process, which results in "an utter trust in the primacy of subjectivism," also leads to a broader affirmation of the validity of Margery's experience and understanding,[36] and is ultimately the foundation upon which the text's assertions of Margery's sanctity rest.

III. The Doubting Saint:
Affirmations of Holiness and the Audience of the *Book*

Throughout the *Book,* God addresses Margery directly to allay her doubts regarding the origins of her feelings. While these private affirmations of the legitimacy of her knowing may not appear with anything like the frequency with which others' skepticism is rebutted, they nonetheless make up an

36. Staley, *Margery Kempe,* 155.

important refrain throughout the text. Why, when the *Book* is so clearly concerned to assert Margery's holiness, should so much space be given to her fears that her visions are of demonic rather than divine origin? She is, in effect, questioning the basis of her visionary authority. One reason that Kempe might have stressed this feature of Margery's experience relates to the conventions of hagiographic vision literature. As Voaden has demonstrated, women mystics in particular were ill advised to exude too much confidence in the divine origins of their visions, as one of the suspicions leveled against women visionaries was that they falsified their visions; it was a common misogynistic assumption, Voaden notes, that women might "deliberately feign visions to attract attention or gain power."[37] For Margery to show concern about her visions' origins is actually evidence of their authenticity. Another possible anxiety of women visionaries is that of seeming proud; a certain degree of skepticism and uncertainty may therefore be expected in a woman's account of her visions. Margery's doubts and the private legitimation of her revelations thus serve to affirm her sanctity for the audience of the *Book,* both the "authorial audience," whom the author has in mind while composing the text, and the "actual audience," the people who in fact read or hear the book, over whom the author has no real control.[38] Where the public legitimation of her knowledge enables her to perform her spiritual practice within the world of the text, justifying her to her immediate audience, this private validation allows her *text* to perform her holiness and articulate it to its authorial and actual audiences. Margery's visionary knowing thus plays an essential part in the establishment of her sanctity— not just through the revelations themselves, but through her doubts regarding them and the strategies of legitimation that assuage those doubts.

Doubt and reassurance feature heavily in Margery's coming to terms with her life of married chastity. The complex of feelings that are associated with her sexuality illustrate Margery's need to grow into a total trust in the authenticity of her feelings and of her sense of herself as blessed and united with Christ, as well as the difficulties that she encounters in developing that trust. Margery's status as a married mother works against her own conception of her holiness: while the chronology of the *Book* is difficult to parse, it seems that early in her mystical life Margery is especially concerned about the fact that she is not a virgin. "A, Lord," she laments in chapter 22, "maydenys dawnsyn now meryly in Heuyn. Xal not I don so? For be-cawse I am no mayden, lak of maydenhed is to me now gret sorwe" (50). This plaint comes well after she has begun to wear white clothing and

37. Voaden, *God's Words,* 67.
38. Glenn, 541–44. See also footnote 32 above.

taken her vow of married chastity;[39] even God's endorsement of such pub-
lic and highly controversial markers of her rejection of the roles of wife and
mother have not allayed her fears, reflecting the extent to which her social
position continues to cause her spiritual anxiety. God assures her, however,
that she is "a mayden in [her] sowle," adding, "I xal take þe be þe on hand
in Hevyn & my Modyr be þe oþer hand, & so xalt þu dawnsyn in Hevyn
wyth oþer holy maydens & virgynes" (52). Yet even this extraordinary
consolation does not permanently satisfy Margery, the divine support for
whose public virginity is reinforced almost continually in the text through
events ranging from God's repeated assurance that she could and should
wear white clothing to her marriages to both Jesus and God.[40] The role of
her visions—especially of her two spiritual marriages to the divine—in
endorsing her public behavior exposes the importance of subjective, inner
experience to the establishment of the mystic's spiritual practice. As she
increasingly behaves in accordance with the divine will and her revela-
tions, her narrative seems to track the development of her confidence in the
reality and indeed primacy of her inner experience.

Yet this development is uneven, as Margery does not always accede
to her feelings, sometimes doubting or even resisting the messages and
instructions that God reveals to her. The *Book* thus discloses the mystic's
struggle to embrace God's will and, in Staley's words, "to trust her 'feel-
ings.'" Her resistance and doubt, which indicate that her confidence in her
revelations is not uniform throughout her life, also suggest that proof of her
knowledge remains necessary to her spiritual self-confidence. The constant
negotiations that characterize her life as a public holy woman thus charac-
terize her inner spiritual life, as well.

One moment of doubt occurs at a time in her life when Margery must
have been feeling particularly vulnerable. Abandoned in Venice by her
fellow pilgrims on their way to Rome, informed that they "wold not go
wyth hir for an hundryd pownd," she receives the following consolation:
"D[rede] þe not, dowtyr, for I xal ordeyn for þe ryth wel & b[ryng þe] in
safte to Rome & hom a-geyn in-to Inglond wyth-owtyn ony velany of þi
body 3yf thow wilt be clad in white clothys & weryn hem as I seyd to
þe whil þu wer in Inglond." But Margery—despite having had two of her
feelings confirmed earlier on the voyage—responds "in gret heuynes &

39. Margery first dons white clothing in chapter 15, in which she and John also take vows
of married chastity. While, again, the chronology here is confusing, it seems that she has al-
ready taken her vow of chastity when she issues her lament to God about her lost maidenhead;
in any event, the fact that she is not a virgin is a recurrent concern for her for much of the
early part of the *Book*.

40. For the latter, see in particular Kempe, 86–87.

gret diswer . . . '3yf þu be þe spiryt of God þat spekyst in my sowle & *I may preuyn þe for a trew spiryt wyth cownsel of þe chirche,* I xal obey þi wille . . . " (76; my emphasis). Lacking confidence in the veracity of her visionary knowing, Margery turns to ecclesiastical authority despite her fraught relationship with the Church. Rhetorically, this admission of anxiety and eagerness to defer to the Church position her as devout and compliant, willing to submit to the authority of ecclesiastical representatives. But the moment seems odd in the context of her narrative. Why, given the extravagant evidence of God's "buxomness" to her that she has received throughout her mystical career, should she now doubt the authenticity of her revelation? In this moment, perhaps wearied by a journey in which God has seen her through many dangers only to lead her into ever-new peril, Margery rejects the primacy of her inner experience. By returning, even if only in her intention, to the necessity of being legitimated by the Church, the mystic indicates that her trust in her feelings is not absolute; she continues to rely upon proofs and validation, and, in the absence of these, upon the Church. And God, though gently rebuking Margery for her doubt ("Þu fondist me neuyr deceyuabyl, ne I bid þe no-thyng do but þat whech is worshep to God & profyte to thy sowle"), will provide that proof. "'Go forth, dowtyr, in þe name of Ihesu,'" he says, "'for I am þe spirit of God.' . . . Than a-non, as sche lokyd on þe on syde, sche sey a powyr man sittyng whech had a gret cowche on hys bakke." The "powyr man," of course, is he who has been ordained by God to help Margery on the next stage of her journey: the broken-backed Richard, whose infirmity is confirmation that her revelations have been true (76). Despite her positioning of herself as submissive to the Church, the Church ultimately drops out of the equation: in the end it is experience, not external authority, that reassures Margery of the validity of her revelations. The evasion of ecclesiastical authorization is grounded here in an interrogation of her knowledge. Inner, subjective experience of God is again validated through external action—and in this case it is Margery, not a doubting clergyman, who must be convinced.

A second instance of Margery's doubting the divine origins of her visions results in the replacement of her consolations with lecherous fantasies that she assumes to be demonic. In this case, as in that discussed above, she receives evidence that her visions are true and divine: God withdraws his kindness and dalliance from her when she doubts their origin, replacing them with disturbing sexual visions. By manipulating her inner experience and causing her to behold "mennys membrys & swech oþer abhominacyons" (145), God demonstrates his power over her inner life. In this case, it is an inner, subjective experience—not the proof of external action—that reas-

sures Margery of God's hand in her visions. Distressed, Margery implores the Lord to remember his promise not to forsake her and is visited by an angel who says that her unpleasant visions have been given to her because she did not believe that it was God who spoke to her in her spirit (146). Here, as above, Margery fails to believe fully in her visions, but this time her conviction is restored by an interior, visionary experience that confirms the divine origin of her spiritual consolations.

These and other moments of doubt express Margery's humility—her wariness of the idea that she is indeed chosen by God to live a life of unusually extravagant spiritual practice. But unlike the ecclesiastical validation of her knowledge discussed in the second part of this chapter, these experiences of anxiety and reassurance do not clearly support the public, performative nature of her spirituality. Instead, they function for the *text's*, as opposed to Margery's, audience—the actual rather than the immediate audience—as a window into her inner life, expressing the extent of her sanctity to the reader or hearer of the *Book*. Margery's holiness is asserted and performed through the chronicling of her doubts and God's reassurance. In the end, her private validations of her knowledge are just as public as those that are addressed to her immediate audience—much more so, in fact, if we consider how many more people have read the *Book* than knew Margery in her life—but that public is extra-textual, weighing her inner life and judging her to be (among other things) a saint, heretic, or madwoman.

The will is central to these moments of doubt and reassurance: Margery's doubts are almost always indicative of a lack of volitional union between herself and God. Where Gertrude of Helfta's knowledge stems from such a union, Kempe exploits the occasional disjuncture between the will of Margery and the will of the divine to assert her protagonist's humility and legitimacy, a rhetorical move that may have been necessary given Margery's brazen self-confidence in the face of external threats. The examples given above indicate Margery's reluctance to perform God's will without sufficient validation that it is he who wills it, an assurance that would be especially important for a woman who has been accused of being led astray by the devil. Nonetheless, Kempe's *Book* implies that volitional union plays a major role in Margery's visionary knowing, as Margery's spirituality is predicated in part upon a union between her will and God's: as God says to her, "I wil þat þu haue no wyl but my wyl" (156). But that union is threatened by the visionary's uncertainty. The *Book*'s exposure of periodic conflicts between Margery's will and God's highlights the necessity of their volitional union while also showing the instability of that union. Rather than being grounded in a prior perfection of her will, Margery's experiences serve to turn her will to God's. Coming to trust in her feelings also means

coming to trust that God's will is operating within her, and the *Book*'s representation of this process, which exposes Margery's hesitation to trust her revelations and the repeated confirmation of their validity, forcefully asserts her sanctity. In its inclusion of a progress narrative, the *Book* resembles dream visions such as *Pearl* and *Piers Plowman*, which illustrate obstacles to visionary knowing and the difficulty of fully embracing God's will. Just as it takes Langland's Will more than one vision even to begin to understand how to approach God, Margery's coming to a total trust in the divine does not happen all at once. Indeed, even after she has lived for some time in a heightened spiritual state, she still records lapses in which she either wills to act in a way that does not accord with God's desires or doubts in his desires altogether. But it is paradoxically these very lapses that enable the text to enact Margery's holiness.

Margery's dialectical inner movement between doubt and reassurance reflects the publicly enacted dialectic between her affirmation of and resistance to ecclesiastical authority. Significantly, the arena in which Margery expresses the greatest reluctance to do God's will is also one of those that garners her the most criticism within the narrative: her weeping. Given that her tears are the most dramatic sign of her spirituality, it is ironic that Margery is most often resistant to God's will in relation to the crying, wailing, and roaring that he causes her to undertake. She objects to this behavior at several points in her narrative, protesting that she does not wish for the copious tears that most visibly and controversially mark her public piety. Her occasional reluctance to make a spectacle of herself points to a concern with decorum and perhaps a desire to comply with behavioral standards. Most tellingly, she asks the Lord to allow her to cry in her chamber rather than out among the people, where she is subjected to their ridicule and disrupts services and sermons (181–82). Unlike Gertrude of Helfta, whose will is perfectly united to God's and who therefore is able to discern divine truth unimpeded, Margery—living beyond the protective walls of a convent—has very real concerns about the practicality of the spiritual practice that God enjoins her to pursue.

Margery's willful resistance does not lead to the loss of God's grace, however, but to a lengthy explanation of why she will still be required to weep. This explanation brings together affective, non-discursive explanation and rational argumentation; it is the union of these means of knowing that draws Margery's will back into harmony with God's. Jesus "answer[s] to hir mende," meticulously explaining why she must go on being "buxom to [his] wil" and accept the gift of tears. The effectiveness of Jesus' explanation in convincing Margery to comply with his will comes not only from the affective impact of her realization of his suffering but from the argu-

ment that he makes to persuade her. Comparing her gift of tears to the lightning that comes suddenly from heaven and the earthquakes that he produces to frighten people and remind them of his power, he tells her that he causes such upsets in her soul in order to bring her back to him. The weeping, he adds, is a token of his love for her (182–83). The images of the lightning bolt and the earthquake operate through analogy, causing a non-discursive understanding of the point that he is making but relying, as well, upon the explanation that supports them. His explanation and examples work: Margery emphatically agrees to comply with his wishes. Re-awakened to compassion, she recognizes that Christ himself has done all that he now bids her to do and remarks that "in al þis werld was neuyr so gret an enmye to me as I haue ben to þe" (183–84). This validation of her practice and the affirmation of her devotion tell the reader that Margery's behavior is indeed divinely sanctioned, legitimating the public performance of her holiness not for skeptical members of her immediate audience—those whom she meets who would have her submit to their control (or simply behave in more conventional ways)—but for Kempe's readers. Her inner revelations thus reassert her position with respect to ecclesiastical authority as a way of amplifying her sanctity for the audience of the *Book*.

All of these episodes point to the role of knowledge in Margery's spiritual practice, which, despite its intensely affective character, continues to rely upon proofs that God's will is working in her. Many of these proofs are direct responses to threats against her spirituality—both external threats from clerics and other authorities who would impede her and internal threats such as her own doubt and uncertainty regarding the origin of her visions. Combating these threats is essential to the establishment of Margery's sanctity. The public scorn and humiliation that she almost continually faces enables her to demonstrate her humility, as does the chronicling of her own doubts. The latter also allows Kempe to show God's assurances and reminders that these experiences are of divine and not demonic origin. The authenticity of her experience is grounded in her privileged knowledge, or "feeling." Knowing and feeling are the inextricable acts that lie at the basis of her intimacy with God and are what repeatedly convince her fellows of the truth of her assertions. The *Book* itself does not question Margery's knowledge; that is the task of her contemporaries (and, at times, of Margery herself). To counteract these doubts, *The Book of Margery Kempe* provides extensive and repeated examples of the successful reception of visionary knowledge.

What we have in the *Book* is thus an account of how knowledge and power intersect. As a laywoman, Margery requires public validation of her knowledge, or "feelings," in order to live the devotional life that she

wishes to pursue. Unlike Gertrude or Julian, she cannot (or simply does not) retire into the contemplative life, but rather remains in the world even as she seeks to rise out of it. As such, her experiences and knowledge must be continually on display if she is to negotiate a position with respect to the Church and her contemporaries from which she can assert her spirituality in the way that she desires. While many of her revelations are indeed private, their implications and their performance are adamantly public.

And yet, the success of Margery's visionary knowing is problematized by the uncertain status both of Margery as a visionary-mystic and of the *Book* itself. As a quasi-auto-hagiography that does not result in the canonization of its "saint" and that documents its protagonist's extremely troubled relationship with her contemporaries, the *Book* is emblematic of the fraught status of the vision in late medieval England—a topic that I will take up in the Epilogue.

Epilogue

HE BOOK OF MARGERY KEMPE may not set out to unsettle the status of the vision as an epistemological tool, but it does chronicle a network of anxieties about claims to visionary experience. Even as it asserts the authenticity of the vision, Kempe's text exposes the obstacles that a lay visionary had to face in her society, from accusations of corrupting other women to threats against her freedom and even her life. The contesting of her sanctity and the controversies surrounding her spiritual practice vividly illustrate the troubled reception of the vision in late medieval England—particularly for a middle-class laywoman who did not have the built-in clerical support that a nun or an anchorite would have had.[1]

In its account of the difficulties faced by its protagonist, *The Book of Margery Kempe* has a surprising amount in common with the dream vision poems discussed in chapters 5 through 7, all of which conspicuously raise the issue of the vision's status. *The House of Fame, Piers Plowman,* and *Pearl* call into question the vision's effectiveness as a means of obtaining divine knowledge, taking several elements of the vision as their targets. Where *Pearl* and *Piers Plowman* highlight the dreamer's limitations by illustrating the potential traps that the misguided will and the rational faculties might set for the would-be visionary, *The House of Fame* suggests that there are inherent restrictions upon visionary knowing, demonstrating the impossibility of deriving any reliable knowledge from either the vision or

1. As Susan Colón points out, Margery's case is more complicated than it would have been for a woman who was a member of a monastic order or an anchorite. "Kempe's claim to be outside a clerical chain of command is more disruptive because she is not in a fixed vowed relationship with a supervisory male authority. Kempe wants the validating seal of profession, but she wants it on her own (or, as she says, on Christ's own) terms" (Susan E. Colón, "'Gostly Labowrys': Vocation and Profession in *The Book of Margery Kempe*," *English Studies* 86.4 [2005]: 293).

the visionary text. In contrast to the writings of Marguerite d'Oingt, Gertrude of Helfta, and Julian of Norwich, which recount successful attempts at visionary knowing, these dream visions, like Margery's moments of doubt regarding the provenance of her visionary knowledge, express the possibility of the vision's failure. In so doing, they point out the limits of revelation's ability to convey knowledge successfully—limits that coincide with the limits of human reasoning and volition.

I began chapter 1 with a brief discussion of *The Apocalypse of Golias the Bishop,* a satirical dream vision that lampoons the clergy but that also takes a jab at visionary authority itself. In its attack on the visionary's credibility, the *Apocalypse* resembles *The House of Fame,* as both texts indicate the fallibility of the human as a potential figure of visionary authority. Where Chaucer's text undercuts the idea of the human dreamer (and reader) as an inherently reliable authority, Golias shows that the dreamer might not properly succumb to divine authority or behave appropriately; despite the lengths to which the angel has gone to ensure that Golias will remember his vision, the angel's rather poor timing and Golias' post-revelatory meal undermine his success. Although these poems were written roughly two hundred years apart, they both suggest that the vision text was ripe for satire in medieval England. Further, these works graphically illustrate the possibility that, owing to some error on the part of the dreamer or visionary, the vision could fail as a source of knowledge.

Of course, *The House of Fame* and *The Apocalypse of Golias* are unlike *Pearl, Piers Plowman,* or *The Book of Margery Kempe* in that they are clearly satirical. But the fact that Chaucer mocks the vision in his poem does not mean that he himself did not believe in the possibility of divine visions or of those visions' conveying meaningful knowledge to their recipients. What these works call into question is the visionary text itself. In the absence of privileged insight into the visionary's mind, and given our inability to re-create his or her experience, we have nothing but the text upon which to rely—and these works show a range of ways in which the visionary or dreamer could fail to adequately reproduce his or her visions in writing. Along with *Pearl* and *Piers Plowman, Fame* and *Golias* demonstrate that visionary knowing was understood to require the active participation of the vision's recipient and that the limitations of the visionary or dreamer could in fact limit the knowledge that was communicated through the vision.

The visionary or dreamer's active role in the vision and the related limits of visionary knowing appear primarily in two ways: in the use of the will and in the integration of the *ratio* and the *intellectus.* First, the dreamer's or visionary's will, as the faculty that determines the objects of the soul's

attachment, must be properly oriented. Unless the will is directed towards God and away from the world, ridding itself of any attachment to other people, ideas, thoughts, and the self, the recipient of the vision usually is unable to understand its content. The importance of the will can be seen most clearly in Gertrude's *Legatus* and in *Pearl;* where the union of Gertrude's will with God's is the declared basis of her detachment from the world and of her visionary experiences, it is the Jeweler's desire to be reunited with the Maiden and his unwillingness to accept their separation that prevents him from understanding what she wishes him to learn. Thus, the will can serve as the foundation of the visionary's or dreamer's relationship with the divine and of his or her capacity for visionary knowing.

The second major element of the active model of visionary knowing is the integration of the *intellectus* and the *ratio*. The *intellectus,* the mind's ability simply to grasp an evident or intuited truth, often seems to be the power that is most important to visionary knowing. Indeed, the frequent use of the words "intellexit" in Gertrude, "understanding" in Julian, and "feeling" in Kempe suggests that the *intellectus* is appropriately viewed as central to the comprehension of the vision. As I have demonstrated, however, the *intellectus* alone is not always sufficient for visionary knowing to occur. Indeed, the engagement of the visionary or dreamer's *ratio* is frequently depicted as necessary for the content of the vision to be understood. *Intellectus* and *ratio* complement one another. Rather than operating in distinct discursive spheres, where the *ratio* is responsible for worldly or academic matters and the *intellectus* is the means of receiving divine knowledge directly, both modes of knowing are required for the visionary fully to understand his or her vision. The applicability of these terms to dream vision poems can be seen in the two epistemological modes that I outlined in chapter 1, the educative and the revelatory. While the educative mode relies upon a rational progression from one step to another, the revelatory mode is in play when the dreamer acquires knowledge through a sudden flash of insight in a moment of divine revelation. In late medieval English dream poems, as in earlier and contemporary visionary literature, both modes are essential for visionary knowing to succeed. Where, in the dream, education prepares the dreamer for the privileged insight of revelation, visionaries' cognitive work of interpretation and meditation enables them to grasp the content of the vision through the use of the *intellectus.*

The fact that both *intellectus* and *ratio* are necessary for visionary knowing to occur complicates previous interpretations of women's mystical literature, which have often emphasized intuitive and affective knowledge to the exclusion of the rational. While it may not be the case that the *ratio* is always essential for visionary knowing to succeed, in the texts examined

here the visionary or dreamer must engage in some kind of analytic process at some point in his or her visionary experience. Even Marguerite's rejection of the definition of *vehemens* as "fort" has analytic overtones, as it implies that she has critically assessed the suitability of the definition, comparing it to her own sense of *vehemens'* meaning before rejecting it and seeking other definitions. The writings of Gertrude and Julian provide even more powerful examples of the integration of the *ratio* into visionary knowing. Owing to her volitional union with Christ, Gertrude's rational powers can actually grant her knowledge of the divine, and Julian's interpretation of her visions is divinely sanctioned—indeed, encouraged—as a way of excavating the deeper meanings from her experiences. Much of the scholarship concerning these mystics has regarded them as essentially affective visionaries who received their knowledge through experience and intuitive understanding.[2] However, in assessing visionary literature, particularly texts written by women, we must not assume that it is only the affect and the intuition—the tools of so-called "feminine" epistemology—that structure their visionary knowing. Attending to the interplay of affective experience and rational or cognitive work in these texts complicates our understanding of medieval women's spiritual experiences and offers points of contact between these texts and major issues in medieval philosophy and theology. Visionary experience seems to have provided a sanctioned way for these women to employ their rational cognitive abilities and to

2. With regard to Gertrude, a reading that emphasizes the affective dimensions of her writings is apparent in Jane Klimisch's observation that "the aim in reading Gertrud's writing is to discover the interaction of Gertrud and the Lord as it occurs in dialog, vision, and the wordless movements of her heart" (Jane Klimisch, "Gertrud of Helfta: A Woman God-Filled and Free," in *Medieval Women Monastics: Wisdom's Wellsprings,* ed. Miriam Schmitt and Linda Kulzer [Collegeville, MN: Liturgical Press, 1996] 251). Similarly, Schmitt's remark that Gertrude was "[f]ormed by the sacramental rites and rhythms of the liturgy . . . [and] also transformed by their grace and sense of mystery" indicates a prominent emphasis upon the affective and emotional aspects of her experiences (Miriam Schmitt, "Gertrud of Helfta: Her Monastic Milieu and Her Spirituality," in *Hidden Springs: Cistercian Monastic Women,* vol. 2, ed. John A. Nichols and Lillian Thomas Shank [Kalamazoo: Cistercian Publications, 1995] 486). While the affective elements stressed by these scholars certainly is present in Gertrude's writing, the overwhelming critical emphasis upon these elements obscures those passages in which she is seen engaging in rational contemplation. For the affective dimensions of Julian's spirituality, see, e.g., Maria R. Lichtmann, "'I desyrede a bodylye syght': Julian of Norwich and the Body," *Mystics Quarterly* 17 (1991): 12–19; Lichtmann, "'God fulfilled my bodye': Body, Self, and God in Julian of Norwich," in *Gender and Text in the Later Middle Ages,* ed. Jane Chance (Gainesville: University Press of Florida, 1996) 263–78; Liz Herbert McAvoy, *Authority and the Female Body in the Writings of Julian of Norwich and Margery Kempe* (Suffolk: D. S. Brewer, 2004); and Ellen Ross, "'She Wept and Cried Right Loud for Sorrow and for Pain': Suffering, the Spiritual Journey, and Women's Experience in Late Medieval Mysticism," in *Maps of Flesh and Light: The Religious Experience of Medieval Women Mystics,* ed. Ulrike Wiethaus (Syracuse: Syracuse University Press, 1993) 45–59.

engage—albeit obliquely—in a form of discourse from which they normally were excluded. A wider consideration of visionary women and the integration of ratiocination into their epistemological schemas would help to elaborate the means through which women developed and used an intellectual discourse that was not openly available to them. More generally, the perceived dichotomy between affective, *intellectus*-based knowing and rational deduction must be rejected if we are to achieve a full understanding of how the medieval vision worked. While the two modes of knowing should be distinguished, it is a mistake to see the one as necessarily precluding the other. Julian's *Showings* vividly demonstrates the integration of rational and intuitive ways of knowing, and any attempt to force a reading that disregards one of these two aspects of her epistemology necessarily will be incomplete.

Regarding visionary knowing as an active interplay between divine revelation and the visionary or dreamer's cognitive abilities also contributes to our understanding of dream vision poems. In particular, the epistemologically troubled dream visions of late fourteenth-century England are clarified by the recognition that dream vision literature and visionary texts were not totally separate cultural phenomena, but that they arose from the same set of presuppositions about the way that the vision worked. Some of the interpretive problems of *Pearl* and *Piers Plowman,* for example, are illuminated if we read them in light of roughly contemporary mystical literature. Given the theological issues that are these poems' focus, it is appropriate to consider broader notions of the vision as possible influences upon their representations of the dreamer and the dream. The problems of the will and the rational faculties that are apparent in *Pearl, Piers,* and even *Le Roman de la rose* in fact reflect the concerns of mystical visionary literature. Dream vision poems are able to dramatize the issues surrounding visionary knowing in a way that hagiographic and mystical vision texts cannot. By discerning the influence of contemporary understandings of the vision upon dream poems, we are given a new way of reading these texts— a reading that highlights the perceived limits of the human mind's ability to adequately understand the divine.

Mystical literature therefore provides a framework for reading dream vision poems that can add substantially to our understanding of the latter texts. In recent decades, critical approaches to these poems have largely been informed by studies that read them through the lens of medieval dream theory. Studies of dream theory in the Middle Ages and earlier—such as *The High Medieval Dream Vision* by Kathryn Lynch; Steven Kruger's *Dreaming in the Middle Ages;* Patricia Cox Miller's *Dreams in Late Antiquity: Studies in the Imagination of a Culture;* and J. Stephen Russell's *The*

English Dream Vision: Anatomy of a Form—have been invaluable in their delineation of the influence of dream theory upon literary works, but their own recognition that many dream poems do not adhere strictly to Macrobian categories suggests that a new interpretive paradigm is needed to understand these texts more fully.[3] By considering mystical visionary texts and their intersections with dream vision poems, we can begin to grasp cultural assumptions regarding the status of the vision as it would have been understood by the authors and audiences of medieval dream poems.

But this kind of analysis also raises several questions, particularly about the troubled attitude towards visionary knowing that is revealed in such works as *Pearl, Piers Plowman,* and *The House of Fame.* Why did these poems adopt such a skeptical attitude towards their dreamers' abilities to understand their visions? If these dream poems engage with the potentially problematic aspects of visionary knowing, then it is clear that the vision was a site of critical interrogation—perhaps even dispute—in late medieval England. Based on how these three poems and *The Book of Margery Kempe* represent the vision, the focus of this dispute seems to have been the human mind's ability to discern divine truth. Called into question in these texts is the reliability of the human faculties, cluttered as they are by loving attachments, by lust, by their reliance on their own ratiocinative powers, and by unconscious interests. These works thus reveal a tension between the truth-bearing potential of the vision and the problems of human intellection and ratiocination. The fact that all four texts were written in England within a short span of time and their pronounced differences from the visions discussed in chapters 1 through 4 suggest that something was happening in late medieval England[4]—and that broader cultural concerns over authority and epistemology are reflected in the vision literature of that period.[5]

3. On the difficulty of applying the Macrobian categories to literary dreams, see J. Stephen Russell, *The English Dream Vision: Anatomy of a Form* (Columbus: The Ohio State University Press, 1988) 163. There has also been some debate over whether Macrobius was even relevant to late-medieval dream theory; Kruger reviews this debate and defends his view that Macrobius' influence in this period was discernible (Steven F. Kruger, *Dreaming in the Middle Ages* [Cambridge: Cambridge University Press, 1992] 85–86).

4. *De Consolatione Philosophiae,* the *Divina Commedia,* and *Le Roman de la rose* are by no means the only dream vision poems that depict dreams whose epistemology is relatively untroubled. Other examples include Christine de Pisan's *Livre de la cité des dames,* Guillaume de Machaut's *Fonteine amoureuse,* and the earlier English poem *The Dream of the Rood.* Read against the backdrop of these other medieval dream vision poems, *Pearl, Piers,* and *Fame* do stand out as exceptional in their explicit depictions of the vision as problematic.

5. It is striking that Julian's *Showings* does not challenge the status of the vision or suggest the kind of problems with visionary knowing that these other texts raise. Julian's difference from these texts further aligns Kempe's *Book* with the "fictional" texts, pointing

Indeed, something like a crisis of authority can be detected in late medieval English philosophical and religious culture. In addition to the issues of Franciscan visual meditation's empowering effect on laypeople that I discussed in chapter 8 and the disruptive effect of the Lollards, nominalism played a key role in the intellectual landscape of the era. It certainly would be going too far to assert that academic debates over nominalism and realism *caused* the persecution of Margery Kempe or the uncertain conclusion of *Pearl*. But, as a direct challenge both to certain forms of authority and to prior conceptions of knowing, nominalist philosophy does mirror some of the concerns that emerge in the vision literature of fourteenth- and fifteenth-century Britain. Like some of these vision texts, nominalism implied a direct challenge to notions of received authority; in fact, it went quite a bit further than the vision literature, challenging much of the accepted foundation of knowledge. The fourteenth-century philosopher William of Ockham's views implied the privileging of experience as a path to knowledge; positing that signs represented individual things, rather than universals, he argued that universals did not in fact exist.[6] Words thus referred to particular individuals, not to universal or ideal forms, and his repudiation of universals shaped his theory of how the human mind comes to know. Direct knowledge of individuals was, for Ockham, "the foundation of all universal knowledge": it was only by experiencing individual things, he asserted, that we could come to grasp the broader categories to which they belonged.[7] This manner of knowing asserted the importance of direct experience, but it also meant that such experience did not lead directly to the knowledge of universal concepts or qualities. Ockham's nominalism was by no means unilaterally accepted, even in England—John Wyclif's *On Universals* was only one of a number of treatises that sought to defend realism—but its impact on late medieval philosophy is undeniable.[8] It is not surprising, then, that late medieval English religious and other writings indicate a level of uncertainty about the possibility of grasping larger truths through language. The thirteenth-century French prioress Marguerite d'Oingt's understanding of God through the word *vehemens,* because it assumes that the word

out the unusual extent to which this professedly "true" vision text incorporates the interrogation and uncertainty characteristic of dream vision poems. Perhaps Julian's greater conventionality—in lifestyle, if not in theology—enabled her text to accept the vision's reliability in a way that Margery's could not.

6. Anthony Kenny, *Medieval Philosophy*, A New History of Western Philosophy, vol. II (Oxford: Clarendon Press, 2005) 144.

7. Gordon Leff, *The Dissolution of the Medieval Outlook: An Essay on Intellectual and Spiritual Change in the Fourteenth Century* (New York: New York University Press, 1976) 38.

8. Kenny, *Medieval Philosophy,* 151–53.

vehemens produces knowledge of an ideal form and has a divine referent, would be incoherent under Ockham's view, and such means of approaching the divine accordingly suspect. Further, the nominalist privileging of experience did not mean that the vision would have been held to be an indisputable source of truth. In fact, the skepticism that arose out of Ockham's views suggests the undermining of some ways of visionary knowing. How could Will, for example, expect to come to a "kynde knowing" of Christ when he remains hung up on the notion of Dowel? The grammatical indeterminacy of "Dowel," in fact, echoes debates over the existence of universals, implying that, even if Langland was not aware of these epistemological controversies, they were diffused throughout Britain's cultural atmosphere.

Nominalist beliefs also entail a skepticism towards other forms of knowledge and authority, and such views are similarly reflected in late medieval English dream poems. Hugo Keiper, speculating about nominalism's impact upon literary texts, projects a literature that would challenge traditional authoritative frameworks. The truly nominalist literary text, he writes, would evince a disruption of realist linguistic reference:

> If . . . literary writers see verbal signification, and language in general, as contingent and its referents . . . as no more than concepts in the human mind, their texts might exhibit a pronounced tendency to emphasize their precarious character as mere human constructs which need not necessarily correspond to the "actual" order of things, or refer to any ultimate or "solid" reality "out there" that can be recuperated through language in any reliable or binding ways.[9]

Nominalism's rejection of the notion that a knowable reality always underlies linguistic reference would, in Keiper's view, result in a tendency

9. Hugo Keiper, "A Literary 'Debate over Universals'? New Perspectives on the Relationships between Nominalism, Realism, and Literary Discourse," in *Nominalism and Literary Discourse: New Perspectives*, ed. Keiper, Christopher Bode, and Richard J. Utz (Amsterdam: Rodopi B.V., 1997) 48–49. Keiper makes a similar argument in "'I wot myself best how y stonde': Literary Nominalism, Open Textual Form and the Enfranchisement of Individual Perspective in Chaucer's Dream Visions," in *Literary Nominalism and the Theory of Rereading Late Medieval Texts: A New Research Paradigm,* ed. Richard J. Utz (Lewiston, NY: Edwin Mellen Press, 1995) 205–34; for a discussion of "realist" versus "nominalist" literature, see especially 229–31. In this article, Keiper uses Chaucer's dream visions to explore the claim that late medieval literature takes a "nominalist turn" ("'I wot,'" 205). Keiper argues that Chaucer's dream poems, as well as other "nominalist" literary works, are "open" texts that demonstrate a "shifting and multiple relationship between signifiers and signifieds, thus undercutting their supposedly stable, unambiguous relation in favor of multiplicity of meaning and ambiguity of (textual) semiosis" ("'I wot,'" 207).

towards linguistic and conceptual indeterminacy. In other words, nominalist literature would express the idea that language does not necessarily lead to truth and that there is no guarantee that it ever will. As "mere human constructs," words—and therefore discourse itself—constitute an unreliable epistemological tool. Keiper develops the implications of such a view:

> Such texts, therefore, might tend to foreground and highlight the inevitable relativity of the various voices and positions they (re)present, revealing them as more or less haphazard interpretations of a multifaceted, shifting "reality" whose "true," essential nature is ineffable, or may be altogether impossible to discover. Hence, such texts would probably stress undecidability and the opacity of discursive self-reference rather than a transparent concept of reality, or epistemological or ontological certainty.[10]

This passage almost reads as a description of *Piers Plowman,* which presents a world where language does not reliably refer to particular concepts and where apparent figures of authority (Reason, Clergy, Conscience) contradict and question one another. Literary texts that adhered to nominalist tenets would be identifiable by their refusal to propose a stable basis of authority, as authority by its very nature relies upon the assumption that one voice is preeminent over others, which would be uncharacteristic of a nominalist text. Conflicting voices would yield different opinions and arguments that, in the absence of a clear means of determining their relative merits, would be presented as of more or less equal value. The various faculties' failure to provide Will with an acceptable definition of "Dowel" is suggestive of the inadequacy of language to signify a shared reality. The locus of authority in *Piers* is further undermined when neither Holy Church nor the clerks and friars are able to provide Will with the information that he desires. The poem thus echoes nominalist concerns regarding the transmittal of knowledge.

The House of Fame is another prime candidate for an interpretation that posits a nominalist basis for the poem's epistemology.[11] Not only does the locus of authority shift between the reader and the dreamer, but both of these figures are, by virtue of the subjective influences over their interpre-

10. Keiper, "A Literary 'Debate,'" 49.

11. Keiper declares that both *The Parliament of Fowls* and *The House of Fame* "come very close" to his "hypothetical idea of a nominalist text" ("'I wot,'" 232). A. J. Minnis, on the other hand, explores the difficulty of ascribing nominalist *views* to either Chaucer or Langland in "Looking for a Sign: The Quest for Nominalism in Chaucer and Langland," in *Essays on Ricardian Literature in Honor of J. A. Burrow,* ed. A. J. Minnis, Charlotte C. Morse, and Thorlac Turville-Petre (Oxford: Oxford University Press, 1997) 142–78.

tive abilities, undermined as possible agents of authoritative interpretation. Fame's house is a kind of nominalist nightmare: the democratization of *all* language as it arrives within her walls and the arbitrariness of her judgments demonstrate what might happen in a world where language ceased to provide access to an underlying reality. Chaucer's poem also expresses an explicit epistemological uncertainty, neatly fitting into Kepier's further assertion that a "nominalist literary text" would "show a marked tendency to focus on the doubtful nature of human, earthly knowledge, but especially on the limits of such knowledge" and, as a result, "be seen to refrain from— or to abandon as futile—the quest for any ultimate source and authority, or for an authorizing, pristine moment of privileged insight or revelation."[12] *Fame*'s Geffrey seems to believe in the possibility of his vision's proving fruitful, but the comic tone of the poem indicates that its audience should not. Sheila Delany describes the wry approach to authoritative knowledge in *Fame* and other of Chaucer's works as "Chaucerian skepticism," "that sense of the unreliability of traditional information which Chaucer deliberately incorporates into the style and structure of his poetry."[13] Certainly for Chaucer the vision's authority is not absolute. Both *Piers* and *Fame,* in their indication of the limits of the vision's ability to convey knowledge to their dreamers, trouble the effectiveness of language and authority in a manner that resonates with contemporary philosophical disputes.

But *Piers Plowman* does not fully reject the possibility of visionary knowing. In Will's pursuit of kynde knowing and in the eschatological vision that prompts his (possibly temporary) religious reform, the poem suggests that the knowledge Will seeks is available and that a true understanding of the divine is possible. Nor does *Pearl* imply that the vision is fundamentally ineffective as an epistemological tool. The Maiden is clearly a figure of authority, and the Jeweler's failure to grasp her transcendent message does not undermine that authority. The obstacles to visionary knowing presented in *Pearl* are more the effect of the dreamer's limitations—limitations that may be inherent to the larger share of humankind, who are unable to relinquish loving attachments to others—than of the limitations of language. Yet the fact that the Maiden's speech can be interpreted in different ways—both with the transcendent meaning that she intends and in harmony with the Jeweler's desires—indicates that the multivalence of language is, in effect, a liability, potentially inhibiting one's access to divine knowledge. Just as Will is unclear on the allegorical meanings of some of the explanations of Dowel and Amant rejects Raison's advice, linguistic ambiguity

12. Keiper, "A Literary 'Debate,'" 49.
13. Sheila Delany, *Chaucer's* House of Fame: *The Poetics of Skeptical Fideism* (Gainesville: University Press of Florida, 1994) 2.

opens the way for misinterpretation and the misdirection of the will. The various interpretations to which a given utterance is subject mean that the hearer can continue to pursue his own desires regardless of authoritative instructions and suggest the undermining of authority that Keiper claims would have been characteristic of nominalist literature. While these texts do retain their faith in the possibility of visionary knowing, then, the difficulties that they show it to entail point out the potential impact of nominalism and its concerns upon their authors.

All of this is speculative, but what can be said with certainty is that many late medieval English vision texts seem somehow uncomfortable with the vision's efficacy, and that there are, moreover, surprisingly few late medieval English vision texts to begin with. Mystical visionary writings in particular—those vision texts that might be understood as asserting a basis in lived experience—are scarce in Britain. While visionary women flourished, relatively speaking, on the Continent, Julian of Norwich and Margery Kempe are the only two visionary women known to have produced texts in medieval England. Other English mystics tend to downplay or even reject the vision in their spiritual praxis. Richard Rolle (d. 1349) and Walter Hilton (d. 1396), two of the most prominent English mystics of the fourteenth century, focus on contemplation and mystical feelings of burning love but do not chronicle extensive visual or auditory experiences of the kind commonly found in visionary literature.[14] Hilton, moreover, protests that visions are ambiguous and ineffective as spiritual tools, writing, "visions or revelations of any manner spirit, in bodily appearing or in imagining, sleeping or waking . . . are not very contemplation. . . . But all such manner of feelings may be good, wrought by a good angel, and they may be deceivable, feigned by a wicked angel."[15] Although he does not express as much skepticism regarding the origins of visions as Hilton does, Rolle also devalues the vision as a less rewarding form of rapture than the "rapture of love" achieved by contemplation. Noting that "even sinners sometimes experience raptures . . . in visions, and see the joy of the good, or the punishment of the wicked," he dismisses such experiences with the rather terse conclusion, "We have read this of many."[16] Visionaries do not seem to have gained the kind of traction in England that they had elsewhere in Europe, and even English dream vision poems that chronicle "fictional" experiences of divine union are characterized by epistemological uncertainty.

14. Walter Hilton, *Scale of Perfection*, ed. Evelyn Underhill (London: John M. Watkins, 1948), e.g., 59; Richard Rolle, *The Fire of Love*, trans. Clifton Wolters (Middlesex, UK: Penguin, 1972), e.g., 45–46.

15. Hilton, 19.

16. Rolle, 166.

Considering the representation of revelation in literary works demonstrates the perceived role of the cognitive faculties upon the reception, comprehension, and communication of the vision in medieval literature. These faculties have a dual effect: to enable visionary knowing and also, in some cases, to limit it. Together, these texts—including those that express most confidently their visionary authority—expose the potentially shaky foundations of the vision. Even Margery Kempe, that most eager of visionaries, falls into doubt and reluctance during the course of her long mystical career. Relying on the human recipient's complaisant will and open intellect, the divine vision ran the risk of being corrupted or even dismissed. Small wonder, then, that the dream visions of late medieval England, where new forms of spirituality that lent themselves to visionary experience were taking root and philosophical developments hinted at the unknowability of the divine, concern themselves with the difficulty of apprehending the truth of revelation. After all, the visionary career was a risky one, and revelation itself an uncertain thing. Filtered through anxious human minds, even divine truth itself could be—like Geffrey's dream—scorned, misjudged, or simply ignored.

Bibliography

Primary Sources

"The Apocalypse of Golias." Trans. F. X. Newman. In *The Literature of Medieval England*. Ed. D. W. Robertson. New York: McGraw-Hill, 1970. 253–61.

Die Apokalypse des Golias. Ed. Karl Strecker. Leipzig: W. Regenberg, 1928.

The Cloud of Unknowing. Ed. Patrick J. Gallacher. Kalamazoo: Medieval Institute Publications, 1997. TEAMS.

The Cloud of Unknowing and the Book of Privy Counseling. Ed. Phyllis Hodgson. London: Oxford University Press, 1944. Early English Text Society Ser. 218.

The Life of Beatrice of Nazareth, 1200–1268. Ed. and Trans. Roger De Ganck. Kalamazoo: Cistercian Publications, 1991.

"Pearl." In *The Poems of the Pearl Manuscript: Pearl, Cleanness, Patience, Sir Gawain and the Green Knight*. Ed. Malcolm Andrew and Ronald Waldron. Berkeley: University of California Press, 1979. 52–110.

Aquinas, Thomas. *Introduction to Saint Thomas Aquinas*. Ed. Anton C. Pegis. New York: Modern Library, 1948.

———. *Summa Theologiae*. Ed. Institutum Studiorum Medievalium Ottaviensis. Ottawa: Commissio Piana, 1953.

———. *The Summa Theologica of Saint Thomas Aquinas*. Ed. Daniel J. Sullivan. Trans. Fathers of the English Dominican Province. Chicago: Encyclopaedia Britannica, 1952.

Arnulfi Monachi de Boeriis. "Speculum Monachorum." In *Patrologiae Latinae* 184. Ed. J.-P. Migne. Turnhout: Brepols, 1981. 1175.

Augustine (Sancti Aurelii Augustini). *De Doctrina Christiana. De Vera Religione*. Turnhout: Brepols, 1962. Corpus Christianorum Ser. 32.

———. *On Genesis (De Genesi)*. Trans. Edmund Hill and Matthew O'Connell. Hyde Park, NY: New City Press, 2002. The Works of Saint Augustine: A Translation for the 21st Century Ser. I.13.

———. *Saint Augustine: The Teacher, The Free Choice of the Will, Grace and Free Will*. Trans. Robert P. Russell. Washington, DC: Catholic University of America Press, 1968. The Fathers of the Church: A New Translation Ser. 59.

———. *Teaching Christianity (De Doctrina Christiana)*. Trans. Edmund Hill. Hyde

Park, NY: New City Press, 1996. The Works of Saint Augustine: A Translation for the 21st Century Ser. I.11.

Birgitta of Sweden. *Life and Selected Revelations.* Trans. Albert Ryle Kezel. Ed. Marguerite Tjader Harris. New York: Paulist Press, 1990.

Boethius. *De Consolatione Philosophiae Opuscula Theologica.* Ed. Claudio Moreschini. Munich: K. G. Saur, 2000.

———. *The Consolation of Philosophy.* Trans. Joel C. Relihan. Indianapolis: Hackett Publishing Company, 2001.

Bunyan, John. *The Pilgrim's Progress.* New York: Penguin Books, 1981.

Chaucer, Geoffrey. "The House of Fame." In *The Riverside Chaucer.* Ed. Larry D. Benson. Boston: Houghton Mifflin, 1987. 348–73.

Dante. *The Divine Comedy.* Trans. and ed. Charles S. Singleton. 3 vols. Princeton: Princeton University Press, 1980.

———. *The Divine Comedy.* Trans. C. H. Sisson. Ed. David Higgins. Oxford: Oxford University Press, 1998.

Eckhart. *Die Deutschen und lateinischen Werke.* Vol. 1. Ed. Josef Quint. Stuttgart: W. Kohlhammer Verlag, 1986.

Gertrude of Helfta. *Œuvres spirituelles.* Ed. Pierre Doyère. 5 vols. Paris: Les Éditions du Cerf, 1968. Sources Chrétiennes Ser. 127, 139, 143, 255, 331.

———. *The Herald of Divine Love.* Trans. Margaret Winkworth. New York: Paulist Press, 1993.

———. *The Herald of God's Loving-Kindness: Books One and Two.* Trans. Alexandra Barratt. Kalamazoo: Cistercian Publications, 1991.

———. *The Herald of God's Loving-Kindness: Book Three.* Trans. Alexandra Barratt. Kalamazoo: Cistercian Publications, 1999.

Guillaume de Lorris and Jean de Meun. *Le Roman de la rose.* Ed. Armand Strubel. Paris: Librairie Générale Française, 1992.

———. *The Romance of the Rose.* Trans. Charles Dahlberg. Princeton: Princeton University Press, 1995.

Hildegard of Bingen. *Hildegardis Scivias.* Ed. Adelgundis Führkötter. Turnhout: Brepols, 1978. Corpus Christianorum, Continuatio Mediaevalis Ser. 43–43A.

———. *Scivias.* Trans. Mother Columba Hart and Jane Bishop. New York: Paulist Press, 1990.

Hilton, Walter. *Scale of Perfection.* Ed. Evelyn Underhill. London: John M. Watkins, 1948.

Hugh of Saint Victor. *The Didascalicon: A Medieval Guide to the Arts.* Trans. Jerome Taylor. New York: Columbia University Press, 1961.

Julian of Norwich. *The Showings of Julian of Norwich.* Ed. Denise N. Baker. New York: Norton, 2005.

———. *The Writings of Julian of Norwich: A Vision Showed to a Devout Woman and a Revelation of Love.* Ed. Nicholas Watson and Jacqueline Jenkins. University Park, PA: Pennsylvania State University Press, 2006.

Kempe, Margery. *The Book of Margery Kempe.* Ed. Stanford Brown Meech and Hope Emily Allen. Oxford: Oxford University Press, 1940. Early English Text Society Ser. 212.

Langland, William. *The Vision of Piers Plowman.* Ed. A. V. C. Schmidt. London: Everyman, 2001.

Macrobius. *Comentarii in Somnium Scipionis.* Ed. Jacob Willis. Leipzig: B. G. Teubner, 1963.

Margaret of Oingt. *Les Œuvres de Marguerite d'Oingt.* Ed. Antonin Duraffour, Pierre Gardette, and Paulette Durdilly. Paris: Les Belles Lettres, 1965.

———. *The Writings of Margaret of Oingt, Medieval Prioress and Mystic.* Trans. Renate Blumenfeld-Kosinski. Newburyport, MA: Focus Information Group, 1990.

Mechthild of Magdeburg. *The Flowing Light of the Godhead.* Trans. Frank Tobin. New York: Paulist Press, 1998.

Rolle, Richard. *The Fire of Love.* Trans. Clifton Wolters. Middlesex, UK: Penguin, 1972.

Thomas de Cantimpré. *The Life of Christina Mirabilis.* Trans. Margot H. King. Toronto: Peregrina Publishing, 1989.

Reference Works

Dictionary of Medieval Latin from British Sources. Vol. V (I-J-K-L). Ed. D. R. Howlett. Oxford: Oxford University Press, 1997.

A Latin Dictionary Founded on Andrews' Edition of Freund's Latin Dictionary. Ed. Charlton T. Lewis and Charles Short. Oxford: Oxford University Press, 1984.

Middle English Dictionary. Ed. Sherman M. Kuhn. Ann Arbor: University of Michigan Press, 1983.

Middle English Dictionary online. University of Michigan. http://quod.lib.umich.edu/m/med/.

Oxford Latin Dictionary, Fascicle III. Oxford: Clarendon Press, 1971.

Stich, Dominique. *Parlons Francoprovençal: Une Langue méconnue.* Paris: L'Harmattan, 1998.

Secondary Sources

Abbott, Christopher. *Julian of Norwich: Autobiography and Theology.* Rochester: D. S. Brewer, 1999.

Adams, Gwenfair Walters. *Visions in Late Medieval England: Lay Spirituality and Sacred Glimpses of the Hidden Worlds of Faith.* Leiden: Brill, 2007.

Akbari, Suzanne Conklin. *Seeing through the Veil: Optical Theory and Medieval Allegory.* Toronto: University of Toronto Press, 2004.

Akel, Catherine S. "'. . . A Schort Tretys and a Comfortybl . . .': Perception and Purpose of Margery Kempe's Narrative." *English Studies* 82.1 (2001): 1–13.

Alici, Luigi. "Sign and Language." In *Teaching Christianity (De Doctrina Christiana).* Trans. Edmund Hill. Hyde Park, NY: New City Press, 1996. 28–33. The Works of Saint Augustine: A Translation for the 21st Century Ser. I.11.

Allen, Peter L. *The Art of Love: Amatory Fiction from Ovid to the* Romance of the Rose. Philadelphia: University of Pennsylvania Press, 1992.

Amtower, Laurel. "Authorizing the Reader in Chaucer's *House of Fame.*" *Philological Quarterly* 79.3 (2000): 273–91.

Asbell, William. "Boethius and the Circular Journey to Wisdom." *Carmina Philosophiae: Journal of the International Boethius Society* 7 (1998): 89–100.

Atkinson, Clarissa. *Mystic and Pilgrim: The Book and the World of Margery Kempe.* Ithaca: Cornell University Press, 1983.

Baker, Denise Nowakowski. "From Plowing to Penitence: *Piers Plowman* and Fourteenth-Century Theology." *Speculum* 55.4 (1980): 715–25.

———. *Julian of Norwich's* Showings: *From Vision to Book.* Princeton: Princeton University Press, 1994.

Bangert, Michael, ed. *Freiheit des Herzens: Mystik bei Gertrud von Helfta.* Münster: Lit Verlag, 2004.

———. "Die Mystikerin Gertrud die Große und das Frauenkloster St. Maria in Helfta." In *Freiheit des Herzens: Mystik bei Gertrud von Helfta.* Ed. Michael Bangert. Münster: Lit Verlag, 2004. 5–21.

Beal, Jane. "The Pearl-Maiden's Two Lovers." *Studies in Philology* 100.1 (2003): 1–21.

Bell, Catherine. *Ritual Theory, Ritual Practice.* New York: Oxford University Press, 1992.

Benson, C. David. *Public Piers Plowman: Modern Scholarship and Late Medieval English Culture.* University Park, PA: Pennsylvania State University Press, 2004.

———. "What Then Does Langland Mean? Authorial and Textual Voices in *Piers Plowman.*" *The Yearbook of Langland Studies* 15 (2001): 3–13.

Blumenfeld-Kosinski, Renate. "The Idea of Writing as Authority and Conflict." In *The Writings of Margaret of Oingt, Medieval Prioress and Mystic.* Trans. Blumenfeld-Kosinski. Newburyport, MA: Focus Information Group, 1990. 71–83.

———. *Poets, Saints, and Visionaries of the Great Schism, 1378–1417.* University Park, PA: Pennsylvania State University Press, 2006.

Boenig, Robert. "The Fragmentation of Visionary Iconography in Chaucer's *House of Fame* and the *Cloisters Apocalypse.*" In *So Rich a Tapestry: The Sister Arts and Cultural Studies.* Ed. Pam Hurley and Kate Greenspan. Lewisburg: Bucknell University Press, 1995. 181–99.

Bogdanos, Theodore. Pearl: *Image of the Ineffable. A Study in Medieval Poetic Symbolism.* University Park, PA: Pennsylvania State University Press, 1983.

Bowers, John. *The Crisis of Will in* Piers Plowman. Washington, DC: Catholic University of America Press, 1987.

Boyle, Marjorie O'Rourke. "Closure in Paradise: Dante Outsings Aquinas." *MLN* 115 (2000): 1–12.

Brandeis, Irma. *The Ladder of Vision: A Study of Dante's Comedy.* London: Chatto & Windus, 1960.

Bridges, Margaret. "The Sense of an Ending: The Case of the Dream-Vision." *Dutch Quarterly Review* 14 (1994): 81–84.

Bullón-Fernández, María. "'By3ond þe Water': Courtly and Religious Desire in *Pearl.*" *Studies in Philology* 91.1 (1994): 35–49.

Burrow, J. A. *Langland's Fictions.* Oxford: Oxford University Press, 1993.

Bynum, Caroline Walker. *Holy Feast and Holy Fast: The Religious Significance of Food to Medieval Women.* Berkeley: University of California Press, 1987.

———. *Jesus as Mother: Studies in the Spirituality of the High Middle Ages.* Berkeley: University of California Press, 1982.

Caciola, Nancy. *Discerning Spirits: Divine and Demonic Possession in the Middle Ages.* Ithaca: Cornell University Press, 2003.

Calin, William. *The French Tradition and the Literature of Medieval England.* Toronto: University of Toronto Press, 1994.

Carruthers, Mary. *The Book of Memory: A Study of Memory in Medieval Culture.* Cambridge: Cambridge University Press, 2001.

―――. *The Search for St. Truth: A Study of Meaning in* Piers Plowman. Evanston: Northwestern University Press, 1973.

Carson, Angela. "Aspects of the Elegy in the Middle English *Pearl.*" *Studies in Philology* 62 (1965): 17–27.

Casey, Michael. "Gertrud of Helfta and Bernard of Clairvaux: A Reappraisal." *Tjurunga: An Australasian Benedictine Review* 35 (1998): 3–23.

Chamberlin, John. *Medieval Arts Doctrines on Ambiguity and Their Place in Langland's Poetics.* Montreal: McGill-Queen's University Press, 2000.

Chance, Jane. "Allegory and Structure in *Pearl:* The Four Senses of the *Ars Praedicandi* and Fourteenth-Century Homiletic Poetry." In *Text and Matter: New Critical Perspectives of the* Pearl-*Poet.* Ed. Robert J. Blanch, Miriam Youngerman, and Julian N. Wasserman. Troy, NY: Whitson Publishing Company, 1991. 31–59.

Cherniss, Michael D. *Boethian Apocalypse: Studies in Middle English Vision Poetry.* Norman, OK: Pilgrim Books, 1987.

Chiampi, James T. "Dante's Education in Debt and Shame." *Italica* 74.1 (1997): 1–19.

Clifton, Linda J. "Struggling with Will: Jangling, Sloth, and Thinking in *Piers Plowman* B." In *Suche Werkis to Werche: Essays on* Piers Plowman *B in Honor of David C. Fowler.* Ed. Míceál F. Vaughan. East Lansing: Colleagues Press, 1993. 29–52.

Clopper, Lawrence M. *"Songes of Rechelesnesse": Langland and the Franciscans.* Ann Arbor: University of Michigan Press, 1997.

Colish, Marcia L. *The Mirror of Language: A Study in the Medieval Theory of Knowing.* Rev. ed. Lincoln: University of Nebraska Press, 1983.

Colledge, Edmund, and James Walsh. Introduction. *A Book of Showings to the Anchoress Julian of Norwich.* Ed. Colledge and Walsh. 2 vols. Vol. 1. Toronto: Pontifical Institute of Medieval Studies, 1978. 1–198.

Colón, Susan E. "'Gostly Labowrys': Vocation and Profession in *The Book of Margery Kempe.*" *English Studies* 86.4 (2005): 283–97.

Cooper, Helen. "The Four Last Things in Dante and Chaucer: Ugolino in the House of Rumour." In *New Medieval Literatures* III. Ed. David Lawton, Wendy Scase, and Rita Copeland. Oxford: Oxford University Press, 1999. 39–66.

Copeland, Rita. "Medieval Theory and Criticism." In *The Johns Hopkins Guide to Literary Theory and Criticism.* Ed. Michael Groden and Martin Kreiswirth. Baltimore: Johns Hopkins University Press, 1994. 500–507.

Courcelle, Pierre. *La Consolation de philosophie dans la tradition littéraire: Antécédents et postérité de Boèce.* Paris: Études Augustiniennes, 1967.

Courtenay, William J. "Nominalism and Late Medieval Religion." 1974. In *Covenant and Causality in Medieval Thought: Studies in Philosophy, Theology, and Economic Practice.* Ed. Charles Trinkaus with Heiko A. Oberman. London: Variorum Reprints, 1984. 26–59.

Davlin, Mary Clemente. *A Game of Heuene: Word Play and the Meaning of* Piers Plowman *B.* Cambridge: D. S. Brewer, 1989.

———. "Kynde Knowyng as a Major theme in *Piers Plowman* B." *The Review of English Studies* 22.85 (1971): 1–19.

———. *The Place of God in* Piers Plowman *and Medieval Art.* Aldershot, UK: Ashgate, 2001.

Delany, Sheila. *Chaucer's* House of Fame*: The Poetics of Skeptical Fideism.* Gainesville: University Press of Florida, 1994 [1972].

Demers, Patricia. *Women as Interpreters of the Bible.* New York: Paulist Press, 1992.

Despres, Denise. *Ghostly Sights: Visual Meditation in Late-Medieval Literature.* Norman, OK: Pilgrim Books, 1989.

Dinzelbacher, Peter. "Die 'Vita et Revelationes' der Wiener Begine Agnes Blannbekin († 1315) im Rahmen der Viten- und Offenbarungsliteratur ihrer Zeit." In *Frauenmystik im Mittelalter.* Ed. Peter Dinzelbacher and Dieter R. Bauer. Stuttgart: Schwabenverlag AG, 1985. 152–77.

Donagan, Alan. "Thomas Aquinas on Human Action." *The Cambridge History of Later Medieval Philosophy: From the Rediscovery of Aristotle to the Disintegration of Scholasticism, 1100–1600.* Ed. Norman Kretzman, Anthony Kenny, and Jan Pinborg. Cambridge: Cambridge University Press, 1989. 642–54.

Dronke, Peter. *Women Writers of the Middle Ages: A Critical Study of Texts from Perpetua († 203) to Marguerite Porete († 1310).* Cambridge: Cambridge University Press, 1984.

Elliott, Dyan. *Proving Woman: Female Spirituality and Inquisitional Culture in the Later Middle Ages.* Princeton: Princeton University Press, 2004.

Evans, Ruth, Andrew Taylor, Nicholas Watson, and Jocelyn Wogan-Browne. "The Notion of Vernacular Theory." In *The Idea of the Vernacular: An Anthology of Middle English Literary Theory, 1280–1520.* Ed. Wogan-Browne, Watson, Taylor, and Evans. University Park, PA: Pennsylvania State University Press, 1999. 314–30.

Fast, Frances. "Poet and Dreamer in *Pearl*: 'Hys Ryche to Wynne.'" *English Studies in Canada* 18.4 (1992): 371–82.

Feeney, Florence. "Love's Response: The *Exercises* of St. Gertrude." *Benedictine Review* 9.2 (1954): 36–39.

Ferrante, Joan N. *To the Glory of Her Sex: Women's Roles in the Composition of Medieval Texts.* Bloomington: Indiana University Press, 1997.

Fienberg, Nona. "Thematics of Value in *The Book of Margery Kempe.*" *Modern Philology* 87.2 (1989): 132–41.

Finan, Thomas. "Dante and the Religious Imagination." In *Religious Imagination.* Ed. James P. Mackey. Edinburgh: Edinburgh University Press, 1986. 65–85.

Finke, Laurie A. *Women's Writing in England: Medieval England.* London: Longman, 1999.

Fischer, Steven R. *The Dream in the Middle High German Epic.* Bern: Peter Lang, 1978.

Fleming, John V. *An Introduction to the Franciscan Literature of the Middle Ages.* Chicago: Franciscan Herald Press, 1977.

———. *Reason and the Lover.* Princeton: Princeton University Press, 1984.

Forman, Mary. "Gertrud of Helfta's *Herald of Divine Love*: Revelations through *Lectio Divina.*" *Magistra: A Journal of Women's Spirituality in History* 2.2 (1997): 3–27.

Foster, Kenelm. *The Two Dantes and Other Studies.* Berkeley: University of California Press, 1977.

Franke, William. "The Ethical Vision of Dante's *Paradiso* in Light of Levinas." *Comparative Literature* 59.3 (2007): 209–27.

Freccero, John. "Allegory and Autobiography." In *The Cambridge Companion to Dante*. Ed. Rachel Jacoff. Cambridge: Cambridge University Press, 2007. 161–80.

Glenn, Cheryl. "Author, Audience, and Autobiography: Rhetorical Technique in *The Book of Margery Kempe*." *College English* 54.5 (1992): 540–53.

Grady, Frank. "Chaucer Reading Langland: *The House of Fame*." *Studies in the Age of Chaucer* 18 (1996): 3–23.

Grimes, Laura Marie. "Gertrud of Helfta and Her Sisters as Readers of Augustine." Ph.D. diss., University of Notre Dame, 2004.

Harwood, Britton J. "Langland's 'Kynde Knowyng' and the Quest for Christ." *Modern Philology* 80.3 (1983): 242–55.

Heffernan, Thomas J. *Sacred Biography: Saints and Their Biographers in the Middle Ages*. New York: Oxford University Press, 1988.

Hide, Kerrie. *Gifted Origins to Graced Fulfillment: The Soteriology of Julian of Norwich*. Collegeville, MN: Liturgical Press, 2001.

Holbrook, Sue Ellen. "'About Her': Margery Kempe's Book of Feeling and Working." In *The Idea of Medieval Literature*. Ed. James M. Dean and Christian K. Zacher. Newark: University of Delaware Press, 1992. 265–84.

Hollywood, Amy. "Inside Out: Beatrice of Nazareth and Her Hagiographer." In *Gendered Voices: Medieval Saints and Their Interpreters*. Ed. Catherine M. Mooney. Philadelphia: University of Pennsylvania Press, 1999. 78–98.

Howes, Laura L. "On the Birth of Margery Kempe's Last Child." *Modern Philology* 90.2 (1992): 220–225.

James, William. *The Varieties of Religious Experience*. New York: New American Library, 1958.

Jeffrey, David Lyle. *The Early English Lyric and Franciscan Spirituality*. Lincoln: University of Nebraska Press, 1975.

———. "Sacred and Secular Scripture: Authority and Interpretation in *The House of Fame*." In *Chaucer and Scriptural Tradition*. Ed. David Lyle Jeffrey. Ottawa: University of Ottawa Press, 1984. 207–28.

Kay, Sarah. "Sexual Knowledge: The Once and Future Texts of the *Romance of the Rose*." In *Textuality and Sexuality: Reading Theories and Practices*. Ed. Judith Still and Michael Worton. Manchester: Manchester University Press, 1993. 69–86.

Keiper, Hugo. "'I wot myself best how y stonde': Literary Nominalism, Open Textual Form and the Enfranchisement of Individual Perspective in Chaucer's Dream Visions." In *Literary Nominalism and the Theory of Rereading Late Medieval Texts: A New Research Paradigm*. Ed. Richard J. Utz. Lewiston, NY: Edwin Mellen Press, 1995. 205–34.

———. "A Literary 'Debate over Universals'? New Perspectives on the Relationships between Nominalism, Realism, and Literary Discourse." In *Nominalism and Literary Discourse: New Perspectives*. Ed. Hugo Keiper, Christopher Bode, and Richard J. Utz. Amsterdam: Rodopi B.V., 1997. 1–85. Critical Studies Ser. 10.

Kenny, Anthony. *Aquinas on Mind*. New York: Routledge, 1993.

———. *Medieval Philosophy*. Oxford: Clarendon Press, 2005. A New History of Western Philosophy Ser. II.

Kirk, Elizabeth D. *The Dream Thought of* Piers Plowman. New Haven: Yale University Press, 1972.

Kiser, Lisa J. *Truth and Textuality in Chaucer's Poetry.* Hanover: University Press of New England, 1991.

Klimisch, Jane. "Gertrud of Helfta: A Woman God-Filled and Free." In *Medieval Women Monastics: Wisdom's Wellsprings.* Ed. Miriam Schmitt and Linda Kulzer. Collegeville, MN: Liturgical Press, 1996. 245–59.

Korolec, J. B. "Free Will and Free Choice." In *The Cambridge History of Later Medieval Philosophy: From the Rediscovery of Aristotle to the Disintegration of Scholasticism, 1100–1600.* Ed. Norman Kretzman, Anthony Kenny, and Jan Pinborg. Cambridge: Cambridge University Press, 1989. 629–41.

Kraman, Cynthia. "Body and Soul: *Pearl* and Apocalyptic Literature." In *Time and Eternity: The Medieval Discourse.* Ed. Gerhard Jaritz and Gerson Moreno-Riaño. Turnhout: Brepols, 2003. 355–62.

Kruger, Steven F. *Dreaming in the Middle Ages.* Cambridge: Cambridge University Press, 1992.

———. "Mirrors and the Trajectory of Vision in *Piers Plowman.*" *Speculum* 66.1 (1991): 74–95.

Leclercq, Jean. "Liturgy and Mental Prayer in the Life of Saint Gertrude." *Sponsa Regis* 32.1 (1960): 1–5.

———. *The Love of Learning and the Desire for God.* Trans. Catherine Misrah. New York: Fordham University Press, 1962.

Leff, Gordon. *The Dissolution of the Medieval Outlook: An Essay on Intellectual and Spiritual Change in the Fourteenth Century.* New York: New York University Press, 1976.

———. *Medieval Thought from Saint Augustine to Ockham.* Hammondsworth, UK: Penguin Books, 1958.

Lewis, Gertrud Jaron. "*Libertas Cordis:* The Concept of Inner Freedom in St Gertrud the Great of Helfta." *Cistercian Studies* 25.1 (1990): 65–74.

Lichtmann, Maria R. "'God fulfilled my bodye': Body, Self, and God in Julian of Norwich." In *Gender and Text in the Later Middle Ages.* Ed. Jane Chance. Gainesville: University Press of Florida, 1996. 263–78.

———. "'I desyrede a bodylye syght': Julian of Norwich and the Body." *Mystics Quarterly* 17 (1991): 12–19.

Lochrie, Karma. *Margery Kempe and the Translations of the Flesh.* Philadelphia: University of Pennsylvania Press, 1991.

Lusignan, Serge. *Parler vulgairement: Les Intellectuels et la langue française au XIIIe et XIVe siècles.* 2nd ed. Paris: Librairie Philosophique J. Vrin, 1987.

———. "Written French and Latin at the Court of France at the End of the Middle Ages." In *Translation Theory and Practice in the Middle Ages.* Ed. Jeanette Beer. Kalamazoo: Medieval Institute Publications, 1997. 185–98.

Lynch, Kathryn L. *Chaucer's Philosophical Visions.* Cambridge: D. S. Brewer, 2000.

———. *The High Medieval Dream Vision: Poetry, Philosophy, and Literary Form.* Stanford: Stanford University Press, 1988.

Macrae-Gibson, O. D. "*Pearl*: The Link-Words and the Thematic Structure." *Neophilologus* 52.1 (1968): 54–64.

Maring, Heather. "'Never the Less': Gift-Exchange and the Medieval Dream-Vision *Pearl.*" *Journal of the Midwest Modern Language Association* 38.2 (2005): 1–15.

Mazzotta, Giuseppe. *Dante's Vision and the Circle of Knowledge.* Princeton: Princeton University Press, 1993.

McAvoy, Liz Herbert. *Authority and the Female Body in the Writings of Julian of Norwich and Margery Kempe.* Suffolk: D. S. Brewer, 2004.

McCabe, Maureen. "The Scriptures and Personal Identity: A Study in the *Exercises* of Saint Gertrud." In *Hidden Springs: Cistercian Monastic Women.* Ed. John A Nichols and Lillian Thomas Shank. Vol. 2. Kalamazoo: Cistercian Publications, 1995. 497–507.

McGerr, Rosemarie P. *Chaucer's Open Books: Resistance to Closure in Medieval Discourse.* Gainesville: University Press of Florida, 1998.

Miller, Patricia Cox. *Dreams in Late Antiquity: Studies in the Imagination of a Culture.* Princeton: Princeton University Press, 1994.

Minnis, A. J. "Aspects of the Medieval French and English Translations of the *De Consolatione Philosophiae.*" In *Boethius: His Life, Thought, and Influence.* Ed. Margaret Gibson. Oxford: Basil Blackwell, 1981. 312–61.

———. "Looking for a Sign: The Quest for Nominalism in Chaucer and Langland." In *Essays in Ricardian Literature in Honor of J. A. Burrow.* Ed. A. J. Minnis, Charlotte C. Morse, and Thorlac Turville-Petre. Oxford: Oxford University Press, 1997. 142–78.

Mitchell, J. Allen. "The Middle English *Pearl*: Figuring the Unfigurable." *The Chaucer Review* 35.1 (2000): 86–109.

Mongan, Olga Burakov. "Slanderers and Saints: The Function of Slander in *The Book of Margery Kempe.*" *Philological Quarterly* 84.1 (2005): 27–47.

Morgan, Gerald. "The Meaning of Kind Wit, Conscience, and Reason in the First Vision of 'Piers Plowman.'" *Modern Philology* 84.4 (1987): 351–58.

Newman, Barbara. "Divine Power Made Perfect in Weakness: St. Hildegard on the Frail Sex." In *Peace Weavers: Medieval Religious Women.* Ed. J. A. Nichols and Lillian Thomas Shank. Vol. 2. Kalamazoo: Cistercian Publications, 1987. 103–22.

———. *From Virile Woman to WomanChrist: Studies in Medieval Religion and Literature.* Philadelphia: University of Pennsylvania Press, 1995.

———. *God and the Goddesses: Vision, Poetry, and Belief in the Middle Ages.* Philadelphia: University of Pennsylvania Press, 2003.

———. "What Did It Mean to Say 'I Saw'? The Clash between Theory and Practice in Medieval Visionary Culture." *Speculum* 80.1 (2005): 1–43.

Nuth, Joan M. *Wisdom's Daughter: The Theology of Julian of Norwich.* New York: Crossroad, 1991.

Palazzo, Éric. *Liturgie et société au Moyen Âge.* Paris: Aubier, 2000.

Payne, Roberta L. *The Influence of Dante on Medieval English Dream Visions.* New York: Peter Lang, 1989.

Pedersen, Else Marie Wiberg. "Can God Speak in the Vernacular? On Beatrice of Nazareth's Flemish Exposition of the Love for God." In *The Vernacular Spirit: Essays on Medieval Religious Literature.* Ed. Renate Blumenfeld-Kosinski, Duncan Robertson, and Nancy Bradley Warren. New York: Palgrave, 2002. 185–208.

Peters, Brad. "A Genre Approach to Julian of Norwich's Epistemology." In *Julian of*

Norwich: A Book of Essays. Ed. Sandra J. McEntire. New York: Garland Publishing, 1998. 115–52.

Petroff, Elizabeth Alvida. *Medieval Women's Visionary Literature.* New York: Oxford University Press, 1986.

Powell, Raymond A. "Margery Kempe: An Exemplar of Late Medieval English Piety." *The Catholic Historical Review* 89.1 (2003): 1–23.

Raabe, Pamela. *Imitating God: The Allegory of Faith in* Piers Plowman *B.* Athens: University of Georgia Press, 1990.

Rhodes, Jim. "The Dreamer Redeemed: Exile and the Kingdom in the Middle English *Pearl.*" *Studies in the Age of Chaucer* 16 (1994): 119–42.

Riehle, Wolfgang. *The Middle English Mystics.* Trans. Bernard Standring. London: Routledge & Kegan Paul, 1981.

Rogers, William. *Interpretation in* Piers Plowman. Washington, DC: Catholic University of America Press, 2002.

Roney, Lois. *Chaucer's Knight's Tale and Theories of Scholastic Psychology.* Tampa: University of South Florida Press, 1990.

Roper, Gregory. "*Pearl*, Penitence, and the Recovery of the Self." *The Chaucer Review* 28.2 (1993): 164–86.

Ross, Ellen M.. "'She Wept and Cried Right Loud for Sorrow and for Pain': Suffering, the Spiritual Journey, and Women's Experience in Late Medieval Mysticism." In *Maps of Flesh and Light: The Religious Experience of Medieval Women Mystics.* Ed. Ulrike Wiethaus. Syracuse: Syracuse University Press, 1993. 45–59.

———. "Spiritual Experience and Women's Autobiography: The Rhetoric of Selfhood in *The Book of Margery Kempe.*" *Journal of the American Academy of Religion* 59.3 (1991): 527–46.

Ross, Robert C. "Oral Life, Written Text: The Genesis of *The Book of Margery Kempe.*" *The Yearbook of English Studies* 22 (1992): 226–37.

Rudd, Gillian. *Managing Language in* Piers Plowman. Cambridge: D. S. Brewer, 1994.

Russell, J. Stephen. *The English Dream Vision: Anatomy of a Form.* Columbus: The Ohio State University Press, 1988.

Schmitt, Miriam. "Gertrud of Helfta: Her Monastic Milieu and Her Spirituality." *Hidden Springs: Cistercian Monastic Women.* Ed. John A Nichols and Lillian Thomas Shank. Vol. 2. Kalamazoo: Cistercian Publications, 1995. 471–96.

Schnapp, Jeffrey T. "Introduction to *Purgatorio.*" In *The Cambridge Companion to Dante.* Ed. Rachel Jacoff. Cambridge: Cambridge University Press, 2007. 91–106.

Scott, Karen. "Mystical Death, Bodily Death: Catherine of Siena and Raymond of Capua on the Mystic's Encounter with God." In *Gendered Voices: Medieval Saints and Their Interpreters.* Ed. Catherine M. Mooney. Philadelphia: University of Pennsylvania Press, 1999. 114–46.

Simpson, James. "The Transformation of Meaning: A Figure of Thought in *Piers Plowman.*" *The Review of English Studies* 37.146 (1986): 161–83.

Spearing, A. C. "*The Book of Margery Kempe*; or, The Diary of a Nobody." *The Southern Review* 38 (2002): 625–35.

———. *The Gawain-Poet.* Cambridge: Cambridge University Press, 1970.

———. "Symbolic and Dramatic Development in *Pearl.*" In Sir Gawain *and* Pearl:

Critical Essays. Ed. Robert J. Blanch. Bloomington: Indiana University Press, 1966. 98–119.

———. *Textual Subjectivity: The Encoding of Subjectivity in Medieval Narratives and Lyrics.* Oxford: Oxford University Press, 2005.

Stakel, Susan. *False Roses: Structures of Duality and Deceit in Jean de Meun's Roman de la Rose.* Saratoga, CA: ANMA Libri and the Department of French and Italian Studies, Stanford University, 1991. Stanford French and Italian Studies Ser.

Staley, Lynn. *Margery Kempe's Dissenting Fictions.* University Park, PA: Pennsylvania State University Press, 1994.

———. "*Pearl* and the Contingencies of Love and Piety." In *Medieval Literature and Historical Inquiry: Essays in Honor of Derek Pearsall.* Ed. David Aers. Cambridge: D. S. Brewer, 2000. 83–114.

Stanbury, Sarah. *Seeing the* Gawain-*Poet: Description and the Act of Perception.* Philadelphia: University of Pennsylvania Press, 1991.

———. *The Visual Object of Desire in Late Medieval England.* Philadelphia: University of Pennsylvania Press, 2008.

Tambling, Jeremy. *Dante and Difference: Writing in the* Commedia. Cambridge: Cambridge University Press, 1988.

Taylor, Karla. *Chaucer Reads 'The Divine Comedy.'* Stanford: Stanford University Press, 1989.

Terrel, Katherine H. "Reallocation of Hermeneutic Authority in Chaucer's *House of Fame.*" *The Chaucer Review* 31.3 (1997): 279–90.

Ullén, Magnus. "Dante in Paradise: The End of Allegorical Interpretation." *New Literary History* 32 (2001): 177–190.

Vagaggini, Cyprian. *Theological Dimensions of the Liturgy.* Abr. ed. Vol. 1. Trans. Leonard J. Doyle. Collegeville, MN: Liturgical Press, 1959.

———. *Theological Dimensions of the Liturgy: A General Treatise on the Theology of the Liturgy.* Rev. ed. Trans. Leonard J. Doyle and W. A. Jurgens. Collegeville, MN: Liturgical Press, 1976.

Van Dyke, Carolynn. *Chaucer's Agents: Cause and Representation in Chaucerian Narrative.* Madison: Fairleigh Dickinson University Press, 2005.

Voaden, Rosalynn. "All Girls Together: Community, Gender and Vision at Helfta." In *Medieval Women in Their Communities.* Ed. Diane Watt. Toronto: University of Toronto Press, 1997. 72–91.

———. *God's Words, Women's Voices: The Discernment of Spirits in the Writing of Late-Medieval Woman Visionaries.* Woodbridge, UK: York Medieval Press, 1999.

Ward, Benedicta. "Julian the Solitary." In *Julian Reconsidered.* 2nd ed. Ed. Kenneth Leech and Benedicta Ward. Oxford: SLG Press, 1992. 11–29.

Watson, Nicholas. "The Composition of Julian of Norwich's *Revelation of Love.*" *Speculum* 68.3 (1993): 637–83.

———. "'Yf wommen be double naturelly': Remaking 'Woman' in Julian of Norwich's *Revelation of Love.*" *Exemplaria* 8.1 (1996): 1–34.

Wellek, René. "The *Pearl:* An Interpretation of the Middle English Poem." In *'Sir Gawain' and 'Pearl': Critical Essays.* Ed. Robert J. Blanch. Bloomington: Indiana University Press, 1966. 3–36.

Wilson, Edward. "Word Play and the Interpretation of *Pearl*." *Medium Aevum* 40.2 (1971): 116–34.

Wilson, Katharina M. *Medieval Women Writers*. Athens: University of Georgia Press, 1984.

Wimsatt, James I. *Allegory and Mirror: Tradition and Structure in Middle English Literature*. New York: Western Publishing Company, 1970.

Index

Abbott, Christopher, 85–86, 105n16, 114–15
Adams, Gwenfair Walters, 2n3, 219n24
affective experience, 23, 29, 53, 69, 70, 79–81, 83–84, 175–76, 215, 234–36; in *The Book of Margery Kempe,* 218, 222–23, 224, 229–30; in Julian of Norwich, 98, 100–104, 109, 115, 116, 215; in *Piers Plowman,* 163, 166–67, 168–70, 177, 181–82
Akbari, Suzanne Conklin, 181, 196n29, 199
Akel, Catherine, 213n12
Alain de Lille, 24
Alfonso de Jaen, 191
Alici, Luigi, 53
Allen, Peter L., 33n48
Amtower, Laurel, 199
The Apocalypse of Golias the Bishop, 13–15, 16–17, 26, 233
Aquinas, Thomas, 11, 18–19, 19–22, 42–43, 60, 93, 99, 173–76
Arnoul of Bohériss, 93
Atkinson, Clarissa, 215n17
audiences and readers: active reading and, 53–54, 59–60, 62; in *The Book of Margery Kempe,* 213–14, 222, 225, 228, 230; in *The House of Fame,* 26, 189–91, 192–93, 195, 197–98, 202–3, 206–7; in Julian of Norwich, 114, 118; in Marguerite d'Oingt, 50–51, 58–60, 62, 67, 68; of mystical visionary literature, 203–5
Augustine of Hippo, 11, 77n15, 100; concepts of *usi* and *frui,* 53, 64, 143–44, 150; devotional reading and, 52–53, 93; divine wisdom and, 80–81; on love,

123, 143–44; prayer and, 64; theories of language and signification, 50–51, 52–54, 62n40, 63–64, 65, 128, 144; on visions, 191–92
Avicenna, 29

Baker, Denise Nowakowski, 102, 106n21, 116, 160n14, 215
Bangert, Michael, 70n4, 72n5
Barratt, Alexandra, 79n24
Beal, Jane, 122n4, 125n8
Beatrice of Nazareth, 204
Bell, Catherine, 82–83
Benson, C. David, 155n5, 157, 167n28, 211n4
Bernard of Clairvaux, 70, 77n15, 157
Birgitta of Sweden, 16, 18, 26n33, 212–13
Blumenfeld-Kosinski, Renate, 7n15, 54, 55, 59, 63, 67
Boenig, Robert, 195
Boethius. See *De Consolatione Philosophiae*
Bogdanos, Theodore, 122n2, 139
The Book of the Duchess (Chaucer), 5, 153n4
The Book of Margery Kempe (Kempe), 11, 23, 208; affective experience in, 218, 222–23, 224, 229–30; audiences of, 213–14, 222, 225, 228, 230; clerical authority and, 209, 213–14, 216–19, 220–22, 223, 224, 227, 230; critical reception of, 11n19, 210–11; genre of, 3, 6, 11, 209, 210–14, 237n5; *The House of Fame* and, 208–10; *intellectus* and, 222–23; Lollardy and, 209, 215–16,

257